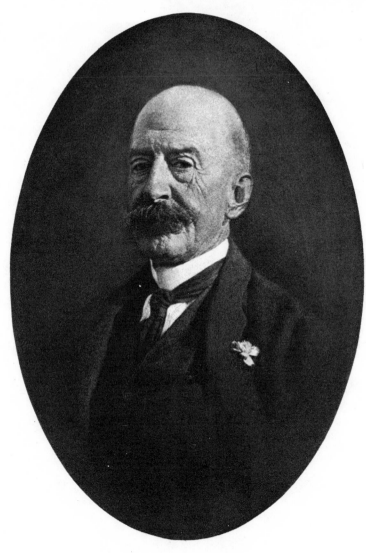

Winslow Homer

**PORTRAIT OF WINSLOW HOMER AT THE AGE
OF SEVENTY–TWO**

*From a photograph taken at Prout's Neck, Maine, in
1908. Photogravure*

THE LIFE AND WORKS
OF
WINSLOW HOMER

WILLIAM HOWE DOWNES

DOVER PUBLICATIONS, INC.
NEW YORK

Foreword to the Dover Edition Copyright © 1989 by Dover Publications, Inc.
All rights reserved under Pan American and International Copyright Conventions.

Published in Canada by General Publishing Company, Ltd.,
30 Lesmill Road, Don Mills, Toronto, Ontario.
Published in the United Kingdom by Constable and Company,
Ltd., 10 Orange Street, London WC2H 7EG.

This Dover edition, first published in 1989, is an unabridged
republication of the work originally published in 1911 by Houghton
Mifflin Company, Boston and New York. Some of the illustrations have been
moved from their original positions. The Foreword to the Dover Edition was
written specially for this edition by Bennard B. Perlman.

Manufactured in the United States of America
Dover Publications, Inc.
31 East 2nd Street
Mineola, N.Y. 11501

Library of Congress Cataloging-in-Publication Data

Downes, William Howe, 1854–1941.
The life and works of Winslow Homer / William Howe Downes.
p. cm.
Reprint, with new introd. Originally published: Boston :
Houghton Mifflin, 1911.
Bibliography: p.
Includes index.
ISBN 0-486-26074-7
1. Homer, Winslow, 1836–1910. 2. Painters–United States–
Biography. I. Title.
ND237.H7D6 1989
759.13—dc20

[B] 89-7722
 CIP

FOREWORD TO THE DOVER EDITION

WHEN this volume initially appeared in 1911, it represented the first full-length study of the life and works of Winslow Homer, whose death had occurred just the year before. Since then virtually every other biography of the artist has cited this book among its references.

The author, William Howe Downes (1854–1941), developed an early appreciation for the art of Winslow Homer (1836–1910), having once affirmed, "From my boyhood I loved his pictures." As art critic for *The Boston Transcript* from 1883 to 1922, Downes had ample opportunity to write about Homer and enthusiastically promoted him in other ways as well. On one occasion, when the Copley Society of Boston planned a Whistler exhibit only to find the artist uncooperative, it was Downes who suggested Homer as an alternate, providing a lengthy justification for the choice (unfortunately his advice was not heeded).

The artist recognized Downes's efforts, crediting him with "twenty-five years of hard work in booming my pictures," an activity that certainly contributed to Winslow Homer's reputation and success.

Homer's art is equally appealing in subject matter, design and technique. Beginning with his early illustrations for *Harper's Weekly*, he captured the essence of nineteenth-century rural America's active yet unhurried life. Homer's depictions of youngsters farming, swimming, gathering berries and just lolling about call to mind an observation in Whitman's *Leaves of Grass:* "Now I see the secret of the making of the best persons, / It is to grow in the open air, and to eat and sleep with the earth."

Homer's compositions are masterly, with shapes so arranged that the spectator's eye is directed around and through the pictures. Unusual vantage points, the visual extension of existing lines and striking, asymmetrical balance combine to heighten the dramatic force of his works. The watercolors, purposely lacking in finish, possess a spontaneous quality and dry-brush sparkle unusual in their day, a time when technical brilliance and academic perfection were virtually defined by the meticulous execution of exacting detail.

Because of the author's exhaustive research—he elicited observations and reminiscences from the artist's brothers, nephews, friends and acquaintances, as well as numerous museum and art gallery officials—there are descriptions and anecdotes that were initially recorded here. Downes's portrayal of Homer's eight-by-ten-foot portable studio—it was placed on runners and moved along the rocky ledges of Prout's Neck, enabling the artist to paint his close-up masterpieces of thrashing sea and plunging surf—allows the reader to witness an artistic drama as it unfolds.

The Winslow Homer story is significantly aided by a plentiful supply of illustrations, over one hundred in number. Some of them are quite unusual, such as a pencil drawing produced when the artist was only eleven and identified as "the earliest of his works now in existence." Not only is it an anatomically convincing depiction of four playmates engaged in the then-popular game of Beetle and Wedge, but the figures are competently drawn, logically shaded and placed in a believable landscape. This piece is illustrative of the precocious ability of the young Homer; others his age would have been expected merely to copy from reproductions. He also possessed a methodical mind belying his years, as evidenced by the inclusion of a key at the bottom of the picture identifying the foursome he had sketched.

When William Howe Downes sought permission from Homer

in August 1908 to write this book, the artist demurred, saying, "The most interesting part of my life is of no concern to the public." Besides, he added, "I am making arrangements to live as long as my father and both my grandfathers, all of them over eighty-five." Homer died two years later, at the age of seventy-four, and Downes decided to proceed with his project. We are indeed beneficiaries of that decision.

BENNARD B. PERLMAN
Baltimore

ACKNOWLEDGMENTS

THE author is grateful to all those persons who have aided him in the preparation of this biography. To Winslow Homer's two brothers he owes especially cordial thanks. Mr. Charles S. Homer has been most kind in lending indispensable assistance and most patient in answering questions. Mr. Arthur B. Homer with fortitude has listened to the reading of the entire manuscript, and has given wise and valuable counsel and criticism. To Mr. Arthur P. Homer and Mr. Charles Lowell Homer of Boston the author is indebted for many useful suggestions and interesting reminiscences. Mr. Joseph E. Baker, the friend and comrade of Winslow Homer in his youth, and his fellow-apprentice in Bufford's lithographic establishment in Boston, from 1855 to 1857, has supplied interesting data which could have been obtained from no other source. Mr. Walter Rowlands, of the fine arts department of the Boston Public Library, has made himself useful in the line of historic research, for which his experience admirably qualifies him, and has gone over the first rough draft of the manuscript and offered many friendly hints and suggestions for its betterment. Thanks are due to Mr. Thomas B. Clarke of New York, who has freely placed at the disposal of the author all his stores of information, and has liberally offered a mass of material for illustrative purposes. To Mr. John W. Beatty, director of fine arts, Carnegie Institute, Pittsburgh, warm acknowledgments are made for his constant and generous interest.

Mr. William V. O'Brien of Chicago, Mr. Burton Mansfield

of New Haven, Mr. Ross Turner of Salem, Mr. William J. Bixbee of Marblehead, Mr. Harrison S. Morris of Philadelphia, Messrs. T. Gerrity, Gustav Reichard, J. Nilsen Laurvik, Sidney W. Curtis, Bernard Devine, and C. Klackner, all of New York, Messrs. Doll & Richards of Boston, Mr. J. W. Young of Chicago, Mr. J. H. Gest of the Cincinnati Museum Association, Mr. Bryson Burroughs of the Metropolitan Museum of Art, and the officers of the art museums of Boston, Philadelphia, Chicago, Providence, Washington, Milwaukee, and Worcester are also to be mentioned among those whose coöperation has been of value.

To the courtesy and kindness of these and other men, whatever merit the history of Winslow Homer's life may possess is very largely due. Without their help the difficulties would have been immeasurably greater. Only a year ago, it would have been impossible to gather sufficient authentic first-hand information to construct any definite and connected account of Homer's life. With admirable loyalty his brothers have scrutinized every personal detail with sole regard to what he would have been likely to approve, and the family habit of reserve in such matters is strong. The best things are often those which do not get into print. The reader has the privilege of reading between the lines, and if he chooses to exercise it here, he will find nothing but what is creditable and honorable to Winslow Homer.

BOSTON, *March* 1, 1911.

CONTENTS

INTRODUCTORY NOTE. xv

CHAPTER I. THE ARTIST AND THE MAN.

Winslow Homer's Chief Titles to Fame — His Individuality and
Americanism — The Poetry of Real Life — Single-mindedness —
Painter of the Ocean — Adverse Criticism — Personal Character
and Traits — Kindness and Charity — Love of Flowers — Sense
of Humor 3

CHAPTER II. EARLY DAYS IN BOSTON AND CAMBRIDGE.
1836–1859. To the Age of 23.

The Homer Family — Winslow Homer's Parents — His Birth-
place — Removal to Cambridge — School Days — Juvenile Draw-
ings — "Beetle and Wedge" — Apprenticed to Bufford — First
Drawings Published — Studio in Boston 21

CHAPTER III. NEW YORK — THE GREAT WAR.
1859–1863. Ætat. 23–27.

Studio in Nassau Street — Studio in the University Building,
Washington Square — Bohemian Life — His Friends — Lincoln's
Inauguration — McClellan's Peninsular Campaign — First Oil
Paintings — "The Sharpshooter on Picket Duty" — "Rations"
— "Defiance" — "Home, Sweet Home" — "The Last Goose
at Yorktown". 34

CHAPTER IV. EARLY WORKS.
1864–1871. Ætat. 28–35.

Pictures of Camp Life — Made an Academician — "The Bright
Side" — "Pitching Quoits" — "Prisoners from the Front" —
First Voyage to Europe — What he did not do — "The Sail-
Boat" — Drawings for "Every Saturday". 51

CHAPTER V. LIFE IN THE COUNTRY.

1872–1876. Ætat. 36–40.

Studio in West Tenth Street — "New England Country School" — "Snap the Whip" — A Summer on Ten-Pound Island — The Gloucester Watercolors — Urban Subjects — Last of the "Harper's Weekly" Drawings — "The Two Guides" — Relations with La Farge 69

CHAPTER VI. AMONG THE NEGROES.

1876–1880. Ætat. 40–44.

"The Visit from the Old Mistress" — "Sunday Morning in Virginia" — "The Carnival" — An Episode in Petersburg — The Model who Ran Away — The Houghton Farm Watercolors — "The Shepherdess of Houghton Farm" — "The Camp Fire" — Gloucester again — Homer's Mastery in Composition . . . 85

CHAPTER VII. TYNEMOUTH — THE ENGLISH SERIES.

1881–1882. Ætat. 45–46.

The Dwelling at Cullercoates — "Watching the Tempest" — "Perils of the Sea" — "A Voice from the Cliffs" — "Inside the Bar" — A Turning-Point in the Artist's Career — Watercolors Dealing with Storms and Shipwrecks 99

CHAPTER VIII. PROUT'S NECK.

1884. Ætat. 48.

How the Homer Brothers discovered and developed a Summer Resort in Maine — Description of the Place — Winslow Homer's Studio — His Garden — His Way of Living — Identification of his Masterpieces with Prout's Neck 109

CHAPTER IX. "THE LIFE LINE."

1884. Ætat. 48.

The Story-Telling Picture — Sources of Prejudice against it — Various Comments on and Descriptions of "The Life Line" — Exhibitions in Boston — An Anecdote of a Commission for a Picture which was declined 120

CHAPTER X. Nassau and Cuba.

1885–1886. Ætat. 49–50.

A Winter in the Bahamas and the South Coast of Cuba — The Color of the Tropics — "Searchlight, Harbor Entrance, Santiago de Cuba" — "The Gulf Stream" — Later Trips to Nassau, Bermuda and Florida 128

CHAPTER XI. Marine Pieces with Figures.

1885–1888. Ætat. 49-52.

"The Fog Warning" — "Lost on the Grand Banks" — "Hark! the Lark" — "Undertow" — "Eight Bells" — The Genesis of a Deep-Sea Classic 137

CHAPTER XII. Etchings — Paintings of the Early Nineties.

1888–1892. Ætat. 52–56.

The Series of Reproductions of his Own Paintings — "Cloud Shadows" — "The West Wind" — "Signal of Distress" — "Summer Night" — "Huntsman and Dogs" — "Coast in Winter" 150

CHAPTER XIII. Milestones on the Road of Art.

1893–1894. Ætat. 57–58.

Honors at the World's Columbian Exposition — "The Fox Hunt" — "Storm-Beaten" — "Below Zero" — "High Cliff, Coast of Maine" — "Moonlight, Wood Island Light" — Adirondacks Watercolors 165

CHAPTER XIV. The Portable Painting-house.

1895–1896. Ætat. 59–60.

"Northeaster" — "Cannon Rock" — The First Journey to the Province of Quebec — "The Lookout — All's Well!" — "Maine Coast" — "The Wreck" — "Watching the Breakers" — Honors at Pittsburgh and Philadelphia — "Hauling in Anchor" — Mr. Turner's Reminiscences of Homer 176

CHAPTER XV. THE GREAT CLIMACTERIC.

1896–1901. Ætat. 60–65.

Reminiscences of Mr. Bixbee — Winslow Homer and his Father — On the Pittsburg Jury — "Flight of Wild Geese" — "A Light on the Sea" — Sale of the Clarke Collection — Honors in Paris — "Eastern Point" — "On a Lee Shore" — Letters — A Shipwreck 198

CHAPTER XVI. THE O'B. PICTURE.

1901–1903. Ætat. 65–67.

The Process of Making the "Early Morning after Storm at Sea" — A Peep behind the Scenes — A Lesson in Etiquette — The Temple Gold Medal — Off for Key West 212

CHAPTER XVII. HOURS OF DESPONDENCY.

1904–1908. Ætat. 68–72.

"Kissing the Moon" — An Unfinished Picture — Atlantic City — Advancing Age — "I no longer paint" — "Early Evening" — "Cape Trinity" — The Loan Exhibition in Pittsburg — First Serious Sickness — Letters 223

CHAPTER XVIII. INCIDENTS OF THE LAST YEARS.

1908–1910. Ætat. 72–74.

Aversion for Notoriety — The Rubber-Stamp Signature — Characteristic Sayings — Mural Paintings — "Right and Left" — "Driftwood" — Foreign Opinion — Dread of Counterfeiters — Mr. Macbeth's Visit — Questions that were never Answered . . . 237

CHAPTER XIX. HOMER'S DEATH.

1910. Ætat. 74.

The Last Sickness — Heart Failure — A Glorious Passing — The Funeral — Burial Place at Mount Auburn — His Will — The Memorial Exhibitions of 1911 in New York and Boston — The Verdict . 250

CONTENTS xi

APPENDIX 273

List of Pictures by Winslow Homer exhibited in the Exhibitions of the National Academy of Design, New York, from 1863 to 1910 276

List of Watercolors by Winslow Homer exhibited at the Exhibitions of the American Watercolor Society, New York, from 1867 to 1909 278

List of Oil Paintings by Winslow Homer exhibited at the Exhibitions of the Pennsylvania Academy of the Fine Arts, Philadelphia, from 1888 to 1910 282

List of Works exhibited by Winslow Homer in the Exhibitions of the Society of American Artists, New York, from 1897 to 1903 . 283

List of Oil Paintings and Watercolors by Winslow Homer in the Collection of Mr. Thomas B. Clarke of New York 283

List of Works in the Loan Exhibition of Oil Paintings by Winslow Homer held at the Carnegie Institute, Pittsburg, Pennsylvania, in May and June, 1908 285

List of Works in the Winslow Homer Memorial Exhibition held in the Metropolitan Museum of Art, New York, February 6 to March 19, 1911 286

List of Works in the Winslow Homer Memorial Exhibition held in the Museum of Fine Arts, Boston, February 7 to March 1, 1911 288

BIBLIOGRAPHY 291

INDEX 297

ILLUSTRATIONS

PORTRAIT OF WINSLOW HOMER AT THE AGE
OF SEVENTY-TWO FRONTISPIECE
*From a photograph taken at Prout's Neck, Maine, in
1908. Photogravure*

BEETLE AND WEDGE; OR, THE YOUTH OF
C. S. H. PAGE 4
*Pencil drawing made by the artist at the age of eleven,
the earliest of his works now in existence. Made at
Cambridge in 1847. By permission of Mr. Arthur B.
Homer, Quincy, Massachusetts*

PORTRAIT OF WINSLOW HOMER AT THE AGE
OF TWENTY-ONE 5
*Pencil drawing made in Boston from life in 1857 by Joseph
E. Baker. By permission of Mrs. Joseph De Camp*

PORTRAIT OF WINSLOW HOMER AT THE AGE
OF FORTY-TWO 12
*From a photograph taken by Sarony in 1878. Courtesy
of Mr. Charles S. Homer*

PORTRAIT OF WINSLOW HOMER AT ABOUT
THE AGE OF THIRTY-FOUR 12
Courtesy of the New York Herald

A FAMILY GROUP: THE HOMERS AT PROUT'S
NECK 12
*From a photograph taken in 1896. (Charles Savage
Homer, Senior, Charles Savage Homer, Junior, Wins-
low Homer, Arthur B. Homer, Arthur P. Homer,
Charles L. Homer)*

WINSLOW HOMER AND HIS FATHER AND HIS
DOG SAM 13
*From a photograph taken at Prout's Neck by S. Towle.
Courtesy of Mr. C. S. Homer*

A GOOD CATCH: WINSLOW AND CHARLES S.
HOMER RETURNING FROM A DAY'S FISH-
ING 13
From a photograph. Courtesy of Mr. Charles S. Homer

AN IMPROMPTU LECTURE ON ART: WINSLOW
HOMER AND HIS MAN-SERVANT LEWIS 20
From a photograph

PORTRAIT OF WINSLOW HOMER IN HIS STU-
DIO AT PROUT'S NECK, SCARBORO, MAINE 20
*From a photograph. Taken while he was painting "The
Gulf Stream"*

WINSLOW HOMER AND HIS STONE WALL 21
*From a photograph taken at Prout's Neck, December 2,
1902. On the back of the original print is written, in the
artist's own handwriting: "Photo of stone wall built by
Winslow Homer. Taken on Dec. 2, 1902. This poor old
man seen here is* WINSLOW HOMER, SCARBORO, ME.*"
(Rubber stamp signature.) Courtesy of Mr. William V.
O'Brien, Chicago*

THE STUDIO AT PROUT'S NECK 21
*From photographs taken in 1910. The east and the
southwest views*

MOUNT WASHINGTON 28
*From the oil painting in the collection of Mrs. W. H. S.
Pearce, Newton, Massachusetts. Photograph by Chester
A. Lawrence*

FEEDING THE CHICKENS 28
From the oil painting in the collection of Mr. Arthur B.
Homer. Painted at Belmont, Massachusetts, about 1858.
The model for the figure was the present owner of the pic-
ture. Photograph by Chester A. Lawrence, Boston

MILITARY PASS ISSUED TO WINSLOW HOMER
FROM THE PROVOST MARSHAL'S OFFICE
IN WASHINGTON, APRIL 1, 1862 29
Courtesy of Mr. Arthur B. Homer

RATIONS 38
From the oil painting in the collection of Mr. E. H. Bern-
heimer, New York

THE BRIGHT SIDE 38
From the oil painting in the collection of Mr. W. A.
White

A WINTER MORNING—SHOVELING OUT 39
From a drawing engraved on wood by G. A. Avery for
Every Saturday, *Boston, January 14, 1871*

CUTTING A FIGURE 39
From a drawing engraved on wood by W. H. Morse for
Every Saturday, *Boston, February 4, 1871*

GATHERING BERRIES 46
From a drawing engraved on wood for Harper's Weekly,
July 11, 1874

A COUNTRY STORE — GETTING WEIGHED 46
From a drawing engraved on wood by W. J. Linton for
Every Saturday, *Boston, March 25, 1871*

FLIRTING ON THE SEASHORE AND ON THE
MEADOW 46
From a drawing engraved on wood for Harper's Weekly,
September 19, 1874

SNAP THE WHIP 47
*From the oil painting in the collection of Mr. Richard
H. Ewart, New York*

GLOUCESTER HARBOR 56
*From the drawing in the collection of Mr. Horace D.
Chapin, Boston. Photograph by Chester A. Lawrence*

GLOUCESTER HARBOR 56
*From the watercolor belonging to the Edward W.
Hooper estate, Boston. Photograph by Chester A. Law-
rence*

BOYS SWIMMING 57
*From the drawing belonging to the Edward W. Hooper
estate, Boston. Photograph by Chester A. Lawrence*

BOY WITH SCYTHE 57
*From the drawing belonging to the Edward W. Hooper
estate, Boston. Photograph by Chester A. Lawrence.*

RAID ON A SAND–SWALLOW COLONY — "HOW
MANY EGGS?" 64
From a drawing engraved on wood for Harper's Weekly,
June 13, 1874

WAITING FOR A BITE 65
From a drawing on wood by Lagarde for Harper's
Weekly, *August 22, 1874*

SEESAW — GLOUCESTER, MASSACHUSETTS 65
From a drawing engraved on wood for Harper's Weekly,
September 12, 1874

THE SAND DUNE 72
*From the oil painting in the collection of Mr. Arthur B.
Homer. Painted at Marshfield, Massachusetts. Wins-
low Homer's mother posed for the figure. Photograph by
Chester A. Lawrence, Boston*

ON THE BEACH AT MARSHFIELD 72
*From the oil painting in the collection of Mr. Arthur B.
Homer. Photograph by Chester A. Lawrence, Boston*

THE CARNIVAL 73
*From the oil painting in the collection of Mr. N. C.
Matthews, Baltimore, Maryland*

THE VISIT FROM THE OLD MISTRESS 73
*From the oil painting in the permanent collection of the
National Gallery of Art, Washington. William T. Evans'
gift*

A HAPPY FAMILY IN VIRGINIA 80
*From the oil painting in the collection of Colonel Frank
J. Hecker, Detroit*

LITTLE ARTHUR IN FEAR OF HARMING A
WORM 81
*From the drawing in the collection of Mr. Arthur B.
Homer. Photograph by Chester A. Lawrence, Boston*

LITTLE CHARLIE'S INNOCENT AMUSEMENTS 81
*From the drawing in the collection of Mr. Arthur B.
Homer. Photograph by Chester A. Lawrence, Boston*

THE HONEYMOON (MR. AND MRS. A. B. HOMER) 81
*From the drawing in the collection of Mr. Arthur B.
Homer. Made at Kettle Cove, Prout's Neck, Maine,
1875. Photograph by Chester A. Lawrence, Boston*

FISHERWOMEN, TYNEMOUTH 88
*From the drawing in the collection of Mr. William
Howe Downes. Photograph by Chester A. Lawrence,
Boston*

WATCHING THE TEMPEST 88
*From the watercolor in the collection of Mr. Burton
Mansfield, New Haven, Connecticut*

PERILS OF THE SEA 89
From the etching by Winslow Homer, after his water-
color in the collection of Mr. Alexander C. Humphreys,
M.E., Sc.D., LL.D., President of the Stevens Institute
of Technology, Castle Point, Hoboken, New Jersey.
Copyright by C. Klackner, New York

MENDING NETS; OR, FAR FROM BILLINGSGATE 96
From the watercolor in the collection of Mr. Charles W.
Gould, New York

SHIPWRECK 97
From the drawing in the collection of Mrs. Roger S.
Warner, Boston. (Inscribed: "Wreck of the Iron Crown,
Tynemouth, Oct. 25, 1881.") Photograph by Chester A.
Lawrence

FISHERWOMAN, TYNEMOUTH 97
From the watercolor belonging to the Edward W. Hooper
estate, Boston. Photograph by Chester A. Lawrence

RETURNING FISHING BOATS 104
From the watercolor in the collection of Mr. Horace D.
Chapin, Boston. Photograph by Chester A. Lawrence

STORM ON THE ENGLISH COAST 104
From the watercolor in the collection of Mrs. Roger S.
Warner, Boston. Photograph by Chester A. Lawrence

STORM AT SEA 105
From the drawing in the collection of Mrs. Roger S.
Warner, Boston. Photograph by Chester A. Lawrence

THREE GIRLS 105
From the drawing in the collection of Mrs. Roger S.
Warner, Boston. Photograph by Chester A. Lawrence

THE LIFE LINE 114
From the etching by Winslow Homer, after his oil paint-

ing in the collection of Mr. G. W. Elkins. Copyright by
C. Klackner, New York

GOING BERRYING 115
From the watercolor in the collection of Mr. Horace D.
Chapin, Boston. Photograph by Chester A. Lawrence

BAHAMA 115
From the watercolor belonging to the Edward W. Hooper
estate, Boston. Photograph by Chester A. Lawrence

ILLUSTRATION TO WILLIAM CULLEN BRY-
ANT'S POEM, "THE FOUNTAIN" 115

ON THE FENCE 115
From the watercolor in the collection of Mr. William
Howe Downes. Painted at Houghton Farm, Mountain-
ville, New York, in 1878. Photograph by Chester A.
Lawrence, Boston

CUSTOM HOUSE, SANTIAGO DE CUBA 122
From the watercolor in the collection of Mrs. Roger S.
Warner, Boston. Photograph by Chester A. Lawrence

UNDER A PALM TREE 122
From the watercolor in the collection of Mr. F. Rocke-
feller, Cleveland, Ohio

MARKET SCENE, NASSAU 122
From the watercolor in the collection of Mr. R. A.
Thompson

THE GULF STREAM 123
From the oil painting in the permanent collection of the
Metropolitan Museum of Art, New York

THE FOG WARNING 130
From the oil painting in the permanent collection of the
Museum of Fine Arts, Boston

BANKS FISHERMEN; OR, THE HERRING NET 131
From the oil painting in the collection of Mr. Charles W. Gould, New York

HARK! THE LARK 138
From the photogravure, copyright by Winslow Homer and published by C. Klackner, New York, after the oil painting in the permanent collection of the Layton Art Gallery, Milwaukee, Wisconsin

UNDERTOW 139
From the oil painting in the collection of Mr. Edward D. Adams, New York

EIGHT BELLS 146
From a wood engraving by Henry Wolf, after the oil painting by Winslow Homer in the collection of Mr. Edward T. Stotesbury, Philadelphia. Courtesy of the Century Company, New York

TO THE RESCUE 147
From the oil painting in the collection of Mr. Thomas L. Manson, Jr., New York

MOONLIGHT, WOOD ISLAND LIGHT 147
From the oil painting in the collection of Mr. George A. Hearn, New York

ROWING HOMEWARD 154
From a watercolor

CLOUD SHADOWS 154
From the oil painting in the collection of Mr. R. C. Hall, Pittsburg, Pennsylvania

SUMMER SQUALL 155
From the oil painting in the collection of Mr. Morris J. Hirsch, New York

SUNLIGHT ON THE COAST 155
From the oil painting in the collection of Mr. John G. Johnson, Philadelphia

THE WEST WIND 162
From the oil painting in the collection of Mr. Samuel Untermeyer, New York

THE SIGNAL OF DISTRESS 163
From the oil painting in the collection of Mr. Edward T. Stotesbury, Philadelphia

A SUMMER NIGHT 170
From the oil painting in the Luxembourg Museum, Paris

HOUND AND HUNTER 171
From the oil painting in the collection of Mr. Louis Ettlinger, New York

HUNTSMAN AND DOGS 178
From the oil painting in the collection of Mrs. Bancel La Farge

THE TWO GUIDES 178
From the oil painting in the collection of Mr. C. J. Blair, Chicago

THE FOX HUNT 179
From the oil painting in the permanent collection of the Pennsylvania Academy of the Fine Arts, Philadelphia. By permission. Copyright by Pennsylvania Academy of the Fine Arts

BELOW ZERO 186
From the oil painting in the possession of M. Knoedler and Company

WEATHER–BEATEN; OR, STORM–BEATEN 186
From the oil painting in the collection of Mr. F. S. Smithers, New York

ON THE CLIFF 186

From the watercolor in the collection of Mr. Thomas L. Manson, Jr., New York

HIGH CLIFF, COAST OF MAINE 187

From the oil painting in the permanent collection of the National Gallery, Washington, D. C. Gift of Mr. William T. Evans

THE FISHER GIRL 194

From the oil painting in the collection of Mr. Burton Mansfield, New Haven, Connecticut

SALMON FISHING 195

From the watercolor in the collection of Colonel Frank J. Hecker, Detroit

ADIRONDACKS 195

From the watercolor belonging to the Edward W. Hooper estate, Boston. Photograph by Chester A. Lawrence

WATERFALL, ADIRONDACKS 202

From the watercolor in the collection of Mr. Charles L. Freer, Detroit

NORTHEASTER 203

From the oil painting in the permanent collection of the Metropolitan Museum of Art, New York

CANNON ROCK 212

From the oil painting in the permanent collection of the Metropolitan Museum of Art, New York

SHOOTING THE RAPIDS 213

From the watercolor in the collection of Mrs. J. J. Storrow Boston. Photograph by Chester A. Lawrence

THE PORTAGE 213

From the watercolor in the collection of Mr. Desmond

FitzGerald, Brookline, Massachusetts. Photograph by
Chester A. Lawrence

THE LOOKOUT — ALL'S WELL 220
From the oil painting in the permanent collection of the
Museum of Fine Arts, Boston

FAC–SIMILE OF A LETTER FROM WINSLOW
HOMER TO THE AUTHOR 224

THE MAINE COAST 228
From the oil painting in the collection of Mr. George A.
Hearn, New York

THE WRECK 229
From the oil painting in the permanent collection of the
Carnegie Institute, Pittsburg, Pennsylvania

WATCHING THE BREAKERS: A HIGH SEA **236**
From the oil painting in the collection of Mrs. H. W.
Rogers

HAULING IN ANCHOR 237
Watercolor in the permanent collection of the Cincin-
nati Museum Association. Painted at Key West

A LIGHT ON THE SEA 237
From the oil painting in the permanent collection of the
Corcoran Gallery of Art, Washington

RIGHT AND LEFT 244
From the oil painting in the collection of Mr. Randal
Morgan, Philadelphia

FLIGHT OF WILD GEESE 244
From the oil painting in the collection of Mrs. Roland
C. Lincoln, Boston. Photograph by Baldwin Coolidge

ON A LEE SHORE 245
From the oil painting in the permanent collection of the
Rhode Island School of Design, Providence, Rhode Island

EARLY MORNING AFTER STORM AT SEA 252
From the oil painting in the collection of Mr. W. K.
Bixby, Saint Louis

KISSING THE MOON; OR, SUNSET AND MOON-
RISE 253
From the oil painting in the collection of Dr. Lewis A.
Stimson, New York

EARLY EVENING 260
From the oil painting in the collection of Mr. Charles L.
Freer, Detroit

CAPE TRINITY, SAGUENAY RIVER 261
From the oil painting in the collection of Mr. Burton
Mansfield, New Haven, Connecticut

DRIFTWOOD 261
From the oil painting in the collection of Mr. Frank L.
Babbott, Brooklyn, N. Y.

RUM CAY, BERMUDA 266
From the watercolor in the permanent collection of the
Worcester Art Museum. Copyright, Detroit Publishing
Company

BOYS AND KITTEN 266
From the watercolor in the permanent collection of the
Worcester Art Museum. Copyright, Detroit Publishing
Company

SHOOTING THE RAPIDS, SAGUENAY RIVER 267
From the unfinished oil painting, given to the Metropoli-
tan Museum of Art, New York, by Mr. Charles S.
Homer, in 1911

INTRODUCTORY NOTE

IT is an agreeable task which the author of this volume
has invited me to perform, the writing of a few lines of
introduction to his book. It is especially pleasant be-
cause it affords me the opportunity to express briefly my
high opinion of Winslow Homer's power as a painter and
of the frank and forceful character of the man.

The dominating trait of Homer's character was honesty,
and this priceless characteristic colored every act of his life
and found abundant expression in his art. His mind operated
in a direct and forceful manner, and sincerity was expressed
in everything he did or said.

The basis of his art, I think, was simple truth ; and this
quality, easily comprehended by all, was that which made
Homer's paintings universally popular and easily under-
stood. Truth, in whatever form, needs no explanation, being
its own best interpreter.

No one, I think, was ever heard to talk about Homer's
manner of painting, or about his technical skill, as of special
importance. It was always the verity of the work, or the
dignity and grandeur of the ocean, often expressed by him
without apparent effort, but always in a perfectly direct and
simple manner, which was the theme of conversation.

He approached nature as a child might, without a thought
of displaying technical dexterity, and he transmitted or re-
produced that which impressed him with simplicity and with
a devotion akin to unquestioning reverence. Never did the
thought of taking from or of adding to that which was his
task seem to occur to him for a moment.

Notwithstanding this mental attitude, he was exacting to the last degree in the selection of the particular phase or effect of nature which he desired to reproduce. On one occasion he said : —

"The rare thing is to find a painter who knows a good thing when he sees it."

I also recall his statement that he had waited six months for the coming of a particular effect or expression of nature. To lie in wait for the rare or exceptional phase of nature, and especially the dramatic, and to reproduce with fidelity and power the effect waited for or discovered, seemed to be Homer's purpose, especially during the latter years of his life. Thus it is that many of his paintings represent the tempestuous ocean.

Indeed, when I knew him he was comparatively indifferent to the ordinary and peaceful aspects of the ocean, referring once to the sea as a "mill pond," as if it possessed little interest for him in that mood. But when the lowering clouds gathered above the horizon, and tumultuous waves ran along the rock-bound coast and up the shelving, precipitous rocks, his interest became intense.

There came one morning at Prout's Neck, with a misty and threatening sky, when gray clouds, bewitching in their silvery tones, went hurrying across the troubled sea. By noon it was blowing a gale, and the waves were lashing the coast, sending spray high into the air. The driving rain slanted sharply under porch and awning, and the summer boarders gathered about wood fires, with complaining voices. Once and again, great clouds of mist drove across the deserted rocks, and the music of old ocean rose to an ominous and resounding tone. Nothing could have induced a soul to go forth, save only a mission of mercy ; but at three o'clock

Homer hurried into my room, robed from head to foot in rubber, and carrying in his arms a storm-coat and a pair of sailor's boots. "Come!" he said, "quickly! It is perfectly grand!"

For an hour we clambered over rocks, holding fast to the wiry shrubs which grew from every crevice, while the spray dashed far overhead. This placid, reserved, self-contained little man was in a fever of excitement, and his delight in the thrilling and almost overpowering expression of the ocean, as it foamed and rioted, was truly inspiring.

There comes to my mind an incident which will illustrate his unyielding attitude towards absolute truth. On the occasion of one of my visits to his home, we were picking our way along the coast, over the shelving rocks he painted so often and with such insight and power, when I suddenly said : —

"Mr. Homer, do you ever take the liberty, in painting nature, of modifying the color of any part?"

The inquiry seemed to startle him. Arresting his steps for an instant, he firmly clenched his hand, and, bringing it down with a quick action, exclaimed : —

"Never! Never! When I have selected the thing carefully, I paint it exactly as it appears." Turning towards his studio, and pointing to the gallery which hangs along the second story, he added: "When I was painting the Luxembourg picture, I carried the canvas, repeatedly, from the rocks below, hung it on that balcony, and studied it from a distance with reference solely to its simple and absolute truth. Never!" he reiterated, as we moved on in the direction of the sea.

Winslow Homer was extremely reluctant to express any opinion touching his art; and indeed in the latter years of his life he rigorously avoided the subject. This frank and

emphatic expression, which seemed to comprehend and express a profound conviction, was doubtless called forth by the apparent folly of my question. I will admit that the provocation was great, and that the query belied my innermost belief touching the essential quality in art.

Notwithstanding Homer's sturdy character, as illustrated by these incidents, there was another side of his nature. His intense fondness for flowers was but one expression of his gentler side. There could not be a more thoughtful host, and his solicitude and delicate attentions were almost womanly in their charm. Not a single morning passed by during my several visits when he did not present to me, with his greeting, a few flowers, and with the members of his family this was his daily custom.

He was reticent, probably morose to some extent, but never uncharitable. I do not recall a harsh criticism spoken by him in reference to the work of any fellow painter.

Not all of Homer's pictures are equal in technical qualities, but those of his later and most powerful period, among which may be included the "High Cliff, Coast of Maine," now in the National Gallery at Washington, are masterly works. He painted the inspiring grandeur and dignity of the ocean with a power not excelled by any painter in the entire history of art, and he has left a rich legacy and an inspiring record.

JOHN W. BEATTY.

THE LIFE AND WORKS OF
WINSLOW HOMER

THE LIFE AND WORKS OF WINSLOW HOMER

CHAPTER I

THE ARTIST AND THE MAN

Winslow Homer's Chief Titles to Fame — His Individuality and Americanism — The Poetry of Real Life — Single-mindedness — Painter of the Ocean — Adverse Criticism — Personal Character and Traits — Kindness and Charity— Love of Flowers — Sense of Humor.

THE life of Winslow Homer, as revealed in his works, is a study worthy of the serious attention of the historian and critic. I bring to this labor of love at least one valid qualification, that is to say, a lifelong interest in and enthusiastic admiration for his works.

Winslow Homer is an important figure in the annals of American art, and the period in which he lived and wrought, the last half of the nineteenth century, produced no American painter so thoroughly national in style and character. He was the most original American painter of that time, and at the same time the most representative. His art was intensely personal and intensely American. These two pre-eminent qualities are his chief titles to fame.

Through the last half of the nineteenth century American art was gradually finding itself. One of the results of the Civil War was a heightened national consciousness which found expression in art. George Inness, William Morris Hunt, John La Farge, Eastman Johnson, George Fuller, and

Augustus Saint-Gaudens are of the illustrious names which belong to this period. But none of these artists was either as individual or as national as Winslow Homer. His contribution is new, fresh, novel, has nothing of foreign tradition in it. It therefore marks a distinctly significant evolution, and takes a conspicuous place in a historic sense. Up to the time of Winslow Homer's appearance on the stage of events, our art had been in great measure a reflection of the European traditions. It did not lack cleverness, elegance, charm; in individual instances it did not lack passion, power, poetry; but — speaking in terms of broad generalization — it lacked a vernacular accent. It was, in a word, eclectic.

It is Winslow Homer's distinction that he was the first American painter to use an American idiom. Not only his subjects, but his manner of treating them; not only his motives, but his point of view; not only his material, but the style and sentiment in which he clothes it, have the stamp of Americanism indelibly impressed on them.

To say that his style is American, is to say that it is new, unrelated in its externals to the traditions of painting in Europe and Asia, though its content may be, of course, as old as the search for truth, which has always existed. It is an American trait to ignore the processes and experiences of older races and communities, to try for results without studying into the means used by older civilizations in reaching the same goals; and in some departments of human activity this trait must assuredly be set down as costly and foolish. But in the art of painting it has manifest advantages. One of these is the disciplinary effect of the independent and unaided struggle to invent the means of expression; "he that overcometh shall inherit all things." The easy way is to acquire the trick of the trade from some

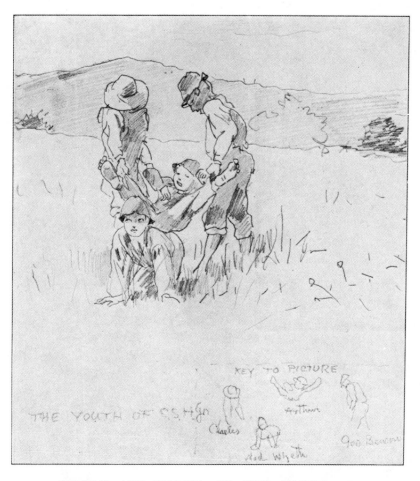

BEETLE AND WEDGE; OR, THE YOUTH OF C. S. H.

Pencil drawing made by the artist at the age of eleven, the earliest of his works now in existence. Made at Cambridge in 1847. By permission of Mr. Arthur B. Homer, Quincy, Massachusetts

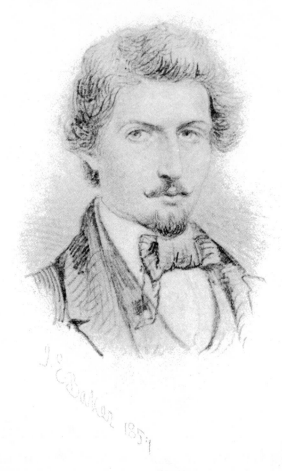

PORTRAIT OF WINSLOW HOMER AT THE AGE
OF TWENTY-ONE

Pencil drawing made in Boston from life in 1857 by Joseph
E. Baker. By permission of Mrs. Joseph De Camp

skillful master; it is a specious but delusive policy. Oddly enough, one painter can learn but little that is worth while, in technical matters, from another painter, at least so far as practice is concerned. This is why the schools of art do not educate the art student. Every painter has to begin at the beginning and construct his world for himself. He stands or falls by his own degree of personal capacity to create his own language, for if he uses a vocabulary already current, he is merely an echo of an echo.

Winslow Homer created his method of painting as truly as Velasquez created his method, that is to say, from the very ground up. The same spirit of truth animated both these men. They were equally loyal to the light within. They obeyed the injunction, "Be thou strong and very courageous, that thou mayest observe to do according to all the law; turn not from it to the right hand or to the left." Different as these men were, both dealt exclusively with realities — visible, tangible, material realities; they painted only what they saw; and their works illustrate the good old adage that truth is stranger than fiction, in the sense that it is more interesting.

It would be a mistake to suppose that the work of the exponent of realities is necessarily wanting in the element of poetry. Real life is not without poetry; far from it. The poet is he who discovers the interesting and beautiful aspect of common and everyday things. It is because Winslow Homer possessed in an exceptional degree simplicity of spirit, love of truth, and single-mindedness, that his work so abounds in the unexpectedness of the usual. The newness of the impression arises, not from the novelty of the subject-matter, but from the personal point of view of the painter. The poetry of rhythm is frequently felt in his design, which

is noble, plastic, and of monumental breadth. But a still more essential poetry is that of "the still, sad music of humanity" which makes itself manifest in his pictures of men in their age-long and unending struggle to bend the forces of nature to their uses.

And, if it would be an error to suppose that he who deals in realities must needs be prosaic, it would be also dangerous to assume that a painter whose vision is so unprejudiced and sane and penetrating, whose attachment to simple truth is so evident, and whose works all have to do with the life of to-day, is destitute of imagination. On the contrary, Winslow Homer's ability to perceive the scene in its integrity, the vivid and convincing appearance of actuality that he imparted to form, movement, and color, are so many implications of the high attributes of imagination in the artist. But the unique and individual quality of imagination in his case precluded any tampering with the truth. He saw and felt the tremendous significance of the visible world, and he disdained all puerile attempts to improve upon the works of God. He understood instinctively that —

> To gild refined gold, to paint the lily,
> To throw a perfume on the violet,
> To smooth the ice, or add another hue
> Unto the rainbow, or with taper-light
> To seek the beautous eye of heaven to garnish,
> Is wasteful and ridiculous excess.

Thus his relations with Mother Nature, his only teacher, were those of a beautifully docile and humble student. In reality he had no other teacher. He belonged to no school. He leaves no pupils, no followers. In nature and life he found all the beauty, interest, and meaning that he so simply and sincerely expressed in his pictures. His style is the nat-

ural and necessary exterior form of his unique and solitary temperament. It is characterized by invariable honesty and seriousness, by an intuitive sense of self-respect and high reserve. Unsentimental, but far from unfeeling, his sympathies were for the natural, primitive, elemental, universal things in men and landscape alike. He was singularly gifted with the faculty of seeing these great things in their stark integrity, and of giving to their physical embodiments that air of individual distinction which is so often a concomitant of simplicity and modesty.

I have spoken of his single-mindedness. His was a career in which no side issues, no distractions, no wavering of the will, no possible question about the aim of effort, the goal to be sought, were suffered to interrupt the steady, resolute, tenacious progress from stage to stage, from the day of small things to that of great things. He knew from the outset what he wanted to do, and he went about the doing of it with a deadly seriousness. He taught himself to draw. All men who would learn to draw must needs do likewise. Drawing did not come easily to him. Does it to any one? There is no royal road to art. We speak with bated breath of the self-made man ; but are not all men self-made, if they are made at all? Surely, Winslow Homer's school was not the class-room, nor did he choose to avail himself of the customary advantages of professional training, and possibly that is one of the very reasons why he could make the best of himself. The man was indomitable. Obstacles only stimulated his ambition. His academy was the real world ; it was everywhere and at all times his atelier, for he worked at all hours and places. Art was his vocation. He did not choose it. It chose him.

From the beginning his art concerned itself with the lives

of men and women, and more particularly with soldiers, sailors, fishermen, and their wives and children ; woodsmen, hunters, pioneers, farmers, and, in general, the people who live and labor in the open. The landscape background against which the human figures are projected has a large importance and a great significance ; the environment of the soldier being the camp, the bivouac, the entrenchments ; that of the sailor the deck of the ship at sea ; that of the fisherman his fishing smack or dory ; that of his women-folk the fishing village or the harbor or the beach ; that of the woodsman, guide, and hunter, the wilderness of Canada or Maine or the Adirondacks ; while the farmer is shown at his work in the fields. It is not always possible to say definitely whether the landscape or the figures in it play the dominant part in the composition, so inextricably knit together are the elements which unite in the pictorial ensemble. Oftenest it is the man or the men, doubtless, who occupy, as it were, the middle of the stage. But the setting is never a negligible quantity. On the contrary, it is made to enhance, to explain, even to exalt the actor ; to supplement and complete the impression made by him ; to throw new light upon his vocation and kindle the imagination of the observer as to its possibilities in the promotion of manly virtues.

The early drawings contributed to "Harper's Weekly" during the Civil War possess a double title to our interest. They are first-hand documents concerning that greatest of our wars, and they illustrate from month to month just how the young artist was acquiring his training. The seventeen years of drudgery (if it was drudgery), when he was obliged to make his way by doing black-and-white work for the illustrated press, proved to be the severest and most useful course of practice for a painter, more prolonged, more ardu-

ous, and more tangible in its results, than any possible schooling in a regular art academy. Nature was the model, and he drew from nature in every imaginable phase : the human figure, animals, landscape, marines, everything that came in his way. Consider the immense range of his subject-matter from the beginning : camp life in Virginia, negro genre, rustic life and farm episodes in New England, hunting and fishing scenes in the North Woods and the Province of Quebec, the life of the sailor and fisherman both afloat and ashore, the tropical life and scenery of the Bahama Islands, Cuba, Key West, and Florida, city street scenes in New York and Boston, the American summer resorts and watering places, — and verily it seems as if he might have taken for his motto : *Humani nihil alienum.*

As the painter of the ocean, Winslow Homer stands preeminent. There have been many marine painters of ability in the history of nineteenth-century art, but there is only one Winslow Homer. The painter of "The Maine Coast," "On a Lee Shore," "Cannon Rock," "The West Wind," "High Cliff, Coast of Maine," and "A Summer Night" is *sui generis.* Other men have given excellent interpretations of the sea in its moods of peace or storm, calm or fury; I would not disparage their achievements by invidious comparisons; American artists have won legitimate laurels in this difficult field of effort, — there is glory enough for them all.

In Homer's marine pieces there is the consummate expression of the power of the ocean. The subject may be and often is storm and stress, but the most violent manifestations of what we call the anger of the wind and wave are interpreted without exaggeration. In the very "torrent, tempest, and whirlwind of [his] passion" he had the temperance that gave

it smoothness; he did not o'erstep the modesty of nature.
The weight and thrust of an Atlantic billow, the rush and
turmoil of the surf, the dynamic force of the pounding seas
in a winter gale, are realized in his paintings with an invig-
orating vividness, it is true, but the synthetic method by
which his art conveys such impressions is the result of a life-
long course of patient observation and experimentation; the
instantaneous vision of a huge toppling breaker, the affair
of the fraction of a second, may have cost the close study of
years. It is natural to be carried away by the sheer strength
and swiftness of the movement of these ocean symphonies,
but the wonderful things about them, after all, are their deli-
cacy and reserve. The artist found a way to simplify the
complexities of a motive which abounds in perplexing cross-
currents and eddies, to reduce a seeming chaos to order, to
suggest beneath the apparent anarchy of troubled waters the
universal reign of law. Though he must have felt the exhila-
ration caused by extraordinary manifestations of natural forces,
such as a northeaster on the coast of Maine, his style, free
from the spectacular, remains natural. The tempest's rage is
not in his blood; calm in the midst of its violence, his hand
and eye are steady, and his work betrays neither agitation
nor haste. Nothing but truth endures. It is sufficient. The
art which rests on that lives and will live.

I think we can read between the lines in Homer's works a
conviction of the superiority of nature to art. He realized,
with Emerson, that "the best pictures are rude draughts of
a few of the miraculous dots and lines and dyes which make
up the everchanging 'landscape with figures' amidst which
we dwell." He measured his success as a painter, not by those
standards which are in the last analysis a group of memories
of pictures, but by the degree of the exactitude with which

he was able to give the look of nature in his own terms. Now, this loyalty to the naked truth is not a common trait in painters. No doubt they all profess it ; they all aspire to it ; but it is not given to many to attain to it. How much of this was an inborn gift it is not for any man to say.

Every original artist's work has the defects of its merits — a paradox which contains a germ of truth. It is not to be expected that the productions of a painter like Homer shall escape adverse criticism. There are many artists who are quite ready to outlaw a painter whose methods are so antagonistic to all their preconceived ideas and principles. Homer offended many of his professional brethren by his aggressive individuality. His way of doing things was in itself an offense to the mediocre painter. Yet there were also artists of mark and likelihood, themselves original and independent searchers for truth, who failed to understand him and his art ; and I need not say that the loss was theirs. His lofty indifference to what other men in the profession were doing was, of course, hard to hear. If it was regarded as a pose, never was there a graver mistake. He was incapable of posing. It was, however, a part of a settled and consciously adopted policy. When he was an apprentice in Bufford's lithograph shop in Boston, at the age of nineteen, he said to J. Foxcroft Cole : "If a man wants to be an artist, he must never look at pictures."

The adverse criticisms on his work may be summed up in a few quotations from the writings of three critics. Mr. Isham [1] speaks of Homer's "ignorance of or indifference to what other men have done before." But the rest of the sentence shows such a keen realization on Mr. Isham's part of the

[1] *The History of American Painting*, by Samuel Isham. New York : The Macmillan Company, 1905.

advantages of that ignorance or indifference, that the comment, taken in its entirety, amounts to a complete æsthetic justification of the painter's ignorance or indifference. Indeed, Mr. Isham's judicial estimate of the peculiar artistic merits to be found in certain of Homer's pictures wherein "things which have been generally accepted as impossible of representation" have been admirably achieved, seems to be a virtual vindication of ignorance. I do not, however, accept this unpleasant word, in connection with Homer's mental attitude towards the works of other men. He was not ignorant concerning what other men had done; and if he was indifferent, as we have every reason for supposing he was, it was because he found Nature so much more interesting and the study of it so much more profitable for his own purposes. He did not turn his back on the traditions of the art of painting because of any feeling of disdain, but in accordance with a deep-seated policy and purpose, and that policy and purpose were worked out with triumphant success.

Mrs. Van Rensselaer [1] alludes to Homer's early pictures as crude, harsh, and awkward, but admits that there was the true breath of life in them. Like Mr. Isham, her animadversion has the advantage of suggesting its own rejoinder. For who would not pardon a good deal of crudity, harshness, and awkwardness in any picture, provided it had the true breath of life in it? The critic should beware of the error of looking for drawing-room graces and refinements in a man whose art is concerned with larger and more universal interests. I was once in a picture gallery where a fine Millet was on exhibition, and heard a solemn person say: "How much more in-

[1] *Six Portraits*, by Mrs. Schuyler Van Rensselaer. Boston and New York: Houghton, Mifflin & Co., 1894.

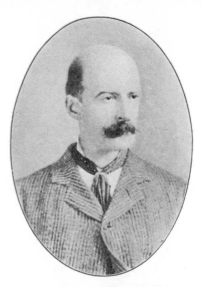

PORTRAIT OF WINSLOW
HOMER AT THE AGE
OF FORTY–TWO

*From a photograph taken by
Sarony in 1878. Courtesy
of Mr. Charles S. Homer*

PORTRAIT OF WINSLOW
HOMER AT ABOUT THE
AGE OF THIRTY-FOUR

*Courtesy of the New York
Herald*

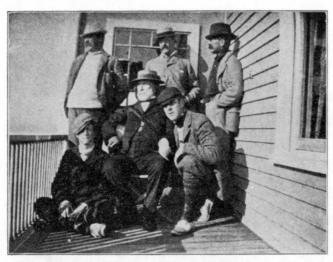

A FAMILY GROUP: THE HOMERS AT
PROUT'S NECK

*From a photograph taken in 1896. (Charles Savage
Homer, Senior, Charles Savage Homer, Junior,
Winslow Homer, Arthur B. Homer,
Arthur P. Homer, Charles L. Homer)*

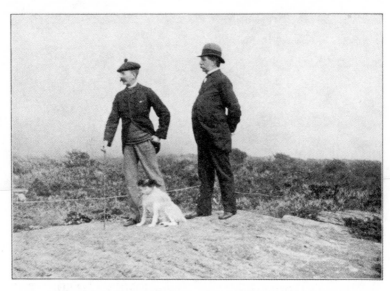

WINSLOW HOMER AND HIS FATHER AND HIS
DOG SAM

From a photograph taken at Prout's Neck by S. Towle.
Courtesy of Mr. C. S. Homer

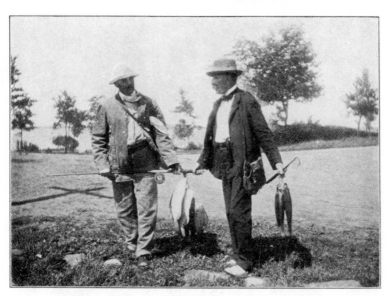

A GOOD CATCH: WINSLOW AND CHARLES S
HOMER RETURNING FROM A DAY'S FISH–
ING

From a photograph. Courtesy of Mr. Charles S. Homer

teresting Millet's paintings would have been if he had painted a better class of people!"

Leila Mechlin,[1] writing of Homer's oil paintings, has said that "there is none who, from the technical standpoint, commonly paints more hatefully than he." Again, she has said: "Apparently the mode of delivery does not concern him beyond the point of sincerity and truth." And again: "In his method of rendering Mr. Homer outrages the strongest convictions of perhaps nine tenths of the present-day painters." I dissent most emphatically from each and all of these assumptions. The charge of painting "hatefully" cannot be taken seriously: this is one of those things that one would have wished to express otherwise. Yet beneath the infelicity of the adverb there is a real censure, and the expression of a real dislike, which is to be regretted. One man's method of painting differs from another's, as one man's handwriting differs from another's, but to assert that this method is the right one and that the wrong one is to perpetrate a critical puerility. As for the mode of delivery, why should it concern him or any one "beyond the point of sincerity and truth"? It would be difficult to specify any convictions regarding methods of painting which would be agreed upon by nine tenths of the present-day painters, but even were this possible, it would by no means follow that their technical standpoint was the only tenable one, or that it would be incumbent upon a Winslow Homer to conform to it. The assumption here is that there is one correct and orthodox method of workmanship in painting, but I am sure that Miss Mechlin is too intelligent to be willing to go on record as holding any such view as that.

In painting, as in other fields of effort, results are what count, and all honorable means are open to the worker. More

[1] *Winslow Homer*, by Leila Mechlin. The International Studio, June, 1908.

than in most lines of human activity, in the art of the painter is it true that the tree is known by its fruit. Moreover, it is impossible to lay down a hard and fast line of demarcation between the mode of expression and the thing expressed, as we see it in the finished work. Therefore, if the result is satisfactory, if the effect intended is produced, if the picture has power and veracity, nobility and authority, it is idle to scrutinize the brushwork to see whether it has been done in accordance with any individual's or school's notions of the best ways and means. For in these things the painter, if he be worth any notice at all, is a law unto himself.

Homer's personal character was inevitably embodied in his works. He had an insurmountable aversion to the kind of publicity which concerns itself with personal matters, and indeed the intensity of his feeling on this subject amounted to eccentricity. The isolation of his life at Prout's Neck for the last twenty-seven years was significant of the mental attitude that his temperament imposed upon him with respect to society. He was from his earliest youth jealous of his independence, and he guarded it with instinctive vigilance against intrusion. It was neither chance nor design that led him to pass so much of his time in solitude ; it was his own obedience to the laws of his nature. Exceptional men are justified in adopting an exceptional mode of life, and the artist has the right to surround himself with safeguards against all manner of interruptions, distractions, and frictions, which may impair his capacity for sustained work. He has to be his own judge as to the means to this end. If his work is of paramount importance, all minor interests must yield to it. But the solitude of Winslow Homer was never irksome to him : he had resources within himself. The sea was there. He tended his little garden. He made frequent journeys to

the Adirondacks, to Canada, to Nassau, to Florida, and his mind was always full of projects for work.

He was, probably, all his life, more or less of a problem, even to the friends who thought they knew him best. Most of us need human companionship; he appeared to feel no need for it. He was, in a sense, self-sufficient. He was sometimes brusque in his manner, but he never was intentionally rude or unkind. He never said a harsh thing without quickly repenting it and offering the *amende honorable*. Beneath the crust of reticence, indifference, and coldness, there was a fund of genuine kindness, which extended to the humblest of his acquaintances. He would go out of his way to show attention and courtesy to the most insignificant persons, surprising and touching them by the evident sincerity of his interest in them. Instances of his stealthy manner of doing good to poor and sick persons are numerous. He took extraordinary pains not to let his left hand know what his right hand was doing.

There was an intemperate old man living in Scarboro, whose wife finally left him, and who became such an inveterate victim of alcoholism, that he could get no regular employment, because no one could rely upon him. He lived miserably, alone, in a hut, and there seemed to be no hope and no future for him. Now, just at the time when it seemed to this outcast that the world had no more use for him, and that all men despised him, Winslow Homer gave him some work to do, — odd chores about the garden, say, and he also taught him to pose as a model. In some mysterious way the influence of Homer over this man became so strong, that it seemed as if he could do what he liked with him; and the poor old sinner was so grateful and so loyal, that he would have gladly laid down his life for his friend. He did more

than that, — he succeeded in keeping sober whenever he was working for Homer, a miracle of self-control.

Another instance will serve to demonstrate that there was a beautiful side of Winslow Homer's character which the world never knew. One of his nephews, hard hit by a financial disaster, and too proud to ask for aid so long as he had a pair of strong arms to work with, had gone to Wilmington, Delaware, in 1900, and got a job at ten dollars a week. As long as he had his health, that was enough to support him, but he fell sick, and, what with doctors' bills and the long enforced loss of wages, he was near being in a very tight sort of place. Still, he did not let his people know anything about his condition, and one day he was very much astonished to receive a letter bearing a Florida postmark and running as follows : —

"DEAR ——, — No thanks for the enclosed.
 UNCLE WINSLOW."

"The enclosed" was a substantial check, which was enough to pay off the young man's debts and set him squarely on his feet. I leave the reader to imagine whether that youth loved and honored the uncle. In telling me of it, he said, with the characteristic terseness of the Homers, "It was like him. A kinder man never walked the earth."

Another incident remains to be recorded which serves to show this tender and beautiful side of his character in a new light. A lady living in New York, who was afflicted by an incurable malady, and who had seen some of his pictures at one of the loan exhibitions of the Union League Club, was deeply desirous to possess one of his Prout's Neck subjects, but, feeling that she could not perhaps afford to pay the full

price for it, she resolved to write to the artist, and frankly to
lay before him the passionate admiration she entertained for
his work, her unfortunate situation, and the yearning of her
heart to own a Winslow Homer before she died. It appears
that she had been born in Maine, and her longing for a pic-
ture of that rugged coast where she had spent her childhood
made her bold enough to address a personal appeal to the
artist. Her letter was for some months unanswered, but at
last a letter came, accompanied by three sketches of the
Maine coast, which Homer presented to her with his com-
pliments, making light of his generosity by saying that he
was "quite through with them." His letter was as follows: —

SCARBORO, MAINE, *Sept.* 14, 1906.
MRS. GRACE K. CURTIS,

DEAR MADAM, — I have at last received your request of
last winter. As I am never here after Nov. 1st until the next
spring, about May, and as I never have my mail sent to me,
I missed receiving your letter.

I now send to you with my compliments three sketches of
the Maine coast. I am quite through with them and I take
pleasure in presenting them to you.

Yours very truly,

WINSLOW HOMER.

Two weeks later he wrote again: —

SCARBORO, MAINE, *Sept.* 27, 1906.
MRS. GRACE K. CURTIS,

DEAR MADAM, — I consider myself very much honored
by the receipt of this beautiful Portrait. It was delayed at the
station for my signature (four miles from my home). I shall
treasure it highly, and I am so glad to have for a few mo-

ments diverted your thoughts from the unfortunate condition that you mention in regard to your health.

Yours respectfully,

WINSLOW HOMER.

The next letter, five months later, was addressed to the lady's husband, and runs thus : —

February 23, 1907.

MR. SIDNEY W. CURTIS,

MY DEAR SIR, — I appreciate your attention in calling on me, and I sincerely thank Mrs. Curtis for sending me these fine grapes. It is now fifteen days since I sprained my ankle very badly. It will take quite a long time to fully recover its use. I have been downstairs only twice, but am improving rapidly; in the meantime I do not feel like receiving any company. When I do, I will with pleasure let you know and make an appointment.

Yours very truly,

WINSLOW HOMER.

" I am so glad — " These heartfelt words of sympathy tell the whole story. They reveal

> that best portion of a good man's life,
> His little, nameless, unremembered acts
> Of kindness and of love.

Winslow Homer liked the society of common people, the working classes, the rough, homely, uneducated folk, better than that of the "nice people." His old comrade, Joseph E. Baker, speaking of the summer that he passed at Gloucester and Annisquam in 1880, remarked: "He knew plenty of nice people, but he associated with two fishermen, and preferred their company." An amusing instance of his fondness

for the society of plain people is best given in the very words of another informant : —

"Old —— was a butcher, who used to come around to Prout's Neck with his wagon, and Winslow Homer bought chickens and so forth from him. Now, you know, Homer would never let any one criticise his paintings, even if he let any one in the studio at all, but it is a fact that he would have old —— in there sometimes a whole hour at a time, sitting and smoking with him, and he would let him tear his pictures all to pieces."

I have an idea that the butcher was not so incisive a critic as his profession would seem to indicate he might be.

Winslow Homer was passionately fond of flowers. He had a garden at Prout's Neck, and he built a high fence all around it so that no one could see him when he was in it. He cultivated old-fashioned flowers, such as English primroses, cinnamon pinks, etc. He also raised vegetables for his own table. When any one was sick, he took great pains to send flowers daily. His sister-in-law had a tedious illness one summer, and every morning a quaint nosegay of old-fashioned flowers came to the door, borne by the artist in person ; in fact, he came twice a day to ask after her health, and the morning bouquet was never forgot. If he went to make a call upon a lady, — a rare event, — he always made it a point to carry a nosegay from his garden for his hostess.

To those who were privileged to know him he was the soul of fine feeling and gentle courtesy. He did not wear his heart upon his sleeve, but there was not a particle of misanthropy in his nature. He was so constituted that any kind of feigning was positively impossible to him. There was no humbug in him or about him, and he could not tolerate any kind of falseness. He was in every respect a gentleman, and

he possessed a strong sense of honor. He was himself under all circumstances, — genuine, natural, unaffected. Self-respect and independence were among his most noticeable traits of character.

Homer was an indefatigable worker. It is hardly an exaggeration to say that he worked all the time. He was always planning pictures and drawings, always looking for subjects, always absorbed in his work, which was his very life. Somebody once asked him where he got his talent. "Talent!" he said. "There's no such thing as talent. What they call talent is nothing but the capacity for doing continuous hard work in the right way." This definition is at least more exact than the often-quoted maxim about genius which runs very much to the same effect.

To his other personal characteristics Homer added a very marked sense of humor. He had a quaint, solemn way of saying the most whimsical and delightful things, and he could utter stinging sarcasms without a smile. His sense of humor kept him from taking himself or anybody else too seriously. He detested hypocrisy and pretence of all kinds, and his preference for the society of humble folk was mainly due to their plain, blunt, and candid character and conversation. He rarely talked about himself or his work. His art was sacred to him; it was his religion. Whether the public liked his pictures or not seemed to be a matter of indifference to him. During his early professional life in New York his work was sometimes severely criticised, but this appeared to make no impression upon him whatever. He was conscious of his own powers, but he was not moved either by praise or censure. The most enthusiastic compliments from his friends seldom elicited anything more than a grunt from him.

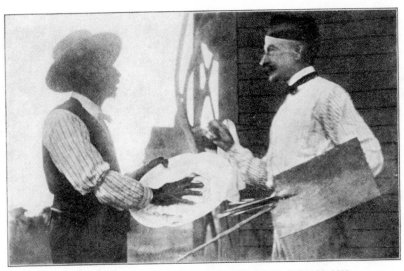

AN IMPROMPTU LECTURE ON ART: WINSLOW
HOMER AND HIS MAN–SERVANT LEWIS
From a photograph

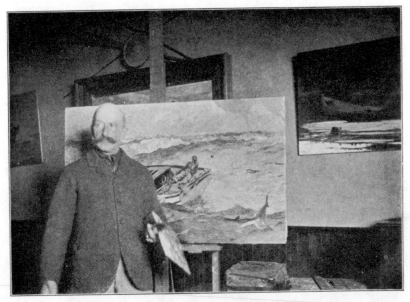

PORTRAIT OF WINSLOW HOMER IN HIS STU-
DIO AT PROUT'S NECK, SCARBORO, MAINE
*From a photograph. Taken while he was painting " The
Gulf Stream"*

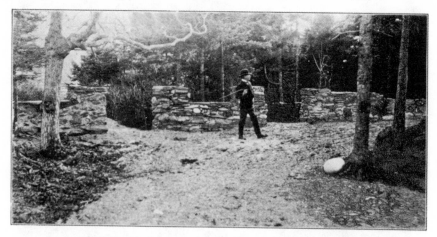

WINSLOW HOMER AND HIS STONE WALL

*From a photograph taken at Prout's Neck, December 2, 1902. On the
back of the original print is written, in the artist's own handwrit-
ing: "Photo of stone wall built by Winslow Homer. Taken
on Dec. 2, 1902. This poor old man seen here is* WINS-
LOW HOMER, SCARBORO, ME." *(Rubber stamp
signature.) Courtesy of Mr. William V.
O'Brien, Chicago*

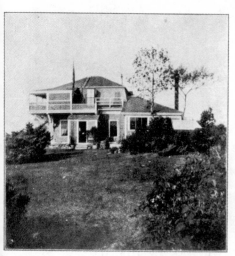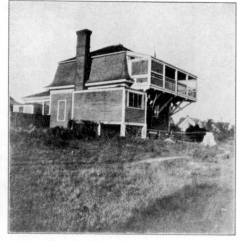

THE STUDIO AT PROUT'S NECK

From photographs taken in 1910. The east and the southwest views

CHAPTER II

EARLY DAYS IN BOSTON AND CAMBRIDGE

1836–1859. To the Age of 23

The Homer Family — Winslow Homer's Parents — His Birthplace — Removal to Cambridge — School Days — Juvenile Drawings — " Beetle and Wedge " — Apprenticed to Bufford — First Drawings Published — Studio in Boston.

THE Boston of 1836 was a snug little seaport town, confined for the most part to the peninsula between the harbor and the Charles River, a picturesque site, with its three hills and its irregular water-front. Well-to-do persons still lived at the North End and the old West End on the Northern side of Beacon Hill. In the network of narrow and crooked streets lying between Faneuil Hall and Causeway Street was situated the modest dwelling-house in which Charles Savage Homer and his family lived, No. 25 Friend Street, and there, on February 24, 1836, Winslow Homer was born. To-day the place is a grimy, noisy business thoroughfare, in the heart of the downtown trade quarter, near the North Station. All the old residences have disappeared, and on the spot where No. 25 Friend Street stood in 1836 there is now a plain five-story brick business building.

The family was of good old New England stock. The Homers have lived in Massachusetts for more than two hundred and fifty years. The first member of the family to come to America, Captain John Homer, was an Englishman, who crossed the Atlantic in his own ship, landed at Boston

in the middle of the seventeenth century, and settled there. From him was descended the family to which Winslow Homer belonged. Eleazer and Mary (Bartlett) Homer, Winslow Homer's grandfather and grandmother, were living in a house which stood at the corner of Hanover and Union Streets, Boston, in 1809, when Charles Savage Homer, Winslow's father, was born. The date of Charles Savage Homer's birth was March 7, 1809. The homestead in Hanover Street was a comfortable house, with a garden. Charles Savage Homer married Henrietta Maria Benson, the daughter of John and Sarah (Buck) Benson, who was born in Bucksport, Maine, in 1809. Her mother's father was the man for whom the town of Bucksport, Maine, was named. Both the Homers and the Bensons were vigorous, sturdy, long-lived people. Both of Winslow Homer's grandfathers lived to be over eighty-five, and his father died at the age of eighty-nine.

Winslow was the second of three sons. His elder brother, Charles Savage Homer, Junior, was his senior by two years, and his younger brother, Arthur B., was born five years after Winslow's birth. Among the boys' relations was a sailor, their father's brother, James Homer, known to them as Uncle Jim. With this uncle, however, Winslow never had any intercourse worth mentioning. Uncle Jim owned a barque, and made voyages to Cuba and other West Indian islands. Winslow Homer, speaking of his ancestry, once remarked, in a tone of dry humor, that he had been looking up his family tree, but when he got back two or three generations he discovered that one of his ancestors was a pirate, and he did not dare to look any farther. This did not refer to his Uncle Jim, however, but to his Grandfather Benson, and the dim legend about his being a pirate rests upon such a

feeble foundation that it must be dismissed as a very foggy sort of yarn. John Benson was neither a pirate nor a sailor; he was just a simple Down-East storekeeper.

Winslow Homer's father was a hardware merchant. His firm was that of Homer, Gray & Co., importers of hardware, 13 Dock Square (now Adams Square). Later the firm name was changed to Holmes & Homer, and again to Homer & Layton, and finally it became Charles Savage Homer. The store was moved from Dock Square to Merchants' Row. In 1849, the year of the discovery of gold in California, Mr. Homer sold out his hardware business, and made a journey to California by the way of the Isthmus of Panama in the interest of the Fremont Mining Company. He loaded a vessel at Boston with mining machinery, and sent it around Cape Horn to the Pacific Coast; he proceeded by the shorter route himself, and was gone two years; but the venture was unsuccessful. When he arrived in California he found that the claim of the company in which he was interested had been "jumped," and his efforts to regain possession of the property were unavailing. It is recalled that when he set out for the Pacific Coast his baggage was impressive in its newness, brass-bound trunks eliciting the admiration of the boys, but when he came back two years later his gripsack was tied with a string. Mr. Homer is described by his contemporaries as having been a handsome man, of dignified presence. Mrs. Homer was a gracious, gentle lady, who had a pretty talent for painting flower pieces in watercolors. So interested was she in this work that she took lessons in painting after she was married. Many of her flower pieces, which are altogether excellent as studies, are still piously preserved by her sons.

During the years that the Charles Savage Homer family

lived in Boston and Cambridge, in the first half of the nineteenth century, they were a migratory people, after the American fashion, and lived in seven different houses. After leaving the Grandfather Homer homestead in Hanover Street, at the time of his marriage, Charles Savage Homer established himself in Howard Street, where his oldest son was born in 1834. The removal to No. 25 Friend Street soon followed. Both of these locations were convenient with respect to Mr. Homer's place of business in Dock Square. But from the Friend Street house, not long after Winslow's birth, in 1836, the Homers moved to a new home at No. 7 Bulfinch Street, near Bowdoin Square. There the youngest son was born, in 1841, and there the family lived until Winslow was six years old, when they moved to Cambridge, in 1842. This move was made chiefly for the purpose of giving the three boys educational advantages; but, as it turned out, only the oldest son, Charles S. Homer, Junior, proved to be of sufficient tenacity as a student to go to college. He entered Harvard, and was graduated from the Lawrence Scientific School, with the degree of S. B., in 1855. The two younger boys were destined to acquire their knowledge for the most part outside of the usual academic channels.

The new home in Cambridge was in Main Street (now Massachusetts Avenue), in a big wooden house with a pseudo-classical portico, opposite the end of Dana Street, on the south side of the street. That part of Old Cambridge was in 1842 not radically different from what it is now, barring the recent innovations in the way of underground transit; but a little farther out it had all the characteristics of a roomy, umbrageous, overgrown village; and the opportunities for fishing, boating, and other rural sports dear to the heart of boyhood, were eagerly seized by the Homer boys. The early

years of Winslow's life, which were passed here, until he
went to work at Bufford's, were always looked back upon
with pleasure in after years, as a period of joyous freedom,
and we may be sure that the beautiful surroundings had
their part in the formation of the boy's tastes and tendencies.
From the Massachusetts Avenue house the Homers shortly
moved to a more comfortable home in Garden Street, next
door to the Fay house, where now stands the principal
building of Radcliffe College, facing the spacious Common,
and very near the Washington Elm.

Winslow was now sent to the Washington Grammar
School, in Brattle Street, near Harvard Square. His school-
mates remember him as a quiet, sedate, undemonstrative
lad, with straight dark brown hair and dark brown eyes. He
was, even as early as 1847, when he was only eleven years
old, fond of drawing sketches. Thirty years later he told
his friends that he had still kept a heap of crayon draw-
ings of his own, made in the Cambridge school-days, each
drawing being carefully signed and dated. The most unusual
part of the proceeding, however, for a boy of eleven, was that
he actually drew from life, and did not make copies of other
pictures. Among the juvenile drawings which date from
about this period are "A Man with a Wheelbarrow" which
was drawn from a living model, and "The Beetle and
Wedge," or, as the youthful artist himself called it, "The
Youth of C. S. H.," representing a group of four school-
boys playing that impish game, which requires four partici-
pants, one to play the part of the wedge, one to serve as the
beetle, and the other two to bring the beetle and wedge into
violent collision. This drawing, which is the earliest work of
Winslow Homer now in existence, is a very remarkable
piece of work for a boy of eleven to have produced, as will

be acknowledged by every one. At the lower right-hand corner of the design a "key to the picture," introduced evidently as an afterthought, identifies the four boy models. The two bigger boys are Charles Homer and George Benson, a cousin. The hapless beetle is little Arthur Homer, then nine years of age, and the wedge is Ned Wyeth. To compose a group of four figures and to draw them from life, with a broadly suggested landscape background of hills, is certainly one of the most astonishing manifestations of artistic precocity on record; and we note in this juvenile effort the forerunner of the picture of "Snap the Whip" and several similar subjects.

"His father encouraged his leaning towards art, and on one occasion, when on a visit to Paris, sent him a complete set of lithographs by Julian — representations of heads, ears, noses, eyes, faces, houses, trees, everything that a young draughtsman might fancy trying his hand at — and also lithographs of animals by Victor Adam, which the son hastened to make profitable use of. At school he drew maps and illustrated text-books stealthily but systematically."[1]

On the strength of the suggestion conveyed in this last statement, Mr. McSpadden[2] draws a fanciful word picture of the scene in the Cambridge school-room, when young Homer is discovered making surreptitious sketches on the margins of his text-books, and is ignominiously sent into the dunce corner as a punishment.

In 1855, when Winslow Homer was nineteen, and his father was thinking of trying to obtain a job for the boy as a salesman in a Cambridge haberdashery, an unexpected oppor-

[1] *Art Journal*, London, August, 1878.

[2] *Famous Painters of America*, by J. Walker McSpadden. New York: Thomas Y. Crowell & Co.

tunity arose to place the lad as an apprentice in a lithographer's shop in Boston. Bufford, the proprietor of this establishment, whose place of business was at the corner of Washington and Avon streets, advertised for a boy who must "have a taste for drawing." It seems that Bufford was a friend of Charles Savage Homer, and a member of the volunteer fire company of which the latter was foreman. Application was made forthwith to Bufford, and the boy was accepted on trial for two weeks.

"He suited, and stayed for two years, or until he was twenty-one. He suited so well, indeed, that his employer relinquished the bonus of three hundred dollars usually demanded of apprentices in consideration of their being taught a trade. His first work was designing title-pages for sheet-music ordered by Oliver Ditson of Boston, 'Katy Darling' and 'Oh, Whistle and I'll Come to You, my Lad' being the subjects of his initial efforts in this direction. Bufford assigned to him the more interesting kinds of pictorial decorations, leaving such avocations as card-printing to the other apprentices. His most important triumph at the lithographer's was the designing on stone of the portraits of the entire Senate of Massachusetts. But his sojourn there was a treadmill existence. Two years at that grindstone unfitted him for further bondage; and, since the day he left it, he has called no man master."[1]

The other apprentices at Bufford's shop were Joseph Foxcroft Cole and Joseph E. Baker. Naturally, Winslow Homer became very intimate with these two comrades. Before the three apprentices had been taken on, Bufford was in the habit of doing most of his designing himself, but he found that the boys were capable of bettering his efforts, and he soon turned

[1] *Art Journal*, London, August, 1878.

all the designing over to them. Winslow Homer at the age of nineteen was rather under the average height, delicately built, very erect, and performed most of his work standing, for the purpose of avoiding the tendency to get round-shouldered. He had a thick mass of dark brown hair, and hazel eyes. He seldom showed any emotion, and was somewhat stolid. When Bufford found fault with his work, he never manifested any feeling about it. His extreme cleverness in sketching was noticeable from the very first. Mr. Baker recalls that he made many quick sketches in working hours, and tossed them on the floor, where Baker and Cole sometimes picked them up. He began to grow a tiny moustache and his first beard. It was not the fashion to shave the chin then. His beard grew in irregular patches, and he said of it: "My beard is in house-lots, is n't it?" His drawings did not always print well on the lithographic stone, and he hated the work at Bufford's, as has been intimated.

Many a morning while he was working at Bufford's, he would rise at three o'clock and go out to Fresh Pond (two miles distant) to fish before breakfast. Returning home, he took the omnibus for Boston, for there were no street cars then. He was obliged to begin work at Bufford's at eight A. M. Many years afterwards, a gentleman who was born in Cambridge met him in New York, and said to him: "How is it, I do not remember ever meeting you in Cambridge, yet we must have been living there at the same time?" "I remember you," retorted Homer, "for you were ten years older than I, and you used to push me off the step sometimes when I was trying to hook a ride on the omnibus to Boston."

It was while he was working at Bufford's that Winslow Homer became acquainted with a French wood engraver named Damereau, who gave him some practical notions of

MOUNT WASHINGTON

From the oil painting in the collection of Mrs. W. H. S.
Pearce, Newton, Massachusetts. Photograph by Chester
A. Lawrence

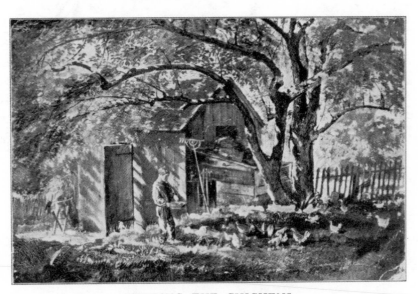

FEEDING THE CHICKENS

From the oil painting in the collection of Mr. Arthur B.
Homer. Painted at Belmont, Massachusetts, about 1858.
The model for the figure was the present owner of the pic-
ture. Photograph by Chester A. Lawrence, Boston

MILITARY PASS ISSUED TO WINSLOW HOMER
FROM THE PROVOST MARSHAL'S OFFICE
IN WASHINGTON APRIL, 1 1862

how to draw on the block in such a manner as to suit his lines to the process. This was a very essential part of the training for the work of an illustrator in those days. One afternoon, Homer, with Cole and Baker, went into Dobson's picture gallery, where they were looking at a painting of a kitchen interior with figures by Edouard Frère, when Moses Wight came in, and Baker introduced him to Homer. After a little, Homer said: "I am going to paint." Wight asked him what particular line of work he was intending to take up. He pointed to Frère's genre painting, and said: "Something like that, only a —— sight better."

When the two years of his apprenticeship at Bufford's were up, — on his twenty-first birthday, February 24, 1857, — he rented a studio in Winter Street, in the building occupied by "Ballou's Pictorial," and made some drawings for that periodical. His first illustration there was a sketch of a street scene in Boston. This was published in the issue dated September 12, 1857, and it was entitled "A Boston Watering Cart." The place depicted is in Summer Street, in front of the store of C. F. Hovey & Company. This was the beginning of a long period of active productiveness for the young artist. At that time there lived in Boston a conceited and pompous Frenchman named Paunceloup, who was well known to everybody as a man about town. Homer made a sketch of him, with his chest thrown out, and his big waxed moustache, as he walked down the street, and on showing it to his tailor, at once sold it for a suit of clothes. It was at about the same time that Homer made a series of drawings of "Life in Harvard College," one of these depicting a football game.

In 1858 he began to send drawings to Harper & Brothers, in New York. "Harper's Weekly" had just been founded.

Prior to 1861, its illustrations had very little of the news quality, which later was to become its chief feature.

The first of his drawings to appear in "Harper's Weekly" was "Spring in the City." It was signed W. H., and the date of its publication was April 17, 1858. This was another street scene in Boston, with about thirty figures in the composition. The place looks very much like the corner of Tremont and Winter streets. On May 22, 1858. "The Boston Common," signed *Homer del.*, appeared. This was a view of the Beacon Street mall near the Joy Street steps and gate, looking westward. There were children at play in the foreground. At the right, in the distance, a glimpse of the houses in Beacon Street; at the left, the fountain playing in the Frog-Pond. There were many figures. The next drawing to make its appearance was published on September 4, 1858, and was entitled "The Bathe at Newport." It was signed *Homer del.* There were about twenty figures of bathers in the surf. In the background were some spectators on the beach. A row of bath-houses stood behind them, and at the right, in the distance, were the cliffs.

On November 13, 1858, "Husking the Corn in New England," signed *Homer del.*, was the first of the long series of rustic genre pictures in black-and-white which so truthfully and amusingly illustrate the episodes of farm life. Imagine the interior of a barn, in the evening, lighted by two lanterns hung on a rope which is stretched from one hay-mow to the other. In this composition there are about forty figures. Near the foreground two red ears of corn have evidently been discovered, for there are two couples engaged in struggles preliminary to the kissing which is *de rigueur* on these occasions. At the left, a boy who has been sitting on a three-legged stool has been upset and is falling on his back. On the opposite

page of "Harper's Weekly" are supplementary drawings by Homer depicting "Driving Home the Corn" and "The Dance after the Husking." The third canto of Barlow's poem in praise of Hasty Pudding elucidates the laws of husking : —

> The laws of husking every wight can tell,
> And sure no laws he ever keeps so well :
> For each red ear a general kiss he gains,
> With each smut-ear he soils the luckless swains.

To "Harper's Weekly" for November 27, 1858, Homer contributed four drawings illustrative of Thanksgiving Day, — "Ways and Means," "Arrival at the Old Home," "The Dinner," and "The Dance." On the next page was a poem called "Our Thanksgiving," describing the preparation, the arrival, the dinner, and the dance, and it appears obvious that the drawings were made to fit the verses. Similarly, on December 25, 1858, we have a series of four illustrations appropriate to the Christmas holiday : "Gathering Evergreens," "The Christmas Tree," "Santa Claus and His Presents," and "Christmas Out-of-Doors." The last-named drawing shows the corner of Tremont and West streets, Boston, in a snowstorm, and there are twelve figures in it.

"Skating at Boston," without any signature, but unquestionably drawn by Homer, appeared on March 12, 1859. On April 2, 1859, "March Winds," signed *Homer del.*, was another Boston street scene, with about a dozen figures, and quite a generous display of hosiery : it was the period of hoopskirts. "April Showers," in the same issue of "Harper's Weekly," is another Boston street scene, the locality being in front of Ditson's music store in Washington Street. The pavements are wet, and again there is a liberal display of the ladies' ankles. On August 27, 1859, a drawing called "Au-

gust in the Country — The Seashore," with some twenty
figures, appeared. This was followed on September 3 by an
illustration of "A Cadet Hop at West Point."

September 24, 1859, Homer signed a double-page engrav-
ing in "Harper's Weekly" depicting "The Grand Review
at Camp Massachusetts, near Concord, September 9, 1859."
The article on the next page states : "We engrave herewith
a fine picture of Camp Massachusetts — in other words, the
general muster of the Massachusetts militia, which took place
near Concord on the 7th, 8th, and 9th instant. . . . The evo-
lution selected for illustration by our artist is the grand de-
tour executed by the militia before Governor Banks, General
Wool, and the magistracy and legislature of the state. The
Governor will be seen, mounted on his famous Morgan horse,
in the background of the picture near the flagstaff. On his
right sits General Wool ; around him are the Senate and
other public bodies ; in his rear are the Cadets, his personal
bodyguard."

Next appeared in the same periodical " Fall Games — The
Apple Bee," November 26, 1859. This is an interior of a farm-
house, with about twenty figures. Everybody is paring ap-
ples. In the centre of the foreground a young woman is
throwing an apple-paring over her right shoulder. Strings of
dried apples are hung from the ceiling.

Of course these juvenile productions are by no means
masterpieces, yet any one who will take the trouble to turn
over the files of "Harper's Weekly" for 1859, will instantly
notice one thing about Homer's illustrations : they are dif-
ferent from all others, and possess an individuality of their
own. Already he was his own man, he was standing on his
own feet.

In the autumn of 1859 he gave up his Boston studio, said

good-by to his parents, and went to New York to seek his fortune. He never returned to Boston to stay, but all through his life he visited the city frequently, and retained his affection for the place of his birth. Nowhere has his genius met with more cordial recognition. And that recognition was given at a time when it meant much to the artist.

CHAPTER III

NEW YORK—THE GREAT WAR

1859–1863. Ætat. 23–27

Studio in Nassau Street — Studio in the University Building, Washington Square — Bohemian Life — His Friends — Lincoln's Inauguration — McClellan's Peninsular Campaign — First Oil Paintings — "The Sharpshooter on Picket Duty" — "Rations" — "Defiance" — "Home, Sweet Home" — "The Last Goose at Yorktown."

QUITE unknown, upon his arrival in New York, in 1859, Homer took a studio in Nassau Street, which he occupied for about two years. He lived in a boarding-house kept by Mrs. Alexander Cushman, at what is now No. 128 East Sixteenth street. Living in the same house at that time were Alfred C. Howland, the painter, and his brother Henry, who afterwards became Judge Howland. The old Düsseldorf Gallery in Broadway was then open. Of course Homer visited it. He saw, among other pictures, William Page's "Venus," painted in Rome, which was then much discussed by all the young artists and art students. "What I remember best," Homer told the writer of the article in the "Art Journal," 1878, "is the smell of paint. I used to love it in a picture gallery."

Harper & Brothers sent for him, and made him a generous offer to enter their establishment and work regularly for them as an artist. "I declined it," said Homer, "because I had had a taste of freedom. The slavery at Bufford's was too fresh in my recollection to let me care to bind myself again. From the time that I took my nose off that litho-

graphic stone, I have had no master, and never shall have any."

By degrees Homer became acquainted with the artists of New York, and in 1861 he moved to the old University Building in Washington Square, where several of the men whom he knew had their studios. Among the painters who were in the building at that time were Marcus Waterman, Alfred Fredericks, Edwin White, Eugene Benson, and W. J. Hennessy. Homer's studio was in the tower room, to which access was gained by climbing a flight of steep stairs fashioned like a step-ladder. This place just suited his taste. There was a door opening from the studio to the roof, which was flat, and protected by a solid parapet. Later, when he had taken up oil painting in earnest, he found the roof an excellent place to pose his models when he wished to get an effect of sunlight on the figures.

There were some very jolly evenings in that studio in the sixties. We are afforded a glimpse of the life of Bohemia in a brief description of one of these evenings given to me by one who was there: A dozen artist friends are in the room. In the midst of a hubbub of talk, story-telling, laughter, and badinage, Homer himself, sitting on the edge of the model-stand, under the gas-light, is working furiously on a drawing on the box-wood block which has to be finished by midnight for the Harpers. "Here, one of you boys," he shouts, "fill my pipe for me! I'm too busy to stop."

Who were his friends among the painters? R. M. Shurtleff, the landscape painter, Homer D. Martin, John F. Weir, Alfred C. Howland, with his neighbors in the University building; and, later, John La Farge and William M. Chase: these are some of them. "He was one of my oldest friends in the profession," says Mr. Shurtleff in speaking of Homer.

Martin was one of the silent admirers of Homer's work, — one of his "pals," for, as La Farge says, he had "pals," and was singular in their staid admiration and friendship. This friendship between Homer Martin and Winslow Homer must have been a sort of pantomime: " Martin was capable of long stretches of silence, and Homer had manners of telling you things without words." Then there was Weir: he was another "pal" of Homer's in the sixties. He recalls how Homer visited him once at West Point, and how on waking in the morning he found him up and dressed in time to see the sunrise; "he got up and sat on the window sill at sunrise, fascinated, watching it over the garden." These glimpses are but fleeting, yet they help to picture the man as he was.

His determination to become a painter had long since been made. He attended the night school of the National Academy of Design, then in Thirteenth Street, under Professor Cummings's tuition; and for one month, in the old Dodworth Building, near Grace Church, he took lessons in painting of M. Rondel, an artist from Boston, who, once a week, on Saturdays, taught him how to handle his brush, set his palette, etc. This Frederic Rondel, a French artist, then in great repute in New York as a teacher, would in all likelihood have been vastly astonished could he have foreseen that his extremely slight connection with the then unknown young pupil would prove eventually to be his chief title to distinction. How much did he really teach young Homer? Not much, in one month, giving him a lesson a week, even allowing that he was a wonderful teacher. I am inclined to believe that the young man got more useful instruction in the night school of the National Academy, and it would not be surprising to learn that he got still

more useful hints from the fellow-painters who dropped in to smoke and chat in the Washington Square studio.

The first drawings by Homer published in "Harper's Weekly" after his arrival in New York appeared in December, 1859. A double-page illustration entitled "A Merry Christmas and a Happy New Year" (signed *W. Homer, del.*) was published on December 24. This design was divided in four panels, the subjects being respectively "A Children's Christmas Party," "The Origin of Christmas" (the shepherds adoring the Infant Jesus in the stable at Bethlehem), "Fifth Avenue," and "Fifty-ninth Street"—which was then a region of squatters' shanties, goats, and ledges, soon to make way for the palatial quarter adjoining the Central Park.

"Harper's Weekly" for January 14, 1860, contained two more Manhattan motives, namely, "The Sleighing Season — The Upset," and "A Snow Slide in the City." In the first-named drawing a sleigh with three occupants has been overturned near the old "St. Nicholas" road-house, and a man and two women are flying headforemost through the air. In the second drawing a crowd of foot passengers on a sidewalk have been overtaken suddenly by a falling mass of snow and ice from a house-top, and several victims of the mishap are to be seen sprawling on the pavement. On January 28, 1860, a double-page drawing called "Skating on the Ladies' Skating Pond in the Central Park, New York," presented an animated composition with a large number of figures in it.

The thirty-fifth exhibition of the National Academy of Design, in 1860, held in the galleries in Tenth Street, near Broadway, contained a drawing of "Skating in the Central Park," by the young artist, and there is but little question it

was the same drawing as that published in "Harper's Weekly." In the summer of 1860 (September 15) "Harper's Weekly" contained "The Drive in the Central Park," also a double-page illustration, showing in the foreground many pleasure vehicles with elegantly attired occupants, and a few riders. In the background are slopes with diminutive trees, but lately set out, and a derrick. Central Park was then in its infancy, and Homer was making the most of it as a novelty.

The sort of occasional illustrations which were much in vogue in 1860 and thereafter are well typified by Homer's "Thankgiving Day, 1860 — The Two Great Classes of Society," a double-page cartoon, which appeared on December 1. In this design, the two great classes of society referred to in the title are classified as "those who have more dinners than appetites" and "those who have more appetite than dinners." There are no less than eight panels or subdivisions in this composition, depicting respectively a fine lady at her toilet, having her hair dressed by her maid; a leisurely sporting gentleman smoking in front of an open grate fire; a group of smart folk in a box at the opera; a miser gloating over his money in solitude; a thief robbing a chicken roost; a poor emaciated needlewoman sewing by dim candle-light in a tenement attic; two women starving in a poverty-stricken lodging where a cradle is to be seen; and a bootblack who has stolen a loaf of bread coming in at the door.

The portentous year 1861 marks a decisive turning-point in the career of Winslow Homer. He was now twenty-five years of age, for several years had been able to support himself by his black-and-white work, and was ready to take advantage of the momentous historic events which fol-

THE BRIGHT SIDE

From the oil painting in the collection of Mr. W. A. White

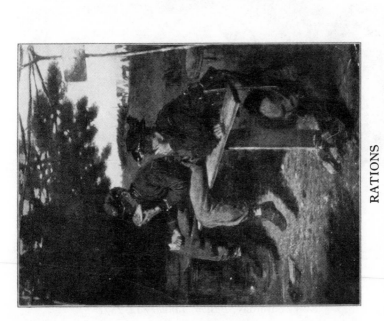

RATIONS

From the oil painting in the collection of Mr. E. H. Bernheimer, New York

CUTTING A FIGURE
From a drawing engraved on wood by W. H. Morse for
Every Saturday, *Boston, February 4, 1871*

A WINTER MORNING — SHOVELING OUT
From a drawing engraved on wood by G. A. Avery for
Every Saturday, *Boston, January 14, 1871*

lowed fast upon the inauguration of President Lincoln in March, 1861. The Art Journal historian laconically remarks: "Funds being scarce, he got an appointment from the Harpers as artist-correspondent at the seat of war, and went to Washington, where he drew sketches of Lincoln's inauguration, and afterwards to the front with the first batch of soldier-volunteers." The illustrations of the inauguration of the President published by "Harper's Weekly" on March 16, 1861, are not signed, and the same is true of the subsequent Washington subjects published on April 27 and June 8, which, however, are in all probability worked up from hasty sketches made on the spot by "our special artist in Washington." The number for March 16 contained a large double-page view of the inaugural ceremony at the Capitol, a picture of the procession, and a drawing of Lincoln and Buchanan entering the Senate Chamber. The number for April 27 contained a drawing of "General Thomas Swearing in the Volunteers called into the Service of the United States at Washington." The issue of June 8 contained a stirring drawing of "The Advance Guard of the Grand Army of the United States Crossing the Long Bridge over the Potomac at 2 A. M. on May 24, 1861."

There could be no shadow of doubt as to the authorship of the "Harper's Weekly" war illustrations that followed, even were they unsigned. "The War — Making Havelocks for the Volunteers" was published on June 29. It was signed: *Homer*. This group of ladies busily sewing in an interior brings back one of the phases of the early days of the great war. A double-page drawing entitled "Songs of the War" followed on November 23, 1861. At the lower left corner is a marching regiment singing the refrain of that stirring song about John Brown's Body: "Glory Hallelujah!" At the

lower right corner "Dixie" is symbolized by a negro seated on a barrel labeled "Contraband." Above are appropriate illustrations to the popular songs, "The Bold Soldier Boy," "Hail to the Chief" (with a figure of General McClellan), "We'll be Free and Easy Still," "The Rogue's March," and "The Girl I Left Behind Me."

But the earliest drawing duly signed by Homer which bears unmistakable internal evidence of having been made at the front is the "Bivouac Fire on the Potomac," of December 21, 1861. This double-page illustration represents a picturesque firelight effect, and contains about forty figures. In the foreground two soldiers are playing cards. Near the fire is a negro playing on a fiddle and another negro dancing. The rest of the men are either sitting or lying on the ground, smoking and watching the dancer. In the dim background are tents, and the nocturnal sky with the moon peeping from behind the clouds.

A week later was published a double-page illustration of the "Great Fair Given at the City Assembly Rooms, New York, December, 1861, in Aid of the City Poor." January 18, 1862, is the date of a country scene, a moonlight effect, with twelve figures, entitled "The Skating Season, 1862." Thereafter for a year at least these peaceful episodes had no more place in the programme.

General McClellan's Peninsular campaign was begun in the spring of 1862 with high hopes. The Army of the Potomac was landed from troop-ships at Fort Monroe, Old Point Comfort, Virginia, and marched towards Yorktown, the historic little village on the banks of the York River, where Lord Cornwallis had surrendered his British army to the combined forces of Washington and Rochambeau in 1781. The Army of the Potomac in 1862 had just been

organized, and, although composed of excellent material, was inexperienced, and, what was still more certain to nega- tive all its plans and efforts, it was commanded by a gen- eral who was fatally deficient in initiative, decision, and self-confidence. It appears to be evident, from the inter- esting and historically valuable series of drawings by Homer published in "Harper's Weekly" in the months of May, June, and July, 1862, that "our special artist, Mr. Winslow Homer," was with the Army of the Potomac throughout the greater part of the Peninsular campaign, beginning with the so-called Siege of Yorktown in April, and ending with the Battle of Malvern Hill in July. This brief, disappointing, and disastrous campaign, in which, however, the defeated army of the Union inflicted severe punishment upon the Southern forces, afforded many alluring opportunities to the military artist, — brisk and bitter fighting, forced marches, and all the pageantry of an active campaign in the heart of the enemy's country, with the thousand-and-one scenes and episodes, amusing or pathetic, of bivouac and camp. By our venturesome young man of twenty-six the hardships of the campaign, which the artist naturally had to share with the rank and file of the army, were accepted with phi- losophy. The majority of his drawings offer convincing in- ternal evidence that they were made from life and on the spot; moreover, they differ radically from any and all pre- ceding war illustrations, attempting no idealization of the stern and sordid aspects of the subject, but describing with the strictest veracity and with that accent of unexpected and unconventional candor which is already Winslow Homer's exclusive personal *cachet*, just those little things in army life which had before passed unobserved or unheeded by the military painters of other schools. Most of the series

pertaining to the Peninsular campaign deal with events of
the earlier part of the campaign, that is to say, from York-
town up to the first of the engagements in the vicinity of
Richmond, at Fair Oaks and Seven Pines. Of the succeed-
ing Seven Days' Battles, from Gaines's Mill to Malvern
Hill, we find here no record, from which it may be fairly in-
ferred that Homer had left the front before McClellan's
"change of base."

It will not escape the notice of the observer who studies
the war drawings made by Homer that he does not choose
for his motives, as a rule, the customary battle scenes, with
long lines of troops advancing or retreating, clouds of gun-
powder smoke, heroic officers waving their swords and
calling upon their men to "Come on!" — and all the rest of
the stock material of the School of Versailles. Quite the
contrary: he, who, as we shall see later, was sensitively
conscious of the dramatic possibilities of every subject for
a picture, was usually content to sit down and draw such
compositions as the "Bivouac Fire on the Potomac" of
1861, the "Thanksgiving in Camp" of 1862, the "Pay Day
in the Army of the Potomac" of 1863, or the "Holiday in
Camp — Soldiers Playing Football" of 1865. These may
possibly be thought comparatively tame and trivial motives,
at such a time of storm and stress, but candor compels
the admission that Homer succeeds better in these camp-
life drawings than in his infrequent and soon-abandoned
excursions into the field of bayonet charges and cavalry
combats.

On going to the front Homer was attached unofficially to
the staff of a young officer who was to distinguish himself
by brilliant services later in the war, and who did everything
in his power to help the young artist and to facilitate his

work. This was Colonel Francis C. Barlow, who, promoted on his merits, step by step, through all the Virginia campaigns, at length attained the important position of Brevet Major-General in command of a division of the Second Corps.

The pass issued to Homer from the Provost Marshal's office in Washington bears the date of April 1, 1862, and the reproduction of it here has been made from the original in the possession of Mr. Arthur B. Homer. The original is somewhat discolored by time, moisture, and the wear and tear incidental to a long sojourn in the pocket of the bearer.

The first three drawings of the series illustrating the events and incidents of the Peninsular campaign were published in "Harper's Weekly" on May 17, 1862. These drawings represented episodes which evidently came under the direct observation of the artist at Yorktown. They are: "Rebels Outside their Works at Yorktown Reconnoitring with Dark Lanterns," "The Charge of the First Massachusetts Regiment on a Rebel Rifle Pit near Yorktown," and "The Union Cavalry and Artillery Starting in Pursuit of the Rebels up the Yorktown Turnpike." On June 7, a drawing entitled "The Army of the Potomac — Our Outlying Picket in the Woods" was published. Next, a double-page cartoon entitled "News from the War," which was duly credited to "Our Special Artist, Mr. Winslow Homer," appeared on June 14. This comprised six related themes, grouped under the one general head. "The Newspaper Train" showed the arrival of the train at a station near the army headquarters; "Wounded" represented a weeping wife who has just received a telegram; "News for the Staff" and "News for the Fleet" illustrated the eager interest with which letters from

home were received; "From Richmond" suggested the keen anxiety with which tidings from the prisoners were awaited; and finally in the drawing of "Our Special Artist" we see Homer himself sitting on a barrel and sketching the full-length likenesses of two giants belonging to one of the western regiments, E. Farrin and J. J. Handley, who were said to be six feet and seven inches tall.

On July 5, Homer's drawing of "A Cavalry Charge" was published; and on July 12 he contributed two drawings, namely, " The Surgeon at Work at the Rear during an Engagement," and "The War for the Union, 1862 — A Bayonet Charge." According to a short article in "Harper's Weekly" of July 12, these drawings are " by our artist, Mr. Winslow Homer, who spent some time with the Army of the Potomac, and drew his figures from life." "The Bayonet Charge," adds the writer, "is one of the most spirited pictures ever published in this country." It depicts a hand-to-hand encounter of infantry, presumably in one of the engagements near the Chickahominy, and possibly at the Battle of Fair Oaks, although there is room for some doubt as to this point. There was a charge of five regiments of the Second Corps, under General Edwin V. Sumner, near the Adams house, just northeast of the Fair Oaks station, towards the close of the day, May 31, one result of which was the capture of three field officers and about one hundred men from the rebel forces. The episode is quite elaborately described in General Francis A. Walker's " History of the Second Army Corps," on pages 34, 35, 36, and 37. This charge was made by the Fifteenth and Twentieth Massachusetts, the Seventh Michigan, the Thirty-fourth and Eighty-second New York regiments. But, on the other hand, General Francis W. Palfrey, who at that time commanded the Twentieth Massachusetts,

in his comments on Fair Oaks (*vide* "The Peninsular Campaign of General McClellan in 1862," vol. 1 of the Papers of the Military Historical Society of Massachusetts, 1881), makes the disillusionizing remark: "I know that our so-called charge was only a rapid and spirited advance. I do not believe that a man in the five or six regiments which took part in it used the bayonet."

On November 15, a drawing entitled "The Army of the Potomac — A Sharpshooter on Picket Duty" was published in "Harper's Weekly," with the legend, "From a painting by W. Homer, Esq." It shows a soldier sitting on the limb of a great pine tree, far above the ground, aiming his rifle with the utmost care, resting the barrel on a branch to steady it. His canteen, hanging on a bough near at hand, suggests that the sharpshooter has taken up his lofty position with the forethought that he does not intend to be driven to abandon his coign of vantage by thirst. On November 29, Homer describes, not without a touch of humor, "Thanksgiving in Camp." The scene takes place in front of a sutler's tent, where crudely painted signs announce that pies, herring, cider, etc., are for sale. A dozen or more figures of soldiers, who are eating, drinking, smoking, gossiping, are shown in this exceedingly unsentimental composition.

"A Shell in the Rebel Trenches," which was published in "Harper's Weekly" on January 17, 1863, represented negroes cowering and throwing themselves on the ground as a shell exploded. "Winter Quarters in Camp — The Inside of a Hut" was published a week later. In this drawing, to quote the explanatory text which accompanied it, "Mr. Homer shows us the interior of a hut, in which a glowing fire is blazing, shedding light and warmth around. Stretched on the floor, bunks, and seats, are soldiers in every imaginable

position, — smoking, chatting, reading, card playing, and sleeping. Almost in every company there is one sharp-witted fellow who can tell a good story. The soldiers' great delight is to get this man into a tent or hut, and start him on a good long old-fashioned yarn, which lasts from dark until far on in the night."

"Pay Day in the Army of the Potomac" was a double-page drawing, published on February 28, 1863. The four panels composing the design were respectively devoted to "Pay Day," "A Descent on the Sutler," "Sending Money Home," and "The Letter."

The first sea picture in black-and-white ever signed by Homer was published in "Harper's Weekly" for April 25, 1863. Its title was "The Approach of the British Pirate 'Alabama.'" The scene was the deck of an American merchant vessel. An officer, in the centre of a group of figures, was looking through a telescope. On the far horizon a ship was visible. Four women were gazing at the hostile craft with an expression of apprehension.

"Home from the War" appeared in the "Weekly" for June 13, 1863. It represented mothers, wives, and sweethearts welcoming the returning soldiers. On November 21, 1863, Homer signed a drawing of double-page size depicting "The Great Russian Ball at the Academy of Music" which had been one of the features of the timely visit of the Russian fleet early in that month.

His first oil paintings were pictures of war scenes. They were begun in 1862, immediately after his return to his New York studio from the Peninsular campaign. The earliest of them all was "The Sharpshooter on Picket Duty," already mentioned. Its size was about sixteen by twenty inches. Mr. R. M. Shurtleff, the landscape painter, has related how he

A COUNTRY STORE—GETTING WEIGHED. (*above*)

From a drawing engraved on wood by W. J. Linton
for Every Saturday, Boston, March 25, 1871

GATHERING BERRIES. (*above, left*)

From a drawing engraved on wood for Harper's Weekly,
July 11, 1874

FLIRTING ON THE SEASHORE AND
ON THE MEADOW. (*left*)

From a drawing engraved on wood for Harper's Weekly.
September 19, 1874

SNAP THE WHIP

*From the oil painting in the collection of Mr. Richard
H. Ewart, New York*

sat with Homer in the studio many days while he was at work on this picture, and he remembers discussing with him how much it would be advisable to ask for it. "He decided not less than sixty dollars, as that was what Harper paid him for a full-page drawing on the wood." When "The Sharp-shooter" was completed, he placed it, with another picture,[1] in an exhibition, and declared that if they were not sold he would give up painting and accept Harper & Brothers' proposition. The two pictures were bought by a stranger, whose name the artist learned only after a lapse of seven years. This may have been a crisis in his career.

After disposing of "The Sharpshooter," he felt greatly encouraged. He went on with his oil paintings and completed "Rations," "Home, Sweet Home," and "The Last Goose at Yorktown." "Rations" is a small upright painting, eighteen by twelve inches in dimensions, which was finished in 1863 from studies made in 1862. It became the property of Mr. Thomas B. Clarke of New York, and was sold for five hundred dollars at the Clarke sale in 1899, the buyer being Mr. E. H. Bernheimer of New York. The description of this picture in the Clarke catalogue is as follows :—

"There are hard times in camp. Rations are short and the sutler's shed, under its arbor of pine boughs in the foreground, is the cynosure of many hungry eyes. One campaigner, happy in the possession of funds, is seated on the rude plank table at the sutler's door complacently devouring a huge segment of cheese as a flavor for his hard-tack. Another trooper leans upon a shelf and watches his occupation with a melancholy born of an empty purse and a craving

[1] A picture of a soldier being punished for intoxication. Of this Homer himself said, many years afterwards, "It is about as beautiful and interesting as the button on a barn-door."

stomach, with nothing but unflavored hard-tack to fall back upon. The humor of the situation is accentuated by the side glance which the lucky enjoyer of extra rations — who is a private soldier — casts upon his neighbor, whose uniform shows him to be an officer a few grades above him in rank. In the background are seen the tent lines of the encampment and the troop horses."

"Defiance" is the title given to a small oil painting, measuring twelve by twenty inches, of an episode in the Peninsular campaign which came under the artist's personal observation. In the foreground is a line of hastily constructed earthworks, behind which are many figures of soldiers. A negro near the foreground is playing on the banjo. A foolhardy young infantry private has climbed up on the top of the entrenchments, in full view of the enemy, where he stands, with his form outlined against the sky, a conspicuous target, striking a pose which plainly says: "I dare you to shoot me!" Such silly exhibitions of bravado were probably more common in the very early days of the war than they were later. The landscape in this picture illustrates how a country occupied by two armies looks after the trees have been cut down to facilitate the operations of the artillery; out in front of the entrenchments there is a ghastly neutral zone dotted with stumps, extending to the distant line of works occupied by the enemy's forces. This interesting and little-known picture was for many years in the collection of Mr. Frederick S. Gibbs of New York. At the sale of the Gibbs collection in 1904, it was bought by Mr. T. R. Ball, for three hundred and twenty-five dollars.

"The Last Goose at Yorktown" and "Home, Sweet Home" were exhibited at the National Academy of 1863. These two works, both of them illustrating camp scenes be-

fore Yorktown, were the first oil paintings ever exhibited at the Academy by Winslow Homer. "Home, Sweet Home" represented the soldiers of McClellan's army listening, perhaps with a touch of homesickness, to the playing of a regimental band. "The Last Goose at Yorktown," an amusing incident of the early days of the Peninsular campaign, was bought by Mr. Dean of New York. It may well be supposed that the exhibition of these war scenes during the stress and excitement of 1863 served to draw the public attention to the young artist in no ordinary degree.

After returning from the seat of war to his New York studio Homer made a series of six lithographs which he published under the general title of "Campaign Sketches." These small lithographs depict camp scenes, such as "The Coffee Call," and similar incidents of army life, in the same vein as many of the illustrations already described.

At that period of his life Homer was a good-looking and alert young man of twenty-seven. He was genial and friendly in his manner, was not averse to society, dressed with scrupulous neatness and in good taste, and, in his quiet way, was fond of fun. Calling, one day, at the studio of an artist acquaintance in Boston, he pulled a handful of ribbons from his pocket, and remarked, with a twinkle in his eyes, that he had been shopping.

"What do you want of so many ribbons?" asked his friend.

He explained that he did not want the ribbons, but he had bought them in order to make a pretext for going into the stores and talking with the pretty sales-girls. Whenever he saw a pretty face in the stores he would stop and buy some ribbons.

He was invited out a good deal, and appeared to enjoy

society. "He had the usual number of love affairs when he was a young man," said one who knew him well at that time; but Mr. Baker told me that he always spoke of women "in a remote tone," as of a subject which did not closely or personally interest him.

CHAPTER IV

EARLY WORKS

1864–1871. Ætat. 28–35

Pictures of Camp Life — Made an Academician — "The Bright Side" — "Pitching Quoits" — "Prisoners from the Front" — First Voyage to Europe — What he did not do — "The Sail-Boat" — Drawings for "Every Saturday."

ENCOURAGED by the interest shown in his paintings of war scenes, Homer continued to produce pictures of camp life as he had observed it in the Army of the Potomac. At the National Academy of Design of 1864 he exhibited his "In Front of the Guard-House" and "The Briarwood Pipe." He was made an associate of the National Academy that year, and was elected an Academician the following year, when still under thirty years of age. It is of interest to note that Elihu Vedder and Seymour J. Guy were elected Academicians the same year as Homer. Eastman Johnson had been elected five years earlier. John La Farge became an Academician in 1869. Frederic E. Church's election dated from 1849. George Inness and A. H. Wyant were elected in 1868 and 1869 respectively. The exhibition of 1864 was held in the galleries of a building known as the Institute of Art, at 625 Broadway, but that of 1865 was the first exhibition held in the then new building of the Academy, on the corner of Fourth Avenue and Twenty-Third Street, a structure of white and gray marble in the Venetian Gothic style, which was regarded as a splendid monument of architecture, and was often spoken of as a modified copy of the

Ducal Palace at Venice. Homer, from the day of his election, in 1865, to his death, in 1910, continued to be a loyal member of the Academy, and regularly exhibited his most important oil paintings there for a quarter of a century.

The year of his election, 1865, he sent three paintings to the Academy exhibition. They were "The Bright Side," "Pitching Quoits," and "The Initials." "The Bright Side," a small canvas, about thirteen inches high by seventeen inches wide, was quite generally pronounced the best oil painting that the young artist had made up to that time. "Four negro teamsters are lying in the sun against the side of a tent. The man at the right wears a battered high hat, a military coat, and top boots, and holds a whip in his left hand ; beyond his raised knee is the head of the second figure in a peaked military cap. The next one wears a red shirt and broad-brimmed gray hat, and his hands are clasped back of his head; the farthest one, with arms folded, wears a broad-brimmed military hat. In the opening of the tent is the head of another negro with a broad-brimmed hat; a corn-cob pipe is in his mouth. Beyond, at the left, are commissariat wagons with rounded canvas tops, and near by are unharnessed mules. In the distance is the camp. In the immediate foreground, at the right, part of a barrel shows." [1]

This was the first work in color to show any positive promise of what Homer's talent for actuality might become. The figures of the negro teamsters are admirably characterized, though they are of the nigger-minstrel type of Cullud Gemmen ; they are well drawn and quite living. This picture was bought by Mr. W. H. Hamilton. Later it passed into the possession of Mr. Lawson Valentine, and still later it was

[1] Catalogue of the memorial exhibition of 1911 at the Metropolitan Museum of Art, New York.

acquired by Mr. Thomas B. Clarke. At the Clarke sale in 1899 it was bought by Mr. Samuel P. Avery, Jr., for five hundred and twenty-five dollars; and it is now in the collection of Mr. W. A. White.

The painting entitled "Pitching Quoits," another camp scene, has been known generally since its first appearance in 1865 as "Zouaves Pitching Quoits." Although a good deal larger than "The Bright Side," it is more ordinary in color, and less interesting in characterization. The scene was one that the young artist witnessed in the camps of the Army of the Potomac in front of Washington before the army moved down to the Peninsula of Virginia under McClellan in 1862. A group of eight or nine of the volunteers from New York wearing the uniforms of the Hawkins Zouaves — poor fellows! the amount of chaffing they had to endure on account of their absurd uniforms must have been a worse ordeal than going under the fire of the enemy! — are diverting themselves by playing that good old game of quoits. Three of the figures at the right are nearest the foreground, and one of these is in the act of pitching the quoit. Another group of the men, about ten yards away, to the left, watch his attempt. In the background are rows of tents, and a sutler's store, with an extemporized awning of boughs — the same that was introduced in "Rations." This was the largest canvas that the artist had painted; its interest, at the time purely illustrative, is now chiefly historic; and it must be frankly confessed that, though everything relating to the Civil War is of value, no one would have ventured to predict the future greatness of the painter on the basis of this performance in 1865. The picture now belongs to Mr. Frederic H. Curtiss, and it made its reappearance, after many years, in the Boston memorial exhibition of 1911.

The only drawings published in "Harper's Weekly" in 1864 were: " 'Anything for Me, if You Please?' " a scene in the post-office of the Brooklyn fair in aid of the Sanitary Commission (signed *Homer* on one of the letters); and "Thanksgiving Day in the Army: — After Dinner: The Wish-Bone" ("Drawn by W. Homer"). The drawings published in 1865 were three in number: "Holiday in Camp — Soldiers Playing Football," July 15; "Our Watering-Places — Horse-Racing at Saratoga," August 26 (the design showing the crowd of spectators in the grand-stand, watching the finish of an exciting race); and "Our Watering-Places — The Empty Sleeve at Newport," August 26, an illustration to a story in the same issue of the paper.

It was not until the war was over that Homer exhibited his most celebrated war painting, "Prisoners from the Front." This work appeared at the National Academy exhibition of 1866, together with one other painting, "The Brush Harrow."

"Prisoners from the Front" served to confirm the favorable impression which had been made by "The Bright Side." Mr. Caffin [1] writes that this picture made a profound impression. "Popular excitement was at fever heat, so the picture fitted the hour; but it would not have enlisted such an enthusiastic reception if it had not approximated in intensity to the pitch of the people's feeling. It has, in fact, the elements of a great picture, quite apart from its association with the circumstances of the time: a subject admirably adapted to pictorial representation, explaining itself at once, offering abundant opportunity for characterization, and in its treatment free from any triviality. On the contrary, the painter has felt beyond the limits of the episode itself the profound

[1] *American Masters of Painting*, by Charles H. Caffin. New York: Doubleday, Page & Co., 1906.

significance of the struggle in which this was but an eddy, and in the generalization of his theme has imparted to it the character of a type."

The picture was bought by John Taylor Johnston; was exhibited at the Paris International Exposition of 1867; also at the Centennial Loan Exhibition of 1876, held in the Metropolitan Museum of Art, at 128 West Fourteenth Street, New York; and, at the sale of the Johnston collection in 1876, was sold to the late Samuel P. Avery, the picture dealer, for eighteen hundred dollars. Mr. Avery sold it to a collector, and when the committee which had charge of the Homer Memorial Exhibition of 1911 in New York tried to ascertain its whereabouts and ownership, it was found to be impossible to locate it. Mr. Bryson Burroughs, curator of the department of paintings in the Metropolitan Museum of Art, informs me : —

"We were not able to find the name of the owner of 'Prisoners from the Front.' We corresponded with a Mrs. ——, No. — West —— Street, who knows about the picture, but she was not at liberty to give the owner's name. She was approached by several people in regard to it, but always gave the same response."

The committee even induced Mr. Charles S. Homer to open a correspondence with the lady, but she remained obdurate, and addressed her reply to " Miss Homer."

While Homer was painting " Prisoners from the Front " and the rest of the army subjects of that period, he had a lay figure, which was alternately dressed up in the blue uniform of the Union soldier and the butternut gray of the Confederate soldier, serving with soulless impartiality, now as a Northerner and now as a Southerner. One day, while he was at work on the roof of the University Building,

where he had posed his effigy in order to get the effect of the full sunlight on his figure, a sudden gust of wind came up and was like to have carried the lay figure off the roof before the artist could catch it and secure it.

It has been stated repeatedly that Homer owed his election as an Academician to the picture of " Prisoners from the Front," and this would seem strange in view of the fact that his election occurred in 1865, while the picture was not exhibited in the Academy until 1866, did we not know how quickly the news of a successful picture spreads through the little world of the studios. John La Farge, as late as 1910, when, on his death-bed in the Butler Hospital at Providence, Rhode Island, he dictated a pathetic tribute to Homer, in a letter to Mr. Gustav Kobbé, the art editor of the " New York Herald," remembered the " Prisoners from the Front," and thus spoke of it : —

" He made a marvellous painting, marvellous in every way, but especially in the grasp of the moment, the painting of the ' Prisoners at the Front' when General Barlow received the surrender of the Confederates. Strange to say, because usually there are objections, this man was accepted, I believe, by everybody."

The impression must have been indeed strong to remain in La Farge's busy mind for forty-four years.

It was in 1866 that Homer assisted in organizing the American Watercolor Society, though at that period he had not painted any watercolors. Later in the history of the society's annual exhibitions, as will be shown, he won some of his most legitimate laurels in this field. The opening exhibition of the new society in New York was the first general exhibition of watercolors ever held in America.

In 1867 Homer made his first voyage to Europe. This was

GLOUCESTER HARBOR

*From the drawing in the collection of Mr. Horace D.
Chapin, Boston. Photograph by Chester A. Lawrence*

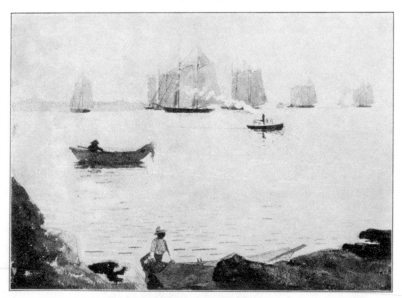

GLOUCESTER HARBOR

*From the watercolor belonging to the Edward W.
Hooper estate, Boston. Photograph by Chester A. Law-
rence*

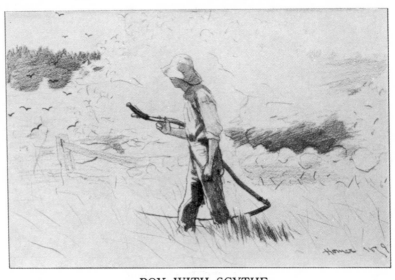

BOY WITH SCYTHE

*From the drawing belonging to the Edward W. Hooper
estate, Boston. Photograph by Chester A. Lawrence.*

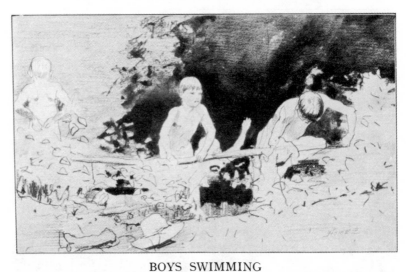

BOYS SWIMMING

*From the drawing belonging to the Edward W. Hooper
estate, Boston. Photograph by Chester A. Lawrence*

the year of one of the first great international expositions in Paris. Two of his paintings were exhibited there: " Prisoners from the Front" and " The Bright Side." Of them the " London Art Journal," November 1, 1867, said: " In genre, and scenes simply domestic, American painters, as might be anticipated, are more at home than in history. Certainly most capital for touch, character, and vigor, are a couple of little pictures, taken from the recent war, by Mr. Winslow Homer, of New York. These works are real: the artist paints what he has seen and known." A great many high-flown art criticisms have not the force of this simple comment, " These works are real." Paul Mantz, the French art critic, in an article published in the " Gazette des Beaux-Arts," wrote that " Mr. Winslow Homer in justice ought not to be passed by unobserved. There is facial expression and subtilty in his 'Prisoners from the Front' (*Prisonniers confédérés*); we like much also the 'Bright Side' (*Le Côté clair*), which shows a group of soldiers stretched out in the sun near a tent. This is a firm, precise painting, in the manner of Gérôme, but with less dryness."

Homer received no official recognition, however, at Paris. The only award given to any American artist was the medal conferred on Frederic E. Church. Albert Schenck, a well-known painter of animals, especially noted for his pictures of sheep, who was a member of the international jury on paintings, told the late Thomas Robinson that four members of the jury voted to give a medal to Homer, but there were not votes enough to carry the motion. The Goupils were then publishing reproductions of Church's landscapes, including his " Niagara," and he was better known to Europeans than any other American painter of the time. William Morris Hunt was an exhibitor, but his work showed so

plainly the influence of Millet and Couture that the French artists justly deemed him far less original than Homer.

It does not appear that much attention was bestowed upon the works of the American artists. The number of the exhibits was relatively insignificant, and the pictures were tucked away in an obscure corner of the art department. I have searched through the files of the French, English, and American art periodicals of 1867 without finding any mention of the American art section, with the exception of those in the "Art Journal" and "Gazette des Beaux-Arts" which have been quoted.

After the close of the Paris Exposition "Prisoners from the Front" and "The Bright Side" were sent to Brussels and to Antwerp, where they were shown in two international exhibitions, and, according to a report from the then American Minister to Belgium, Mr. Henry Sanford, these two works, with others by American painters, were highly successful. Henry T. Tuckerman's "Book of the Artists," published in New York in 1867, states : —

"At the late Fine Arts Exhibitions in Antwerp and Brussels, several landscapes by American painters attracted much attention. The American Minister at Belgium, Mr. Sanford, writes that an artist of Brussels of much merit and celebrity declared the works of our artists there exhibited to be among the most characteristic of the kind ever brought to that city, and that admiring crowds were gathered around them at all hours. . . . Winslow Homer's strongly defined war sketches are examined with much curiosity, especially the well-known canvas, 'Prisoners from the Front.'"

The praise of the unnamed Brussels artist of celebrity and merit is not extravagant. "Among the most characteristic of the kind" is even a little bit ambiguous. But it is quite a

gratifying thing to have an admiring crowd in front of one's picture at all hours: that at least is a substantial and comforting evidence of success.

Homer spent ten months in France. At the end of that time his money gave out, and he was obliged to return home. He did no studying and no serious work of any kind worth mentioning while he was in Paris, and it is probable that he devoted most of his time to sight-seeing and recreation. He did make a series of studies of the figures of dancing girls at the Jardin Mabille and the Casino de Paris, somewhat after the manner of Degas's subjects, though totally different in style, but I am not aware that he ever worked these up into pictures. The two drawings of Parisian public balls, "Dancing at the Casino" and "Dancing at the Mabille," which he sent to "Harper's Weekly," and which were published on November 25, 1867, were almost wholly in outline, with but little shading. In one of these drawings the *Can-Can* is in progress for the special delectation of tourists, with the usual feats of high kicking by the paid *danseuses;* and in the other a couple are waltzing madly, the man having spun his partner so swiftly that both her feet have left the floor.

What he did not do while he was in France is somewhat significant. He did not enter the atelier of the most renowned French master; he did not make copies of the famous masterpieces in the Louvre; he did not go to Concarneau or to Grèz or to any of the favorite painting-grounds of the young American artists; and he did not, so far as is known, make many friends among his fellow-artists. That he visited the Louvre and the Luxembourg and the Cluny and the picture galleries of the international exposition may be taken for granted; but what he thought of all that he saw there he never told anybody. It is a fact of the most vital import that the great

works of the masters in the galleries of the Old World made
a less permanent impression upon his mind than the three
thousand miles of ocean that he had to cross, going and com-
ing. Who shall say that he was not manifesting uncommon
sagacity in giving deeper attention to the works of Nature
than to those of Man? That first long sea voyage was un-
questionably one of the factors that eventually determined
his choice of motives, although it was not until the eighties
that he began to specialize in marine painting and to devote
his energies solely to the great theme with which his name
and fame were to be associated.

Soon after his return to New York, he contributed to " Har-
per's Weekly" a double-page drawing entitled "Homeward
Bound," representing the scene on the deck of an ocean steam-
ship, with the figures of many passengers. The observer is sup-
posed to be looking forward along the port side of the deck,
and the ship is rolling considerably to port. One sees no
steamer-chairs such as are so universally used nowadays. Sev-
eral officers are seen on the bridge, and one of them is look-
ing through a marine glass at a school of porpoises or
dolphins which are disporting themselves off the port bow.
This interesting drawing was published on December 21, 1867.
Three weeks later a drawing called " Art Students and Copy-
ists in the Louvre Gallery, Paris," served to show conclu-
sively where the artist had spent a good part of his time
while in the French capital. The Long Gallery of the Louvre
was shown in perspective, with many copyists at work, both
men and women. Soon after his return to New York, Homer
met J. Foxcroft Cole and Joseph E. Baker in Astor Place, and
invited them to come into his University Building studio,
where he showed them a number of studies of dancing girls;
there was also a drawing of one of the rooms in the Louvre

where the antique marbles are exhibited. Cole, commenting on Homer's naïveté, pointed out that in the latter drawing the imperfections of the statues were clearly to be discerned.

A small oil painting entitled "Musical Amateurs" was finished and dated in 1867. It is a picture of two men playing violin and 'cello in a studio interior. The hands are poorly drawn, and the figures are somewhat lacking in modeling. It is, however, executed with such evident sincerity of purpose as to be thoroughly convincing, despite its shortcomings. "It has the mark of a man who was in dead earnest," remarks J. Nilsen Laurvik, "even though one might not at that time have been able to predict from this canvas the coming master."

In the National Academy of 1868 Homer exhibited " The Studio," " Picardie," " A Study," and " Confederate Prisoners at the Front," the last-named work being in all probability the same picture as the " Prisoners from the Front," first shown in 1866, since it is accredited in the catalogue to the J. Taylor Johnston collection. It would be considered a most exceptional, indeed, a preposterous thing, nowadays, to exhibit the same picture twice within two years in the Academy; but in endeavoring to account for this proceeding I suppose we must remember that the Academy in 1868 was a close corporation, with more or less of a family atmosphere, and it is also to be borne in mind that by common consent this picture was deemed the most successful delineation of a scene from the Civil War, so much so that its reappearance may have been allowed in response to something like a popular demand.

The " Harper's Weekly" drawings of 1868 included: "Winter — A Skating Scene," published January 25 ; " St. Valentine's Day — The Old Story in All Lands," published

February 22; "The Morning Walk — Young Ladies' School Promenading the Avenue," published March 28; "Fireworks on the Night of the Fourth of July," published July 11 (an amusing view of the upturned faces of the crowd illuminated by the glare of the fireworks, and at the right of the foreground, a fallen rocket-stick striking the crown of a silk hat, jamming it down over the head of the astonished wearer); "New England Factory Life — 'Bell-Time,'" published July 25, soon after one of his occasional visits to his brother Charles, at Lawrence, Massachusetts, where the great army of operatives is seen crossing a bridge over the canal which supplies the waterpower to one of the huge mills; and, finally, "Our Next President," published October 31, the design showing a group of five figures, two men and three women, drinking a patriotic toast to General Grant, whose portrait is seen on the wall.

From Lawrence he went to Belmont to visit his father and mother, and after a few days there he journeyed to the White Mountains in search of subjects to paint. He also went to Manchester, Massachusetts, and Salem. He exhibited at the National Academy of Design in 1869 but one painting, the "Manchester Coast." His black-and-white work of that year ranged from mountain to sea subjects. A spirited drawing of seven or eight sailors aloft taking in sail in a snow-storm, while far below them we see the after part of the deck with two men at the wheel, the foaming wake of the vessel, and a dark sea and sky, was published January 16, and had for its title "Winter at Sea — Taking in Sail off the Coast." It gives every internal evidence of being drawn from life on the spot, and is, I believe, the first drawing of life at sea on a sailing vessel made by the artist.

As to the drawing of "The Summit of Mount Washing-

ton," it depicts tourists (of whom the artist himself was one) on horseback and afoot, climbing the mountain, by way of the old Crawford bridle path, and the summit of the mountain looms up in the background with its little inn. This drawing was made before the completion of the central cograil railroad up Mount Washington, the invention of Sylvester Marsh, which was finished, however, that same year. An oil painting of the same composition bears the date of 1869, and was exhibited in 1870 under the title of "The White Mountains." It belongs to Mrs. W. H. S. Pearce of Newton, and was in the memorial exhibition of 1911 in Boston. The scene is at the base of the cone, where a group of several saddle horses are standing. The tourists, four in number, are resting just before beginning the last stage of the climb. All around are the huge rocks which form the peak. Two ladies are on horseback, and the two gentlemen who accompany them are on foot. In the distance and above, the summit is visible through a rift in the clouds. The figures and the horses are carefully and well drawn, and, while it would be extravagant to call the work great, it is assuredly a remarkable production for a man who had been painting only four or five years.

Some of the "Harper's Weekly" illustrations of 1869 included the "Christmas Belles," January 2, representing a party of five young women and one man sleighing in a big three-seated sleigh; "The New Year — 1869," a plump boy on a bicycle riding through a paper hoop which is held up by a coryphée, while poor old 1868 is being borne away ignominiously in a wheelbarrow by Father Time; and by way of novelty, a court-room scene, "Jurors Listening to Counsel, Supreme Court, New City Hall, New York," February 20, of which the editor of the "Weekly" truthfully remarks

that "the picture is remarkable for its delineation of character, apart from its value as a faithful representation of life in the arena of jurisprudence."

The year 1870 was not only exceptionally prolific, but it also marked an appreciable advance in respect to Homer's art. For at this period his drawing begins to improve noticeably. No less than eleven of his paintings were exhibited at the National Academy of Design. They were: "White Mountain Wagon," "Sketch from Nature," "Mt. Adams," "Sail-Boat," "Salem Harbor," "Lobster Cove," "As You Like It," "Sawkill River, Pa.," "Eagle Head, Manchester," "The White Mountains," and "Manners and Customs at the Seaside."

Of these paintings, that which is perhaps as characteristic as any is "The Sail-Boat." He repeated this motive in the form of a watercolor which is in Mr. Charles S. Homer's collection. Many a Yankee boy has been fascinated by the glorious suggestion of free and buoyant movement in this little picture, the luminous and bracing look of the air and sea and sky, the keen impression of a big, wholesome, wide outdoor world.

At the same time Homer's indefatigable pencil was as busy as ever in the making of drawings for "Harper's Weekly." In a double-page cartoon published on January 8, 1870, he gave in pictorial form, under the title "1860–1870," an epitome of American history for the decade just closed. His review embraced the great events of the War for the Union and the period immediately following the close of hostilities. Some of the important features of the war were suggested, such as the firing on Fort Sumter, the uprising of the North, the fight between the Monitor and the Merrimac, the Proclamation of Emancipation, and the Surrender

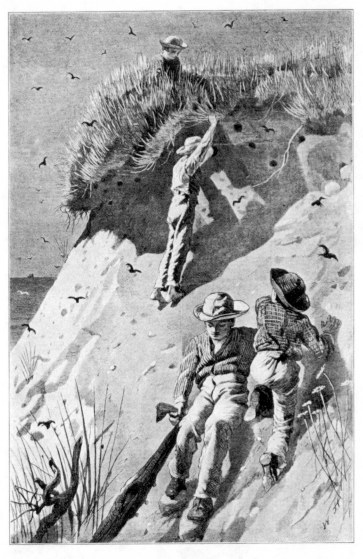

RAID ON A SAND–SWALLOW COLONY -— "HOW
MANY EGGS?"

From a drawing engraved on wood for Harper's Weekly,
June 13, 1874

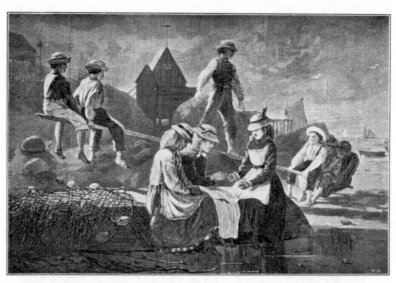

SEESAW — GLOUCESTER, MASSACHUSETTS
From a drawing engraved on wood for Harper's Weekly,
September 12, 1874

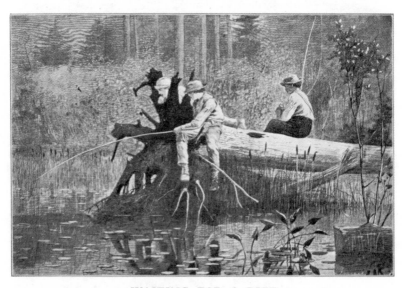

WAITING FOR A BITE
From a drawing on wood by Lagarde for Harper's
Weekly, *August 22, 1874*

of Lee at Appomattox. He followed this historical essay with an unusual example of ethical symbolism, under the title of "The Tenth Commandment," which was published on March 12. In the centre of the design we see a wife kneeling at prayer in church ; and in the four corners of the composition are a house, a maid, a servant, and an ox and an ass. A drawing published on April 30 represented "Spring Farm Work — Grafting." "Spring Blossoms" appeared on May 21 : this rustic scene depicted a stone wall and a way-side water-trough under the boughs of an apple-tree in full blossom ; on the wall three country children were seated. The bare-foot boy sitting on one end of the trough dangled one foot in the water ; and a young woman was leaning against the wall. It was signed with the artist's initials on the sail of a tiny toy sail-boat which floated on the water. "The Dinner Horn" was published in "Harper's Weekly" for June 11. Just outside the door of a farmhouse the buxom figure of a young woman, with her back turned towards the observer, stood as she sounded the dinner call to the men who were at work in the fields. This figure was well drawn, stood on its feet firmly, and the drapery, which was blown by the breeze, was excellently treated. The effect of the sun-light on the figure, too, was observed with the most studious veracity. The last of the series of drawings for 1870 was "On the Bluff at Long Branch, at the Bathing Hour," pub-lished on August 6. A group of five ladies were about to descend a flight of wooden steps to the bath-houses on the edge of the beach below. The strong sea-breeze played pranks with their voluminous flounced skirts. A glimpse of the beach was given, with many figures of bathers entering the surf ; and on the ocean were a number of sailing craft in the distance.

In 1871, Homer contributed a series of full-page drawings to "Every Saturday," a short-lived weekly pictorial paper published by James R. Osgood & Co., of Boston. This series dealt with various everyday scenes of rural life and manners, hunting, maritime motives, and the episodes of a summer resort. The subjects included the following titles : "A Winter Morning, — Shovelling Out," " Deer-Stalking in the Adirondacks in Winter," " Lumbering in Winter," " A Country Store, — Getting Weighed," " At Sea, — Signalling a Passing Steamer," "Bathing at Long Branch, — 'Oh, Ain't it Cold !' " and " Cutting a Figure." These drawings as published were approximately nine by twelve inches in dimensions, and were engraved on wood by W. J. Linton, J. P. Davis, G. A. Avery, and other engravers of the period.

"A Winter Morning, — Shovelling Out" represented a farmhouse in Northern New England on the morning after a heavy fall of snow. A man and a boy in the foreground were making a path through the drifts from the house door to the road, or, perhaps, to the barn. As they stood on the ground the surface of the snow came nearly to the level of the shoulders of one of the shovelers, and even with the hips of the other one. Nearer to the house a woman holding a plate in her hand was throwing crumbs to the birds. The sky was still clouded in part, and was of a darker tone than the snow beneath, though in the foreground there were some cast shadows which indicated that the sun was breaking through the clouds. A few large flakes were, however, still falling. The values in the snow were subtly rendered, and the wintry atmosphere vividly suggested. The fantastic arabesque of an old apple-tree in front of the farmhouse was drawn with much care, its network of boughs and twigs, each with its silver line of sticky snow adhering to the upper side,

being relieved against the sullen sky. The action of the figures was given with some stiffness, but was sufficiently definite to tell its story.

"Deer-Stalking in the Adirondacks in Winter," the first subject taken from the North Woods by Homer, who afterwards found many congenial motives there, showed a pair of hunters on snow-shoes, running, an action which is as far removed from the poetry of motion as anything can well be. In the distance, at the right of the composition, was a deer, and a dog was springing at its throat, while a second hound was coming up a short way back. The forest where this episode was taking place was for the most part without underbrush, and was desolate in its wintry aspect.

"Lumbering in Winter" showed a pine forest, with two figures of brawny lumbermen. The man in the foreground wore snow-shoes, and stood with his axe swung back over his shoulder, in the act of felling a giant tree, which was almost ready to topple over. A few yards farther away was the stout trunk of a tree already cut down, on which stood the second lumberman, who was cutting it in two in the middle.

"A Country Store,—Getting Weighed" had a group of five figures in it. There were four ladies, one of whom was standing on the scales, while a gentleman adjusted the weights, and the others awaited their turns. The fashions in dress of 1871 are interestingly recalled by this drawing. The flounced skirts and overskirts are quite characteristic of the period, as are the small, low-crowned hats. The weighing was going on in the midst of the variegated stock of soap, fresh eggs, new brooms, flour, rakes, clothes-lines, lard, etc., of the country store, which also, of course, contained the post-office.

"At Sea,—Signalling a Passing Steamer" was a dra-

matic drawing of an incident which had more novelty than
the preceding motives, and was picturesque in a different
and more emphatic sense. It was night, and the black hull
of a transatlantic liner loomed through the shadows. On the
bridge were the figures of four officers. One of them had
just discharged a rocket from the starboard end of the bridge,
the sudden glare lightening up the waves far beyond the bow,
and bringing into sharp relief the shrouds and stays, masts
and yards, of the fore part of the vessel. This instantaneous
effect, which must have been drawn from memory, was given
with graphic intensity. One felt that the blinding glare of
the fireworks would fade and die away as quickly as it had
come. Dark shapes of several seamen on the main deck were
visible ; they were peering through the darkness for the an-
swering signals.

"Bathing at Long Branch, — 'Oh, Ain't it Cold !'" de-
picted a group of three buxom girls in the water; having
waded out to a depth of about two feet, they were hesitating
to take the final chilly plunge. Two bolder bathers were
shoulder-deep a little distance away, and several vessels were
visible on the far horizon. "Cutting a Figure" was a double-
page drawing, in which a pretty young woman was just
completing an elaborate manœuvre on the ice of a large skat-
ing-pond in the country ; a few other skaters being visible
in the distance at the left. As will have been noted, this was
a favorite subject with Homer, who fully appreciated the
graceful possibilities of it, and returned to it several times.

CHAPTER V

LIFE IN THE COUNTRY

1872–1876. Ætat. 36–40

Studio in West Tenth Street — "New England Country School" — "Snap the Whip" — A Summer on Ten-Pound Island — The Gloucester Water-colors — Urban Subjects — Last of the "Harper's Weekly" Drawings — "The Two Guides" — Relations with La Farge.

MORE and more the artist turned his steps towards the country in search of the kind of subjects that appealed to him. He endured the city, but he was not at home there. He made frequent trips to little villages in New York State and in New England in the early seventies, and never returned empty-handed. One of the villages that he was fond of going to was Hurley, New York, four miles west of Kingston. He found some of his most interesting rural subjects in this Ulster County village, in the southern part of the Catskills. When he went to Belmont, Massachusetts, to visit his parents, he usually did some work in that neighborhood. I have seen an oil painting that he made of the famous and very venerable trees known as the Waverley oaks, at Waverley, Massachusetts. Against the sky rise the majestic outlines of these monster oaks, naked, or nearly so, forming a complicated pattern of dark lines. The foreground has blackened sadly; one can barely discern in its depths of shadow the figure of a boy driving home three or four cows. The work is chiefly interesting for its extremely careful and loving drawing of the wide-spreading primæval trees.

In 1872 Homer moved his studio to No. 51 West Tenth Street. At the National Academy exhibition of that year he showed five oil paintings, namely, "The Mill," "The Country School," "Crossing the Pasture," "Rainy Day in Camp," and "The Country Store." A drawing entitled "Making Hay," which was published in "Harper's Weekly" for July 6, 1872, was, I believe, made during one of the visits to Belmont. The editor of the "Weekly" enthusiastically remarked: —

"Mr. Winslow Homer's beautiful picture is a poem in itself, a summer idyl, suggestive of all that is most pleasant and attractive in rural life."

One can hardly agree with this judgment. Making hay is pleasant and attractive to the spectator, perhaps, but it is hard and hot work for the haymaker; moreover, this drawing was far from being one of Homer's best. It showed a field sloping gradually towards a stream at the right. Two farmers were mowing by hand. One of them was "in the shade of the old apple-tree" in the foreground, where two children were sitting on the ground, near a pail and a tin drinking-cup. Homer told the following anecdote to Albion H. Bicknell concerning the circumstances attending the making of this drawing. One warm Sunday morning, in Belmont, the artist's father, who was a regular church-goer, asked Winslow if he was going to church, and the latter replied in the negative. For some reason, Mr. Homer slipped out of church earlier than usual, and made an unexpected return to the house. After a look around the premises, he found Winslow drawing the haymaking scene in the open air, back of the barn, where the man of all work was posing with a scythe as his model. The elder Homer was much displeased by this Sabbath-breaking proceeding.

Two other drawings were published in the course of the year 1872. In August "Harper's Weekly" contained an illustration entitled "On the Beach — Two Are Company, Three Are None," made to accompany an anonymous poem which puts this melancholy avowal into the mouth of the principal figure, a woman: —

> "And so at last I left them there,
> And all unheeded went away,
> Lest e'en the birds should read my heart,
> As I had read myself that day."

I feel sure that it will not be deemed extravagant praise to say that the illustration is better than the poem.

On September 14, "Harper's Weekly" contained an engraving after a painting by Homer entitled "Under the Falls, Catskill Mountains." The only oil painting exhibited by him at the Academy of 1873 was "A New England Country School." This characteristic composition, in which a pretty young school-teacher, who was standing, book in hand, behind her pine desk, in the centre of the picture, hearing her pupils recite their lesson, was the chief figure, attracted much favorable attention. The class was a small one, consisting of four boys and three girls. Unoccupied forms and desks on either hand suggested provision for a larger class in the winter season. The walls were bare, save for a blackboard behind the school-mistress and a window on either side revealing a glimpse of the green and sunny country outside. Of the work it has been justly said that the artist inspired it with the severe simplicity of a serious life and people and yet reconciled it with picturesqueness. It was thoroughly realistic, grave without harshness, and held a hint of romance in the comely young teacher with the June rose flaming on her desk. "A New England Country School" was bought by

Thomas B. Clarke of New York. In 1891 it was exhibited, together with eleven other pictures by Homer, at the Pennsylvania Academy of the Fine Arts, Philadelphia. It was also one of the pictures by Homer exhibited at the Paris International Exposition of 1878.

No less than eleven drawings were contributed to " Harper's Weekly " in the course of the year 1873. The first of these was an illustration of one of the painful incidents of the wreck of the steamship Atlantic of the White Star Line. It represented a rocky coast, with the dead figure of a woman, partly clothed, lying on a ledge, where it had been washed up by the tide. The body was just being discovered by a fisherman. It will be remembered that the Atlantic, bound from Liverpool for New York, was wrecked on the rocks of Mars Head, N. S., April 1, 1873, and five hundred and sixty-two lives were lost. Homer's drawing was published on April 26 ; it was called " The Wreck of the Atlantic — Cast up by the Sea."

" The Noon Recess," published on June 28, recalled the painting of " The New England Country School," which has been described. A small bare-foot boy who had been kept in the schoolroom as a punishment for some transgression was sitting on a bench, with his face buried in a book. The schoolmistress, who looked tired, cross, and worried, also sat on a bench, resting her elbow on a long desk or table. Through an open window there was a glimpse of children at play out-of-doors. A sufficient idea of the quality of the poem which went with this drawing may be derived from the first verse :

> Yes, hide your little tear-stained face
> Behind that well-thumbed book, my boy ;
> Your troubled thoughts are all intent
> Upon the game your mates enjoy,

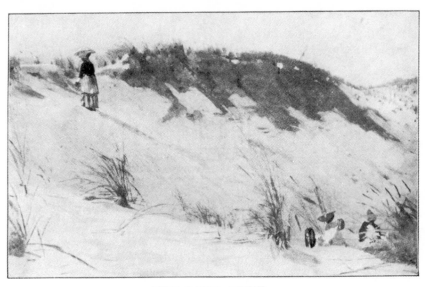

THE SAND DUNE

From the oil painting in the collection of Mr. Arthur B.
Homer. Painted at Marshfield, Massachusetts. Wins-
low Homer's mother posed for the figure. Photograph by
Chester A. Lawrence, Boston

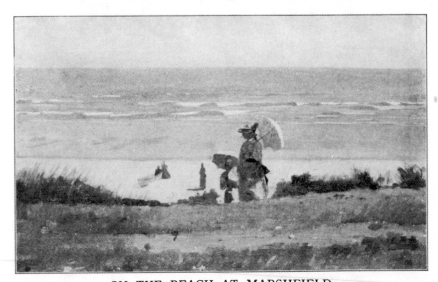

ON THE BEACH AT MARSHFIELD

From the oil painting in the collection of Mr. Arthur B.
Homer. Photograph by Chester A. Lawrence, Boston

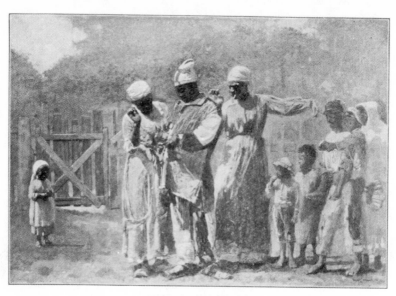

THE CARNIVAL

From the oil painting in the collection of Mr. N. C.
Matthews, Baltimore, Maryland

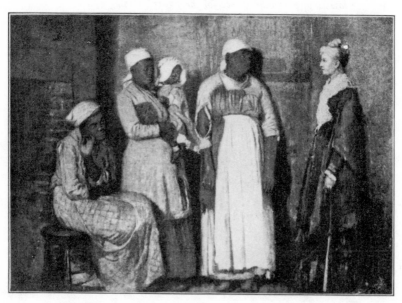

THE VISIT FROM THE OLD MISTRESS

From the oil painting in the permanent collection of the
National Gallery of Art, Washington. William T. Evans'
gift

While you this recess hour must spend
On study bench without a friend.

"The Bathers," from a picture by Winslow Homer, was published on August 2. Not every one could agree with "Harper's Weekly" when it remarked, in reference to this drawing, that "the pretty figures in the foreground of Mr. Homer's charming picture illustrate the advantages of a costume peculiarly adapted to a graceful exit from the bath."

"The Nooning" was published on August 16. Near a white farmhouse three barefoot boys and a dog are sprawling on the grass. The dog is gnawing a bone. In the background, two houses, with trees near them, and clothes hung out on the line to dry. "Sea-Side Sketches — A Clam-Bake" was published a week later. A dozen little boys are seen on a rocky beach; more than half of them are clustering about a fire; the others are bringing water and driftwood for fuel; in the background is the sea.

"Snap the Whip," dated 1872, was reproduced in a highly satisfactory double-page wood engraving in "Harper's Weekly" for September 20, 1873. It measures twenty-two and one quarter inches high by thirty-six inches wide. This picture was bought by Mr. John H. Sherwood, and at the sale of his collection in 1879 it passed into the possession of Mr. Parke Godwin. It is now in the collection of Mr. Richard H. Ewart. Nothing, not even the "New England Country School," had been quite so racy of the soil as this sturdy picture of a line of nine or ten barefoot boys holding hands and racing across a level common in front of a little rustic schoolhouse among the hills. The boys at the right of the line have made a sudden halt, and the two victims at the left end are sent tumbling head-over-heels on the green-

sward. Beyond, at the left, are two little girls with a hoop and other children at play. The landscape in "Snap the Whip" is extremely rough and rugged, and unmistakably of Northern New England. There is something pungent and rude and bracing in the uncompromising naturalism of it. How it must have brought back to many a town-dweller in 1872 the recollection of boyhood days! It was lent to the Philadelphia Centennial Exposition of 1876, and to the Paris International Exposition of 1878; and was illustrated in line in the Sherwood catalogue of 1879. It reappeared in the New York Memorial Exhibition of 1911.

The watercolor drawings entitled "Berry Pickers" and "Boys Wading," which belonged to the collection of Mrs. Lawson Valentine of New York, are dated 1873. The "Berry Pickers," which was painted in the summer of 1873, probably near Gloucester, represents a rocky field with a number of children carrying tin pails and picking berries near the seashore. At the left a girl is leaning against a gray boulder, holding her pail in her right hand. She wears a dark skirt, a yellowish apron and blouse trimmed with red, and a straw hat with a brown ribbon. The head and shoulders of another girl appear above the boulder at the extreme left. Two boys and a girl are seated on the grass. The little girl in the immediate foreground in the centre of the picture, with her back toward the spectator, wears a yellow dress; facing her at the right is a boy in brown trousers and vest, white shirt-sleeves, and a straw hat; while the other boy, seen from the back, has dark trousers and a white shirt. Beyond, at the right, two other figures are suggested. The ground is covered with low bushes and wild flowers. In the distance is a line of blue water, and sail-boats are on the horizon at the right.

"Boys Wading" shows a sandy beach in the foreground. In the shallow water two boys stand knee-deep, bending over and rolling up their trousers. The one at the right, with his back toward the observer, wears gray trousers, a white shirt, and a brown hat; the one at the left, seen in profile, facing his companion, wears a straw hat, light brown trousers and vest, with white shirt-sleeves. In the background is a dock with sheds, and a two-masted green schooner with sails down is moored alongside the dock. This was painted at Gloucester. Both of the watercolors were in the New York Memorial Exhibition of 1911.

There is something positively charming about the naïveté with which these pictures of country children are painted. I cannot analyze it. In point of method, these Gloucester watercolors of 1873 are literally watercolor drawings; that is to say, they are, first, drawings, and then colored; and, while they are very far from having the breadth and power of the later watercolors, their precision of draughtsmanship, the closeness of observation displayed, and the adorable genuineness of the types, make them most admirable and interesting.

That summer of 1873 was a fruitful time and must have been a happy season. Homer, by a happy inspiration, on reaching Gloucester, had "persuaded Mrs. Merrill, the light-house-keeper's wife, to take him in," as a boarder, at her house on Ten-Pound Island, in Gloucester harbor; and there he lived for the whole summer, rowing over to the town only when in need of materials or in search of fresh subjects. "The freedom from intrusion which he found in this little spot was precisely to his liking, and here he painted a large number of watercolors of uniform size, but of a wide range of boldly conceived and vigorously executed subjects.

No experiment, however fraught with risk of failure, had any terrors for him. He painted absolutely as he saw, entirely unafraid, caring for nothing so much as his freedom to express himself with unfettered independence. Failures were to be found when this notable group of watercolors was shown in a Boston gallery (this may have been in about 1878), but they had much of the significance of Rubinstein's false notes on the piano. On the other hand, the successes—and they were far the larger number—showed, as Emerson said, 'the devouring eye and the portraying hand.' Most of these admirable little pictures were eagerly bought by Boston admirers, the prices ranging from seventy-five to one hundred dollars each." [1]

Two of the best of the "Harper's Weekly" drawings of this period were "Gloucester Harbor" and "Ship-Building, Gloucester Harbor." In the former drawing, published September 27, 1873, there were two dories in the foreground, with seven boys on board. In the middle distance were fishing schooners; and many sails were seen on the horizon. The play of the reflections in the water, and the drawing of the boats, were equally admirable. Still more effective and striking was the ship-building scene, which was published October 11, 1873. A schooner was on the stocks, under construction, and many laborers were busy about the hull, caulking, planing, hammering, boring, etc. In the foreground were five boys, two of them making toy boats, and the others gathering chips for kindling-wood. The light-and-shade effect was very handsome.

Three more " Harper's Weekly" drawings were published in November and December, 1873. These were:

[1] "Some Recollections of Winslow Homer," by J. Eastman Chase: *Harper's Weekly*, October 22, 1910.

"Dad's Coming," November 1, "The Last Days of Harvest," December 6, and "The Morning Bell," December 13. In "The Last Days of Harvest" two lads were husking corn in the field, while at a little distance two men were loading pumpkins on a wagon. The two other drawings were made as illustrations to poems.

"Dad's Coming" was used as the motive for a painting that was finished at about the same time, and was exhibited at the National Academy of 1874. In this composition a mother with two children, one of them an infant, was waiting on the beach for the arrival of her sailor-husband. Spars, dories, nets, and similar fishermen's belongings, were strewed about the foreground, and in the background was the sea. Three other paintings were sent to the Academy by Homer in 1874: "School Time," "Girl," and "Sunday Morning." A watercolor entitled "In the Garden" is of this year. A gardener, leaning against the wall of a country house, stood talking to a maid who was looking out of a window. There was a contrast of the red brick wall and the redder shirt of the man. Some flowers were relieved with fine effect against the white plaster, and to the left a cat was stealing silently through the grass.

During the winter and spring of 1874 Homer busied himself with a series of urban illustrations, and he contributed four of these New York City subjects to "Harper's Weekly" in February, March, and April. As we have already seen, the artist was far from having ignored the pictorial possibilities of the city. His "Station-House Lodgers," published February 7, showed the interior of a large basement room in a police station, the floor being covered by the recumbent figures of sleeping men. On February 28 his drawing of "The Watch-Tower" maintained by the fire department of that day

at the corner of Spring and Varick streets, was published. "The Chinese in New York," March 7, was a scene in a Baxter Street club-house; and "New York Charities," April 18, was a drawing of St. Barnabas House, in Mulberry Street. After this he was ready to turn his back on the city for a good long summer campaign, which took him to Gloucester, Long Branch, and presently to the Adirondacks, a region which was to yield him many rich and congenial motives for pictures.

The rural scenes in "Harper's Weekly" for 1874 exhibited the same distinct advance in light-and-shade that has been noted in reference to those of the preceding year. The "Raid on a Sand-Swallow Colony — 'How Many Eggs?'" published June 13, presented a fine brisk effect of outdoor light and atmosphere. It represented the summit of a great sand dune, the top of which was tufted with coarse and wiry grasses; at the left a glimpse of the ocean; four boys had climbed to the upper part of the steep slope where there were numerous holes in the sand-bank, the abodes of the sand-swallows, which are being robbed of their eggs.[1] "Gathering Berries," published July 11, contained eight figures of country boys and girls berrying in an old pasture near the seashore. All but one of them were intent upon their work. One little girl was standing up, leaning against a boulder, and holding a tin pail in her left hand; possibly she had filled her pail first and was waiting for the rest. The sky was partly overcast; a schooner in the distance was at the left; the moving ribbons on the little girls' hats indicated a breeze. This drawing differs only in trivial details from the watercolor called "Berry Pickers," in Mrs. Lawson Valentine's collection. "On the Beach

[1] A watercolor version of the subject is in the collection of Mr. Edmund H. Garrett of Boston.

at Long Branch—The Children's Hour," published August 15, showed a group of two nurse-maids, a mother, and two children in the foreground, with many other figures farther removed from the foreground; the sea and a steamer in the offing; bath-houses and the bluff at the right. "Waiting for a Bite," published August 22, was an intensely characteristic drawing, of extraordinary breadth and carrying force. Here were three boys perched comfortably on an old fallen trunk of an uprooted tree which projected most conveniently over the shallow water of a secluded pond, where lily pads abounded, and cat-tails grew in the still coves, and the background was closed in by thick woods. Two of the boys were supplied with poles and lines, and one of them was fishing, while the other was baiting his hook. A third boy, lying flat on his stomach, was watching operations. "Seesaw, Gloucester, Massachusetts," published September 12, contained nine figures of boys and girls. Three girls were sitting on the bottom of an overturned dory, playing at "Cat's-Cradle," in the foreground. Just beyond them, six small boys had arranged a seesaw, consisting of a long plank balanced on a rock. While one of the boys stood in the middle, the rest were seated on the two ends of the plank, seasawing. The background was a picturesque jumble of shanties, wharves, etc., with the harbor at the right. " Flirting on the Seashore and on the Meadow," published September 19, was divided into two panels. In the upper panel, a moonlight evening on the beach, a man and a woman were sitting on the sand ; in the lower one, a little maid was sitting on the grass of the meadow, while two barefoot boys, lying on their stomachs, were chatting with her. "Camping Out in the Adirondack Mountains," published November 7, represented two men sitting on the ground, one of them smoking a pipe and looking dreamily into the fire,

the other overhauling his stock of flies. A shelter built of bark, a birch-bark canoe, a landing net, a dog, and a fallen tree, are items of the scene; and in the background were a lake and a mountain.

With the drawing of "The Battle of Bunker Hill — Watching the Fight from Copp's Hill, in Boston," published June 26, 1875 (the scene being on the roof of a house), the long series of illustrations in "Harper's Weekly" comes to an end. Extending through seventeen years, or from his twenty-second to his thirty-ninth year, with few breaks, this series of drawings had not only made Homer known to many thousands of his countrymen, but it had also been in a sense a school of invaluable assistance in the development of his art and in the disciplining of his talent. I have given more attention to the early drawings in this series than their intrinsic merits would warrant, perhaps, partly because all of the formative stages of a great artist's *œuvre* have their significance and interest, and partly because of the extraordinary interest that attaches to any and all documents relating to the Civil War. In a more or less indirect way, moreover, the "Harper's Weekly" drawings give us the clue to what the artist was doing, what he was thinking about, what plans and purposes he was cherishing, and in what places he was working, during these seventeen years of his early life, before painting had absorbed all his energies, and before he had turned to marine painting as his special vocation.

The success of a self-made man depends upon his inborn natural gifts, and upon the degree of his will to make the best of himself. The "Harper's Weekly" drawings offer valid evidence of Homer's indomitable determination to teach himself how to draw. He attacked any and every kind

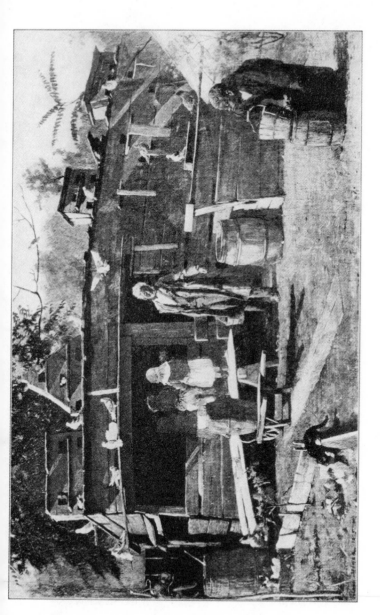

A HAPPY FAMILY IN VIRGINIA

From the oil painting in the collection of Colonel Frank

J. Hecker, Detroit

THE HONEYMOON (MR. AND MRS. A. B.
HOMER)

*From the drawing in the collection of Mr. Arthur B.
Homer. Made at Kettle Cove, Prout's Neck, Maine,
1875. Photograph by Chester A. Lawrence, Boston*

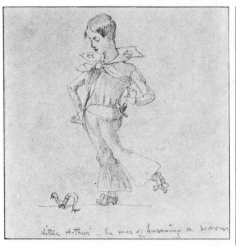

LITTLE ARTHUR IN FEAR OF
HARMING A WORM

*From the drawing in the collection of Mr.
Arthur B. Homer. Photograph by
Chester A. Lawrence, Boston*

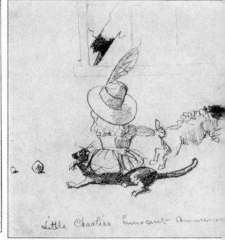

LITTLE CHARLIE'S INNOCENT
AMUSEMENTS

*From the drawing in the collection of Mr.
Arthur B. Homer. Photograph by
Chester A. Lawrence, Boston*

of subject, as we have seen, shirking nothing, evading no difficulties, using his own faculties of perception, solving his own problems, ever learning, even from his own defeats. In a literal sense he was his own master and his own severest critic. Nothing daunted him. Mr. Coffin [1] has written : —

"Sometimes it is asked, 'What might not Winslow Homer have done if he had had a thorough art education at the beginning of his career?' I fancy that those who ask this question do not know what a great school Nature is when the pupil is a persistent searcher for truth and has the strength of purpose that has enabled Mr. Homer to find adequate forms of expression in his own way."

At the National Academy Exhibition of 1875, Homer exhibited four paintings: "Landscape," "Milking Time," "Course of True Love," and "Uncle Ned at Home." The Centennial Exhibition of 1876 at Philadelphia, a landmark in the history of American art, contained the following list of Homer's works: "Snap the Whip" (belonging to the Sherwood collection) and "The American Type," in oils; "The Trysting Place," "In the Garden," "Flowers for the Teacher," and "The Busy Bee," in watercolors. In the official report of the art display at the Centennial Exhibition, written by Professor John F. Weir, he speaks thus of the two oil paintings mentioned : —

"Winslow Homer was represented by two pictures, 'Snap the Whip' and 'The American Type,' the latter a characteristic example of this artist's pronounced individuality. The expression of the figures is intense, full of meaning, and the tenacity of his grasp upon the essential points of character

[1] "A Painter of the Sea," by William A. Coffin: *Century Magazine*, September, 1899.

and natural fact is very decided. No recent work of this author has equalled the remarkable excellence of his celebrated 'Prisoners from the Front,' an incident of the late war, which is a unique work in American art; but all his pictures have the merit of a genuine motive and aim. . . ."

Among the pictures which Homer painted in 1876 was an Adirondacks subject, "The Two Guides." Of this picture Samuel Swift wrote as follows in the "New York Mail and Express," March 19, 1898: "'The Two Guides' shows an old man and a younger one standing on the slope of a mountain side. The veteran seems to be pointing out to his companion certain landmarks in the vast wilderness. They are typical men of the North Woods, these two. One wears a red shirt that has an insistence of color rarely attained in these later years of more subdued garments, and the other carries an axe. Their expression and bearing, however, bespeak their characteristics better than the mere labels of shirt and axe. The great stretch of mountain and valley that lies before the two woodsmen is silent and lonely and grand. The artist evidently felt the bigness of the place."

The picture was bought by Mr. Thomas B. Clarke, and was sold at the sale of his collection in 1899 for eight hundred and seventy-five dollars. It became the property of Mr. C. J. Blair of Chicago, who lent it to the loan exhibition held at the Carnegie Institute, Pittsburgh, in 1908. Somewhat more elaborate and rhetorical, yet interesting enough to quote, is the descriptive paragraph concerning "The Two Guides" which was published in the Clarke catalogue of 1899.

"'The Two Guides.' The pioneer of the past is schooling his young successor, to whom he will soon abdicate his place, in some of the secrets of his craft. The old man, still stalwart and lusty for all the frost that whitens his beard, and the power-

ful young woodsman, are crossing a mountain ridge. The ground is wet and dark with dews and midnight showers. Out of the depths behind them mists rise from the streams and springs below, and floating flecks of cloud blow along the flanks of the mountains. The guides have halted at the summit of the ridge, and the older man points forward, at some landmark beyond. Two grand and rugged types amid a grand and rugged nature, they seem instinct with, and eloquent of, the spirit of a scene and life which is yielding steadily to time, and of which this picture will, in the future, be a historical reminder and landmark."

Mr. R. M. Shurtleff, referring to "The Two Guides," tells us that the principal figure depicts "Old Mountain Philips," a character since made famous by Charles Dudley Warner, and the other figure is that of a young man noted in the Adirondacks for his size and his red shirt. "He still lives here," says Mr. Shurtleff, writing from Keene Valley, "and is still wearing, if not the same shirt, one precisely like it."

It was while Homer was occupying his studio in the old studio building in West Tenth Street that he became acquainted with John La Farge, who had a studio in the same building. In his letter to Mr. Gustav Kobbé,[1] La Farge relates the following incident of those days : —

"I met him [Homer] on the stairs as I was going up, and I knew by his gesture that he was coming to me. We went up to his room without a word, and he pointed to a picture he had just painted. It was that of a girl who had hurt her hand, and the expression of the face was what in my Newport language I know as 'pitying herself.' This was as delicate an expression as it is possible to conceive. The painter of the surf and the fisherman and the sailor and the hunter

[1] Published in the *New York Herald*, December 4, 1910.

and every active and fierce edge of the sea was here touching one of the most impossible things to render. He said nothing; he pointed; I understood. He wished to show me that he, too, could paint otherwise, and we went downstairs together without a word."

Mr. La Farge was, however, in error when he stated that the education of Winslow Homer was "developed from the studies of especially the French masters of whom there were only a very few examples in the country as far as painting went." There is no evidence to support this assertion, and there is ample internal evidence in his pictures to show that this alleged source of inspiration did not exist for him. If it is true that Homer copied some lithographs by French artists of the so-called Barbizon school, as has been stated on the authority of Mr. La Farge, there is no evidence either of the fact itself or of any influence from the works in question in his own practice. This mistake is of a piece with the false statement that "the year in the Paris schools greatly improved his technique." He did no work in France, and entered no schools in Paris. If he took any interest in French art, old or modern, he never made it known, orally or otherwise. Indeed, I am forced to conclude that Mr. La Farge knew Homer only superficially; he confesses as much when he says: "Quite late this man went to Europe and studied there," and "he seems to have dealt little with the French artists, nor do I know exactly the degree of appreciation which met him from Americans; nor have I ever heard what he thought or said of the great masters' works." It is very strange that La Farge should have been ignorant of the degree of appreciation which met Homer from Americans, for this was a matter of common knowledge at the time his words were written.

CHAPTER VI

AMONG THE NEGROES

1876-1880. Ætat. 40-44

" The Visit from the Old Mistress " — "Sunday Morning in Virginia " — "The Carnival " — An Episode in Petersburg — The Model who Ran Away — The Houghton Farm Watercolors — The " Shepherdess of Hough-ton Farm " — The " Camp Fire " — Gloucester Again — Homer's Mastery in Composition.

SEVERAL of Homer's most successful and popular paintings of negro life in Old Virginia were painted in the late seventies. " The Visit from the Old Mistress," which has been catalogued as "The Visit to the Mistress" and "The Visit of the Mistress," was painted in 1876. "Sunday Morning in Virginia" and "The Carnival" were painted in 1877. While with the Army of the Potomac in Virginia in 1862, Homer's attention had been strongly attracted to the negroes, and in his "Bright Side" (1865), he had made his first essay in utilizing the African type as a motive for a picture. Conceiving a desire to return to this class of subjects, he went to Petersburg, Virginia, in 1876, and there made a series of careful studies from life. The principal results of this journey, which had like to have tragic results for the artist, were the three very sympathetic and interesting genre paintings which have been mentioned. While he was at work in Petersburg, it became known to a group of young fire-eaters there that he was consorting with the blacks, and they resolved to drive him out of town as a "d—d nigger-painter." Word had come to him that

the place was to be made too hot for him, but he paid no attention to the warning. One day he was sitting on the porch of the hotel where he was staying, when a "bad man" rode up to the gate, dismounted, tied his horse, and started to come up the walk, with a most threatening aspect. Homer, relating the incident, said : —

"I looked him in the eyes, as Mother used to tell us to look at a wild cow."

The artist was sitting with his hands in his pockets. When half-way to the porch, the "bad man" hesitated, halted, and, turning on his heel, strode back to his horse, mounted, and rode away. He had no sooner disappeared than a gentleman from Texas, who had been sitting on the porch near Homer, crawled out from under an adjacent bench.

"What did you get down there for?" asked Homer.

"Well," said the Texan, "it was n't my fight, and I thought there was going to be some shooting."

"Why did he go away?" asked Homer.

"Well, I 'll tell you. He thought you had a Derringer in each hand and were going to get the drop on him."

He went on to explain that sometimes men shot from their pockets. Homer was not molested. He went on, finished what he had begun, and returned North.

In "The Visit from the Old Mistress" there is an extraordinary presentation of female negro character. The three former slaves are observed and described most vividly and keenly. In their solemnity of demeanor, the humility of their expression, and the evident awe which the presence of the old mistress inspires, there is a blending of pathos and humor, which belongs to the situation, and is all the better for not having been injected into it. The colored baby in the arms of one of the women is an interesting type, and one

wonders why the *grande dame* is not human enough to take
notice of it. The place is the cabin of the negro women, and
not, as the altered title would imply, the kitchen of the
" great house." A large old-fashioned open fireplace is seen
at the left. The position and expression of the "mammy"
sitting on a stool near this fireplace are admirably caught.
This picture was bought by Mr. Thomas B. Clarke, and at
the sale of his collection in New York, in 1899, it was sold
for three hundred and twenty dollars to Mr. M. H. Lehman
of New York. Afterwards it passed into the possession of
Mr. William T. Evans, who presented it to the National
Gallery of Art, Washington, D. C. It is catalogued as " The
Visit of the Mistress " in Mr. Rathbun's catalogue,[1] but the
original title, as given in the catalogue of the National
Academy of Design for 1880, explains the situation more
clearly.

In " The Carnival " some negro women are helping to
dress a colored man in a fancy costume, in order that he
may take part in the festivities of the carnival. His coat, like
that of Joseph, is of many colors. It is undoubtedly of home
make, and blazes with the reds and yellows so dear to the
hearts of the Africans. A group of little negroes stand by,
watching the preparations, with awe and envy in their faces.
An old crone, with a pipe in her mouth, is sewing the stuff
together. At the left of the composition there is a gate, and
at the right is a house with tall chimneys. Sunlight falls on
the group of figures, producing strong lights and shadows.
This work is notable for its fine color as well as its capital
delineation of character. It was bought by Mr. Clarke, and
when his pictures were sold in 1899 it was acquired by Mr.

[1] "The National Gallery of Art, Department of Fine Arts of the National
Museum," by Richard Rathbun. Washington, 1909.

N. C. Matthews of Baltimore for two hundred and twenty dollars.

"Sunday Morning in Virginia" represents a group of four negro children, sitting on a bench and stools in the chimney corner, painfully spelling out the words in a Bible which they hold on their knees. Beside them sits an old "mammy," leaning on her staff, and listening to the reading. The rich and sober scale of color in this work, with its deep browns, blues, and reds, admirably related, was the subject of much favorable comment. This picture, eighteen inches high by twenty-four inches wide, was bought by Mr. William T. Evans, and it was sold at the Evans sale in New York, in the winter of 1900, for four hundred dollars, the buyer being Mr. J. C. Nicoll, the artist.

While engaged in painting his negro subjects, Homer met with some amusing characters among his models, and had some diverting experiences. He needed an elderly woman model to sit for him, in order to complete one of his groups, and, while walking along West Street, in New York, with this idea in his mind, he ran across a type of "colored person" who had just arrived from the South and who in age, avoirdupois, and complexion, was precisely what he was looking for. Her costume also, by the way, was in keeping with all the rest. He spoke to her, told her who and what he was, explained what he wanted, gave the address, and found her entirely willing to pose for him on the morrow. At the appointed hour she came to the studio in the old University Building, and although looking somewhat overawed by the sight of the easel, canvas, model-stand, palette, brushes, lay-figure, screen, and other studio properties, she took her pose, as instructed, and the work was about to begin; when, turning his back for a moment or two, or

FISHERWOMEN, TYNEMOUTH

*From the drawing in the collection of Mr. William
Howe Downes. Photograph by Chester A. Lawrence,
Boston*

WATCHING THE TEMPEST

*From the watercolor in the collection of Mr. Burton
Mansfield, New Haven, Connecticut*

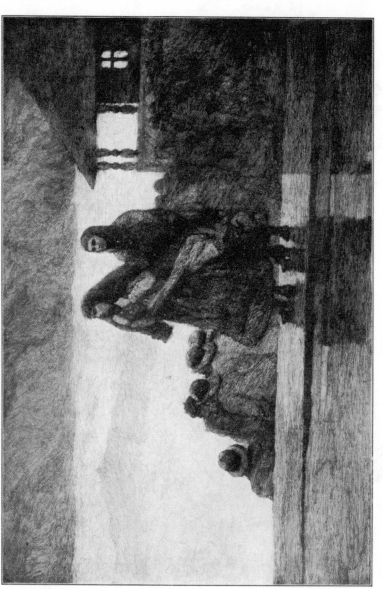

PERILS OF THE SEA

*From the etching by Winslow Homer, after his watercolor in the collection of
Mr. Alexander C. Humphreys, M.E., Sc.D., LL.D., President of the
Stevens Institute of Technology, Castle Point, Hoboken, New Jersey.
Copyright by C. Klackner, New York*

stepping behind a screen to get something, Homer, as soon
as he looked again, discovered to his amazement that
the bird had flown! Before he could reach the top of the
steep and step-ladder-like flight of stairs, she was half tum-
bling down the lower steps, falling over her own skirt in her
panic; and when he looked out of the window the next
minute, the old woman was making record time across
Washington Square, as if the Evil One himself were at her
very heels. As Homer expressed it, she "was only hitting
the high places," so swift was her flight. Some racial super-
stition, perhaps, had overcome her mind at the critical mo-
ment, and her fear of being bewitched may have culmi-
nated as she watched the artist's mysterious preparations to
paint her generous figure.

Another negro picture which was the outcome of the
journey to Virginia in 1876 was the "Cotton Pickers," repre-
senting two stalwart negro women in a cotton field. This
canvas, about thirty by forty inches, in a scale of browns
and silvery grays, was exhibited some time in the seventies at
the Century Club, of which, by the way, Homer was a mem-
ber. An English gentleman saw it there, bought it, and took
it to England; and Mr. F. Hopkinson Smith, who has sent me
this information, together with a rough sketch of the compo-
sition, thinks that the picture is practically unknown in
America.

At the National Academy exhibition of 1877, "Answering
the Horn" and a landscape were exhibited. The price placed
upon the former was seven hundred and fifty dollars. The
list of watercolors shown at the American Society of Paint-
ers in Watercolors exhibition in that year included five
titles: "Book," "Blackboard," "Rattlesnake," "Lemon,"
and "Backgammon." In the National Academy of 1878

were " The Watermelon Boys " (or, " Eating Watermelons"), and " In the Fields," which were engraved on wood for the " Art Journal," London, August, 1878; and there were also in the same exhibition "The Two Guides," " Morning," "Shall I Tell Your Fortune?" and "A Fresh Morning."

Two oil paintings which were originally entitled " A Fair Wind " and " Over the Hills," belonging to this period, were bought by Mr. Charles Stewart Smith of New York, and are pleasantly and appreciatively described by Mr. Strachan in his "Art Treasures of America,"[1] under altered titles. In the Smith Collection, according to Mr. Strachan, the best example of American art was Homer's " Breezing up" ("A Fair Wind"), a boating scene of admirable quality. " Of all the frank and direct nature studies of Winslow Homer, the sketch of boys in a boat had been settled upon by the artists as the author's greatest hit since the 'Confederate Prisoners.' — The type of the skipper's young American son, gazing off to the illimitable horizon of that picture" was "accepted by the discerning as one of the neatest symbols yet struck off of our country's quiet valor, hearty cheer, and sublime ignorance of bad luck." Of the other picture in the Smith collection, which he names "Rab and the Girls," Mr. Strachan writes : " How native and racy it is: the two fresh girls, themselves far enough from life's autumn, who roam the wild, lone hills bearing home over the downs the first blood drawn by aggressive winter, the first scarlet branch of that most American tree, the maple, the first triumph of the coming cold over the snappy vigor of Yankee summer; around them gambols their attendant Rab, sufficient and trusted escort in a land where handsome girls are safe in an atmosphere of honest chivalry ; the

[1] "The Art Treasures of America," edited by Edward Strachan. Philadelphia: George Barrie, 1879.

picture seems to include the most delicate and pensive aroma of Coleridge's 'November,' while at the same time it speaks the American accent, with incorrigible bravery of hopeful maidenhood, of cherry-cheeked leafage, of bounding animal life, of broad moorland freedom."

At the Paris universal exposition of 1878, Homer's contributions were more numerous, more important, and much more noticed than had been his *envois* in 1867. He exhibited there " The Bright Side," " The Visit from the Old Mistress," "Sunday Morning in Virginia," "A Country School-Room," and "Snap the Whip." The two last-named canvases were from the collection of John H. Sherwood. The picture here mentioned as "A Country School-Room" is identical with "A New England Country School," dated 1873, which has been described.

The artist spent a part of the summer of 1878 at Houghton Farm, Mountainville, New York, a few miles from Cornwall. There he painted (among other things) the two excellent little watercolors which were lent to the New York memorial exhibition of 1911 by Mrs. Valentine Lawson, "Hillside" and " Shepherdess." In the foreground of "Hillside" a young girl is seated, with her figure in profile, looking to the right. Her hands are clasped back of her head, and her brown hair hangs in a braid down her back ; she wears a brownish dress. Immediately back of her is a green hillside, and on its crest, at the left, are trees and red buildings. Other trees are on the ridge of the hill, which slopes down at the right. There is a blue distance and a light cloudy sky. In the foreground of the "Shepherdess," on a grassy knoll, in shadow, a young girl wearing a red dress and a sunbonnet lies at full length, with her head propped on her right arm; near her at the left are two sheep. Beyond, at the extreme left, a large tree throws

its shadow across the field; a stone wall back of the tree fol-
lows the rise of a hill towards a clump of trees at its top.
Sheep are grazing on the hillside, which is in bright sunlight.
There are distant blue hills at the horizon, and the sky is
light blue with thin white clouds.

These two watercolors, with twenty-two others, all, or
nearly all of which were painted at Houghton Farm, were
exhibited in 1879 in the exhibition of the American Water-
color Society. The titles then were "Watching Sheep" and
"On the Hill." Another of the Houghton Farm subjects,
"On the Fence," is in my possession; it is dated 1878, was
in the watercolor exhibition of 1879, and reappeared in the
Boston memorial exhibition of 1911. It shows a demure and
wistful little maid of about twelve years, painted from the
same model who is seen in "Hillside," seated on a stone
wall, against a background of white weeds and green shrub-
bery. Mr. Henry Sayles of Boston also owns a watercolor of
the same date, with a single figure, and a garden with flow-
ers in the background. The rest of the Houghton Farm wa-
tercolor series of 1878 will be found listed in the Appendix.
They were all shown in the watercolor exhibition of the fol-
lowing year.

The three oil paintings sent to the thirty-fourth annual ex-
hibition of the National Academy of Design in the spring of
1879 were: "Upland Cotton," a scene on a southern planta-
tion; "Sundown," a girl on the seashore; and "The Shep-
herdess of Houghton Farm," an American idyll. In all prob-
ability "the Shepherdess of Houghton Farm" may have
been the "half-grown, long-legged girl with a crook and
knots of ribbons on her ill-fitting dress, standing out in the
sunlight among the mullein stalks, a New England concep-
tion of a Boucher shepherdess," which is recalled by Mr.

Isham.[1] "Any one else," he adds, "would have rendered her with some recollection of the grace of the prototype if only by way of caricature; but Homer in a few firm strokes draws her exactly as she was, with no more suggestion of the court of Louis XV than if she had been a lumberman, and yet the child with the funny attempt at finery finishes by being more charming than any attempt to resuscitate the eighteenth century."

In the picture called "Upland Cotton" one of the critics of 1879 found a suggestion of Japanese influence. He expressed the view that this picture was "a superb piece of decoration with its deep, queer colors like the Japanese, dull greens, dim reds, and strange neutral blues and pinks." The same writer thought that the artistic subtlety of Japanese art had been precisely assimilated by Homer, and that this picture was "original and important as an example of new thought."

"Mr. Homer can see and lay hold of the essentials, and he paints his own thoughts — not other people's," said the "Art Journal," London, 1878. "It is not strange, therefore, that almost from the outset of his career as a painter, his works have compelled the attention of the public. They reveal on the part of the artist an ability to grasp dominant characteristics and to reproduce specific expressions of scenes and sitters; and for this reason it is that no two of Mr. Homer's pictures look alike. His negro studies, brought from Virginia, are in several respects — in their total freedom from conventionalism and mannerism, in their strong look of life, and in their sensitive feeling for character — the most successful things of the kind that America has yet produced."

[1] *The History of American Painting*, by Samuel Isham. New York: The Macmillan Company, 1905.

Concerning the three paintings shown at the National Academy of 1879, "Upland Cotton," "Sundown," and "The Shepherdess of Houghton Farm," the Editor's Table of "Appleton's Journal" expressed the following judgment and ventured the following prediction : —

"In three pictures this year there are more reach and fullness of purpose than in his recent works, and they indicate unmistakably, we think, that when conditions all unite favorably Mr. Homer will produce a truly great American painting. The elements are all within him; they are simply to be adequately mastered and grouped."

The prophecies of art critics are seldom so marvelously and so promptly vindicated as in this case. It is not too late to pay our compliments to this clear-sighted critic of 1879.

In 1880 the artist returned to Cape Ann, painting at Gloucester and Annisquam. He was chiefly engaged in making small watercolors, and how profitably he employed his time was evident the following winter, when, at the fourteenth annual exhibition of the American Watercolor Society, he exhibited no less than twenty-three works, most of them Gloucester subjects. Among these were : "Gloucester, Massachusetts," "Eastern Point Light," "Coasters at Anchor," "Gloucester Boys," "Bad Weather," "Schooners at Anchor," "The Yacht Hope," "Fishing Boats at Anchor," and "Sunset." An indoor figure piece entitled "Winding the Clock" was also shown at this exhibition. It was lent by General F. W. Palfrey, and a sketch of it in the catalogue, drawn by F. S. Church, shows a girl standing on a stool in front of a tall hall clock, apparently blowing the dust out of the key. Several of the Gloucester watercolor series of this year, owned in Boston, were shown at the Boston memorial exhibition of 1911. These include the "Children Wading at Gloucester,"

belonging to the Edward Hooper estate; the "Children and Sail-Boat," belonging to Mrs. Greely S. Curtis; "Sailing Dories," belonging to the Edward Hooper estate; and, I think, "The Green Dory," belonging to Dr. Arthur T. Cabot.

At the fifty-fifth exhibition of the National Academy of Design, in 1880, the oil paintings shown were the "Camp Fire," the "Visit from the Old Mistress," "Sunday Morning," and "Summer."

The "Camp Fire" is a nocturnal scene, representing a man lying on a bed of pine needles in a half-open tepee or wigwam built of saplings and walled with bark. Another man is sitting on the ground outside, with his back against the hut. His face, in profile, is lit by the glow of the fire in the foreground, which sends forth bright red sparks. In the background is a thick wood. The darkness is broken by the firelight in a way that emphasizes the solitude of the surrounding forest. Tongues of flame flash and writhe, and the sparks leap upward in quick, sinuous curves that carry the eye aloft to follow them. This picture was bought by Mr. Thomas B. Clarke, and it was sold to Mr. Alexander Harrison of New York in 1899 for seven hundred dollars. It was exhibited at the World's Fair, Chicago, 1893; and has been exhibited three times in New York,— in 1880, 1910, and 1911. It is twenty-four and one-quarter inches high by thirty-eight inches wide. At present it belongs to Mr. H. K. Pomroy, and it is esteemed a sterling example of the artist's originality by all competent judges. Mr. R. M. Shurtleff, the landscape painter, informs us that this picture was made in Keene Valley, Adirondacks, and he adds that it is so real that "a woodsman could tell what kind of logs were burning by the sparks that rise in long curved lines." Finally, I quote from the Clarke catalogue of 1899 the following excellent

description, which brings the scene vividly to the imagination:—

" 'Camp Fire.' Deep in the wilderness the fisherman has made his camp, near a convenient trout stream. Beneath a storm-uprooted cedar, whose sturdy branches support it from falling prone upon the ground, he has built his hut of saplings, with open front, walled with bark stripped from the trees. Under this shelter his guide lies, sleeping soundly, after a weary day, on a bed of aromatic pine needles cut green from their branches. The sportsman, relieving his servitor from the watch, sits with his back against the improvised cabin. The gloom and loneliness of the place and hour have set him thinking, and the face the camp fire lights is serious and pensive. The fire blazes in front of the hut, sending up a stream of sparks like fiery serpents, and rolling from its fresh logs the smoke that protects the camp from insect pests. All around is the mysterious obscurity of the primeval forest, that obscurity and mystery which provide the spice of the true sportsman's life."

Coincident with the beginning of Homer's series of sea pieces and his abandonment of work for the illustrated press, was a marked development of his faculty for making a striking and original pictorial design or pattern. From 1880 onward we shall find this faculty constantly working out remarkable results in all his pictures. It was not, however, such a sudden accomplishment as it might seem to the casual observer, for if we look back through the pages of "Harper's Weekly" in the early seventies we cannot fail to note here and there those apparently fortuitous felicities in the disposition of the light and dark masses which contribute so tellingly to the impressiveness of a picture. This is what a discerning critic has called the mysterious power of unerring

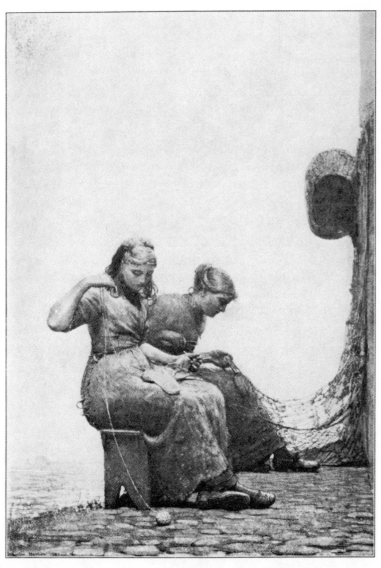

MENDING NETS; OR, FAR FROM BILLINGSGATE
From the watercolor in the collection of Mr. Charles W.
Gould, New York

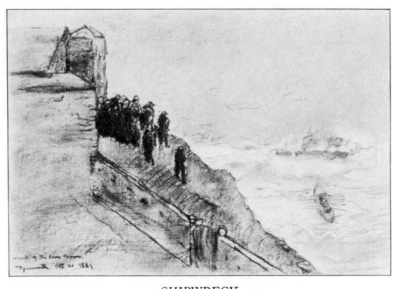

SHIPWRECK

From the drawing in the collection of Mrs. Roger S. Warner, Boston. (Inscribed: "Wreck of the Iron Crown, Tynemouth, Oct. 25, 1881.") Photograph by Chester A. Lawrence

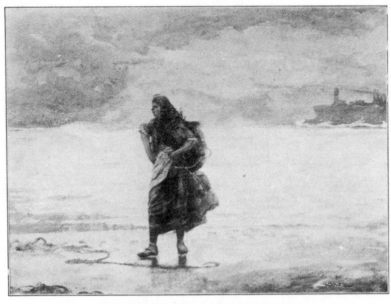

FISHERWOMAN, TYNEMOUTH

From the watercolor belonging to the Edward W. Hooper estate, Boston. Photograph by Chester A. Lawrence

choice. "The construction, the very shape of these pages of nature remain in the mind as he presents them," writes Mr. Fowler,[1] — "the spots, the masses, the relation they bear to one another, stay in the memory, while the transcript of some lesser man, making slight mental appeal, soon fades from one's remembrance. This is a suggestive fact—it is not through technical address that such a result is achieved — it must be something other. In fact, treating the subjects Homer does, one would not care for too glib and facile handling; and, on consideration, you feel that the touch is the natural and consequent outcome of the theme. It is largely the design which gives them their potency in memory — they have their stamp, and this is indeed their *cachet*. . . . Nature, broad, spacious, elemental, seems to have sunk into his mind, fixed there in some shape or pattern, strong spots of sky or water, almost savage at times in their coloring. Nothing for whim; no straining for originality. His vision is as clear as a window pane through which one might look out upon the scene; but the selection is that of an artist who seizes the most salient and typical point of view. There is no softening of effect nor prettifying of facts — great nature suffices, and his works possess the true beauty of essential fidelity. Design is always there, for it is the mysterious power of unerring choice. This it is which places Homer above the plane of a competent painter and proclaims him an artist of the first rank."

Homer's services were in demand as an illustrator of books; and in 1880 there were two of his illustrations, engraved on wood, in a publication entitled "Songs from the Published Writings of Alfred Tennyson set to music by

[1] *An Exponent of Design in Painting*, by Frank Fowler, in *Scribner's Magazine*, May, 1903.

Various Composers," edited by W. G. Cusins, and published by Harper & Brothers, New York. His subjects were "The Miller's Daughter" and "Tears, Idle Tears." The former is a half-length figure of a girl, with a roguish expression in her face. In the illustration to "Tears, Idle Tears," a slight concession to the sentimentality of the theme is evident in the half-length figure of a maiden with downcast eyes. In the edition of Tennyson's poems, published by James R. Osgood & Company, Boston, 1872, Homer's drawing of "The Charge of the Light Brigade" appeared. He also contributed at least one illustration to an edition of the poems of William Cullen Bryant, the subject being "The Fountain." In this drawing there are two figures of girls by the bank of a stream. One, standing erect, carries a pail in her hand; the other, on her knees, at the water's edge, is about to dip up a pailful of water. He also made illustrations to stories printed in the magazines of the day, and I have before me a wood engraving of one of his drawings, which depicts a group of a half-dozen young women in a billiard room, one of them being about to attempt a shot, which will infallibly prove a miscue, if I may judge from the way in which she holds the cue: this is entitled "Jessie Remained Alone at the Table," the legend probably being taken from the text of the tale. There remains to be noticed a series of outline illustrations to James Russell Lowell's dialect poem, "The Courtin'," published by James R. Osgood & Company, Boston, 1874. The seven drawings are in silhouette, reproduced by the heliotype process. From the moment when "Zekle crep' up quite unbeknown" and "peeked in thru' the winder," this series takes us rapidly to the not unexpected dénouement of this affair of the heart, "in meetin' come nex' Sunday."

CHAPTER VII

TYNEMOUTH — THE ENGLISH SERIES

1881–1882. Ætat. 45–46

The Dwelling at Cullercoates — "Watching the Tempest" — "Perils of the Sea" — "A Voice from the Cliffs" — "Inside the Bar" — A Turning-Point in the Artist's Career — Watercolors Dealing with Storms and Shipwrecks.

IN 1881 a happy chance directed the steps of the painter to the east coast of England, where he worked with his customary zeal for two entire seasons at Tynemouth, in Northumberlandshire, a well-known watering-place, with a fine beach, overlooked by picturesque cliffs. Tynemouth is also a seaport and fishing-town with a population of more than fifty thousand; and a better place for Homer's purposes could hardly have been found in all England. In a suburb called Cullercoates he was fortunate enough to find a dwelling which just suited him, a little house surrounded by a high wall, with one gate, to which he had the key, so that he was safe from intrusion. The works that he produced there sounded a deeper, stronger, more serious note than any that had preceded them. The sea, and the lives of those who go down to the sea in ships, became, from this time, his one great theme, and even the earliest and least pretentious of his marine motives had in them the ring of that inalienable veracity, that deep-seated and heart-felt enthusiasm, which have made of his sea pieces the incomparable masterpieces that they are. The Tynemouth series of watercolors, bearing the dates 1881 and 1882, had to deal especially with tem-

pests and wrecks and the daring deeds of the coast-guards, and they formed a worthy prelude to the long line of ocean epics that was to follow through at least twenty years of productive activity.

To the Tynemouth series belong those stirring scenes of storm and peril, "Watching the Tempest," "Forebodings" (or "The Perils of the Sea"), "The Life Brigade," and "The Ship's Boat;" as well as those noble compositions, "A Voice from the Cliff," "Inside the Bar," "The Incoming Tide," and "Tynemouth."

In "Watching the Tempest" the atmosphere of excitement, dread, and suspense, as the life-boatmen prepare to launch their craft to go to the aid of an unseen vessel in distress, is conveyed in every touch of the brush. The storm is raging with fury; the air is filled with clouds of wind-swept spray; yet in the midst of the emergency the observer feels that the group of men who stand on the beach ready to put the boat into the water are cool and collected, prepared to do their duty manfully, but taking it all as a part of the day's work, without any consciousness of heroism. The background shows a bluff, with buildings silhouetted against the stormy sky, and a crowd of spectators watching the doings of the coast-guardsmen. When the editor of the Thomas B. Clarke catalogue of 1899 wrote of this water-color, "It is a period of wild excitement and expectation, when humanity feels with deep emotion the deadly tumult and peril of the elements," he was expressing precisely what every sensitive person must feel in looking at this wonderful little picture. Yet it is to be observed that the work is utterly free from all traces of factitious appeal; it is dramatic without being in the least theatrical; there is no aim in it but the truth, the whole truth, and nothing but the truth;

and when one looks at a picture of this kind the thought is not of the skill of the painter nor of the beauty of the design, but of the " deadly tumult and peril of the elements " and the courage of the men whose business it is to risk their lives in saving the lives of others.

"Watching the Tempest," which measures fourteen by twenty inches, was sold for three hundred and seventy dollars at the sale of the Thomas B. Clarke collection, in New York, February, 1899. The buyer was Mr. Burton Mansfield, of New Haven, Connecticut. This, like all of the Tynemouth subjects, was a watercolor.

"The Perils of the Sea" appears to have been inspired by the same storm as that so stirringly depicted in the foregoing composition. "The entire community of a coast settlement has turned out to watch a wreck off shore," says the descriptive catalogue of the Clarke collection. "On a pier in the foreground two women stand in attitudes expressive of intense and anxious attention. Below the pier, on the beach, many figures crowd with all eyes bent upon the raging of the wintry surf. At the left a part of a summer cottage is seen." [1] Although there is the same atmosphere of suspense and agitation in this work as in " Watching the Tempest," the composition is not so good. "The Perils of the Sea" was also in the Clarke sale, and brought two hundred and ten dollars. The buyer was Dr. A. C. Humphrey, of the Lotos Club, New York. In the fall of 1891, when the Clarke collection, including twelve of Homer's works, was exhibited at the Pennsylvania Academy of the Fine Arts, Philadelphia, a variation of this watercolor, catalogued as "Forebodings," was described as follows : —

[1] The building is not a summer cottage, but an observatory for the use of the coast-guard.

"It is wild and squally weather on the sea. The wind whirls the cloud racks in the sky, and a white surf rages along the shore. In the foreground two young mothers, each carrying her babe, study with boding expectancy the angry deep on which their husbands' boats are being tossed. Signed at the left, and dated 1881. Watercolor."

"Forebodings" seems to have been virtually the same design as "The Perils of the Sea," with the exception of the babes in the former.

"A Voice from the Cliffs" is one of the most important of the Tynemouth series of watercolors. Three English fisher-girls are grouped on the beach, their forms being outlined against the gray cliffs behind them. A striking feature of the arrangement of this compact group of figures is the repetition of lines in the arms of the girls as they hold their baskets. This gives a swing of movement to the group which is highly effective and rhythmical, without monotony. The heads are the prettiest female heads painted by Homer up to this time, though they are probably all painted from the same model, which is a detail of no great importance. The drawing has an unusually potent element of charm, and the first and last impression is of the extraordinary beauty of the composition. This, with three other watercolors, "Inside the Bar," "The Incoming Tide," [1] and "Tynemouth," was exhibited at the sixteenth annual exhibition of the American Watercolor Society, New York, in 1883.

"Inside the Bar" has for its chief figure a sturdy, bareheaded fisher-woman standing on the beach, holding an empty basket on her left arm, with her right arm akimbo,

[1] Owned by Mr. Charles S. Homer. A caricature of this work was exhibited in New York under the title "Hoop-la ! Dad 's Gone !" Winslow Homer saw it and was much amused by it.

her feet firmly planted rather wide apart, as she braces herself to stand against the strong wind, which blows her apron out like a sail. The background is the sea, with a short stretch of still water, then a sand bar, against which the surf breaks in white foam, and two boats are seen in the middle distance to right and left. There is vigorous movement in the chief figure, which is superb in the unintentional nobility of its pose. The line formed by the apron as it is blown out by the wind is a truly admirable touch. The dark sky, with its masses of gray clouds and its implications of wind, is vigorously suggested.

"The Incoming Tide" shows a fisherwoman retreating up the wet beach before the swiftly coming waves. She carries two or three baskets slung over her back, her arms are akimbo, her skirt kilted up to save it from a wetting, and her figure is vaguely reflected in the shallow pool through which she is stepping. In the distance is a sailboat, and the sky is full of dark gray clouds.

"Tynemouth" is mainly remarkable for the play of light on the surface of a troubled sea. It is surprising to see how simple are the means used to give this wonderful effect of reality. This was the forerunner of the greatest of Homer's marine masterpieces in oils, painted in the eighties and nineties. So far as the ability to counterfeit nature is concerned, it was already unsurpassed, unequaled, unique.

"The Life Brigade" is a small watercolor quite similar in subject, design, and execution to "Watching the Tempest" and "Forebodings." The rage of the storm, the tremendous weight and force of the surf, the flying clouds of spray, the frowning threat of the dark skies, and the consciousness of imminent danger, fill this dramatic little aquarelle with power and interest.

"The Ship's Boat" is a still more direct and thrilling chapter of wreck. The boat has been capsized, and four seamen are clinging to the hull, which is lifted by a monstrous wave, and borne towards the rocks. "The water is drawn and colored with signal knowledge and power. Its liquidity and translucence, the countless accidents of its surface, the rush and whirl of its eddies, and, above all, the upheaving power of its movement, have been seized, comprehended, and fixed with unsurpassed fidelity and breadth." [1]

During his sojourn at Tynemouth, Homer made many studies in black and white, using a variety of mediums, such as charcoal, crayon, lead pencil, chalk, India ink, and water-color wash, on paper of various tints. Although these studies were of the nature of memoranda, forming simply one of the stages of the process of making pictures, some of them were carried to a degree of completeness that gave the impression of the scene in a most satisfying manner. The use of white chalk for putting in the lights in the charcoal studies on tinted paper was remarkably effective. Many familiar figures were to be seen in this series of studies, which appeared later in finished watercolors or oil paintings, such as the women knitting stockings as they pace the beach, the men of the life-saving service at their arduous work, the fishermen, and other Tynemouth characters with which the artist has made us acquainted in his English pictures. His knowledge in the drawing of the human figure was exemplified in such studies as his "In the Twilight," "A Walk Along the Cliff," "A Little More Yarn," etc.; and his intimate appreciation for the sea in action was very impressively manifested in such things as his "The Life Boat," "A Rolling Sea," and "The

[1] *Twelve Great Artists*, by William Howe Downes. Boston: Little, Brown & Co., 1900.

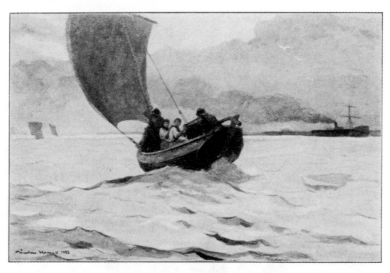

RETURNING FISHING BOATS

*From the watercolor in the collection of Mr. Horace D.
Chapin, Boston. Photograph by Chester A. Lawrence*

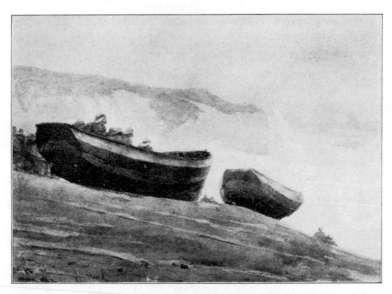

STORM ON THE ENGLISH COAST

*From the watercolor in the collection of Mrs. Roger S.
Warner, Boston. Photograph by Chester A. Lawrence*

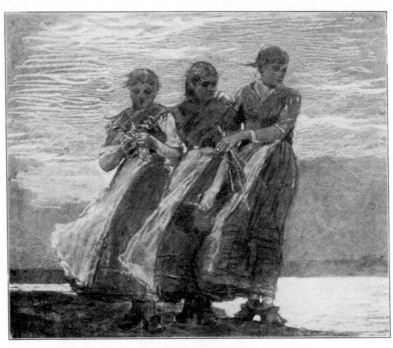

THREE GIRLS

From the drawing in the collection of Mrs. Roger S.
Warner, Boston. Photograph by Chester A. Lawrence

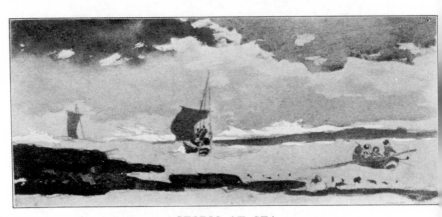

STORM AT SEA

From the drawing in the collection of Mrs. Roger S.
Warner, Boston. Photograph by Chester A. Lawrence

Wreck of the Iron Crown" off Tynemouth. Some of the studies were very slight in character, but they told their stories with all of the vividness and point of finished pictures. The studies of clouds were excellent in their movement and light and shade.

The entire Tynemouth series of watercolors was precisely as true to English facts, conditions, and character as the American pictures had been to American facts, conditions, and character. This because the artist had no *parti pris*, in either case; he painted the things he saw, and added no comment. His work continued to be, in a certain sense, historical rather than critical. Homer was, all his life, a historian, a reporter, but in an uncommonly impartial and detached manner. His natural and unstudied adherence to literal truth, seemingly not a singular merit in an artist, was, after all, the great thing that stayed with him throughout his career. How rare it is will be discovered by any investigator who candidly sets out to seek for it in the works of men. His power or faculty of seeing things in their integrity, and of rendering that aspect of them in pictures, is one of the least common of attainments. This is what makes his pictures of the Tynemouth series, in common with his American subjects, so different from those of other men; this it is which gives them the weight of authority, the power of striking the mind, and of remaining in the memory.

The English series of watercolors exhibited at the American Watercolor Society's exhibition of 1883, with a subsequent special exhibition of Tynemouth watercolors at Doll & Richards's gallery in Boston, 1884, followed up by an exhibition of drawings and studies a year later, caused many persons to range themselves among the admirers of Homer's works who had been perhaps somewhat lukewarm in their

appreciation before that time. The Tynemouth work might therefore be called a turning-point in the artist's career, so far as popular esteem is concerned. There were critics who had found his earlier work crude, harsh, and awkward, who hastened to acclaim the English series as masterpieces. The praise or blame of critics, however, never made any difference with Homer, who went serenely on his way, as unconcerned with such matters as any man that ever lived.

At the National Academy exhibition of 1883 Homer's contribution was a large oil painting entitled "The Coming Away of the Gale," one of the Tynemouth subjects. It represents a group of fishermen and coastguardsmen at a life-saving station, looking out over the sea, and making preparations to launch the lifeboat. The principal figure in the foreground is a young fishwife, with her child on her back, who is walking along the edge of the bluff, bracing herself as she walks against the gale, which blows her draperies about her form in picturesque disorder.

"One Boat Missing," another Tynemouth composition, depicts three fishermen's wives gazing seaward from the lofty cliffs to count the sails of the home-coming fishing fleet. Two of these women are sitting on the rocks; the third stands apart, holding a child in her arms. The clouds overhead are beginning to break away after a storm. The fluttering skirts of the women indicate the force of the wind. The design is novel and fine, and the relation of the figures to the landscape is organic.

Still another Tynemouth subject, called "The Breakwater," and bearing the date of 1883 (a watercolor), found its way into Mr. Clarke's collection. This shows two young fishwives of the Christie Johnstone type, one of whom holds a basket in her hand, leaning over the stone wall of a break-

water against which the surf is dashing. Other figures are seen towards the end of the jetty, and at the right rises the cliff. In the distance some vessels are outlined against the horizon, and boats are drawn up on the far beach.

Although Homer returned from England in 1882, we shall see the Tynemouth *mise-en-scène* reappearing from time to time in his later works, with those sturdy and supple figures of the English fishwives which fit in so well with the genius of the locality. How graphically the characteristic features of Tynemouth are embodied in these works is attested by those who are familiar with the place itself. The beach, the cliffs, the town, the breakwater, the observatory of the coastguards-men — commanding a bird's-eye view of a vast expanse of the North Sea — all appear and reappear in the Tynemouth series. The picturesque phases of the life of the fishing com-munity, — the fishermen, the fishwives, the coastguardsmen, — are set forth with the intimate actuality that we always find in Homer's work, so that Tynemouth and its people will always be associated with his name and fame. His slightest crayon studies of figures have the pictorial distinction, the fine sense of movement, and the singular beauty of design, which belong only to the great masters. There is one of these in which we see a dozen figures of fishwives with creels full of fish on their backs, climbing the sand bank from the beach, and silhouetted against a squally sky, which, in the nobility of its masses and lines and movement, is of mon-umental and classical beauty. When the fishermen beach their boats at Tynemouth, they carry the anchors well in-shore, and leave the women to discharge the cargo, while they, the men, weary from their labors, go straight home to eat and sleep. The fishwives go aboard and unload the catch, carrying the fish to market, and attending to the sell-

ing. Then they return to the boats, clean them up, and provision them, even arranging the tackle, so that by the time the fishermen have had a good night's rest and plenty of home food, their craft are all ready for the next trip to sea.

CHAPTER VIII

PROUT'S NECK

1884. Ætat. 48

How the Homer Brothers discovered and developed a Summer Resort in Maine — Description of the Place — Winslow Homer's Studio — His Garden — His Way of Living — Identification of his Masterpieces with Prout's Neck.

O N the east side of Saco Bay, in the town of Scarboro, Maine, one hundred and nine miles from Boston, and twelve miles from Portland, Prout's Neck is a promontory which juts out into the Atlantic, the great cliffs facing the south and southeast, and ranging from fifty to eighty feet high above low-water mark. Named for the family which originally owned all of the land on the peninsula, the locality was but sparsely settled until after the Homer brothers came to the place in 1875 and made it their summer abiding-place. In 1875, when Arthur B. Homer first discovered the point, and perceived its advantages, there were only three families living on Prout's Neck, whereas in 1910 there were sixty-seven houses and seven hotels. From 1875, Arthur B. Homer began to go there regularly every summer, from his home in Galveston, Texas, but he did not build his first cottage until 1882. He was followed by his father and mother and his two brothers, and the Homers eventually bought up most of the land on the water front, and set out to develop the place systematically as a summer resort. Winslow Homer had made several visits to Prout's Neck in the summer season before he went to England in 1881, making his stay

usually at a boarding-house or a hotel; and although one of his purposes in going there was to be with his parents and his brothers, he soon became very much in love with the rugged and picturesque character of the coast, and, after his return from England, he determined to make it his home. This decision was fortified by his intense aversion to jury duty in New York, which was one of the factors that influenced him in leaving the city. He therefore turned his back on the metropolis for good in 1884, and from that time to the end of his life, in 1910, he lived at Prout's Neck, " far from the madding crowd's ignoble strife," but not by any means in that hermit-like seclusion which exaggerated accounts would have us believe.

Prout's Neck is a very beautiful place, with superb cliffs; and the surf that breaks on this bold headland in easterly weather is something that must be seen to be realized. From the top of the cliffs the ground slopes gently upwards, and the summer cottages that now line the shore from the Checkley House to the bathing beach are set back some fifty yards or more from the rocks, having between them and the sea a fine expanse of green sod and shrubbery. There is a surprising and unusual variety of landscape, since only a few rods inland one finds a noble pine grove, known as the Sanctuary, so-called because religious services were in former years held there in the open air. A strip of land which includes this extremely impressive spot has been given to the Prout's Neck Improvement Society by Charles S. Homer for a public park. In the solemn aisle of this pine wood there was a dead tree, which it was proposed to cut down and remove, but Winslow Homer advised his brother to leave it alone, for there was something about it that appealed strongly to him, perhaps because it emphasized the wildness and solem-

nity of the forest, and reminded him of the vast, hushed solitudes of the Canadian and Adirondack woods that he loved so much.

No sooner had the artist resolved to make his permanent abode at Prout's Neck than he set about building a snug little cottage for himself, not far from the summer homes of his brothers and parents. The situation that he chose was, as might be expected in the case of a painter, singularly fine. It is near what we may call the southwest corner of the promontory, with a southerly view over the ocean, and directly overlooking some of the most interesting rocks of the entire Neck. The entrance to the house is on the east side, and the whole of the ground floor, with the exception of the kitchen space, is given over to the studio. A prominent feature of the cottage is the balcony on the ocean side. The door is of old, weathered wood, natural color, and of a very beautiful grain, with a handsome bronze knocker, bearing in low relief the face of a Sibyl, or, possibly, one of the Fates, with flowing hair and features of a classic symmetry and impassiveness.

In the little garden behind the cottage, surrounded by a high board fence, topped with lattice-work, the artist found recreation and solace in raising all sorts of old-fashioned garden flowers, such as roses, cinnamon pinks, English primroses, marigolds, pansies, heliotropes, petunias, etc., and various vegetables, including sweet corn, of which he was very fond.

By way of experiment he undertook also, one season, to raise a crop of tobacco in the garden. He procured some seed from the Vuelta Abajo district in Cuba, planted and cultivated it, and the tobacco plants grew nicely. He learned how to sweat and dry the leaves, then he went to a cigar

factory in Portland and took lessons from the workmen in making cigars. He found this part of the undertaking more difficult than he had expected, and his cigars were, on the whole, rather rude specimens. He did not repeat the experiment.

Out in front of the cottage, and to the east of it, the lawn is accented by the most admirable junipers, which the artist trained, after the Japanese fashion, by propping up the branches, so that they became in time like wide-spreading cedars, of magnificent shape and color and texture. Left to themselves, the junipers hug the ground, but when cared for in this way, they become wonderfully ornamental trees. Nearer the cliffs and the sea, great patches of wild huckleberry bushes, which, when I saw them in October, had taken on a royal crimson color, of almost dazzling brilliancy, formed a nearly impenetrable coppice. Outside of the garden fence, near its eastern end, stands an ancient sundial, having for its pedestal a worn old mill-stone from some disused grist-mill, with its channels chiseled in its surface. On the other side of the house stands a gray and weather-worn old pair of bitts from a wreck, of which more anon.

The cottage is of wood, painted a pale green. It has no architectural pretensions. In the studio a litter of artist's materials, properties, costumes, canvases, and the like, a birch-bark canoe from Canada, and an astonishing amount of fishing-tackle and sporting appurtenances were usually to be seen. Of his brother as a fisherman, Charles S. Homer says: "He did not go in for expensive or elaborate tackle, but he usually caught the biggest fish." One might make a parable of this and apply it to his art.

The most absurd tales are told about Winslow Homer's hermit-like manner of living at Prout's Neck. Naturally, as one

of his purposes in settling there was to obtain freedom from interruption during his sustained efforts, he could not open his doors to all the casual callers who knocked for admission, some of whom were inspired by nothing more serious than idle curiosity to meet a noted painter and see his work in his studio. It may well be that he sometimes, through inadvertence, turned away from his door a visitor whom he would really have been glad to welcome, if he had only known what his object was; it is certain that those who did partake of his hospitality had no cause to complain of any coldness.

In the library which Winslow Homer collected there was a copy of Chevreul's book on color, which his elder brother had given him many years ago, and this copy was almost read to pieces, so worn was it with use.

He was accustomed to do a great deal of looking before he decided upon a subject to paint; and sometimes he would spend whole days just looking at the sea, without touching a brush. Although he was one of the first painters in America to take the trouble to carry a canvas several miles for the purpose of making a study from nature in some place which had interested him, yet he did not always work directly from nature. His extraordinary memory for visual impressions served him so well, that at times he could record the scene he wished to paint without any preparation except the slightest of notes and the hastiest memoranda. He was an early riser, and frequently he would get up at half-past four o'clock in the summer, and go off for long walks, before anybody else was up, so as to be sure of being alone.

He knew and loved every part of the cliffs and rocks. A beautiful walk runs along the top of the cliffs from his cot-

tage to the eastward, winding along in front of the unenclosed grounds of the cottagers, like the cliff walk at Newport and the similar walk at Nahant. As one strolls along this path, never out of sight and sound of the sea, there are numerous striking points of view, and it is easy to recognize many of the subjects of Homer's most masterly marine pieces. Here are Cannon Rock, the Spouting Cave, Kettle Cove, Eastern Point, Pulpit Rock, and the Gilbert Rocks. Now one can scramble down over the huge sloping ledges to a spot just above high-water mark, and, looking back to the westward, obtain a profile view of the subject immortalized in the "High Cliff, Coast of Maine." Yonder, over miles of open water, lies Wood Island Light, and Biddeford Pool, far in the south. Beyond Eastern Point the path turns to the north, and leads back to a pretty cove, with a clean sand beach, the bathing-beach, with its rows of bath-houses, a short distance from which lie rocky islets which are the resorts of seals. Just back of the bathing beach is a neat bath-house built by Winslow Homer, which he rented to the Prout's Neck people until he had got back the amount of money it had cost him, when he gave it to the local improvement association.

Homer usually stayed at Prout's Neck until the first heavy snow-storm in December, then he locked up his cottage for the rest of the winter, and started for the south, — Florida, Nassau, or Bermuda; but he generally returned to Prout's Neck as early as the month of March. There were some years that he remained at the shore all winter, though he made occasional trips to Boston and New York. He employed a man to come to the house in the morning and attend to the household chores. The rest of the time he was alone, except when he had occasion to employ a model. In

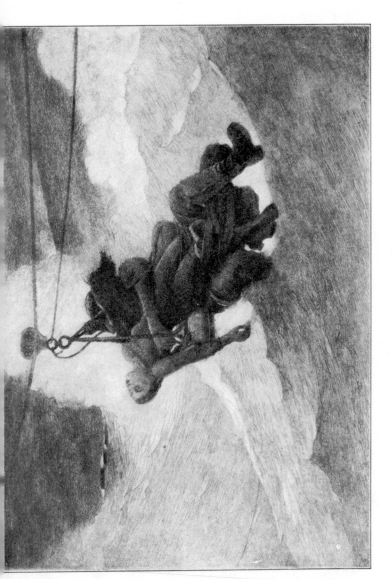

THE LIFE LINE

From the etching by Winslow Homer, after his oil paint-
ing in the collection of Mr. G. W. Elkins. Copyright by
C. Klackner, New York

BAHAMA. (*left*)

From the watercolor belonging to the Edward W. Hooper estate, Boston. Photograph by Chester A. Lawrence

ILLUSTRATION TO WILLIAM CULLEN BRYANT'S POEM, "THE FOUNTAIN." (*right*)

ON THE FENCE. (*left*)

From the watercolor in the collection of Mr. William Howe Downes. Painted at Houghton Farm, Mountainville, New York, in 1878. Photograph by Chester A. Lawrence, Boston

GOING BERRYING. (*right*)

From the watercolor in the collection of Mr. Horace D. Chapin, Boston. Photograph by Chester A. Lawrence

the summer there would usually be quite a colony of the Homers here, consisting of Mr. and Mrs. Arthur B. Homer and their two sons, Arthur P. and Charles L. Homer, Mr. and Mrs. Charles S. Homer, and Winslow's father, who, after the death of his wife, in 1884, lived with Winslow until his own death in 1898.

Arthur B. Homer's cottage is but a few steps away from Winslow's studio. For ten or eleven years Winslow's constant companion was his dog Sam, an Irish terrier, whose death was such a source of grief to his master that he would never get another dog. Winslow Homer was very fond of his two nephews, and when they were small boys he made two amusing drawings of them, setting forth in slightly sarcastic fashion their respective characteristics. "Little Arthur in Fear of Harming a Worm" is stepping gingerly over an angle-worm, full of consideration lest he should injure it; while in the drawing of "Little Charlie's Innocent Amusements" the dear child is shown sitting on a pet cat and mercilessly pulling the tail of the dog. He also made a drawing in lead-pencil of Mr. and Mrs. Arthur B. Homer during their honeymoon, at Prout's Neck: the lady seated on the ground near Kettle Cove, while her husband, reclining at her feet, looks up at her. This is on gray paper, with the lights touched in with Chinese white.

Besides the little cottage which he occupied himself, Winslow Homer built and rented to summer sojourners another cottage, near Kettle Cove, a little farther east. He said that he intended to live there when he got to be old. "Other men build houses to live in," he once remarked; "I build this one to die in." He never occupied it, but he hung in the ground-floor rooms a few of his early oil paintings, which I saw when I was at Prout's Neck in the fall of 1910.

There were, among other canvases, all unframed, the study of the Waverley Oaks, painted when the Homers lived at Belmont; the landscape with the figures of two boys, which perhaps is identical with the "Crossing the Pasture" of 1872; a picture of a number of figures climbing Mount Washington, dating from 1869 or 1870; a study of the kneeling figure of a young woman, one arm and hand being left unfinished; a study of a girl in a rose-pink shirt-waist leaning against the massive trunk of a great beech tree; and the full-length figure of a girl in an apple orchard.

In Arthur B. Homer's cottage are a certain number of early works in oil, watercolor, and black-and-white by Winslow. In the living-room is an autumn scene in the country, where two boys and a girl are holding up a large table-cloth under the branches of a chestnut tree while a boy (who is unseen) shakes down the nuts. There is an oil painting of a great sand dune, with figures, painted in the fifties, at Marshfield, Massachusetts. The chief figure was painted from the artist's mother.

Between the periods of strenuous work on his oil paintings it was Homer's custom to do some manual labor, a sensible and useful change of occupation, which rested him and for the time being relieved the strain on his nerves. He not only performed the garden work of which we have spoken; he built a stone wall, constructed a dog house for Sam; and once, when he had made a firm of picture dealers wait a long time for a reply to a business letter, he finally wrote, apologizing for his tardiness by stating that he had been very busy building the dog-house.

Homer lived well at Prout's Neck. He arranged to have a box or a barrel of fresh provisions sent down from the Boston market once or twice a week, and he had the best

that the market afforded. He did most of his own cooking, and was an adept at it ; but when he got deeply absorbed in painting he often forgot to eat at regular intervals. One of his personal idiosyncrasies was his custom of buying things in large quantities. If he found anything in a store that suited him he would buy all there was of it in stock. Thus he purchased his underclothing by the gross, — imagine buying one hundred and forty-four pairs of socks at once, for instance. When one of his brothers gently remonstrated with him for this extravagance, he retorted : "When will you learn that the time to buy a thing is when you find what you want? If you go back the next year and try to get more, they will try to sell you something else."

One summer, many days passed in which Homer did no painting at all. His brothers did not quite understand this unusual idleness. Finally his elder brother ventured to remonstrate. "What is the use of all this fooling around?" he asked. "Why don't you do something?" In a good-natured tone he was told to mind his own business, but no explanation was offered. There in the studio was a large canvas, the palette all set, and yet day after day passed, and nothing was done. Presently it became apparent that the painter was waiting for a certain effect of weather or of light. The whole summer passed away, and he did not get what he wanted. "But he got it the next year," remarked his brother. He knew precisely what he wanted, and could wait patiently until the opportunity came to him.

Few American painters are so closely identified with one locality as is Homer with Prout's Neck. The spot is and will be always associated with his life and work and personality. The grandeur of its cliffs, and the rush and turmoil of the surf on the ledges cannot be seen without the thought of the mas-

terpieces of art created among these scenes. Prout's Neck is
as intimately associated with Homer's labors of a quarter of a
century as Barbizon is with the works of Millet. Turn where
we may, there is something to remind us of Winslow Homer.
The spirit of the place is bound up in his pictures. In winter
storms, in moonlit summer nights, in time of peril and wreck,
at the still hours of dawn and sunset, all the moods of nature
recall his creative activity, and the loving familiarity with
which each phase of beauty or of grandeur has been inter-
preted.

As the great waves break upon these dark and streaming
rocks, and toss high their plumes of silvery spray, we see
him at work, and realize anew the unfaltering fidelity and
noble simplicity with which he strove to make himself the
true and modest translator of nature's marvels. The breezes
that sweep up from the North Atlantic through the Maine
pines are not more pungent and bracing than his pictures.
Here, when the dull roar of the northeaster fills the air with
its vibrating diapason, and the thickening snow drives before
the bitter gale, the voices of the storm must forevermore
recall the man who loved the wild and wintry rage of the
elements as others love soft sunshine, summer calm, and fire-
side comfort. There was something in that solitary soul
which responded with passionate joy to the call of the tem-
pest. In the midst of its boisterous transports he was at
home, and, like Byron, he could say : —

> And I have loved thee, Ocean ! and my joy
> Of youthful sports was on thy breast to be
> Borne, like thy bubbles, onward ; from a boy
> I wantoned with thy breakers,
>
>
>
> And trusted to thy billows far and near,
> And laid my hand upon thy mane, — as I do here.

Surely it may be said that he was led to Prout's Neck. There he was to confront, contemplate, study, and grapple with all the earnestness of which he was capable the supreme artistic problem of his career. All that he had done and accomplished before, in Boston, New York, Tynemouth, and elsewhere, was as a trifle in comparison, a preliminary essay of his strength, a preparatory course of training for this task appointed for him. He had always been sincere, industrious, single-minded, ardent; he was now to be called upon to be more so than ever. All his knowledge and all his courage were to be demanded of him. The place, the time, and the man were well met. The opportunity was large; the call urgent and unmistakable; and every fibre in his nature responded.

CHAPTER IX

"THE LIFE LINE"

1884. Ætat. 48

The Story-Telling Picture — Sources of Prejudice against it — Various Comments on and Descriptions of "The Life Line" — Exhibitions in Boston — An Anecdote of a Commission for a Picture which was declined.

WHEN he left New York and established his home at Prout's Neck, in 1884, Homer took with him a number of unfinished oil paintings which he had begun from studies made at Tynemouth and at Atlantic City, New Jersey. Living as he now did in a perpetual tête-à-tête with the ocean, which beat upon the great ledges almost at his door, he signalized the beginning of his most important series of sea pieces, a series which was to engross him for more than twenty-five years, by completing and sending to the National Academy exhibition of 1884 his celebrated composition entitled "The Life Line."

The shipwrecks which he had witnessed in England led him to feel the wish to describe in his pictures a not uncommon scene during a storm off the New Jersey coast, the rescue of seamen and passengers from a shipwrecked vessel by the use of the breeches buoy. He had therefore gone to Atlantic City in 1883 and had made friends of the members of one of the life-saving crews there, who gave him every help possible, illustrating and explaining the method of employing the life line. Incidentally, while at Atlantic City, he had the good fortune to see a rescue from drowning, which gave him the

idea for another picture, "Undertow," which he began at once upon his return to his New York studio, but which he did not get ready to exhibit until 1887.

The picture of "The Life Line" is one of the most dramatic and striking of his story-telling pictures, and it had an immediate and emphatic popular success. Modern art criticism views with aversion if not with contempt the story-telling picture; and almost all the American painters of Homer's time, with a few notable exceptions, such as Eastman Johnson and Thomas Hovenden, were more or less inoculated with Whistler's pet doctrine of art for art. Plausible studio theorists would tell you that a "literary" subject — by which they meant a subject in which the human interest predominated — was inevitably fatal to a picture. A part of this feeling arose, perhaps, from a reaction against the banality of the British school of genre painting, as exemplified in the episodic sentimentalities of the Royal Academy. Another source of the prejudice was the unquestionable inferiority of the work of many of our own men whose pictures of familiar life were trivial in motive and mediocre in execution. But the theorists forgot that their attitude on this question could find no justification in a broad view of the history of the art of painting; forgot that the greatest painters of all periods were the most human of men in their sentiments, the most vivid and eloquent illustrators of life and manners, equally great as men and as artists. For the artists who deliberately turned their backs on the life of the day all about them, and sought to divorce their art from the daily interests of the people, the error was a serious one. Now, Winslow Homer was not a theorist; we never hear of him expounding what art is and what it is not, what it can do and what it cannot do. He never had to ask himself whether

he was a realist, an impressionist, a symbolist, a luminarist, or a pre-Raphaelite. He belonged to none of the camps. He told stories in his pictures because the story-telling instinct in him irresistibly impelled him, because it is an instinct that is universal, and responds to a universal impulse in every age and land. He told them without triviality, because triviality was alien to his nature. In some of his sea tales he attempted what no painter before him had ever dared to attempt, and he must have been aware of the extraordinary difficulties, but he was undaunted by them.

It needs but a glance at this subject, "The Life Line," for example, to show that there were possibilities in it of failure, of ineptitude, of anti-climax. It may be assumed that nine painters in ten would have pronounced the design in itself a pictorial impossibility. But where there is a will there is a way. Homer met such problems as this, and by the exercise of artistic tact and audacity, he turned difficulties into triumphs. In spite of all obstacles, he succeeded in developing here a design which compels admiration, and embodies in a novel arrangement one of the most thrilling situations of deadly peril and heroic rescue ever committed to canvas. I need not say that "The Life Line" manifests a masterly grasp of reality. It is awe-inspiring in its delineation of the fearful forces of the tempestuous sea. All the terrors of shipwreck are brought home to the mind by the scene. The spectator, too, may be as much thrilled by the thought of the man's ingenuity who invented the breeches buoy, — a device that has saved so many valuable lives, — as he is by the courage of the sailor hero whose hardihood and *adresse* is put to the test in this hour of dire danger.

It is difficult to describe the composition satisfactorily.

MARKET SCENE, NASSAU

From the watercolor in the collection of Mr. R. A. Thompson

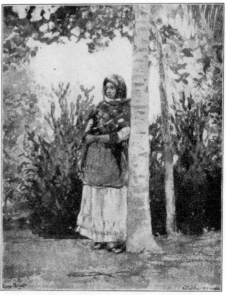

CUSTOM HOUSE, SANTIAGO
DE CUBA

*From the watercolor in the collection
of Mrs. Roger S. Warner, Bos-
ton. Photograph by Ches-
ter A. Lawrence*

UNDER A PALM TREE

*From the watercolor in the collection
of Mr. F. Rockefeller,
Cleveland, Ohio*

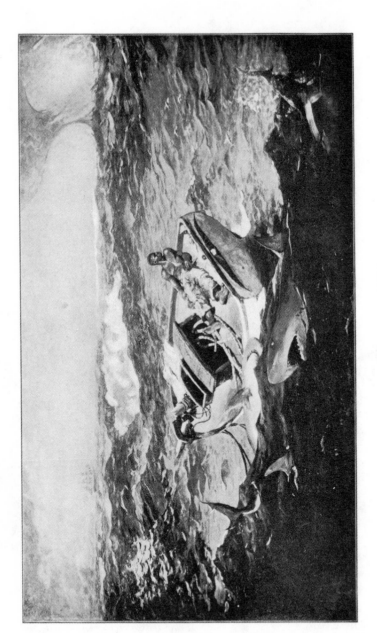

THE GULF STREAM

From the oil painting in the permanent collection of the
Metropolitan Museum of Art, New York

Several writers have made the attempt, and I shall venture
to quote from four of them. A contemporary description
from "The Studio," which was copied in Dr. Charles M.
Kurtz's "Academy Notes" for 1884, runs as follows:—

"The canvas represents the trough of a tremendous sea.
At the left, from a ship, indicated by a rent piece of sail, ex-
tends the life line across the crests, to the shore on the
right. In the centre of the hollowed trough is seen a life
chair suspended from the line by ropes and pulleys, and in
this chair is seated a seaman holding in his arms the uncon-
scious form of a woman. The wet garments cling about her
and the lower portion of the dress has been torn by the vio-
lence of the sea. The seaman's face is not seen, for a muffler,
or tippet, which a gust of wind has blown directly in front
of him."

The description given in the catalogue of the Thomas B.
Clarke collection, 1899, is as follows:—

"Stretched across the upper part of the composition is
a great cable, attached to which is the boatswain's chair,
wherein sits a sturdy seaman, clasping in his strong arms
the fainting figure of a shipwrecked woman. Her clinging
garments, saturated with the salt water, outline her form,
except where they are distended by the force of the gale.
The sea breaks and tumbles about in awful turbulence be-
neath the seaman and his charge as they are being drawn
slowly but surely on the life line to the shore. . . ."

According to Samuel Swift, in the "New York Mail and
Express," March 19, 1898, "The Life Line" is scarcely ex-
celled as an expression of the force and power of the ocean,
of the irresistible might of its blows, and of the comparative
helplessness of human strength amid such titanic stresses
and strains. "It tells a story, but this is merely incidental.

The interest lies less in a speculation whether the brave life-saver will reach land in safety with the half-drowned woman whom he holds fast to him, than in a realization of the ungovernable sway of the water, as illustrated by its effect on the mortals who endeavor to elude its grasp." He adds the remark that " Mr. Homer wisely hid the face of the coast-guard with the scarf that has blown across it, in order to help concentrate attention upon the real subject of the picture."

Description and criticism are blended in Mrs. Van Rensselaer's [1] remarks about " The Life Line " : —

"In a yawning hollow between two watery mountains swings a slender rope, and, made fast to it, a sturdy sailor bearing across his knees the unconscious figure of a girl. No one could have painted a scene like this with such convincing strength who had not lived among the breakers and the tragedies they work ; but no one, on the other hand, who lacked that constructive imagination which the thorough-going realist professes to despise. The theme, in its essentials, was the saving of a woman's life. To express it the painter gave prominence to her blanched face and half-clothed form ; and he clearly showed, in contrast, the vigor of the sinews which upheld her and the tremendous rage of the sea. These he had shown, and all else he had omitted. There is nothing unusual here, you may say — any artist would have gone about his task in just this manner. But how many would have known what Homer knew — that among the things to omit was the sailor's face? How many would have felt that to paint it as it must be painted, if at all, would be to distract attention from the principal figure, to create two

[1] Six Portraits, by Mrs. Schuyler Van Rensselaer. Boston: Houghton, Mifflin & Co., 1894.

centres of interest, to weaken, not enhance, the impressive-
ness of the whole?"

It may be thought that Mrs. Van Rensselaer lays more
emphasis than is necessary upon the covering up of the
sailor's face, makes more of this omission than the circum-
stances warrant. However this may be, it is certain that
Homer, in this as in all his narrative pictures, appeals to the
imagination of the observer with exceptional potency by his
use of the great artistic principle of reserve. He does not
show us everything, but flatters us by assuming that we can
exercise our imaginations and that we are able to reason
from cause to effect. There is seldom a ship to be seen in his
shipwreck pictures, but the tale is usually told by suggestion
and implication. It is an effective method, as is well known,
and it is but one of many evidences of the resourcefulness
and sagacity which characterize the artist's designing and
constructing of his pictures. Mr. Royal Cortissoz has re-
marked that it seems never to have occurred to him to tell
a story in paint after the manner of the artist to whom the
anecdote is everything. "When he attacked a theme he
gave it its full value, but never let it encroach upon the integ-
rity of his technique. His art was beautifully balanced. You
admire it for its own sake, yet this does not keep you from
admiring its subject. Indeed, the very perfection of the equi-
librium he established gives to each phase of his work the
fullest possible force. Thus, while his technique is of the
highest interest, nature speaks through his work with a
peculiar richness and fullness."[1] Mr. Cortissoz applies to
Homer the words used by Matthew Arnold in speaking of
the "natural magic" of Maurice Guérin, his power to so
interpret nature as to give us "a wonderfully full, new, and

[1] *New York Tribune*, February 19, 1911.

intimate sense" of it. "He stands aside and leaves his facts to speak for themselves. His expression corresponds with the thing's essential reality."

"The Life Line" was bought by the late Catherine Loril-lard Wolfe for twenty-five hundred dollars. She in turn sold it to Mr. Thomas B. Clarke. At the sale of the Clarke collection in 1899 it was sold for forty-five hundred dollars, an advance of two thousand dollars over the price originally received for it by the painter in 1884. It is now in the collection of Mr. G. W. Elkins of Philadelphia.

At the seventeenth annual exhibition of the American Watercolor Society, New York, 1884, Homer exhibited two subjects, namely, "The Ship's Boat" and "Scotch Mist." The former, which was illustrated in the catalogue, was a Tynemouth motive. It has been described already. For the first time Homer's address is given in the catalogue of 1884 as "Scarborough, Maine."

After settling at Prout's neck, Homer held a series of exhibitions of his works in Boston. His watercolors, drawings, studies, and oil paintings were shown, year after year, at the old gallery of Doll & Richards, in Park Street, and they met with a gratifying market and liberal recognition. One of the most extensive buyers of his works was the late Edward Hooper, Treasurer of Harvard College and one of the members of the Board of Trustees of the Museum of Fine Arts. Many of his finest watercolors were included in the Hooper collection. These were inherited, upon Mr. Hooper's death, by his daughters, Mrs. Horace D. Chapin, Mrs. Bancel La Farge, Mrs. Roger S. Warner, and Mrs. John Briggs Potter. At that time Homer said that Boston was the only city in the United States that gave him any practical encouragement. It is but fair to state, however, that New York was not long in

extending to his work the practical recognition that means so much to an artist, and the example set by Mr. Thomas B. Clarke was no doubt of the utmost value in directing the attention of other collectors throughout the country to the desirability of his pictures.

Mention of the frequent exhibitions in Boston reminds me of an anecdote. Mr. Moody Merrill, who in the early eighties was president of an important street railway company in Boston, had a fine country seat in New Hampshire, of which he was fond and proud. On meeting Homer one day, he proposed to him that he should paint a picture of the Merrill country home, a sort of portrait of the place, and he went on to explain in considerable detail what he wanted brought into the picture in the way of details, and how it should be done. Homer, with that faintly quizzical expression about the eyes which indicated that he perceived the humorous side of the question, heard him out, with patience and courtesy. Then, without either accepting or declining the proposal, and without commenting upon it, he said, briefly, "Well, Mr. Merrill, I have usually as many as two exhibitions a year in Boston, and if you will step into Doll & Richards's gallery some time, and chance to see anything of mine there that you like, you are welcome to buy it."

CHAPTER X

NASSAU AND CUBA

1885–1886. Ætat. 49–50

A Winter in the Bahamas and the South Coast of Cuba — The Color of the Tropics — "Searchlight, Harbor Entrance, Santiago de Cuba" — "The Gulf Stream" — Later Trips to Nassau, Bermuda, and Florida.

AFTER overseeing the installation of an exhibition of his studies in black-and-white in Boston, early in the winter of 1885–1886, Homer set sail for the Bahama Islands, and passed the rest of the winter at Nassau, New Providence, the capital of the archipelago, subsequently taking passage thence to the South Coast of Cuba. To him, whose eyes were so well fitted for seeing all the glory of the southern seas, this first voyage in the tropics opened up a new world of color. It is not too much to say that he revealed to the North for the first time what the color of the tropics really is like. Other painters had visited Nassau before him, but they could neither realize in their fullness nor record with adequacy the exquisite colors of the amazing harbor of Nassau, with its transparent turquoise blues and emerald greens and changing violets. Tones are there which vie with the rainbow, the peacock's plumage, the diamond, the flowers of the field, and the light of morning skies. Under the keen stimulus of such color Homer produced in Nassau, with extreme rapidity, a series of watercolors which have never been surpassed for sheer brilliancy. He painted that masterpiece of radiance and luminosity, the "Sponge

Fisherman, Nassau," and that unequaled revelation of African character, the "Negress with Basket of Fruit," both of which were bought by Mr. Martin Brimmer of Boston; he painted also the "Port of Nassau," the "Market Boat," "Noon," "Fox Hill," the "Sea Fans," the "Banana Tree," "Song Birds, Nassau," "Native Cabin," "Near the Queen's Staircase," and many another page of gladness. He showed us entrancing glimpses of the flowers and trees and skies and reefs of those coral islands where lives the —

> . . . Magic charm
> Of the Bahaman sea,
> That fills mankind with peace of mind
> And soul's felicity.[1]

It seemed too good to be true. Indeed, to the eyes of those persons who had never looked upon the Bahamas and the Caribbean Sea his pictures of 1885–1886 must have appeared exaggerated in color. But travelers who knew their West Indies were enraptured by the bold, incisive, direct, penetrating veracity with which the almost incredible splendors of those southern waters and islands were rendered.

It had been said more than once, by more than one critic, that Homer was no colorist; that, though his color was good enough, in its way, it had no sensuous charm; that, though it was strong and sure and true, it was sometimes a little harsh. Now the Nassau and Cuba series of 1885–1886 completely, and once for all, cut the ground from under the feet of these critics, and left them with nothing to stand on. Again the painter demonstrated that he was capable of recording the most delicate nuances as well as the most resonant tones, that he was in a singular degree endowed with the faculty of seeing justly and exactly the thing as it exists

[1] Bliss Carman, *A Winter Holiday*. Boston: Small, Maynard & Co., 1899.

in nature, and of setting it forth without extenuation and without prejudice, color and light as well as line and mass. The Antillean watercolors were steeped in tropical sunlight. Fortuny never excelled their sparkle and radiance. They were glowing with the utmost exuberance of intense life. Nothing could have been more radically different from the English series of 1881 and 1882, yet each was perfectly true to local conditions of color, light, and atmosphere.

Three of the Nassau watercolors were in the famous Thomas B. Clarke collection. They were " The Market Scene," " Under a Palm Tree," and " The Buccaneers." In the " Market Scene " the wonderful harbor of Nassau appears, with two boats manned by negro sailors who are bartering fruit and fish. In the centre is a sloop, with a crowd of figures on the deck, dressed in motley costumes. A member of the crew is offering a turtle for sale to the occupants of the craft at the left. " Under a Palm Tree " is an upright composition, with a mulatto girl clad in a gayly colored dress and wearing a scarf about her head and neck, leaning against the tree trunk ; tropical plants fill the background. " The Buccaneers " represents a group of freebooters in the shade of some tall palms, watching eagerly the progress of a distant sea fight. The ocean is of the deep, unfathomable, indigo blue of the tropics ; and against the luminous sky the fronds of the palms are a vivid green. This is a well-imagined reminiscence of the wicked old days of piracy that made the waters of the Bahamas notorious in the time of Blackbeard, whose headquarters were at Nassau.

" Conch Divers," which was bought by Russell Sturgis, is an admirable design, which depicts a group of three negroes on the deck of a sloop, watching the reappearance of a diver who is just emerging from the water alongside, with some

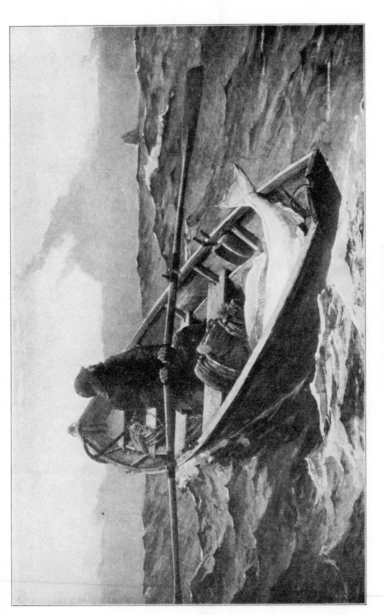

THE FOG WARNING

From the oil painting in the permanent collection of the
Museum of Fine Arts, Boston

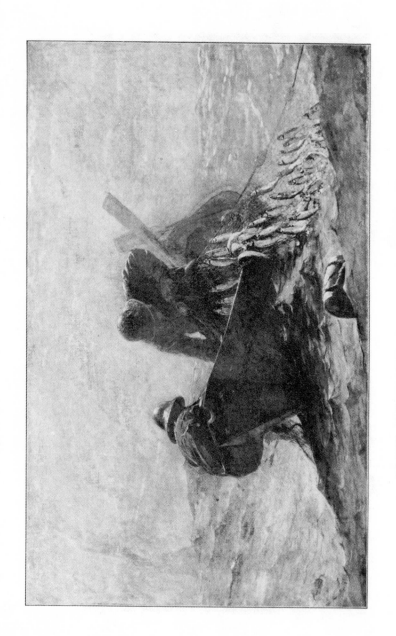

BANKS FISHERMEN; OR, THE HERRING NET

From the oil painting in the collection of Mr. Charles W.
Gould, New York

shells in his hand. The island of New Providence with its palms is to be seen in the distance at the right. "Shark Fishing, Nassau Bar," shows two negroes in a small boat. They have just caught an immense shark, which is in the midst of his final flurry, astern of the craft. Among the landscapes there is one entitled "Approaching Tornado," which is remarkable for its portentous atmosphere. Thus the Nassau watercolors gave a comprehensive idea of the life and landscape aspect of the Bahamas, a part of the world most alluring from the point of view of paintable material, which had not before been exploited.

The Ward Line steamships which touch at Nassau on the way southward make their next port at Guantanamo, on the south coast of Cuba, and thence they proceed westward along the coast to Santiago de Cuba. From this ancient Spanish city Homer brought home with him another rich series of watercolors, showing the grim, mediæval rock fortress, known as the Morro, a sort of Caribbean Gibraltar, which frowns over the narrow entrance to the land-locked harbor; sundry views of this magnificent harbor, with the intensely picturesque town and its grandiose background of far violet mountains forming a flat mass at the horizon; a number of street scenes, with the old cathedral, the custom-house, the Spanish Club, the cockpit, and the houses of Santiago, low, covered by red-tiled roofs, tinted in pale washes of rose, blue, mauve, adorned by the intricately designed wrought-iron balconies that one sees in all Cuban towns, and blending an air of dignity with a down-at-the-heels, squalid, and shiftless condition; the quaint volantes, which were the Cuban cabs of 1886; even the frightful sharks which infest all the neighboring waters. The Americans who looked with casual curiosity at these scenes were far from

foreseeing that Santiago de Cuba was to become in twelve short years from that time the objective of an American army of invasion, and that, off the tortuous entrance to this noble harbor, in sight of the Morro Castle, was to be fought the short, sharp, and decisive naval combat which was destined to free Cuba forever from the domination of Spain and put an end to all Spanish power on this side of the Atlantic.

The two most important oil paintings produced by Homer as the result of his West Indian voyage were not finished until some years after his return home, but they were of course based upon careful studies made on the spot. These were the "Searchlight, Harbor Entrance, Santiago de Cuba," and the "Gulf Stream," both of which are now in the permanent collection of the Metropolitan Museum of Art, New York. The first-named work, which was first seen at a loan exhibition of pictures held at the Union League Club, New York, after the Spanish-American war of 1898 had made the Morro Castle famous, represents in the foreground the corner of the fortress, with a round tower like a sentry-box project- ing above the parapet, and an obsolete type of cannon extending horizontally across the centre of the composition. Beyond these dark shapes is a wide expanse of luminous pale blue sky, athwart which sweeps the wedge-shaped light from a battery on the farther side of the channel, or, possibly, from a ship of war. High at the left the moon floats in a ring of curdled clouds. The solitude and solemnity of the scene impress the imagination, and the mysterious beauty of the nocturnal sky forms a piquant foil to the stern, warlike old stronghold in the foreground, with its romantic associations of Cuban political prisoners languishing in its subterranean dungeons. This picture is not dated, and it was painted at

different times, in the intervals of other work. It was given
to the Metropolitan Museum of Art by Mr. George A. Hearn,
who paid seventy-five hundred dollars for it. In a letter
dated December 30, 1901, addressed to Mr. Thomas B.
Clarke, the artist speaks of the picture as just finished, and
encloses a rough pen-and-ink sketch showing the point of
view of the picture and the topography of the surrounding
country. From this sketch it appears that the searchlight
was on board of one of the picket vessels of the United
States fleet lying off the mouth of the harbor in 1898. Sev-
eral of the ships are indicated on the horizon in this sketch,
but in the painting they are of course invisible. As the
painter was not at Santiago in 1898, the effect of the search-
light introduced in this composition must have been studied
elsewhere and adapted to the subject, which, in all its other
features, was based on sketches made in 1886.

" The Gulf Stream" is as frankly a story-telling piece of
work as " The Life Line." It is the most elaborately literary
of the artist's tropical motives. In this composition, which,
by the way, has too many objects in it to be as unified as
the majority of its author's canvases, we see a stalwart negro
sailor afloat on a dismasted derelict, at the mercy of the ele-
ments, in the deep blue Caribbean waters. His drifting craft
is surrounded by hideous and voracious sharks, waiting im-
patiently for their prey to fall into their hungry maws. In the
far distance passes an unseeing or indifferent merchant ship.
At some distance from the derelict is a waterspout. The
tragedy is enhanced in its horror by the strange beauty of the
southern sea. Here are no heroics, no rhetoric, no explanatory
passages, to detract from the bald and fateful presentation of
cruel fact. The dénouement is only too clearly inevitable. It
is not a pretty drawing-room tale, but a grim and ghastly

one. Kenyon Cox [1] remarks that the work is not without certain obvious faults. "The tubby boat has been objected to by experts in marine architecture, and the figure of the negro is by no means faultless in its draughtsmanship, while there is a certain hardness of manner in the painting of the whole canvas. But these things scarcely obscure the dramatic force of the composition, which renders it one of the most powerful pictures Homer ever painted. Nor is it merely a piece of illustration. Its admirable mastery of design, and the consequent perfection with which it renders the helpless sliding of the boat into the trough of the sea, should be obvious in the photograph. There is not an inch of any of the innumerable lines of the magnificent wave drawing that does not play its part in a symphony of line. What the reproduction cannot render is the superb depth and quality of the blue of the water, of such wonderful passages of sheer painting as the distance, with the ship driving by under full sail, or the dash of spray from the tail of the nearest shark."

"The Gulf Stream" was not finished until 1899, and when it was exhibited a few years later (1906) at the National Academy of Design, the entire jury recommended its purchase by the Metropolitan Museum of Art, a manifestation of the high esteem in which the artist was held by his professional brethren and of the occasional gratifying unanimity of opinion held by American painters regarding works of art. When the painting was brought before the jury, a murmur of admiration was heard, and one of the painters said: "Boys, that ought to go to the Metropolitan!" A letter addressed to the director of the Museum was at once drawn up and signed by all the members of the jury, suggesting that

[1] Kenyon Cox, "Three Pictures by Winslow Homer in the Metropolitan Museum." *The Burlington Magazine*, London, November, 1907.

the Museum should purchase the picture. This was imme-
diately despatched to Sir Caspar Purdon Clarke, and the
following day Mr. Roger Fry appeared at the gallery and
inspected the picture. Two days later the Museum sent word
that it would take the picture.

The "Evening Post" critic called it "that rare thing in
these days, a great dramatic picture," and added: "Partly
because the horror is suggested without a trace of sentimen-
tality, and partly because every object in the picture receives
a sort of even, all-over emphasis that shows no favor to the
dramatic passages, the story never overweighs the artistic
interest." The "Tribune" critic found in the work dramatic
power, a sense of life vividly observed, and, in the ship on
the horizon, a suggestion of hope receding which put, in
Kipling's phrase, "the gilded roof on the horror." The critic
of "The Sun" discovered that the picture contained more
shudders than Géricault's "Raft of the Medusa," and other
writers drew attention to certain similarities of the subject to
Turner's "Slave Ship." Mr. Riter Fitzgerald, in the Phila-
delphia "Item," attacked the work savagely, calling it a
unique burlesque on a repulsive subject, "a naked negro
lying in a boat while a school of sharks were waltzing around
him in the most ludicrous manner." The same writer thought
that the artist had painted it with "a sense of grim humor,"
and that its proper place was in a zoölogical garden. He
stated that when the work was first shown in Philadelphia
it was laughed at. Still another critic remarked that sharks
"are neither pretty nor artistic looking creatures," but that
their presence in this canvas gave it "a touch of grotesque
hideousness that adds immeasurably to the sense of the im-
pending tragedy."

On his return from the West Indies in the latter part of

the winter of 1886, Homer almost immediately prepared and opened a small exhibition of his watercolors at the gallery of Doll & Richards, in Boston. He exhibited fifteen subjects from the Bahamas and fourteen from Santiago de Cuba.

He went to Nassau again several times, and, in later years, to Florida and to Bermuda, during the winter. These trips were made, sometimes alone, and sometimes in company with his father or his elder brother, and they were not always primarily for sketching purposes, though he almost always did some watercolor work, notably in 1898, 1899, 1900, and 1903. Several journeys to Florida with his brother Charles were fishing trips, the place selected for this purpose being Enterprise, on the St. John's River, where the bass fishing is excellent. Enterprise is a little-known winter resort, in Volusia County, on the Florida East Coast Railway, at the head of navigation on the St. John's, and adjoining Lake Monroe.

The brothers also made a fishing trip to Tampa, Florida. I have seen a series of photographs taken by Winslow Homer on this occasion, and in one of the snap-shots there is a good-sized wooden box in the foreground, which was used to carry luncheon in. It chanced to be an old whiskey box, and the name of the distillery was stenciled on the side of the box. When Winslow Homer came to develop the print, and to give his brother a copy of it, he pointed out the lettering on the box, and said, with a smile, "This sort of thing is calculated to give people a wrong impression."

CHAPTER XI

"The Fog Warning" — "Lost on the Grand Banks" — "Hark! the Lark" — "Undertow" — "Eight Bells" — The Genesis of a Deep-Sea Classic.

THE first few years at Prout's Neck were prolific both in oil paintings and watercolors. "The Life Line" of 1884 was the beginning of a notable series of oil paintings of marine subjects with figures, a series which includes "The Fog Warning" and "Banks Fishermen" (or "The Herring Net"), of 1885, "Lost on the Grand Banks," "Undertow," and "Eight Bells," of 1886. With the collection of watercolors from Nassau and Cuba which, as has been noticed, was held in Boston directly after his return from the West Indies in the winter of 1886, were shown a couple of oil paintings which were at that time catalogued as "The Herring Net" and "Halibut Fishing," but which have since then become famous under the altered titles of "Banks Fishermen" and "The Fog Warning."

"Banks Fishermen" depicts two fishermen in a dory hauling in a net full of the silvery and squirming little herring which gave to the work its original name. One of the men is standing amidships and leaning over, emptying the herring from the net into the bottom of the boat. His mate, sitting on the gunwale, at the left, with his back to the observer, pays out the empty net. Back of the two figures, at the right, the crossed oar blades rest against the bow of the dory.

In the foreground the water is greenish, and near the centre is a red buoy. In the hazy distance three sailboats appear on the horizon. The movement of the dory, poised on the side of a wave, and careening away from the observer, the action of the two figures, the flow of the water, are admirably rendered. The color is strong and effective. When the work was shown in New York, at the autumn Academy of 1885, one of the critics justly remarked that it was the only picture in the exhibition calculated to give one a high idea of American art. The canvas measures thirty inches high by forty-eight and one-eighth inches wide. It was exhibited at the World's Columbian Exposition at Chicago, 1893, under the title of "Herring Fishing," and received a medal there. It belongs to Mr. Charles W. Gould.

"The Fog Warning" (or "Halibut Fishing") represents a Banks fisherman in oilskins and sou'wester returning to his schooner with two or three fine halibut as his prizes stowed in the stern of his dory. The water is dark and glassy in the light of late afternoon, and the sea is rough. Aloft the sky is still bright, but near the horizon is a distant bank of fog of a dark slate color. The sails of the schooner are visible far off at the right; and the fisherman rests on his oars momentarily, turning his head in order to make out whereaway his vessel lies. The bow of the dory lifts, letting us see its whole shape, as the stern settles in the trough. The drawing of the wave forms is incisive, clear, firm, expressive, and masterly. The buoyancy of the dory, riding lightly on the choppy seas, and the hard and almost metallic aspect of the water in the dull light, are among the admirably studied details of this simple and noble work. Under the original and soon abandoned title of "Halibut Fishing," which was decidedly too prosaic, there was hardly any suggestion of

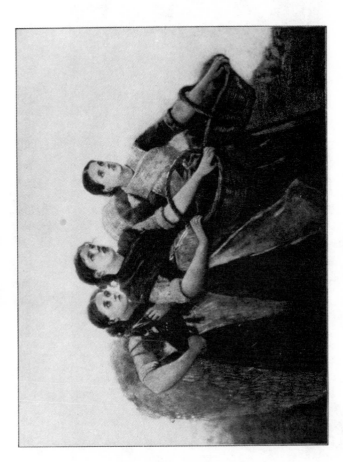

HARK! THE LARK

From the photogravure, copyright by Winslow Homer and published by C. Klackner, New York, after the oil painting in the permanent collection of the Layton Art Gallery, Milwaukee, Wisconsin

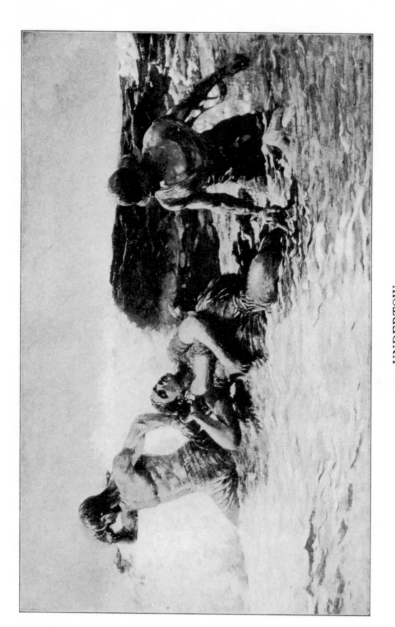

UNDERTOW

From the oil painting in the collection of Mr. Edward D.
Adams, New York

any danger to the man. The revised title is an unusually good example of how a title may be made to give just the requisite direction to the imagination of the observer. There is surely a fog rising yonder, and just as surely a fog may spell danger to the man so far away from his schooner. "Halibut Fishing" does not direct our thought to that possibility of danger; "The Fog Warning" serves to make the picture tell its story better.

"A suggestion of peril in terms of studied restraint is more in consonance with the tone of that life of exposure and risk, where men face death almost incessantly for the sake of a few dollars' worth of fish, than would be a too emphatic insistence or a too particular explanation of the significance of the menace which creeps upward in gray folds from the horizon. Men who are accustomed to danger occupy a mental attitude towards it that has no room for melodramatic pose. Simple, sober, the unconscious hero of the picture turns to get the bearings of his schooner as he bends to his oars with all the steadiness of a man who has a long way to row and who must neither waste his strength in spurts nor lose his head. Small amidst the waves of the Atlantic looks his dory, far away seems the vessel, hard and cruel is the complexion of the sea. . . . Winslow Homer would in all probability be the first to disclaim any intention of philosophy, of literary theories, of didacticism, in his art. If I know anything of the nature of artists, he would say, in effect, that he had no such meaning in his mind when he painted 'The Fog Warning.' All true enough, no doubt. We must admire and approve the narrow, exclusive single-mindedness of the artist; but if life itself be full of these meanings, the art that holds the mirror up to nature cannot fail to reflect them. Let it be the painter's part to see, to ob-

serve, to study the true exterior expression of things, and the interpretation thereof may well be left to take care of itself." [1]

In the making of this picture, Homer was obliged to place the dory where he could draw and paint it under the proper light, but in a motionless pose, so to say; so he had it pulled up on the beach until the bow was elevated at the desired angle against a sand dune; the model then took his position in the boat, and that part of the composition was finished without much difficulty. The surprising success of the combination lies in the buoyancy and swing of the boat in its relation to the water which upholds it. Not only does the dory give the impression of movement and of a thing afloat, it also seems to be miles on miles from land. I have heard several persons speak of the water as too hard. Against this opinion it would be perfectly safe to trust the trained judgment of the painter, even if our own experience did not supply ample evidence in his favor. "The Fog Warning" was given to the Museum of Fine Arts, Boston, in 1894, by Miss Norcross and Mr. Grenville H. Norcross, in the name of the Otis Norcross fund. It has been very extensively reproduced in black-and-white, and is a strong popular favorite with visitors to the museum galleries.

The picture called "Lost on the Grand Banks" is dated 1886. It has certain similarities to the "Fog Warning," but its suggestions of tragedy are even more direct and obvious. The subject may be described as follows: In the foreground is a dory with two fishermen, wearing oilskins and sou'westers. Both men have been rowing, but are now resting on their oars, the stroke bending wearily over his oar,

[1] "American Paintings in the Boston Art Museum," by William Howe Downes, in *Brush and Pencil*, Chicago.

and turning his head to the right to look, vainly, for any signs of the schooner, which has been hid by the wreaths of cold gray fog which are stealing over the surface of the rough sea. The other oarsman, leaving his thwart, and grasping the gunwale to steady himself, has risen stiffly to his feet, and is peering anxiously into the smother of fog off to port, as if he fancied he had seen some dim shape in the distance in that direction, and were straining his eyes to make out if it might perchance be anything more than a figment. The boat is rising, with a twisting motion, on a great wave, the bow to the right, at an angle which brings the starboard quarter of the craft nearest to the point of vision; and the spume of the near wave-crest shoots above the boat's side, as if the sea were hungry to swallow its prey. Is it necessary to say how this sea is rendered? Not, surely, to those who are familiar with the deep-sea pictures of Homer's prime. The drawing of the wave forms, the gradations of gray, saturated atmosphere, the mysterious sense of swirling vapors, alternately thickening and thinning, and the irresistible suggestion of a vast hollow space, far from land, in which the tiny bark is tossing helpless, a mere speck in an infinitude of devouring waters, of boundless and heartless wastes, oppress the mind with a poignant realization of the desperate pass to which these men have come.

Here we see the imagination, using nothing but realities of the strictest nature, working out pictorial results that speak to the emotions and sympathies, appealing to the inextinguishable human reverence for the modest and brave man's performance of the day's duty. If I read the moral into the picture, it is because I cannot help it. The underlying motive of the fisherman's adventure is a heroic unselfishness and a willingness to take what comes. This glorifies the

hard, stern, rough, weary ways of his life; weaves the rainbow hues of romance about his toilsome and risky calling; nay, invests his sufferings, his despair, his death, all borne with silent stoicism, with the sacred light of honor, of hope, of manhood vindicated.

"Lost on the Grand Banks" was first exhibited at the old club-house of the Saint Botolph Club, at 85 Boylston Street, Boston, in the spring exhibition of 1886, held from April 15 to May 1. It was listed at eighteen hundred dollars. It is now in the collection of Mr. John A. Spoor of Chicago, who lent it to the autumn exhibition of American paintings and sculpture at the Art Institute of Chicago in 1910.

"Undertow," finished in 1886, was exhibited in New York in 1887, at the Academy, where it was hung in a place of honor on the north wall of the south gallery. It was exhibited soon afterwards in Boston. As in "The Life Line," of 1884, this composition is an original and thrilling pictorial episode of rescue. The picture had been begun before Homer left New York, and much of the work on it had been done on the roof of the studio building there. The incident itself had been witnessed by the artist at Atlantic City, at the time when he was there for the purpose of obtaining the data for the picture of "The Life Line." The two young women who posed for the half-drowned bathers in "Undertow" were locked in each other's arms and dressed in bathing suits, which were drenched with water thrown over them, so that the effect of the sun on the wet clothing and the bare arms as well as the faces and hair should be entirely in accordance with the natural appearance of the group emerging from the surf. The incident depicted is not uncommon. The two young women are being brought out of the surf by two men who have saved them from drowning. Like all good pictures, this one

tells its own story. Some of the details may be left to the imagination, but every one may infer all the significant and vital effects from an examination of the painting. The interlaced forms of the two women in the middle of the group indicate that in all probability one of the bathers ventured beyond her depth and was caught and swept seaward by the treacherous undertow, and that when the other woman undertook to help her, the more exhausted and frightened of the pair threw her arms about the friend's neck, thus impeding her movements and adding to her own peril. Assistance, however, was at hand in the nick of time: here are two hardy swimmers, one a young man in swimming trunks, the other a fisherman or a member of a life-saving crew, who have succeeded in bringing the women into shallow water, and are just about to carry them up onto the beach, not too soon, however, since one of the two has lost consciousness, and both are apparently helpless and exhausted.

As a background for the group of four figures, which is composed chainwise, all linked together, yet each link having its own individuality, there is a huge blue-green wave coming towards us, and about to break over the figures in the foreground. Shining with moisture, in the full, strong light of a noonday sun, the figures are wonderfully an organic part of the luminous scene. The striking linear beauty of "Undertow" was cordially and justly praised by Mrs. Van Rensselaer, who wrote that the lines of the figures "had that harmony and dignity which we call Greek, for no better reason than that so few of us know how to see and appreciate them when by some happy chance actual existence sets them before our eyes." [1]

[1] *Six Portraits*. By Mrs. Schuyler Van Rensselaer. Boston and New York: Houghton, Mifflin & Co., 1894.

The purely artistic interest and beauty of this work, with its audacious grouping of four figures, was, however, not fully appreciated at the time it was shown, in 1887. On the one hand a certain number of doctrinaires could not accept without protest a painting so literary, so much like a mere illustration, and on the other hand there were naturally many persons who could enjoy its human interest but were not qualified to realize the æsthetic distinction of the picture, its extraordinary beauty of design, its superb construction, the splendor of its lighting and its color.

"Undertow" was excellently reproduced in the "Tatler," a London periodical, on August 3, 1910, with this curiously misleading inscription above the engraving: —

And in their death they were not divided.

Of course the painting depicts a successful rescue from death by drowning, and not, as the "Tatler" editors imply, the recovery of the bodies of two drowned persons.

Although a great work of art may be no greater on account of the special difficulties that beset the artist in making it, we have to remember that such subjects as "Undertow" are necessarily painted in a large degree from memory; and I speak of it here because it is interesting to note to what an extent a painter is able to develop this faculty, the exercise of which involves some of the most astounding mental feats to be seen in the practice of art. One of the things that may be depended upon in Homer's work is the total absence of "chic" or "fake" passages. What he sets before us are the things he has seen and known. He never invented, — in the sense of conjuring up scenes and events. He deals wholly with realities, and is incapable of fiction.

"Undertow" is owned by Mr. Edward D. Adams, of New

York. Winslow Homer's younger brother, in allusion to its sinuous interlocked figures, calls it the "worms for bait picture."

Two watercolors dated 1887 belong to the Tynemouth series, and were completed and dated five years after the studies were made in England. These were the "Sea on the Bar" and "Danger" of the Thomas B. Clarke collection. "Sea on the Bar" is graphically described in the Clarke catalogue of 1899: —

"A breezy sky and sea, with surf piling up, and green water heavily moving. In the foreground is a sand-bar on which the water surges, and, in the distance, a bit of shore dark under a gray sky. A small sailboat labors stolidly, and the swirling clouds fly along, impelled by strong winds. A veritable bit of nature, realistically indicated."

This watercolor was bought by Rev. W. S. Rainsford of New York, for one hundred and thirty-five dollars. The description of the other one, "Danger," is not so good, failing in exactitude. It runs thus: —

" Two fisherwomen trudge along the rocks, unmindful of the gale, to give warning of a ship, to the left, laboring heavily and obviously in trouble. Their faces are set in determination, and their skirts are blown by the terrific wind which piles up the sea against the shore. The sky is dark and fierce-looking, in effective contrast to the brilliancy of the white breakers, which dash furiously on the shore."

According to my recollection, the vessel here alluded to is not a ship, but a sloop, which is simply trying hard to claw off a lee shore. The faces of the two women may be set in determination, but, as they are not turned our way, it is hard to say how the catalogue editor obtained this information.

Charles Savage Homer, Jr., Winslow Homer's brother,

loaned to the American Watercolor Society for its twentieth annual exhibition, in 1887, two beautiful southern landscapes, a "Sketch in Key West" and a "Sketch in Florida," which had been painted in 1886, on the way home from Cuba. The crispness of the treatment, the purity and transparency of the color, and the breadth and firmness of the drawing of the palms, palmettos, live oaks, hung with Spanish moss, and the other tropical vegetation, were truly characteristic of a master painter.

Arthur B. Homer, the younger brother, owned an old plumb-stemmed sloop that he and his two sons used to knock about in at Prout's Neck. In the cabin were three wooden panels, two of them rather wide, on the sides, the third a short one set in the forward partition. Winslow Homer, noticing these vacant spaces, suggested that he would some day paint something to fill the panels. In 1886 he started the series of promised sketches. The two side panels were completed. One of them represented a fleet of Gloucester fishing vessels; the other two schooners at anchor with their sails up against a sunset sky of lemon yellow, a very handsome effect. For the shorter panel forward he began to make a black-and-white oil study of a ship's officer in uniform taking a noon observation, his back turned towards the observer. His brother Arthur posed for this figure. When it was almost done, Winslow Homer suddenly stopped work on it, and, saying, "I am not going to do anything more on this panel. You can have it if you want it," he gathered up his brushes and rushed into the studio. An idea for a picture had suddenly come to him. This, as the reader may have guessed already, is the genesis of that deep-sea classic, "Eight Bells."

Somehow, though nobody can say precisely how, "Eight Bells" fills the remotest corners of the mind with an over-

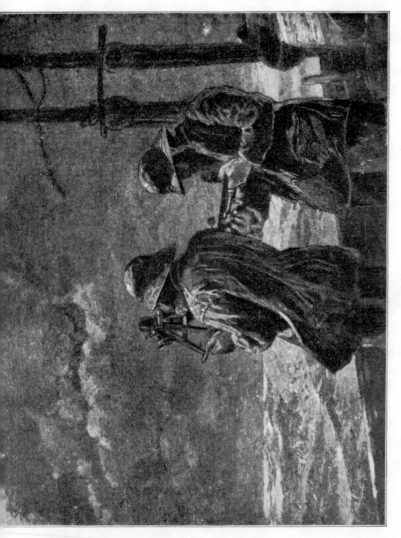

EIGHT BELLS

*From a wood engraving by Henry Wolf, after the oil painting by
Winslow Homer in the collection of Mr. Edward T. Stotesbury, Philadelphia.
Courtesy of the Century Company, New York*

TO THE RESCUE
From the oil painting in the collection of Mr. Thomas L.
Manson, Jr., New York

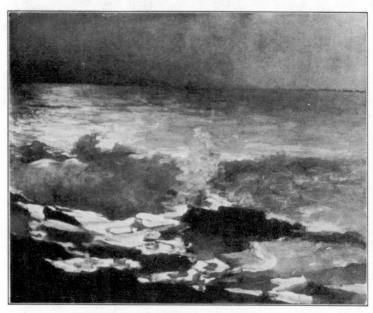

MOONLIGHT, WOOD ISLAND LIGHT
From the oil painting in the collection of Mr. George A.
Hearn, New York

whelming impression of the power and infinitude of the open sea. The action depicted is an ordinary if important part of the day's work, an everyday bit of routine on board ship. There is not the slightest occasion, nor is there the slightest endeavor, to make it appear any more interesting, dramatic, or heroic, than it really is; yet there is something about "Eight Bells" that grips the mind and the memory, and will not let go. Two bearded seamen are seen at two-thirds-length on the deck of a vessel. Both men wear sou'westers and heavy reefing jackets. The chief figure, probably that of the master of the craft, occupies the centre of the composition, and stands near the bulwarks, with his back turned towards the observer, while he holds up the sextant with both hands and gazes into the telescope, "shooting the sun," as it is colloquially expressed by Jack Tar. His assistant, at the right, who is seen in profile, holding the chronometer, bends over it, very intent, to determine the longitude. One sees nothing of the vessel except the upper part of the bulwarks and a stanchion just behind the mate's back. The sea is seething, all weltering with white foam, and seems to have been under the lash of a hard gale, which is perhaps just blowing itself out, for the clouds are breaking, though they are still swirling in heaped-up masses of torn and driven vapors, cold and stern and wild.

We may account for the effect the picture produces on the imagination of the observer in no other way than by realizing the strong influence of the association of ideas. Through this, even in the case of persons who have never been at sea, and whose conceptions of sea life are therefore entirely due to literature and pictures and hearsay, such a common and prosaic detail of the day's routine on board ship as taking the observations at noon to ascertain the position of the vessel is invested with a certain aura of mystery

and wonder. And this is not at all surprising, for, to the least imaginative mind, the ability to ascertain precisely the latitude and longitude at which a given vessel is situated at a given moment, in the vast waste of waters, must be one of the perpetual marvels of science, an achievement worthy of admiration if not of awe. To the sublime thought of the mighty ocean and its thousands of square miles of never-resting billows, is, then, superadded the inspiring idea of the unconquerable ingenuity, tenacity, and bravery of mankind. Such associations of ideas are evoked by "Eight Bells," and when viewed with a full realization of the significance of the action depicted, it assumes that character of symbolic nobility which lifts all Winslow Homer's best pictures of the life of the sailor to a plane of epic grandeur.

"Eight Bells" was bought by Mr. Thomas B. Clarke, and in the sale of his collection in 1899 it brought forty-seven hundred dollars. It was bought by Mr. Hermann Schaus, the dealer, who in turn sold it to the present owner, Mr. E. T. Stotesbury of Philadelphia.

The year 1887 was notable for the production of one of the most important of the painter's figure pieces, "Hark! the Lark." This composition, measuring thirty by thirty-five inches, was regarded by Homer himself as the most important picture he had painted up to that time, and the very best one, as, he said, the figures in it were large enough to have some expression in their faces. It was a replica of the watercolor of 1883, painted from studies made in Tynemouth, and entitled "A Voice from the Cliffs." According to a letter written by Homer in March, 1902, to Messrs. M. O'Brien & Son, picture dealers, in Chicago, this was the only instance in thirty years in which he had made a replica of any of his works. He wrote : —

March 20, 1902.

M. O'BRIEN & SON,

GENTLEMEN, — You ask me if the picture " Lee Shore," recently sold in Providence, is a duplicate. It is not. Only once in the last thirty years have I made a duplicate, and that was a watercolor from my oil picture now owned by the Layton Art Gallery, Milwaukee, called "Hark! the Lark."

It is the most important picture I ever painted, and the very best one, as the figures are large enough to have some expression in their faces. The watercolor was called "A Voice from the Cliff," and well known.

Why do you not try and sell the " Gulf Stream " to the Layton Art Gallery, or some other public gallery? No one would expect to have it in a private house. I will write you again next week.

Yours truly,

WINSLOW HOMER.

[Signed with a rubber stamp.]

SCARBORO, ME.

It is evident, however, that the watercolor, "A Voice from the Cliffs," belonging to Dr. Alexander C. Humphreys, was the original, and the oil painting, "Hark! the Lark," the replica, for the former was dated 1883, and the latter 1887. The oil painting was acquired by the Layton Art Gallery, Milwaukee, Wisconsin, about 1895, and was a gift from the founder of the gallery, Mr. Frederick Layton. It was among the pictures exhibited at the notable loan exhibition of Homer's works held at the Carnegie Institute, Pittsburgh, in the spring of 1908.

CHAPTER XII

ETCHINGS — PAINTINGS OF THE EARLY NINETIES

1888–1892. Ætat. 52–56

The Series of Reproductions of his Own Paintings — "Cloud Shadows" — "The West Wind" — "Signal of Distress" — "Summer Night" — "Huntsman and Dogs" — "Coast in Winter."

IN a letter written in the spring of 1902, Homer spoke of the watercolors made by him during two winters in the West Indies as being, in his judgment, "as good work, with the exception of one or two etchings, as I ever did." The etchings of which he thus wrote were made in the eighties, and were reproductions of his own paintings. He made a series of six good-sized plates, in 1887, 1888, and 1889, after the following pictures and drawings: "Eight Bells," "Fly Fishing, Saranac Lake," "The Life Line," "Mending the Nets," "Perils of the Sea," and "Saved," this last being an alternative title for "Undertow." The etching after the "Perils of the Sea," one of the Tynemouth watercolors of 1881, was made in 1887. The plate was thirteen and three quarters by twenty and one quarter inches in dimensions, and it was published by C. Klackner, the New York fine-art publisher, in two editions, one a remarque parchment, at thirty dollars, and the other on Japan paper at twenty dollars. In 1888 he etched "Saved" ("Undertow"), after the oil painting of the previous year, on a plate measuring seventeen by twenty-eight inches; and this was published by Klackner in corresponding editions. "Eight Bells," which

was painted in 1888, was etched in 1889; the plate was eighteen and three quarters by twenty-four and three eighths inches. I have reason to believe that this etching was one of the "one or two" plates of which the artist thought so highly himself. The motive of "Eight Bells" is one that lends itself most admirably to translation into black-and-white, and the effect of light on the water and in the wind-swept masses of clouds, against which the two men's figures are projected in dark patterns, is largely and simply rendered in the etching. Of the remaining three etchings of the series, "The Life Line" is the most remarkable as a piece of free engraving, the agitated silhouette of the two figures suspended above the waves making a bold and novel mass as it relieves itself against the flying clouds of spray in the background. This plate is on a smaller scale than the others, being only twelve and one quarter by seventeen and one quarter inches in dimensions. Of the "Fly Fishing, Saranac Lake" (fourteen by twenty and one quarter inches), there was no parchment edition, the artist's proofs on Japan paper being offered to the public at fifteen dollars. "Mending the Nets," or, as it has been called, "Mending the Tears," measured fifteen and one half by twenty-one and one half inches, and was copied from one of the Tynemouth subjects, a watercolor representing two sitting figures of women, which was exhibited at the twenty-fourth exhibition of the American Watercolor Society, New York, in 1891.

Mr. Klackner not only published the six etchings, but he issued in 1890 and 1891 photogravure plates after two of Homer's oil paintings, "Hark! the Lark," painted in 1887, and "The Signal of Distress," painted in 1891. Both of these reproductions were very successful, the subjects making a strong appeal to the public taste. The photogravures were

of good size, the "Hark! the Lark" measuring nineteen and three quarters by twenty-five and one half inches, and the "Signal of Distress" seventeen and one half by twenty-seven and one half inches. They were issued in one edition only, artist's proofs on India paper.

As an illustration of what Homer believed to be the vagaries of the public taste, Mr. Chase[1] quotes the following passage from a letter dated Scarboro, Maine, May 14, 1888:

" I have an idea for next winter, if what I am now engaged on is a success, and Mr. K. is agreeable. That is to exhibit an oil painting in a robbery-box with an etching from it in the end of your gallery, with a pretty girl at the desk to sell."

Mr. Chase explains that to Homer the gaudy glamour of a plush-lined shadow-box and thick plate glass meant nothing else than robbery. He adds: "I think it could be truly said that no man was less moved than he by the prestige of high prices and the entrance to great collections, which are so often the 'successful' artist's chief stock-in-trade. His honest soul revolted at a success bought at such a cost." Homer once said to Mr. Chase that if he could be assured of a yearly income from his painting as large as the average salary of a department-store salesman he would be content. If he had any money in his purse he would never worry about where the next was coming from.

I must quote a little further from Mr. Chase's interesting reminiscences: —

" Homer was less influenced by others and by what others had done than any artist — any man, I may as well say — I have ever known. He was a rare visitor to public galleries and exhibitions. When there his attitude was that of a de-

<hr>

[1] "Some Recollections of Winslow Homer," by J. Eastman Chase. *Harper's Weekly,* October 22, 1910.

tached and unprejudiced observer. Names meant little or
nothing to him. He looked at any picture for precisely what
it might have to say to him — the name of the painter, whether
great or small, was of equal indifference. He was not accus-
tomed to speak of a 'Corot' or a 'Turner'; it was the picture,
pure and simple, that interested or did not interest him. His
comment was, as you would suppose, fresh, original, pene-
trating, and free from art jargon."

Charles S. Homer read the foregoing paragraph aloud to
me a few days after the publication of Mr. Chase's article, and
remarked that it was very true. It makes an art critic feel
rather cheap, however; I can testify as to that. How little able
we are to look at a picture for its intrinsic worth to us, regard-
less of its authorship! How we bow down to names! And as
to art jargon — imagine how refreshing it must have been to
talk with a painter who had nothing of it!

The oil painting entitled "Cloud Shadows" was painted
in 1890. This is a seashore subject with two figures. In the
foreground is a sandy beach, with a wide expanse of poverty-
grass just above the high-water mark. The line of the beach
curves to the right, where it extends to a point, beyond which
is deep blue water in the distance, with the sails of several
pleasure boats. A deck, the only remaining portion of an old
wreck which has been cast up on the shore, is partly visible
in the immediate foreground, and on this sits a young woman,
evidently a summer visitor, who is listening, with a smile, to
the yarns of an old fisherman in a sou'wester, who is seated
near her with his back turned towards the observer. The sky
is almost filled by vaporous gray clouds, driven smartly before
the wind, which, as they drift rapidly before the face of the
sun, cast swiftly moving shadows over the creamy gray sands
of the beach. Blue sky appears here and there in the inter-

vals between the swirling masses of clouds. These clouds
present every gradation of bluish and slaty gray as the light
plays upon them. The treatment of this busy sky is most
characteristic and subtle. Its beauty of color and of move-
ment is of a high order. The observer feels that its aspect is
changing even as he looks, and in few pictures is the effect
of "open-and-shut" weather so strongly suggested. Though
the relation of the figures to the landscape is not so important
as it is in many of the artist's more dramatic works, it is suf-
ficiently organic to make it clear that the composition would
suffer by their absence. The pictorial balance and unity of
the work is very perfect, and though the story-telling element
is here only an incident in a landscape of great freshness and
charm, yet it is an essential part of the scheme. This work
belongs to the category of Homer's pictures in which the
splendor and beauty of nature are undimmed by any sugges-
tion of stress or struggle; its atmosphere is exhilarating and
genial; and there is even a hint of the holiday mood. The pic-
ture is owned by Mr. R. C. Hall, of Pittsburgh, Pennsylvania.

"Rowing Homeward," a watercolor, was also painted in
1890. Under an evening sky, in which is seen a red sun,
shining through the purple mist, some sailors are rowing a
boat, while one man steers. The water reflects the pale green
tints of the upper sky, and is quiet, save for a ripple here and
there. The sentiment of evening is finely expressed, and
broadly rendered. This watercolor was in the Thomas B.
Clarke collection, and at the sale in 1899 it was bought by
Charles L. Freer of Detroit, Michigan, for a friend.

"Coast in Winter" and "Sunlight on the Coast," both be-
longing to Mr. John G. Johnson of Philadelphia, were painted
in 1890. The former is thus described in the catalogue of the
New York memorial exhibition of 1911 : —

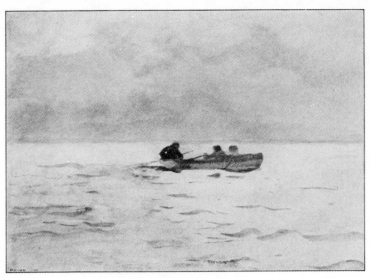

ROWING HOMEWARD

From a watercolor

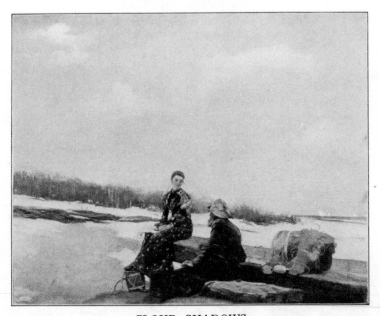

CLOUD SHADOWS

From the oil painting in the collection of Mr. R. C.
Hall, Pittsburg, Pennsylvania

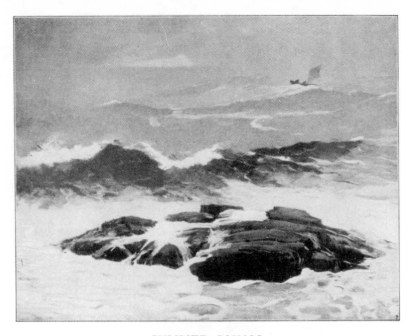

SUMMER SQUALL
From the oil painting in the collection of Mr. Morris J.
Hirsch, New York

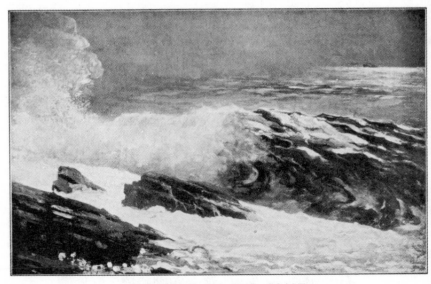

SUNLIGHT ON THE COAST
From the oil painting in the collection of Mr. John G.
Johnson, Philadelphia

"A rough, rocky shore, partly covered with snow, through which the rocks show dark brown in places, with dried grass and weeds growing in the crevices. The cliff slopes down to the right in the middle distance; beyond, green waves dash against the rocks, throwing high their mist against a gray sky. In the foreground stands the small figure of a man wearing a blue coat and carrying on his back a dead wild duck which he holds over his left shoulder; under his right arm is a gun."

Of "Sunlight on the Coast" the same catalogue gives this description: —

"A heavy green wave is breaking over the brown rocks in the lower left corner of the picture. Two masses of rock rise out of the foam, and at the extreme left spray is thrown up. Dull gray sea beyond, with a steamship on the horizon at the right. Gray sky and fog, through which the sunlight falls on the crest of the wave, the spray, and the foam in the foreground."

The most important oil painting of 1891 is "The West Wind." This is a simple design of few and telling lines, in which the steady and powerful sweep of the off-shore wind is suggested with force and grandeur of style. The tawny foreground, sloping from left to right, is overgrown with sparse grasses and junipers, bending under the weight of the blast. At the right, the figure of a woman stands with her back turned, as she watches the surf, while she holds her tam-o'-shanter cap on her head with her right hand. The white spray is flung high as the breakers roll in, and beyond them the troubled surface of the waves recedes into the gray and leaden mystery of the horizon. The impressiveness of the work is due largely to the simple nobility of the design. The canvas, thirty-two by forty-six inches in dimensions, is almost equally

divided into two masses, with the small figure as an accent; but the spacing is absolutely calculated to give the desired pictorial impression, with the least amount of detail consistent with verisimilitude. Everything is condensed into the most succinct and significant form, and every stroke tells. The imagination is powerfully stirred through the appeal to associations. "The West Wind" was bought by Mr. Samuel Untermeyer of New York at the Clarke sale in 1899, for sixteen hundred and seventy-five dollars.

"The Signal of Distress," "A Summer Night," and two Prout's Neck marine pieces were first exhibited at Reichard & Company's gallery in New York in the winter of 1891. Alfred Trumble, editor of "The Collector," an accomplished art critic, wrote of this group of works in his paper, February 1, 1891, as follows: —

"To say that Mr. Winslow Homer exhibits at Reichard & Company's galleries the four most complete and powerful pictures he has painted is to do them but half justice. They are in their way the four most powerful pictures that any man of our generation and people has painted. Nothing of the artist's previous work touches them, and, what is better still, they are sufficient to indicate to any one who has followed the career of this original and rarely gifted man, that he has worked the problem of his art to a solution from which he will not retrograde.

"Of the four canvases, one only comes within the limits of an actual composition, and it is in fact more of a dramatic bit of realism in itself. It is called 'The Signal of Distress.' It is morning at sea, after a night of winter and of tempest. The great tumbling seas are still agitated and pallid with wrath, in the livid storm light lingering in the sky. Out of the mist that hangs over the horizon, a full-rigged ship, with

all sail set, as if flying for her life from a pursuing doom, flies her flag from the royal yard, union down. In the foreground is a strip of the deck of a steamer, dripping with washes of brine. The officer of the deck shouts a command. The watch come rushing to the life-boat, rude, strong figures, in their oilskins of the night. Two men clamber into the boat, which swings at its davits. One can see that in a moment more the falls will be cast off and the rescue be tossing in the foaming lee of the ship. The color of this picture, the wild sweep of wind and sea, the feeling of penetrating moisture, and of the titanic power of angry elements, — all go together in one magnificent harmony of conception and execution, and render it a veritable masterpiece.

" Of less interest of mere subject, and much greater power of execution and massiveness of quality is the picture called 'Moonlight.' [1] Across the foreground goes the platform of a seaside hotel, perched on a rocky bluff above the surf. On the platform two girls dance as partners, their figures lighted by the lamplight from the house. Below the platform, figures make a dim group on the rocks, watching the breakers. The sea rises to a high horizon, heaving in enormous swells, which burst in foam on the shore. On the rollers an unseen moon makes a great, scintillating pathway to the horizon, and the figures of the dancers are modeled against it. Far away to the right, on a low headland, the red light of a light-house spots the purple night like a star. To say that the water in this picture moves, is not all. It flashes into ripples under the eye, its great, resonant rumble and its crashing onset on the shore fill the ear. The painting of it is of a vast and splendid boldness, but ample in finish and of the greatest resolution of handling.

[1] "A Summer Night."

"In 'A Marine on the Coast' a colossal breaker of the intense, translucent green that belongs to the sea on deep and rocky coasts is combing over to pound down upon the iron shore. Its flanks and hollows reflect flashes of light from the cold sky. . . . The fourth picture is also a Maine coast subject. It is in winter. The steep and rocky shore descends from left to right, its stratified slope patched with ice and snow. Behind it the unseen surf breaks, whirling a billowing cloud of foam towards the steel-cold sky. To those who have ever been fascinated by the terrific reality of such a scene, this picture will come like the opening of a window in their memories. They will surely feel in it the piercing cold, and the tremor of the earth under the shock of the sea, and hear, through the long thunder of the surf rolling down the shore, like cannon on a line of battle, the bitter piping of the blast.

"A great American artist in the full greatness of an art as truly American as its creator — what words could mean more?"

I have quoted from Mr. Trumble's criticism at some length, because it seems to me that no one could improve upon his spirited description of the four pictures in question. "The Signal of Distress" is one of Homer's best illustrative paintings of sea life. Like his other pictures of that life, it does not attempt to tell too much, but leaves something to the imagination. It deals with a situation which is of almost daily occurrence, yet which never loses the power to thrill us by its possibilities of tragedy and of heroism. It gives but a glimpse of one momentary aspect of the story; all the rest is implied. As Mr. Trumble's words show — "in a moment more the falls will be cast off and the rescue be tossing in the foaming lee of the ship" — one cannot look upon the

picture without prefiguring in the mind's eye all that is going to happen. The artist has chosen well the moment to put before our eyes; and he has limited wisely the visual field. It may be said, without invidious comparisons, that he escapes the pitfalls that so often beset painters of moving accidents by flood and field, through his understanding and use of the artistic principle of suggestion. "The Signal of Distress" is more than an illustration; it may stand for a symbol of the helping hand of the larger freemasonry of the open sea, where the desperate need of all fellow-creatures in emergencies is the imperative call to prompt and willing and instant aid. Finally, the picture is one of those characteristically fine compositions which have the air of inevitability, of almost startling familiarity, as of a scene that one has witnessed in a dream.

"The Signal of Distress" was exhibited in the sixth exhibition of the International Society of Sculptors, Painters, and Gravers, at the New Gallery, Regent Street, London, in the winter of 1906. An American sent a communication to the "Pall Mall Gazette," protesting indignantly against the action of the hanging committee in giving the work a very poor place. Thereupon the authorities of the International Society vouchsafed an amusing semi-official explanation to the effect that the committee had intentionally placed the picture in a comparatively obscure location because they considered it to be one of his inferior works.

As for "A Summer Night," the description written by Mr. Trumble is preferable to my own longer one, which, I fear, sounds too much like an attempt at fine writing; yet, after this preamble, I am inclined to give the substance of it, *quand même*, because it supplements Mr. Trumble's sketchy outlines by a little more of the color and emotion of the work : —

"The ocean, at night, seen from the brow of a high cliff; a broad and glittering field of moonlight reflected on the tossing waters; the shadowed curve of a mighty wave about to fall and break upon the rocks; on the brink of the cliff, the sombre silhouette of a group of people watching the surf; and in the foreground two stalwart girls waltzing in the moonlight. The blue, purple, slate, and silver-gray hues of the night form a bold, rich, and novel harmony in a minor key, an effect of splendid and moving majesty. The movement of the waves is indicated by the broadest methods known to the painter's art; that is to say, by the masterly suggestion and summary characterization of the forms momentarily assumed by the most mobile of elements, the play of light upon those forms, and all the accidents and whims of what seems like the chaotic acme of instability. Under the phantasmal light of the moon, the titanic lift of the dark billow which comes impending to its crashing fall, the fantastic shape of its crest uplifted against the lighted expanse of glimmering blue and molten silver behind it, and the swirling hollow weltering in its front, are full of the expression of power, grandeur, and mystery. The group of figures is a well composed, flat, dark mass against the illuminated sea; and in it is to be noted the rhythmic effect of a repetition of slightly varied lines." [1]

The genesis of "A Summer Night" is easily divined. It is a virtually literal transcript of a scene which Homer saw in front of his own studio at Prout's Neck. The platform is the only part of the composition which did not exist in the real scene. The girls were dancing on the lawn. As usual, the artist painted exactly what he saw. The group silhouetted

[1] *Twelve Great Artists*, by William Howe Downes, Boston: Little, Brown & Company, 1900, pp. 118, 119, 120.

at the right, on the rocks, was composed of a number of young people belonging to the summer colony, and included several of the Homers. This picture was exhibited at the Carnegie Institute, Pittsburgh, in the spring of 1899. For several years it was loaned to the Cumberland Club of Portland, Maine, where it was excellently placed. It is now in the Luxembourg Gallery, Paris.

"The Return from the Hunt" (or "Huntsman and Dogs") is an oil painting which was finished in 1891, from an Adirondacks motive. It was first exhibited in New York in December, 1891. Extremely uncompromising in its naturalism, it did not please the critics, who thought it too cold and unsympathetic. "Every tender quality of nature seems to be frozen out of it," wrote Alfred Trumble in "The Collector," "as if it were painted on a bitter cold day, in crystallized metallic colors on a chilled steel panel. The type of the hunter who carries the pelt of the deer over his shoulder, and its front and antlers in his hand, is low and brutal in the extreme. He is just the sort of scoundrel, this fellow, who hounds deer to death up in the Adirondacks for the couple of dollars the hide and horns bring in, and leaves the carcass to feed the carrion birds. The best thing in the picture is the true doggishness of the hounds. One does n't expect hounds to have any instinct above slaughter. Throughout, however, the picture — albeit well composed and firmly drawn — is a cold and unsympathetic work, entirely unworthy of the artist, unless he had made it as the original for a newspaper illustration." The picture was in the Boston Memorial Exhibition of 1911. It belonged to Mr. Edward Hooper, from whose estate it passed into the possession of his daughter, Mrs. Bancel La Farge.

"Mending Nets" and "On the Cliffs," two watercolors, are

of the same year, 1891. The former was exhibited at the twenty-fourth exhibition of the American Watercolor Society, New York. It was painted from a study made in Tynemouth, and shows two seated figures of fishwives. "On the Cliffs" depicts children at play on a bluff overlooking the sea; they are plucking flowers or standing to look at the ocean beyond them. This watercolor was acquired by Mr. Thomas L. Manson, Jr., New York, who bought it for two hundred and twenty-five dollars at the Clarke sale in 1899.

Mr. Manson also bought at the same time another watercolor entitled "Canoeing in the Adirondacks," for which he paid one hundred and seventy-five dollars. This was painted in 1892. The description of it in the Clarke catalogue runs as follows: —

"Two hunters are seated in a canoe, paddling quietly along in the deep shadow made by the wooded shore. The man in the stern, in a red shirt which makes a fine color note, is looking backward, and a trail of whitened water is left behind. Some pines are outlined against the sky, which is of brilliant whitish gray. The tones are rich, and recall with vivid realism the dense woodland fastnesses of the wilderness."

In the two models for the men in the canoe are to be recognized, probably, the same Keene Valley characters alluded to by Mr. Shurtleff, "Old Mountain Philips" and the "young man noted for his size and his red shirt," who served as models for the figures in "The Two Guides" of 1876.

Another oil painting, with the title of "Coast in Winter," painted in 1892, is one of the first of the midwinter pictures of the surf at Prout's Neck. The rocks in the foreground are partly covered by snow. The sea is very rough, and the

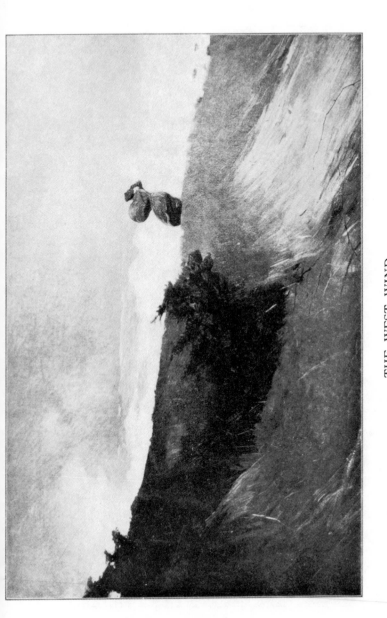

THE WEST WIND

*From the oil painting in the collection of Mr. Samuel
Untermyer, New York*

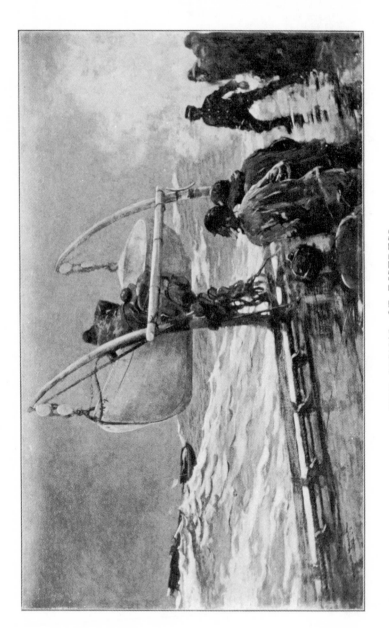

THE SIGNAL OF DISTRESS

*From the oil painting in the collection of Mr. Edward T.
Stotesbury, Philadelphia*

spray is flying high in the air. The desolate character of the effect, the aspect of the gray sky frowning upon the perturbed ocean, and the sense of chill and of solitude, are wellnigh oppressive. This canvas, thirty by forty-eight inches in dimensions, was bought by Mr. Clarke, and at the sale of his collection, 1899, it passed into the possession of Mr. C. J. Blair, of Chicago, Illinois, who paid twenty-six hundred and twenty-five dollars for it.

"Hound and Hunter" also bears the date of 1892. In the centre of this composition is a boat in the stern of which a hunter lies at full length, grasping with his right hand the antlers of a deer that is in the water. In the foreground, at the left, a hound is swimming towards the boat. A shore with dense autumn foliage forms the background. This work has been exhibited frequently, having been shown in Chicago, New York, Pittsburgh, and Boston. It measures twenty-eight inches high by forty-seven and one half inches wide. It belongs to Mr. Louis Ettlinger. In a letter from the artist to Mr. T. B. Clarke, dated October 25, 1892, he speaks of "Hound and Hunter" as his only new oil painting. "I cannot say now what my plans are for the winter," he writes, "but I think I shall show in Boston my only new oil color with ten or so watercolors (all Adirondacks), the oil to go to Chicago, and the lot to go to New York after being shown at 2 Park street. I have painted very few things this summer, for the reason that good things are scarce and I cannot put out anything [which is] in my opinion bad. . . . I think I owe it to you to give you more particulars about this oil picture. I have had it on hand over two seasons, and now it promises to be very fine. It is a figure piece pure and simple, and a figure piece well carried out is not a common affair. It is called 'Hound and Hunter.' [Pen and ink sketch here.]

A man, deer, and dog on the water. My plan is to copyright it, have Harper publish it in the 'Weekly' to make it known, have Klackner publish it as a print, and then exhibit it for sale, first in Boston (at $2000), with my watercolors." This plan was carried out only in part.

CHAPTER XIII

MILESTONES ON THE ROAD OF ART

1893–1894. Ætat. 57–58

Honors at the World's Columbian Exposition — " The Fox Hunt " —
" Storm-Beaten " — " Below Zero " — " High Cliff, Coast of Maine " —
" Moonlight, Wood Island Light " — Adirondacks Watercolors.

AT the World's Columbian Exposition, at Chicago, in
1893, fifteen of Homer's oil paintings were exhibited.
The list in the official catalogue was as follows: —
Dressing for the Carnival.
A Great Gale.
Camp Fire.
Eight Bells.
March Wind.
Coast in Winter.
The Two Guides.
(The above seven paintings were lent by Thomas B. Clarke,
New York.)
Sailors Take Warning (Sunset.)
Hound and Hunter.
Lost on the Grand Banks.
The Fog Warning.
Herring Fishing.
Coast in Winter. (Lent by J. G. Johnson, Philadelphia.)
Sunlight on the Coast. (Lent by J. G. Johnson, Phila-
delphia.)
Return from the Hunt. (Lent by Reichard & Co., New
York.)

The painter visited the exposition, and while there painted a monochrome picture in oil of the famous fountain by Macmonnies under the electric light. The work shows the pair of sea-horses and their driver with the water playing about and over them. In the band of light that falls on the basin in the foreground there is a gondola with two gondoliers rowing and two women passengers. This interesting souvenir of the memorable Court of Honor is owned by Mr. Charles S. Homer, and was first exhibited to the public at the New York memorial exhibition of 1911.

A gold medal was conferred on the artist for the picture called "The Gale" (or "A Great Gale"). Singularly enough, this was one of the first honors of the kind to be given him. He had now arrived at the age of fifty-seven. He was in the maturity of his powers. We shall see him, from this period to the end, receiving in swift succession every token of the highest appreciation, every testimony of popular favor, and all the honors that can be bestowed on a successful painter; but we shall never see him in the least degree intoxicated by his triumph, vain of his victories, or deviating by so much as a hair from the course already marked out. He was not ungrateful, but he was sagacious enough to esteem these honors at their true value. One evening, at Prout's Neck, when he had just received news of some great distinction that had been conferred upon him, he happened to be at the Checkley House, and, somewhat to his inarticulate disgust, he was being warmly congratulated by a group of ladies, who were rather fulsome in their expressions of pleasure, but he turned it all off by saying to the company, his elder brother being present, "You must remember that my brother here is quite as distinguished in his line of work as I am in mine."

He realized that there are other things in the world besides art. He respected and honored men who accomplished valuable work in science, literature, commerce, invention. Mr. Baker said of him: "I do not think that painting was anything more to him than anything else. He did not care whether he painted or not." This seems as astonishing as it is unusual; and one is at first inclined to be a little skeptical; but that there is truth in it is proved by the artist's own letters late in life, which I shall have occasion to quote in their proper place further on. Even as early as 1893, when he was replying to a Chicago picture dealer's invitation to hold an exhibition of his works in that city, he was in the mood to say, "At present . . . I see no reason why I should paint any pictures." This is the letter.

SCARBORO, ME., *Oct.* 23, 1893.

MESSRS. O'BRIEN & SONS,

GENTLEMEN, — I am in receipt of your letter of October the 8th inviting me to have an exhibition at your Galleries. In reply I would say that I am extremely obliged to you for your offer, and if I have anything in the picture line again I will remember you.

At present and for some time past I see no reason why I should paint any pictures.

Yours respectfully,

WINSLOW HOMER.

P. S. I will paint for money at any time. Any subject, any size. W. H.

As he gave no reason to explain his feeling on this subject, we are left to conjecture. It could not have been owing to any real or fancied lack of appreciation and patronage on

the part of the public or of picture-buyers. Nor was it because
of any hostile criticism, for at that time there was not any-
thing of this nature to disturb him, even were he affected by
such things. For the last seventeen or eighteen years of his
life we shall, from time to time, find him declaring that he
would paint no more, but he never gave any explanation
of this attitude, and as a matter of fact he did not lay down
his brush and palette for good until the last year of his
life.

The important picture of the year 1893 was "The Fox
Hunt." It has been variously known as the "Fox and Crows"
and "Winter." The subject of this work is very novel, and
requires a word of explanation as to the fact in natural his-
tory of which it is a dramatic illustration. In the depths of
winter, when for long intervals the ground is covered with
snow in Maine, it has been observed that a flock of half-
starved crows will occasionally have the temerity to attack
a fox, relying on their advantage of numbers, the weakened
condition of the fox, and the deep snow, which makes it
peculiarly difficult for the victim either to defend himself or
to escape. This, then, is the curious occurrence that Homer
took for the subject of his picture, which is as original and
forcible as the rest of his productions. In the snow which
covers the foreground, near the shore, a weary and harassed
fox is running painfully along, in his vain effort to find a
refuge from his approaching foes. Two savage crows already
hover nearly over him, ready to strike, and the rest of the
hungry flock is seen coming rapidly to the spot from the
direction of the shore. The canvas is large enough to permit
the representation of a life-size fox, and the reddish color of
his coat and brush in the midst of the expanse of white
makes an interesting point in the color scheme. The ocean

is visible in the distance, and overhead is a dark gray wintry sky, in which there are only two small rifts, allowing a cold silvery light to fall on the water near the left side of the picture. The green surf breaks on the rocks and throws up a cloud of spray. There is something uncommonly impressive and solemn about this stern and frigid landscape, and it seems a fit theatre for the impending catastrophe. The painting of the drifted snow in the foreground is exceedingly interesting in the delicate gradations of the values on the undulating surface, in the delicacy of its color, which is apparently very simple, yet is full of variety. The sky also is one that perhaps no other painter except Homer would have the courage to oppose to such a foreground, or, rather, that few other painters would be able to put in its right place.

Mr. Fowler cites this picture as an example of the fine sense of quantities in space that characterizes so markedly much of Homer's best work. "The disposition of the forceful spots in this rectangle is most happy," he writes. "The strong and daring mass of black offered by the crows in the upper right-hand corner, suggesting an even greater volume to the mass by the partly disappearing wings and the approaching numbers of crows — this black, modified and broken by the reflected light on the feathers and the surface light on the beaks, is further distributed by the accents of dark carried to the ears and left forepaw of the fox with fine judgment and effect. So much for the strong and organic notes of the picture. Nothing could show better control of these forcible accents than the manner in which the artist has chosen to place them on the canvas and then given them cohesion by silhouetting these telling spots of black against a darkened sky, and placing the lighter tonal value

of the fox against the snow. The space in front of the fox suggests much distance for his apprehensive flight — the very direction of his head and ears unites these two active quantities of the scene." [1]

This is one of Homer's largest canvases, measuring thirty-eight by sixty-eight inches. It was bought by the Temple fund in 1894 for the permanent collection of the Pennsylvania Academy of the Fine Arts, Philadelphia.

We come now to the year 1894, a year of marked activity and fertility in Homer's life, the date of four of his great paintings of the sea: " Storm-Beaten," " Below Zero," "High Cliff, Coast of Maine," and " Moonlight, Wood Island Light." For the first-named picture he found the subject ready to his hand on a point of rocks at Prout's Neck, just after a prolonged easterly gale, when the Atlantic was in its most spectacular mood. Never had he given such a free rein to his brush in the broad, emphatic, confident description of the ponderous and magnificent onset of the billows along that exposed, rock-bound shore of Maine. The overwhelming force of the great waves, falling with their full weight on the ledges, churning in foam, uptossing fountains of silvery spray, crashing and thundering, in a riotous tumult and confusion, seems almost to threaten the foundations of the land. To describe it in words would require a genius equal to that of the painter himself. One cannot stand before a picture like " Storm-Beaten " without being mentally stimulated and exalted: such is the potency of a personal imagination working with natural fact for its sole material. It is, to use Mr. Berenson's happy phrase, "life-enhancing." Reality is made more real ; we are more acutely

[1] *Scribner's Magazine*, May, 1903, "An Exponent of Design in Painting," by Frank Fowler.

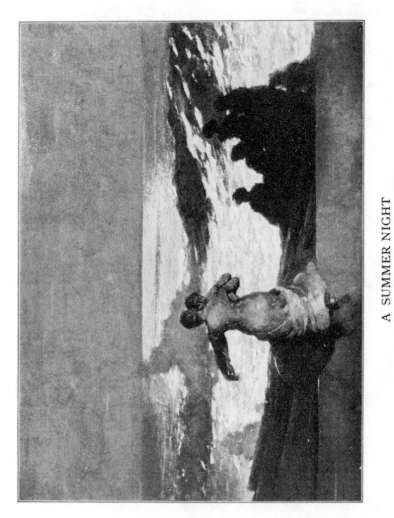

A SUMMER NIGHT

From the oil painting in the Luxembourg Museum, Paris

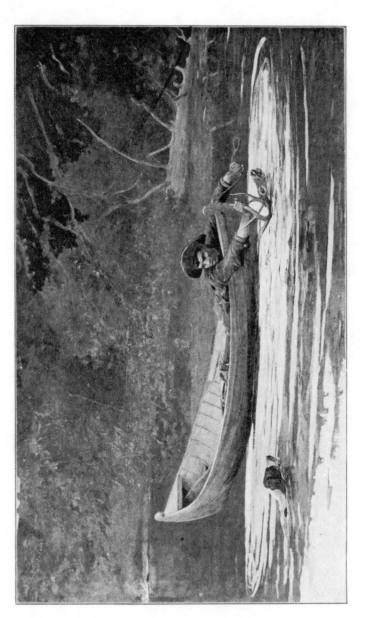

HOUND AND HUNTER

*From the oil painting in the collection of Mr. Louis
Ettlinger, New York*

alive when brought into its presence. Our horizons expand. The immensity and youthfulness of our continent are brought home to our consciousness. We are uplifted; we feel the glory of life; we take deeper breaths; we are newly heartened for our work in this best of all worlds.

"Storm-Beaten" was exhibited at Doll & Richards's gallery, Boston, in 1894, and at the fifty-fifth exhibition of the Boston Art Club in 1896–1897. It was bought by Mr. William T. Evans of New York, and in 1896 it was awarded the gold medal of honor at the Pennsylvania Academy of the Fine Arts, Philadelphia. At the sale of Mr. Evans's private collection, at Chickering Hall, New York, January 31 to February 2, 1900, it was sold to Mr. Emerson McMillin of New York, for four thousand dollars. He resold it in 1911 to M. Knoedler & Company for ten thousand dollars, and they in turn disposed of it to Mr. F. S. Smithers, the present owner. The alternative title of this work is "Weather-Beaten." The canvas is signed at the right, dated 1894, and measures twenty-eight by forty-eight inches.

"Below Zero" presents a truly Arctic scene on the coast in the depths of winter. The ground is snow-covered. The ocean sends up little breaths of steam, a common phenomenon during a cold wave, due to the difference in temperature between the air and the water. On the beach stand two men, dressed in fur costumes like those worn by the Eskimos. They hold snow-shoes in their hands, and they are peering into the mist which hangs over the water. All about reigns that strange impression of silence, of calm, of void, created by an intensely cold day. It is a picture to make the spectator shiver. The size of the canvas is twenty-eight by twenty-four inches. The former owner of this picture, Mr. F. P. Moore, resold it in 1911 to M. Knoedler & Company. It was

loaned to the exhibition of American paintings held at the Art Institute of Chicago in 1910.

The mingling of reality and mystery, of rude strength and atmospheric delicacy, in "High Cliff, Coast of Maine," is unique in this field of painting. There is nothing more wonderful in the achievements of the artist than the ease and certainty with which he has rendered this simple effect of organic strength overlaid by an unspeakable charm of atmosphere and ennobled by the incessant ordered movement, the rhythm of wave and tide, ebb and flow, the poetic expression of the eternal cycle of life in the world of nature. Nor is there anything more perfect in all his *œuvre*, so far as the complete avoidance of commonplace is concerned, in all this direct, simple, virile setting forth of the truth of everyday phenomena. The artist has effaced himself. He is wholly absorbed in his subject. Against this massive and impregnable bastion of flint and granite the huge waves dash themselves to atoms. We look up to the three diminutive human figures yonder on the summit of the cliff, and instinctively take the measure of the immense scale of the rocky structure, with its successive buttresses, based upon unseen foundations laid ages ago beneath our feet and still resisting the encroachments of the ocean, — worn and seamed, telling the story of the long centuries of conflicting forces. One might almost call this work the portrait of the high cliff, a personification of passive and stubborn resistance, stonily confronting the passion of the Atlantic with its inscrutable ancient face, scarred and furrowed by time and tempest.

This work, together with Homer's "Visit from the Old Mistress," was bought by Mr. William T. Evans, and given to the National Gallery of Art, Washington. It is on canvas thirty by thirty-seven and one half inches in dimensions, and

is signed and dated 1894. It was one of the pictures exhibited in the loan exhibition of Homer's works held by the Carnegie Institute, Pittsburgh, in the spring of 1908.

The elusive beauty of moonlight on the ocean is the motive and inspiration of "Moonlight, Wood Island Light," as it had been of "A Summer Night." In the former there are no figures. No one who has lived by the seashore can have failed to treasure the memories of those perfect summer nights when the moon sends its beams athwart the wide field of the moving waters in a path of molten silver; and the fascination of watching this glorious spectacle never lost its power over our artist. One night in the summer of 1894, he was sitting on a bench, smoking, with his nephew, in front of the studio. It was a beautiful evening, with quite a sea running, but not much wind. Of a sudden, Winslow Homer rose from his seat, and said: "I 've got an idea! Good night, Arthur!" He almost ran into the studio, seized his painting outfit, emerged from the house, and clambered down over the rocks towards the shore. He worked there uninterruptedly until one o'clock in the morning. The picture called "Moonlight, Wood Island Light," was the result of that impulse and four or five hours' work. Like his other moonlight pictures, it was painted wholly in and by the light of the moon, and never again retouched. The very essence of moonlight is in it. Close to the rocks the foaming water gives back the fullest, brightest reflections, in a whimsical pattern of shining silver. Beyond the reefs the illuminated track recedes in diminishing brightness clear to the horizon. In the distance, at the right, a long, low cape, in the south, extends into the ocean, from Biddeford Pool, and near the tip of this point is visible the light which gives the picture its name. The moon is not shown, but a gray ring indicates its

position in the sky. The painting was bought by Mr. Thomas B. Clarke, and at the sale of his collection in 1899 it was purchased by Boussod, Valadon & Company, for thirty-six hundred and fifty dollars. It is now in the collection of Mr. George A. Hearn. The canvas measures thirty by forty inches.

In 1894 Doll & Richards of Boston exhibited a group of Homer's watercolors depicting subjects taken at Prout's Neck and in the Adirondacks. One of the Adirondacks compositions represented a gigantic tree, by the stately trunk of which stood a gray-bearded guide or woodsman, looking lovingly, almost reverently, up to the monster, as a man who understands and appreciates and converses with trees, and who has lived among them all his life. Another Adirondacks drawing described powerfully a perfectly smooth lake, where an old man was fishing from a boat, and the dark reflections of the surrounding woods and mountains slumbered deep in the bosom of the still waters, so that the boat and the fisherman almost seemed to be suspended in mid-air. Still another Adirondacks drawing simply showed the solitary figure of a rugged woodsman on the deforested summit of a mountain, his gaunt frame outlined against a sky full of wildly scudding clouds. In another drawing still we were shown a dark, swift, shadowy mountain stream, rushing down over the rocks, in rapids which were broken into strangely beautiful hues, — amber, brown, green, and golden, — and which took on the most fantastic forms, now gliding, now upheaved, now eddying, swirling, beckoning, sinking, under the banks crowded thick with tall forest trees.

The oil painting called by the artist "The Girl in a Fog," and more commonly known as "The Fisher Girl," was painted in 1894. In August, 1904, Homer wrote to the owner of the

picture, Mr. Burton Mansfield, of New Haven, Connecticut, that it was painted about 1894, and "was a most careful study, direct from nature, of the best single figure that I remember having painted." He added that the picture interested him very much. In the letter he drew for Mr. Mansfield a pen-and-ink sketch of the picture. It shows the full-length of a woman standing half-way up a rocky bank. Her head is in profile and her right hand is raised to shield her eyes as she looks toward the sea at the left. A net with cork floats hangs over her left shoulder, and is held by her left hand. Through the fog which hangs over the scene there is a glimpse of rough waves.

CHAPTER XIV

THE PORTABLE PAINTING-HOUSE

1895–1896. Ætat. 59–60

" Northeaster " — " Cannon Rock "— The First Journey to the Province of Quebec — " The Lookout—All's Well ! " — " Maine Coast " — " The Wreck " — " Watching the Breakers " — Honors at Pittsburgh and Philadelphia — " Hauling in Anchor " — Mr. Turner's Reminiscences of Homer.

FOR the purpose of painting the sea in cold or stormy weather, Homer had a little portable painting-house built, and this was set on runners, so that it could be moved to any point where he desired to work. This little building was about eight by ten feet in ground dimensions, with a door on one side and a large plate-glass window on the other side. In a northeaster, when it would be impossible to manage a canvas of any considerable size out-of-doors, and when exposure would be disagreeable and uncomfortable, he would have the painting-house moved down on the rocks of Eastern Point, and, installing himself in this snug shelter, with his materials, he could place himself in the position that commanded his subject, and work as long as the light and other conditions were favorable. Shut up in this convenient shanty, he was secure from intrusion, too, and no inquisitive rambler along the shore could look over his shoulder to see what he was painting. He could never quite reconcile himself to the annoyance of having people prying at his canvas and watching his motions while he was painting in the open air.

Still another advantage arising from the use of the paint-

ing-house was the ability to get down to a level which allowed the painter to occupy a point of view somewhat lower than would have been at times consistent with safety to his life and limb. This applies particularly to Eastern Point, which is very much exposed, and in heavy weather is swept by flying spray. As one stands on the rocks, even in pleasant weather, when an off-shore wind prevails, the crests of the breakers frequently seem to rise higher than the observer's head, and to be of a rather threatening character. Here several of Homer's most famous marine pieces were painted.

"Northeaster" and "Cannon Rock" were painted in 1895. The former is one of the most impressive of its author's surf subjects, and by some persons is considered the best of all, but it is not equal to "The Maine Coast" and "On a Lee Shore," which have no rivals. Still, "Northeaster" is not only a great piece of work, it is also one of the most exciting of his marines, the weight and movement of the oncoming billow giving the impression of an irresistible and overwhelming force. It will be noted that the point of view here is very low, bringing the horizon high in the composition, and giving the onlooker the sense of being below the level of the wave-crest impending to its fall. We are near enough to make out all the shifting and seething patterns of the foam which play upon the immense breast of the coming wave and form an intricate momentary and exquisite diaper-work of milk-white tracery against the blues and greens beneath. The dark edges of the ledge at the left, and the spouting column of spray beyond it close in this simple and beautiful design. "Northeaster" belongs to the Metropolitan Museum of Art, New York, to which it was given by Mr. George A. Hearn, in 1910.

In an article on the paintings by American artists given

by George A. Hearn to the Metropolitan Museum of Art, New York, W. Stanton Howard, in the "Bulletin of the Museum," March, 1906, gives an excellent description of the composition, and adds: "The picture is one of the movements of the great Ocean Symphony which Homer has given us in a dozen canvases, ever striving to set forth its might, majesty, and infinity as he knows it. The mobility, color, and force of the vast miles of water stir the imagination and carry the mind back to other impressions of the beauty and power of the sea and awaken the emotions. There is an endless field for speculation in the subtle agreement between color and mood, between subject and emotion, between the subjective consciousness and the objective impression, which need not be touched upon here."

"Cannon Rock" is taken from a higher view-point, and the spectator feels safer in looking at it. I have spoken of the beauty of the cliff walk at Prout's Neck, and of the interest of the frequent recognition of Homer's subjects to be obtained by the stroller there. Cannon Rock is one of the most easily recognizable landmarks. Looking down from the cliff walk, one sees just the outlines of dark rock against the lighter values of the water that are shown in the picture. Nothing is changed, except that, as a matter of course, the angle of the sunlight on the scene may be different at each given hour of the day. At the right of the foreground one notices the odd outlines of a projecting rock or segment of rock which bears a semblance of the breech of a cannon. As I stopped to look, I heard a dull, muffled boom, apparently coming from the unseen base of the cliff. This, it was explained, is the report of the cannon. Perhaps it is a little far-fetched. Such ideas are apt to be so. In the middle distance, I saw a wave break repeatedly, as is shown in the

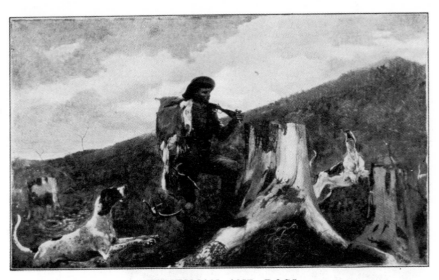

HUNTSMAN AND DOGS
From the oil painting in the collection of Mrs. Bancel
La Farge

THE TWO GUIDES
From the oil painting in the collection of Mr. C. J.
Blair, Chicago

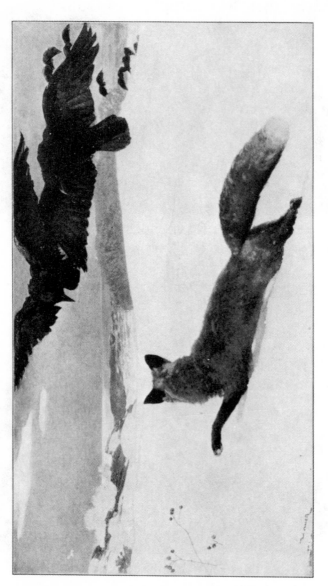

THE FOX HUNT

*From the oil painting in the permanent collection of the
Pennsylvania Academy of the Fine Arts, Philadelphia.
By permission. Copyright by Pennsylvania Academy
of the Fine Arts*

painting. That is caused by a sunken reef some little way from the shore. I do not think the arrangement of lines and masses in "Cannon Rock" is so impressive and satisfactory as in most of the artist's off-shore marine pieces. The effect of light on the water is given with all his customary success. Kenyon Cox, in a recent paper,[1] alludes to this work as follows : —

"The moment chosen here is that of the recoil of the broken wave, and if it does not give quite the overwhelming sense of weight that Homer can convey as no other painter has done in his pictures of breaking waves, there is yet a vast and dangerous bulk in the sullenly gathering water and great truth of observation in the steady, sweeping onset of the second wave, which will be thundering about us in another moment."

"Cannon Rock" is one of the several examples of Homer's work belonging to the permanent collection of the Metropolitan Museum of Art.

"Storm-Beaten," "Northeaster," and "Moonlight, Wood Island Light," were exhibited at the sixty-fifth exhibition of the Pennsylvania Academy of the Fine Arts, Philadelphia, in 1895.

The summer of 1895 saw the Homer brothers, Charles and Winslow, "hitting the trail" through the Canadian wilderness, on their way to the log cabin of the Tourilli Club, in the Province of Quebec, far from the haunts of men. In this remote and lonely spot they had happy days, hunting, fishing, and sketching. They explored the streams, lakes, mountains, and forests of this untamed country, visited the camp of the Montagnau Indians, and experienced the joys of the discoverer and frontiersman. Winslow always carried

[1] *Burlington Magazine*, London, vol. xii, p. 123.

his watercolor box with him in these expeditions, and on this first jaunt to the wilds of the Province of Quebec he made a wonderful series of rapidly wrought drawings, ten of which he sent to a watercolor exhibition held by the Saint Botolph Club in Boston, in October and November of that year. Of these ten drawings, four were in black-and-white wash, slightly warmed with brown tones. The absolutely primitive wildness of the region, which leaves nothing to be desired in that respect, is pungently set forth in this series. The breadth and luminosity of some of these Canadian sketches has never been surpassed. There is splendid movement and depth and life in the skies; the key is forced to a remarkable height of illumination; on a cold principle of coloring, the high lights are the untouched pure white of the paper; yet every value is held precisely where it belongs; and in consequence I think it may be fairly said that in the best drawings of this period the expression of sunlight is unequaled by the most brilliant works of the French impressionist landscape school.

The two scenes in the Montagnau Indian camp were particularly interesting and sonorous in color. They afforded a vivid glimpse of the everyday life of the aborigine *chez lui*, as he and his squaw carry on the cooking, the building of the birch-bark canoe, and all the details of their crude housekeeping. But the vital and memorable thing was the bright, dazzling, cool flood of northern sunlight in which the objects were bathed and enveloped. Another of the sketches showed the mischievous glee gleaming in the small and bead-like eyes of the impish black bear who was amusing himself by clawing the club canoe to tatters. In the drawing of the "Approach to the Rapids" the river smoothly and swiftly bore the canoe towards the white waters swirling and foam-

ing and galloping in the shadows of the dense, dark forest. Sweet was the repose of the tired man in the sketch of "The Guide," who had thrown himself down for a moment's well-earned rest upon the rocks by the deep mountain lake. Savage were the lines of gnarled roots and weather-beaten trees and gray rocks which spoke of solitude and desolation by the side of Lake St. John's. The remaining four drawings in monochrome were of "Lake Tourilli," "Cape Diamond" on the Saguenay River, and "The Province of Quebec," with a sketch taken from St. John's Gate in Quebec.

The Homer brothers were delighted with the camp of the Tourilli Club, and returned there more than once. It is many miles from the nearest human habitation, and the route taken in going to it is a blazed trail through the trackless forest. A "tenderfoot" who started for the camp loitered behind his guide until he found himself alone, and, being unable to follow the trail and unskilled in woodcraft, he became utterly lost and was forced to spend the night in the woods, sitting on the ground with his back to a tree. He was found the next day, and arrived at the camp in such a demoralized frame of mind, after his agitating experience, that he could not make up his mind to stay there, and beat a retreat for Quebec.

Among the oil paintings made in 1896 were five exceptionally important pictures, namely, "The Lookout, — All's Well!" "The Maine Coast" (sometimes called "The Coast of Maine"), "Watching the Breakers," "Sunset, Saco Bay, the Coming Storm," and "The Wreck." Homer was infatuated with the beauty of the night upon the sea; his great success in dealing with this motive in "A Summer Night" and "Moonlight, Wood Island Light" gave him courage to essay the same subject in a new and more difficult form,

that of a figure piece on the deck of a ship at sea; and he undertook to make this work a typical as well as an illustrative page of sea life. His preparations for painting it were so painstaking as to indicate that he had a very definite idea of what he wished to accomplish in it. He went from Scarboro to Boston, and ransacked the junk-shops along the water-front for the purpose of finding, if possible, an old ship's bell of exactly the kind that he had in mind, and, not being able to obtain just what he wanted, he went back to his Prout's Neck studio and modeled one in clay to suit himself, after a style that is nowadays rarely seen. Having done this, he set the sculptured bell up out-of-doors, engaged for his sailorman model one John Getchell of Scarboro, and, when the moonlight nights arrived, he set to work. The entire picture was painted in the moonlight, and it was never touched by daylight. For the accessories, including the mast, ropes, bulwarks, etc., he had to depend on his old shipboard sketches. Not being quite satisfied with these, he went to Boston again and went aboard an ocean steamship in the evening to study the effect of light on the actual objects. His background of ocean was of course always at Prout's Neck, ready to his hand.

Mr. William A. Coffin, the landscape painter, wrote of this picture, in the "Century Magazine," September, 1899:—

" 'The Lookout — All's Well' is one of those compositions in which Mr. Homer depicts with poetic sensibility, as well as with artistic strength, a picture of life at sea. The mariner who calls out the familiar 'All's Well' is a type, not an individual. The ship's bell, with its ornamental metal fixtures, above his head, the starry sky, and, just over the rail, the white foam of a wave breaking as it slides into the place where, a moment before, another broke, are elements in the

composition so rightly disposed and so sensitively rendered as to give the sentiment characteristic of the vastness of the deep and the loneliness of the hour. It is not worth while to find fault with the drawing of the sailor's head and hand, which might be criticized from the academic point of view. They are not faultless in construction, but they are sufficiently right to play their part in the general scheme without jarring. The effect of moonlight is admirably rendered, and the figure, so well placed on the upright canvas, looms up in the night with the grave impressiveness of a storied bronze. The poetry of a humble but free and manly calling is put before us with simplicity, directness, and a sincerity that is as convincing in its expression as it is beautiful in pictorial aspect. There is a breath of great art in this picture, and if the artist had produced nothing but 'The Lookout' and 'Eight Bells,' these two great works would be sufficient to give him a place in the first rank of the world's painters of the poetry of toil on sea and land."

" The Lookout," which is so justly estimated in this criticism, is a work which carries to its ultimate expression the remarkable series of marines with figures which may be classified under the general head of pictures of life at sea. Beginning with the Tynemouth watercolors of 1881 and 1882, which deal with shipwrecks and rescues, the life of fishermen, fishwives, and coastguardsmen, this series was developed in the oil paintings such as " The Life Line " (1884), " Lost on the Grand Banks," and " The Fog Warning " (1885), " Undertow " and " Eight Bells " (1886), and " The Signal of Distress " (1891); and it culminates in the ponderous, solemn, nocturnal vision of this hardy old tar intoning his pithy report of " All 's well!" Such a breath of great art, as Mr. Coffin puts it, is all the more impressive for the rude

form in which the conception is embodied, though it may not, indeed cannot, please the fastidious dilettante for whom art is a part of the furnishing of an elegant salon. Nothing that Homer has painted is more intensely characteristic of him. I will go so far as to say that no picture in existence has more of the romance and the wonder of sea life. The spirit of this is reduced to its simplest, largest terms. It brings to the thought and memory of the observer all the stirring tales of the sailor's life and all the picturesque associations of ocean adventure on which the youth of the seafaring races have from time immemorial fed their fancy and nourished their instinct for hero-worship. It would have been so easy and so inevitable for many painters to make this appeal in some sort meretricious and theatrical, and it was so evidently out of the question for Homer to do so. The able seaman is a rough, uncouth, simple-minded and very unheroic-looking creature, and in this Viking head nothing is extenuated. Our real heroes nowadays wear no fine raiment, are not polished either in their manners or their speech ; and we are too well aware of it to accept any false types. In other words, Homer is one of those artists who has helped us to see things as they are, and not only that, but to realize as never before the romance, poetry, nobility, and beauty that belong to the truth and are inseparable from it.

"The Lookout — All's Well" was one of the thirty-one works by Homer which entered the Clarke collection. It is forty-two inches high by thirty inches wide ; is signed at the right, and dated 1896. At the sale of the Clarke collection in 1899, it was bought by the Museum of Fine Arts, Boston, for thirty-two hundred dollars. It has been reproduced in many forms. An etching after the painting was made by Mr. W. H. W. Bicknell for Messrs. John A. Lowell & Com-

pany of Boston. Homer wrote to Mr. Clarke, March 14, 1897, regarding this picture, as follows: —

March 14, 1897.

DEAR MR. CLARKE, — Your letter received. I have a letter and telegram from Mr. La Farge asking for one or more pictures. By good luck I happen to have one that I have not shown, and I have ordered it sent to New York. The title is "The Lookout." [Pen-and-ink sketch here.] A moonlight, at sea. You will be interested in it, as it will be so unexpected and strange. It was one of the two that I was to send to Pittsburgh, but I concluded it would not be understood by any [one] but myself, and so I only sent one, and kept this, in doubt if I would show it anywhere. But I sent it recently to Doll & Richards in Boston for them to show it privately to some Cunard people and to find out if it was good for anything and could be understood. They report that "they greatly admire it." So I send it to La Farge for his exhibition. ... You mention the idea of a group of my works. That is something that must be postponed for at least ten years, and due notice given me. I hope that you are well.

Yours very truly,

WINSLOW HOMER.

In "The Maine Coast" we have one of Homer's most famous surf pictures. In the judgment of many critics it is his masterpiece in the line of marine pieces pure and simple; others will place it second to "On a Lee Shore." There is not much to describe in it beyond what I have already attempted to suggest in alluding to its predecessors in the same genre. The design is of a rigid simplicity. We are looking seaward from the cliffs of Prout's Neck on a day of

storm. At our feet the dark ledges are streaming with milky retreating foam, and just beyond them a monster wave raises its huge bulk as it comes shoreward with an exuberant look of tremendous power. Still further out to sea, in the gray mist, loom the oncoming lines of wave upon wave, until the horizon loses itself in a far turmoil of dimly seen billows. "The rain-beaten expanse of the ocean rises high in the picture, and meets a sky of lowering gray. The impression of a wild, squally day is admirably given, and the handling of the subject, quite apart from the technical requirements, is comprehensive and lofty. As to the painting, it is this, of course, which makes the picture such a triumph of art. It is virile and broad. The drawing is simple and big, and the color, while veracious, is exceedingly distinguished. The truthful aspect of the work, — the result of highly trained artistic powers of observation — and the effect of the picture as a whole, attracting by its pure pictorial quality, are equally remarkable." [1]

"It is in his marines that he seems to reach the ripest maturity of his genius; and most completely, perhaps, in 'The Maine Coast.' The human import of the ocean has spoken home to him, at last, in its least local significance. This picture involves a drama; but the players are the elements; the text, of universal language; the theme, as old as time. With the enlargement of purpose has come a corresponding grandeur of style; they realize, as no other marines with which I am acquainted, the majesty, isolation, immensity, ponderous movement and mystery of the ocean,

> boundless, endless, and sublime —
> The image of Eternity — the throne
> Of the Invisible.

[1] William A. Coffin, in the *Century Magazine*, September, 1899.

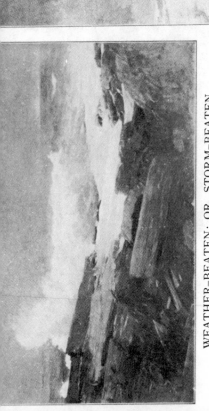

WEATHER-BEATEN; OR, STORM-BEATEN

From the oil painting in the collection of Mr. F. S. Smithers, New York

BELOW ZERO

From the oil painting in the possession of M. Knoedler and Company

ON THE CLIFF

From the watercolor in the collection of Mr. Thomas L. Manson, Jr., New York

HIGH CLIFF, COAST OF MAINE

From the oil painting in the permanent collection of the
National Gallery, Washington, D. C. Gift of Mr. Wil-
liam T. Evans

" They seem to be the spontaneous utterance of a soul full to overflowing with the magnitude of its thoughts." [1]

" The Maine Coast" was also bought by Mr. Thomas B. Clarke, and when his collection was sold, in 1899, it was purchased by Mr. F. A. Bell for forty-four hundred dollars. Mr. Bell later sold it to Mr. George A. Hearn of New York. It is thirty by forty-four inches in dimensions, and is signed, and dated 1896.

Homer sent the picture entitled " The Wreck" to the International exhibition held by the Carnegie Institute, Pittsburgh, Pennsylvania, in the autumn of 1896. On December 5, the trustees of the Institute announced their decision as to the winners of the prizes and awards established by Mr. Carnegie's generosity. The first prize of five thousand dollars for an American painting completed within 1896 and first shown at this exhibition was awarded to Homer for " The Wreck." A gold medal accompanied the award, and the picture, by the terms of the competition, became the property of the Institute. The year 1896 was the only year in which a prize was offered under these conditions. In this composition we do not see the ship which is wrecked, but we get the whole story by suggestion and implication, reading it in the movements and expressions of the figures of the life-saving crew hurrying to the beach with their boat on wheels, in the eloquent silhouettes of the tiny figures of the intent men and women on the top of yonder dunes, relieved against the pitiless leaden sky. The artist has thus told us everything by suggestion, since the calamity itself is taking place beyond our ken. As we have seen, this highly effective method is invariably employed by Homer in his

[1] Charles H. Caffin, *American Masters of Painting*, pp. 79 and 80. New York: Doubleday, Page & Co., 1906.

story-telling canvases, and it serves its purpose well. All the emotional tension of the situation is brought home to the observer, yet there is an element of unsatisfied curiosity, an element of mystery, left in the mind. There is another advantage in this method of narrative art besides its call upon our imaginations: were the painter to attempt to give us the details of what is taking place out of our sight, he would handicap himself by creating two centres of interest. His scheme thus possesses a negative as well as a positive reason, both of which are of prime importance.

Mention is made of "The Wreck" in three letters from the artist to Mr. Clarke, written in October and December, 1896. The first of these letters runs as follows:—

Oct. 5, 1896.

MR. THOS. B. CLARKE,

DEAR SIR,—After all these years I have at last used the subject of that sketch that I promised you, as being the size of and painted at the same time as the "Eight Bells." The picture that I have painted is called "The Wreck," and I send it to the Carnegie Art Gallery for exhibition. I did not use this sketch that I am about to send you, but used what I have guarded for years, that is, the subject which your sketch would suggest. I should like to have you see it (my picture) before it is sent off. I think on Wednesday or Thursday you could see it at Reichard's room. It will be sent on the 9th or 10th to Budworth for shipment to Pittsburgh.

Yours very truly,

WINSLOW HOMER.

The next letter has reference to the sketch.

Oct. 16, 1896.

MY DEAR MR. CLARKE,—I send to-day by the American Express the long and much talked-of sketch that was made

at the time of the "Eight Bells." The date I was doubtful
about (either '85 or '86). I considered, on looking at it, that
it was much better left as it is than it would be made into a
picture by figures in the distance, as it has a tone on it now
that the ten years have given it, and it also has the look of
being made at once, and is interesting as a quick sketch
from nature. I only hope that you have not expected any
more of a picture than this that you now receive. I wish it
were better, but such as it is I now offer it to you. I would
give you this with pleasure, but I know your ideas on that
point, so you can send me, any time in the next ten years
(the time you have so patiently waited), two hundred and
fifty dollars in payment for this sketch. I am very glad that
you like my new picture. I am painting others that I am
sure you will like, but I have very few pictures to put out,
as I must do as well, if not better, than that "Storm-Beaten"
that has been out so long. I will let you know when I send
my Philadelphia Academy picture to Reichard for shipment,
as I wish you to see it. It is a very brilliant sunset with
figures.

<div align="center">Yours very truly,</div>

<div align="right">WINSLOW HOMER.</div>

MR. THOMAS B. CLARKE,
203 West 44th St., New York City.

The third of the letters was written after the award of the
prize and the purchase of "The Wreck."

<div align="right">SCARBORO, ME., *Dec.* 9, 1896.</div>

MY DEAR MR. CLARKE, — I thank you for your very kind
note of congratulation on my success. It is certainly a most
tremendous and unprecedented honor and distinction that I
have received from Pittsburgh. Let us hope that it is not

too late in my case to be of value to American art in something that I may yet possibly do from this encouragement.

Yours very truly,

WINSLOW HOMER.

"Watching the Breakers: A High Sea" is one of the painter's most wonderful winter marine pieces. The place might well be just in front of the studio at Prout's Neck, where a group of three figures — two men and a woman — makes a solid black mass against the snow which lies in spotless drifts this side of the black ledges at the top of the cliff. A huge wave has just fallen with its full weight upon the rocks beneath, and a cloud of flying spray as big as a good-sized house is spouting skyward — a spectacle such as even those who live the year round on the seashore seldom witness. Nothing simpler than the masses and lines here could be devised or conceived, and yet the way in which the picture takes hold of the mind testifies to its extraordinary dramatic effectiveness. In a black-and-white version, "Watching the Breakers" vies with "On a Lee Shore" and "The Maine Coast" for sheer power and sense of inevitableness.

As a matter of course one is utterly unable to express in words what this picture has to tell. Were it describable it would not be the great picture it is. One might try to suggest what sort of impression it makes on the imagination, might try to divine what qualities of temperament were involved in the making of it, what agony and ecstasy were felt as the conception was taking shape in the mind of the maker, — for, after all, however sedulous the artist may be to hide himself in his work, the chief interest in a work of art lies in its revelations concerning the soul of the artist.

In the first place we have to do with a man who, while denying the right of the world to speculate as to the most interesting and sacred things in his life, reveals his nobility plainly in the grandeur of his works, which are his sole and sufficient confession of faith. We owe him a debt of gratitude for his interpretations of the austere beauty of the stern New England coast in winter, a kind of beauty which he was the first to set forth in all its richness and simplicity. I venture to say that there is a vein of the loftiest imaginative power in such crystal pages from Nature's book as "Watching the Breakers." It is akin to the reverential and solemn exaltation of spirit which inspired the words of the Psalmist of old who sang that "the heavens declare the glory of God, and the firmament sheweth his handiwork; day unto day uttereth speech, and night unto night sheweth knowledge." The might and mystery of the sea, a tremendous text, he could not thus feel, and in turn make us feel it, without a deep religious conviction of the significance and moral order that lie beneath its external manifestations of splendor. The artist does not formulate these intuitions into a code; he may be but vaguely aware of their existence; but they form the spiritual foundations upon which he builds.

"Watching the Breakers" is twenty-four and one quarter inches high by thirty-eight inches wide. It has been exhibited in Boston, Worcester, and New York. At the sale of the Hoyt collection in New York, in 1905, it was bought by Mr. A. R. Flower for twenty-seven hundred dollars. It is now owned by Mrs. H. W. Rogers.

"Sunset, Saco Bay, the Coming Storm" was first exhibited at the Pennsylvania Academy of the Fine Arts in 1896–1897. Homer served as one of the members of the jury on paintings at this exhibition, in December, 1896. The picture was

purchased for one thousand dollars by the Lotos Club, New York, which maintains a fund for the encouragement of American art. In the foreground of the picture is a mass of dark rock, on which stand two women with their backs turned toward the ocean. The figures are silhouetted against the sea and sky. The woman at the right, standing on the crest of the rocks, has a fish-net with cork floats over her shoulder. The other woman holds a lobster pot. A rosy glow is on the water. The rim of the setting sun shows above blue clouds at the horizon, and near the top of the canvas are heavy clouds edged with light. Against the horizon there is a small sail-boat at the left and a line of shore at the right.

The gold medal of the Pennsylvania Academy was awarded to Homer. This medal, founded in 1893 by Mr. John H. Converse, is bestowed, at the discretion of the board of directors, "in recognition of high achievement in their profession, to American painters and sculptors who may be exhibitors at the Academy or represented in the permanent collection, or who, for eminent services in the cause of art or to the Academy, have merited the distinction."

To the annual exhibition of American art held by the Cincinnati Art Museum in 1896 Homer sent a watercolor called "Hauling in Anchor," which he had painted during one of his winter journeys to the South. This subject he found at Key West. Like most of his watercolors, it is so broadly and rapidly brushed in that it may be called a sketch, but it is a truly beautiful example of his power of rendering the essentials of an impression and of giving an aspect of completeness to a vivid suggestion. A broad-beamed schooner, of clumsy lines, lies in the foreground of the scene, at the left, with her crew making ready to get under way. Two horses and several pigs form a part of her deck load. In the dis-

tance at the right is a key with palm trees relieved against the sky. The sunlight falls on the water and the starboard side of the vessel's hull and on her sails, with a fine effect of luminosity. This admirable drawing was bought by the Cincinnati Museum Association, on the recommendation of the advisory committee, of which Mr. Frank Duveneck was chairman. "They thought it a characteristic example of his work," Mr. J. H. Gest, the director, wrote to me, "and quite unusual in largeness of feeling and directness of expression." The lovely blues and greens in the water, characteristic of the waters of the South, naturally lose much in the reproduction.

The tubby schooner in this drawing is, I have no doubt, one of the Bahaman island boats which trade between the mainland and the sparse settlements of the archipelago ; and the pigs on her deck are probably some of the descendants of a breed brought to the Bahamas long ago from Africa. One day Homer brought several of his Nassau and Key West watercolors to Doll & Richards's store in Boston to have them framed for an exhibition ; and the little pigs figured in several of the subjects. He told all about the breed, and expatiated on the unusual characteristics of the animals, making no allusion to the qualities of the drawings ; and one would have thought that his sole interest was for the beasts.

I am indebted to Mr. Ross Turner, of Salem, Massachusetts, for an account of a day spent with Homer at Prout's Neck in the month of August, about 1896.

"The Neck," says Mr. Turner, "is one of those superb promontories that are frequently seen on the Maine coast, a huge pile of everlasting gray rock rising up from the sea, clothed with dark evergreen trees, interspersed with granite boulders gray with lichens and mosses.

"We were ushered into a large room on the ground floor.

A very spacious fireplace occupied nearly all of one side of this room, suggesting good cheer and warmth when cold and windy without. We were impressed with the complete originality of this home. Between the front door and the near window was a small table which bore an assortment of good things to tempt the appetite of the transient visitor; Homer called it his 'free lunch.' There were sardines, crackers, and other lunch-like commodities, and it was a nice thing to learn that our painter host liked candy! One of the guests at least had a sweet tooth, and the opportunity to chew was not lost.

"Our painter friend made this studio his home for a considerable part of each year, and with a merry twinkle in his eyes he related to us some of his adventures and experiences in the summer time with the many lady visitors who come to sketch at the Neck. He had been the innocent victim of a bevy of young lady students that summer, and he drolly related how they had kept a constant and tireless watch upon his every movement, a scouting party being at all times on duty, ready for any emergency. When our host sallied forth with his sketching kit and his pipe (to keep insects and other disagreeable things at a distance), a signal was at once given by the sentinel on duty, and a committee, duly prepared to paint or to die, likewise started out, and the painter was tracked, and discreetly but persistently kept in view, and was often obliged to beat a disorderly retreat back to the studio —his castle and his refuge in time of danger. To have assaulted this stronghold might have been somewhat hazardous to the enemy; he pointed to a musket behind the door, which was suggestive, if only as a quiet joke.

"Our painter host was a true yachtsman, as much at home on a vessel as in his studio. He knew all the ways of the wind and the wave, like an old salt. He painted a boat with

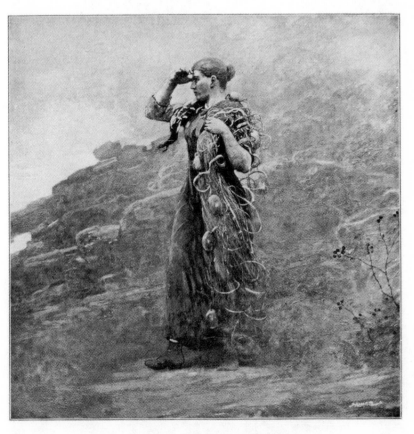

THE FISHER GIRL

*From the oil painting in the collection of Mr. Burton
Mansfield, New Haven, Connecticut*

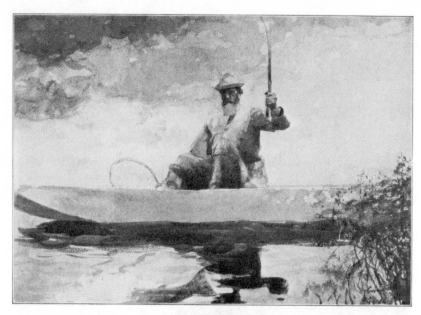

SALMON FISHING

*From the watercolor in the collection of Colonel Frank
J. Hecker, Detroit*

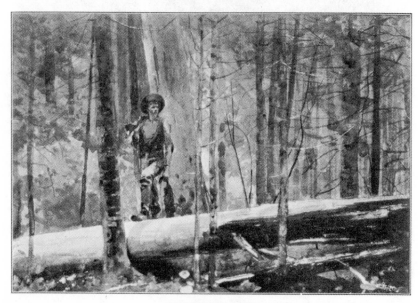

ADIRONDACKS

*From the watercolor belonging to the Edward W. Hooper
estate, Boston. Photograph by Chester A. Lawrence*

all the keen knowledge of a skipper, yet with the supreme touch of an artist. . . . The conversation led us to speak of a mutual friend, a fine yachtsman and generous host, who lived in a bungalow down on the Cape, where Homer often visited him. On one of his many yachting trips Homer anchored one night off Appledore Island, and went ashore for his supper. The next morning a smart favorable breeze invited him to a quick spin over to Annisquam for breakfast at his friend's bungalow, and with all canvas spread a swift run soon brought him to his harbor. . . . M. cordially greeted Homer, assisted him to put his small yacht out of commission temporarily, and hinted that as soon as his larger craft could be made ready they would go out for a little cruise in the open sea. Quite absorbed in making preparations for this run, he forgot to ask if his visitor had breakfasted, and the latter began to feel the pangs of hunger. The sails were unfurled, stores were carried aboard, and in the meantime all hints as to breakfast time fell on unheeding ears, until finally Homer said frankly that he needed something to eat.

" M., in a half absent-minded sort of way, began to think that somebody wanted something, and suggested that our half-famished painter might take a look in the locker, where he could probably find something — peppermint candy and soda crackers: what a breakfast for a man with a real salt-sea appetite! 'Think of me,' said Homer, 'chewing peppermint candy and crackers for breakfast at ten o'clock in the morning. Had n't had a biscuit since supper the evening before, and, as you know, living in Maine, I had no liquid ballast aboard. I said to M. : " Now, remember this, I do not go away from this house until I have breakfasted. You may get it, or I will. Where is that coffee-pot, quick?" M. now bestirred himself, and soon a delightful meal was ready.'

"Our painter's studio had an upper floor for all sorts of things, among them many pictures, mostly watercolor drawings. It was a treat to look these things over, and Homer, most affable and obliging, spared neither time nor pains to entertain his guests. He seemed to paint everything as a vision of light and color; he could touch a distant sail with gold, or the deep shadow of a summer cloud as well. Some of the studies were deep-toned effects in the primitive forests of the Adirondacks, painted simply and truly; they were masterly in composition and with a splendid disregard for all that is conventional and commonplace. The great rocks at the Neck were painted in all their grandeur; the evergreen trees and bushes were touched with tongues of flame; everything was saturated in local color and light. He was a master in sea painting, as one of his black-and-white ink wash drawings before me will testify; a great stretch of sea and cloud, the water silvery, the clouds broken by a few vigorous sweeps of the brush. Over the water are several spiral swirls connecting the distant line of the horizon with the immediate foreground, or, if I may say so, the forewater. A tiny sail off in the middle distance just lends a single note of life, and makes the spaces of sea and air seem vast, almost boundless.

"As the mid-day passed by, our host, not unmindful of his guests' appetites, said: 'We will go down to Father's house for dinner, for I feel that you will be better satisfied there than with the best I could offer you in the studio.' So we adjourned to dinner, and enjoyed a most excellent repast, and our painter was quite in his element, not to speak of the pleasure given to us. This charming day at last came to an end, and we strolled down the hillside, and, finding a conveyance ready, we bade our host farewell, hugging to

ourselves a delightful study, one of the earlier Gloucester subjects, depicting some girls in gayly colored sunbonnets, wading in the shallow water, with just a touch of a white cloud beyond, and a deep rich shade of a hillside in sunlight across the bay. At the memorial exhibition in the Museum of Fine Arts, Boston, one of the large marines in oil suggests the line in a beautiful poem : —

A garden is a sea of flowers, and the sea is a garden of foam.

CHAPTER XV

THE GREAT CLIMACTERIC

1896–1901. Ætat. 60–65

Reminiscences of Mr. Bixbee — Winslow Homer and his Father — On the Pittsburgh Jury — " Flight of the Wild Geese " — " A Light on the Sea " — Sale of the Clarke Collection — Honors in Paris — " Eastern Point " — " On a Lee Shore " — Letters — A Shipwreck.

HOMER passed the entire winter of 1896–1897 at Prout's Neck, with the exception of a few days from time to time in Boston, where his old father was then living. In a letter from Mr. William J. Bixbee, the marine painter, dated at Marblehead, November 2, 1910, he relates his recollections of the father and son at that time : —

" I think it was in the winter of 1896–97," he writes, " I lived at The Winthrop, on Bowdoin Street, Boston, and Mr. Homer, Senior, resided in the same house, — he and his colored valet. Mr. Homer was then about ninety years of age. He was a very agreeable old gentleman to talk with, and was fond of telling reminiscences of his long business life in Boston. His son Winslow used to come there to see his father every two or three weeks, and it was my privilege to become slightly acquainted with Winslow, who was not much inclined to ' talk shop.' But his father never tired of talking of his son, and his son's success. ' But,' he said, ' Winslow was a most unpractical business man.' And then he told me of a picture that Winslow sent to his agents in New York, and told them to get fifteen hundred dollars for

the picture. Some time afterward Winslow received a letter from the dealers telling him of some people who liked the picture very much, and had offered twelve hundred dollars for it. They (the dealers) wished to know if they should sell at that price. Winslow sat down and wrote a very short answer, saying, 'Make the price nineteen hundred dollars.' The old gentleman said that was the most unbusinesslike thing he had ever heard of, and said he was quite vexed about it, and he gave him quite a scolding.

"When Winslow came to Boston that winter, he did not stay at the Winthrop with his father, but used to go to the American House. I asked Mr. Homer why his son did not put up at the Winthrop. 'Well,' he said, 'Winslow likes to stay at a house where he can get something to drink.'

" In my slight acquaintance with Winslow Homer, I found him a rather pleasant man to talk with, but, as I said before, he avoided as much as possible talking about himself, or his work, or about pictures. He did not look professional. He dressed neatly, and had the appearance of a well-to-do business man. No affectation.

" I said to him once : ' I should think you would like to have a studio during the winter months in Boston or New York.' He said : ' I had rather put my pictures in the hands of the dealers when I get through with them. I don't want a lot of people nosing round my studio and bothering me. I don't want to see them at all. Let the dealers have all that bother.'

" His father thought it strange Winslow should want to stay at Scarboro through the winters, alone. During the summer months the family was together, — the old gentleman, Winslow's brothers, and Winslow."

The relations between the son and the father were alto-

gether ideal, and as the latter grew a little childish in his last few years, Winslow's untiring devotion was more than ever beautiful. He was all that a son should be. The old man's pride in his son's success was touching. He could hardly understand it, but it gave him infinite pleasure. He was a strong temperance man, and he did not approve of Winslow's habit of taking what the New England folk call an "eleven o'clocker." When he was at Prout's Neck, Winslow tried to induce his father to take a little something for his stomach's sake. At eleven o'clock he would bring him a cocktail, and the two regularly went through with the following dialogue:

"Now, father, don't you think you'd better take this? It will do you good."

"Is there any alcoholic liquor in that, Winslow?"

"Yes, father."

"Well, I won't touch it, then."

"Father, if you don't take it, I'll drink it myself."

"Well, Winslow, rather than have you destroy the tissues of your stomach by drinking this alcoholic beverage, I'll drink it."

And he did so.

By a vote of the exhibiting artists, Homer was elected a member of the jury on the award of the prizes for the exhibition at the Carnegie Institute, Pittsburgh, Pennsylvania, in 1897; and in October he proceeded to Pittsburgh, where he met his fellow-members of the jury, — John La Farge, Will H. Low, William M. Chase, Frank W. Benson, Edmund C. Tarbell, Cecilia Beaux, Frank Duveneck, Edwin Lord Weeks, and John M. Swan. The jury had four full days of work, and became rather tired. Towards the end of the task, when evidences of weariness began to appear, Mr. John W. Beatty, director of fine arts, invited all the members to go

on a little excursion to look over the great steel works at
Homestead. Everybody seemed glad of the diversion, ex-
cept Homer, who said : —

" Mr. Beatty, I came here to work, and if we go to Home-
stead it will delay us, and I want to get home as soon as I
can, for if I am late my father will be anxious about me."

Mr. Benson has told me that he found Homer much inter-
ested in the works of the painters submitted to this jury, and
extremely conscientious in the performance of his duties as
a juryman. In conversation, Mr. Benson chanced to speak
of " The Lookout — All's Well," and when he praised it
warmly, Homer appeared greatly pleased. He then said that
he had painted it wholly by moonlight. It turned out that he
had seen several of Mr. Benson's pictures, of which he spoke
with cordial appreciation.

The picture entitled " The Flight of the Wild Geese" be-
longs to the year 1897. This canvas exemplifies the original-
ity of the artist's observation and his extraordinary instinct
for a fine composition. The file of startled wild geese fly-
ing above the sand dunes, where a pair of their unfortunate
fellow-fowls have just been brought to earth by a shot, is
remarkable in its swift movement, and the pattern of the
picture is extremely interesting. The picture is in the col-
lection of Mrs. Roland C. Lincoln of Boston. It has been
loaned to several exhibitions, including that at the Carnegie
Institute, Pittsburgh, in 1908, and that of the Worcester Art
Museum in 1910. It was also in the Boston memorial exhi-
bition of 1911.

A collection of landscapes by American artists, arranged
by Mr. William T. Evans, at the Lotos Club, New York, in
1907, contained "The Northeaster" (1895), which occupied
the place of honor. "Storm-Beaten" (1894) was exhibited at

the fifty-fifth exhibition of the Boston Art Club the same
year.

"A Light on the Sea," painted in 1897, was first exhibited
at the Pittsburgh exhibition in the fall of that year, and in
New York in February, 1898, at one of the occasional loan
exhibitions held by the Union League Club. It was hung in
the place of honor at the end of the gallery. A robust fish-
wife is standing in the foreground, with her arms akimbo, and
a net draped over her right shoulder. Beyond her figure, a
gleam of moonlight strikes on an expanse of sea white with
foam. This work did not please all of the critics, and the
figure in particular has been adversely criticised. One of the
New York critics wrote : "The heavy impasto, the vehement
rather than strong manner, and the absence of any indication
of a clear understanding of form, even in the figure, prevent
the picture from being an unqualified success." The "Even-
ing Post" found the work not wholly satisfactory in a tech-
nical sense, and said : " The stolid, huge figure of a woman,
standing on a rocky shore, directly in front of the moon,
which silvers the sea, is too definitely painted to give the true
effect of the light, and there is lack of refinement in the treat-
ment of the detail. But at a distance from which these things
are not noticeable the picture masses with unaffected and
powerful simplicity. The figure and the shore, dark against
the moonlit sea, merge into a single conformation that is
singularly impressive." In spite of these strictures, which I
give here for what they are worth, the work must have found
some admirers, for it was bought by the Corcoran Gallery of
Art, Washington, for its permanent collection.

In March, 1898, the loan exhibition at the Union League
Club was entirely devoted to the paintings by two great
American artists, George Inness and Winslow Homer. The

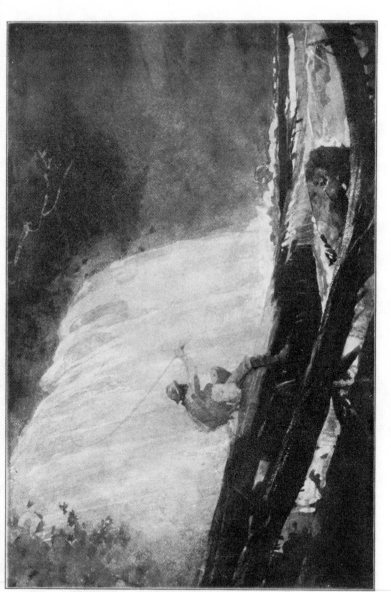

WATERFALL, ADIRONDACKS

From the watercolor in the collection of Mr. Charles L.
Freer, Detroit

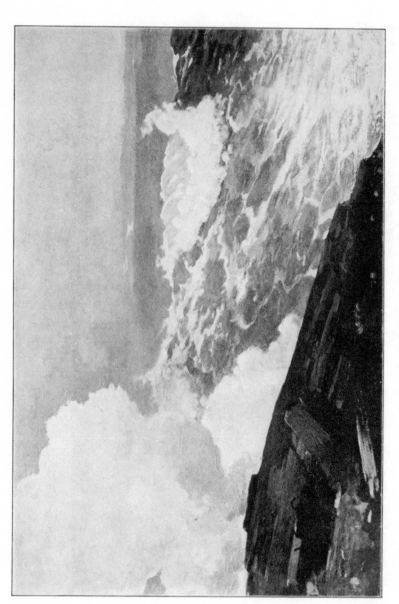

NORTHEASTER

From the oil painting in the permanent collection of the

Metropolitan Museum of Art, New York

exhibition proved to be one of the artistic sensations of the year. All the pictures were loaned by Mr. Thomas B. Clarke, then the chairman of the club's art committee. Twenty-five of Homer's works were included in this collection, and among them were his "Rations," "The Bright Side," "The Two Guides," "The Camp Fire," "The Visit from the Old Mistress," "The Carnival," "The Life Line," "Eight Bells," and "The West Wind." An amusingly cautious estimate of these works appeared in "The Studio," which considered "Rations" and the "Bright Side" "almost equal to Eastman Johnson at his best," and spoke of "The Life Line," "Eight Bells," "Coast in Winter," "The Gale," "The Maine Coast," and "The Lookout — All's Well" as a series of epics and tragedies of the seacoast which might be deemed "almost unique in the annals of American art."

In 1899 an exhibition of twenty-seven watercolors by Homer, illustrating life and scenes in the Province of Quebec, was held at the Carnegie Institute, Pittsburgh, and, later, at the gallery of Doll & Richards, Boston. The collection contained five or six monochrome drawings of the city of Quebec and its environs, and the rest of the works depicted the fishing waters of Lake St. John and the Saguenay River. The general character of this group of drawings may be inferred from the titles: "Ouananiche Fishing," "Entering the First Rapid," "Ile Malin," "Fishing, Upper Saguenay," "The Return up the River," "Under the Falls, Grand Discharge," "Young Ducks," "Sunset, Lake St. John," "End of the Portage," "Wicked Island," "The Trip to Chicoutimi," "Ouananiche, Lake St. John," "Guides Shooting Rapids," "Lake Shore," "The Fishing Ground," "Rapids below Grand Discharge," "Indian Camp," "Canoes in the Rapids," "The Head Guide," "The Rapids are Near," "Cape Dia-

mond," "Indian Boy," "Indian Girls," "St. John's Gate," "Wolfe's Cove," "Canadian Camp," and "Trout Fishing." Four of these drawings were bought by the Museum of Fine Arts, Boston.

The Boston correspondent of the "Art Interchange" wrote of this collection : "The Province of Quebec is not an over-familiar ground to most of us, either in life or in art. This northern scenery may well be bleak, strong, and dark, as the artist has painted it; to enjoy it in actual contact calls for a strain of the old Norseman spirit. Such a picture as the 'Lake Shore,' for instance, shows cold and gray in tone ; the trees lean inland, their roots grip the outcropping rocks. 'Under the Falls, Grand Discharge' shows a dark, formless background, before which the water breaks in a whirlpool of foam, while in the foreground it has a surface of mottled blue. The smooth surface of swift-running water is given in many of these paintings, a surface that usually accompanies an almost resistless current, yet the fragile birch canoes are held steady by their sturdy paddlers among rocks that scatter the water in tawny foam. Fishing is also well represented. 'The Fishing Ground' is abundantly luminous, but as a whole the effect is of impending darkness and storm. One feels that Mr. Homer's broad style and low-toned color-scheme belong to the work that he set himself to accomplish."

"The Gulf Stream," of which I have spoken, was finished in 1899. This was the year of the sale of the Thomas B. Clarke collection in New York. There were thirty-one works by Homer in this collection. Sixteen of them were oil paintings, and fifteen watercolors. The oil paintings brought a total of thirty thousand three hundred and thirty dollars ; the watercolors two thousand nine hundred and sixty-five dol-

lars; making a grand total for the thirty-one works of thirty-three thousand two hundred and ninety-five dollars. The greatest prices were obtained for "Eight Bells" (forty-seven hundred dollars), "The Life Line" (forty-five hundred dollars), "Moonlight, Wood Island Light" (thirty-six hundred and fifty dollars), "The Maine Coast" (forty-four hundred dollars), "The Coast in Winter" (twenty-six hundred and twenty-five dollars), "The Lookout—All 's Well" (thirty-two hundred dollars), "The West Wind" (sixteen hundred and seventy-five dollars), and "The Gale" (sixteen hundred and twenty-five dollars). The oil paintings, large and small, realized an average of a little more than eighteen hundred and ninety-five dollars each. This sale made a distinct sensation, and from it may be said to date a new standard of material values for first-rate American paintings. The only picture by Homer in the Clarke collection which went directly from that collection into a public museum was "The Lookout—All 's Well," which, as we have related, was acquired by the Museum of Fine Arts, Boston.

If Mr. Clarke made a substantial profit on the Homer paintings, it was no more than he deserved to make. Some of them, we may be certain, had doubled in price since they left the artist's studio. But this was not to be the last of their appreciation in value; for several of them have changed hands since the Clarke sale at distinctly enhanced prices.

That the artist was by no means ungrateful for what Mr. Clarke had done for him is shown by a letter written as early as 1892, in which he said: "I never for a moment have forgotten you in connection with what success I have had in art. I am under the greatest obligations to you, and will never lose an opportunity of showing it. I shall always value any suggestion that you may make." This was in answer to a

letter from Mr. Clarke in which he told Homer that he was planning to devote one room in his house to the artist's works and to call it the Homer gallery. In the same letter Mr. Clarke also told him of the visit of the distinguished painter John S. Sargent, who came with Mrs. T. L. Manson, Jr., to see Mr. Clarke's American pictures, and more particularly those painted by Homer. Homer was much pleased to think that Mr. Clarke contemplated keeping his pictures by themselves, and that he was still eager to acquire more of them. "I wish that he could have known how I loved his oils and watercolors," said Mr. Clarke, in telling me of this episode.

Timely recognition came to Winslow Homer. His was not to be one of those pathetic stories of a life-long struggle against indifference and hostility which fill the pages of the histories of so many painters of merit and even of genius. It is subject for rejoicing to reflect that Homer's last decade of life was not embittered by neglect and adversity. It was especially gratifying to observe the spreading fame of the great painter, because his modesty was equal to his deserving. Reputation and reward did not wait for him to pass away before underlining his name in the category of American immortals. The artists, the critics, and the collectors had for long been in accord as to his merits; and they were progressively imposing their own estimation of him upon the rest of the world. The popular opinion as to great works of art is sooner or later controlled by the few who know.

To the universal exposition held at Paris in 1900 Homer sent four of his greatest oil paintings, namely, "The Fox Hunt," "The Coast of Maine," "The Lookout — All's Well," and "A Summer Night." It may interest my readers to scan the list in French, as given in the catalogue : —

HOMER (Winslow), né à Boston, Mass., élève de Frédérick Rendel. — À Scarboro (Maine).

 152. La Chasse au renard.
 153. Le Côte de Maine.
 154. Tout va bien.
 155. Nuit d'été.

He was awarded a gold medal, and the picture of "A Summer Night" was bought by the French government and placed in the Luxembourg Museum, Paris. The grand prizes went to Sargent and Whistler; gold medals to Abbey, Alexander, Cecilia Beaux, Brush, Chase, Homer, and Thayer. Homer served on the national jury on paintings for the American section of the exposition, with twenty other artists (E. H. Blashfield, J. G. Brown, W. M. Chase, Frederick Dielman, Bolton Jones, John La Farge, G. W. Maynard, H. S. Mowbray, Edward Simmons, J. Alden Weir, E. C. Tarbell, F. P. Vinton, C. H. Woodbury, Cecilia Beaux, R. W. Vonnoh, Frank Duveneck, Ralph Clarkson, T. C. Steele, and E. H. Wuerpel).

The French Ministry of the Fine Arts assuredly made a good selection when "A Summer Night" was acquired for the Luxembourg. The French critics of discernment had from the first shown their acumen in singling Homer out for that measure of approbation which they withheld from Americans trained in their own schools. They could perceive that in his work were the racy and racial qualities for which they were looking in vain in the works of the American painters elsewhere. Nothing gave Homer and his friends more legitimate pleasure and satisfaction than this well-won honor.

"Eastern Point" was painted in 1900. The size of the

picture is forty-eight by thirty inches, and the owner is Mr. L. G. Bloomingdale of New York. The painting was exhibited at the Pennsylvania Academy of the Fine Arts in 1903. It was made in the little painting-house of which I have spoken. Any one can easily discover, in exploring the rocks in this part of Prout's Neck, the precise place from which the subject was viewed. The ledges in the foreground are drawn with perfect fidelity, and the surf beyond, with two fountains of wind-driven spray, gives an accurate index of the state of the weather and tide.

Sometimes the painter was asked to suggest a subject that he would be willing to paint for a certain customer; and his feeling with respect to this procedure is well set forth in a letter which he wrote in September, 1900, to a firm of picture dealers. "I do not care to put out any ideas for pictures," he wrote. "They are too valuable, and can be appropriated by any art student, defrauding me out of a possible picture. I will risk this one, and I assure you that I have some fine subjects to paint. . . . When I paint anything that I think your customer would like, I will submit it to you. Please return the enclosed sketch at your convenience." With this he enclosed a small sketch of a composition to which he gave the alternative titles, " On the Banks — Hard-a-Port — Fog."

The marine masterpiece entitled " On a Lee Shore " was finished in 1900, although the picture itself bears no date. It was sent to a Chicago picture dealer, who sold it to Dr. F. W. Gunsaulus, president of the Armour Institute of Technology. Dr. Gunsaulus did not keep the picture long, for in 1901 it was exhibited at the Rhode Island School of Design, Providence, and was bought by that institution with the Jesse Metcalf Fund, which is a fund established for the annual pur-

chase of some work of art by an American painter. The letter in which Homer introduced it to the attention of the Chicago picture dealer is interesting as showing that he was naïvely conscious of having produced one of his very best things.

SCARBORO, ME., *Oct.* 19th, 1900.

MESSRS. M. O'BRIEN & SON,

GENTLEMEN, — I have a *very excellent painting,* "On a Lee Shore" [here he gives a very slight pen-and-ink sketch of the subject], 39x39. The price is (with the frame) $2000, net. I will send it to you if you desire to see it. *Good things are scarce.* Frame not ordered yet, but I can send it by the time McKinley is elected.

Yours respectfully,

WINSLOW HOMER.

"On a Lee Shore" is another wonderful representation of the Atlantic Ocean in its stormy mood as seen from the shore at Prout's Neck. There are no figures. No words are capable of doing justice to the majestic sense of elemental power, the irresistible onrush, the splendor of untamable forces, that make of this marine piece one of the most unforgetable and impressive visions of the sea ever placed upon canvas. It is a page of transcendent beauty and overwhelming might. In it abides the high and solemn poetry of the vasty deep. The composition is singularly strong and novel. The commotion and turmoil of the surf in the foreground is a shade beyond anything in the history of marine painting, and a touch of human interest is added by the little schooner in the offing which is making a brave fight to keep away from the dangerous coast. The passion for truth which had been the main guiding principle of the artist's whole life here

found its greatest culmination and its most perfect form of expression. He had not steeped himself in nature in vain.

Finding that a considerable demand for his pictures existed in Chicago, Homer presently undertook to paint a marine piece as a special commission for Messrs. M. O'Brien & Son, as may be inferred from the following letter : —

Dec. 20th, 1900.

M. O'BRIEN & SON,

GENTLEMEN, — I am extremely obliged to you for your kind letter, and the picture that you refer to I promise to send to you when finished.

I will look upon it in future as your particular picture.

I do not think I can finish it before I have a crack at it out of doors in the spring. I do not like to rely on my study that I have used up to date.

But here is something that I can do. I shall have in about three weeks' time as many as six pictures all framed and on sale and exhibition. I will ship some of them to you, as the present holders should get sick of them after two or three weeks' trial of sales.

I show three at the Union League Club on Jan. 10th.

I will let you have something this winter. I will notify you when I leave here.

Yours very truly,

WINSLOW HOMER.

It was in 1901 or 1902 that the five-masted schooner "Washington B. Thomas" was wrecked on Stratton Island, about a mile and a quarter off Prout's Neck. There was a fog at the time she went ashore, but the sea was comparatively smooth. Homer saw her masts emerging from the fog bank, and hastily sent his man-servant up to the telegraph

office to wire to Portland for assistance. Having then done his duty as a humanitarian, he ran into the studio, seized a large piece of academy-board and his box of watercolors, and, securing a boat, had himself taken out to the island to paint the wreck. He did not quite finish the watercolor, which is in the possession of Charles S. Homer, and shows the crew on the deck. Tugs arrived from Portland, and the men of the crew were taken off, while he was still working on the drawing. Later the masts went by the board, and the vessel's hull was broken in two. The weather-worn bitts in Homer's front door-yard and other fragments of the schooner are still preserved.

CHAPTER XVI

THE O'B. PICTURE

1901–1903. Ætat. 65–67

The Process of Making the "Early Morning after Storm at Sea" — A Peep behind the Scenes — A Lesson in Etiquette — The Temple Gold Medal — Off for Key West.

A GOLD medal for watercolors was awarded to Homer by the fine arts jury of the Pan-American Exposition, Buffalo, New York, in 1901. His oil painting entitled "Fog" (probably the picture referred to by him in his letter of September, 1900, quoted in the foregoing chapter), was exhibited in the sixty-third exhibition of the Boston Art Club. He again served on the jury for the international exhibition of that year at the Carnegie Institute, Pittsburgh. The other members of the jury were John La Farge, Robert W. Vonnoh, Thomas Eakins, Frank W. Benson, F. W. Freer, John W. Alexander, R. W. Allan and Aman-Jean.

The Copley Society of Boston, which had been planning to hold a loan exhibition of Whistler's works, was met with a refusal of coöperation on the part of the painter, and the directors thereupon began looking about with a view to learning what might be done in other directions. Various suggestions were made, such as an exhibition of Gilbert Stuart's portraits, a loan exhibition of American landscapes, and a Picturesque Boston show; and I ventured to suggest an exhibition of Winslow Homer's works. I wrote in the "Transcript": —

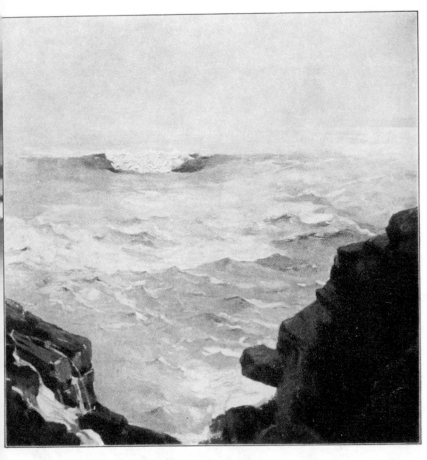

CANNON ROCK
From the oil painting in the permanent collection of the
Metropolitan Museum of Art, New York

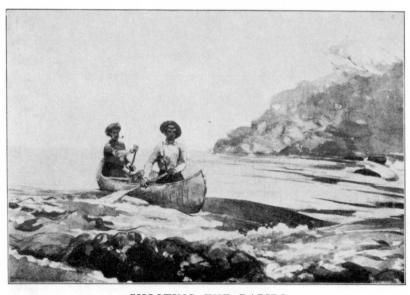

SHOOTING THE RAPIDS

From the watercolor in the collection of Mrs. J. J. Storrow,
Boston. Photograph by Chester A. Lawrence

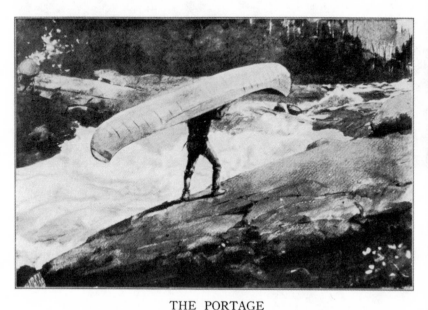

THE PORTAGE

From the watercolor in the collection of Mr. Desmond
FitzGerald, Brookline, Massachusetts. Photograph by
Chester A. Lawrence

"This painter, a native of Boston, is sixty-five years old, and his career, from the time he began to paint, just before the outbreak of the Civil War, up to the present day, covers nearly a half-century of professional activity and incessant productiveness. The number and importance of his oil paintings and watercolors are beyond precise computation, but it is certain that the sum total of his productions would mount well up into the hundreds. There can be no doubt as to the existence of ample material for a great collection. The occasional small exhibitions of his pictures in Boston from time to time during the last thirty years have given but a fragmentary and inadequate measure of his genius. A representative collection of his pictures, including his most typical oil paintings, and a hundred or more well-chosen examples of his watercolors, would be a veritable revelation, and would constitute an art event of national importance. . . . That a representative exhibition of Winslow Homer's works has never been held is a strange anomaly. There is no good reason for waiting until he is dead to do him this honor."

No action was taken on this matter.

"The Gulf Stream," painted in 1899, was exhibited at the international exhibition of art at Venice in 1901.

Writing to Messrs. M. O'Brien & Son, of Chicago, under date of Dec. 3, 1901, Homer read a lesson in etiquette to a photographer who had had the presumption to place his name in a place to which he had no right.

SCARBORO, ME., *Dec.* 3, 1901.

M. O'BRIEN & SON,

GENTLEMEN, — My last letter referred to three photographs that were sent to me by the owner to be signed (" in very black ink," etc.).

Anything written or printed under a print or picture takes the attention from it, and if it is very black or white in any marked degree will utterly destroy its beauty.

When I received these photographs I found much to my disapproval that a photographer had put his name and imprint immediately under the *right-hand side of the print* (the *place for the artist's signature*), in a most pronounced manner. [Pen-and-ink sketch here.]

I have forgotten his name, but he is not the man who took the negative.

The place for the man's name, if he has any right to show it on an unpublished print, is here: [Pen-and-ink sketch showing the name at the lower right-hand corner of the mount.]

That incident is closed.

It is about time that I received my picture the "Gulf Stream" back from Venice, and the beautiful frame on it will go on the O'B. Partic' picture directly I can get hold of it and finish the picture.

Yours respectfully and very truly,

WINSLOW HOMER.

At the bottom of the last page of this letter, underneath the signature, was a hasty sketch of a lighted lamp, with the words, "6.30 A. M. Dec. 3."

The further correspondence with the Messrs. O'Brien, chiefly in regard to the painting which he had promised to make especially for them, extended through the year 1902, and gives an interesting glimpse of the story of the making of the picture. The cause of the delay in completing this painting, which was entitled "Early Morning After Storm at Sea," and which the painter called the best picture of the

sea that he had ever made, will appear in the course of the correspondence.

SCARBORO, MAINE, *March* 15, 1902.

M. O'BRIEN & SON,

GENTLEMEN, — I have ordered M. Knoedler & Co. to send to you the two oil paintings, "The Gulf Stream" and "High Cliff," — the one just home from Venice, the other from Pittsburg.

You appear to expect three pictures. These two are the only ones. I mentioned that the frame on the large picture would fit the "O'Brien" — but the O'B. is not finished. It will please you to know that, after waiting a full year, looking out every day for it (when I have been here), on the 24th of Feb'y, my birthday, I got the light and the sea that I wanted ; but as it was very cold I had to paint out of my window, and I was a little too far away, — and although making a beautiful thing — [here is inserted a rude sketch of a trumpet, marked "own trumpet"] — it is not good enough yet, and I must have another painting from nature on it.

The net price to me on "High Cliff" is $2000 (two thousand dollars).

The net price to me on "The Gulf Stream" is $3000 (three thousand dollars).

Yours truly,

WINSLOW HOMER.

March 30, 1902.

M. O'BRIEN & SON,

GENTLEMEN, — I am in receipt of your letter. In reply I will say that I think it is quite possible that the O'B. picture will be the last thing of importance that I shall paint. The

present "High Cliff" that you have is the best of the two or three oil paintings that I now own. I have many water-colors, — "Two Winters in the West Indies," — as good work, with the exception of one or two etchings, as I ever did.

With the duckets that I now have safe, I think I will retire at 66 years of age, praise God in good health.

I take note of your flattering request for photograph of myself. I think I may have one made, and I will send it to you. Yours very truly,

WINSLOW HOMER.

SCARBORO, ME., *Sept.* 27, 1902.

MESSRS. M. O'BRIEN & SON,

GENTLEMEN, — I find on looking up my drawings, that I have not seen for fifteen years, that I have only twelve. These I have sent to you to-day by the American Express.

Please handle them very carefully until they are framed with a narrow half-inch black wood frame and in the same mats in which they are; in fact, open them once, and take the measure, and then put them away until in the frames, and after that show them *together* as you see fit.

[They should be] sold to some Western museum.

As quick sketches from nature (untouched) — you cannot beat them.

[Here a pen-and-ink sketch of a man blowing his own trumpet vigorously.]

I will take $400 net for the lot.

Yours very truly,

WINSLOW HOMER.

P. S. Will you please acknowledge receipt of these draw-ings when you receive them?

Why do you not sell that "High Cliff" picture? I cannot do better than that. Why should I paint?

SCARBORO, ME., *Oct. 29*, 1902.

M. O'BRIEN & SON,

GENTLEMEN, — When you receive the two paintings from Des Moines please let me know, as I wish to place them in some other locality in order that I may make room for "the O'Brien picture." This one will be quite enough to show, and the people who are in the clean-up of October corn may be able to buy it, but no others, as the price will be too high. This is the only picture that I have been interested in for the past year, and as I have kept you informed about it, and promised it to you to manage, I will now say that the long-looked-for day arrived, and from 6 to 8 o'clock A. M. I painted from nature on this "O'B.," finishing it, — making the fourth painting on this canvas of two hours each.

This is the best picture of the sea that I have painted.

The price that you will charge is five thousand dollars — $5000. The price net to me will be $4000.

This may be the last as well as the best picture.

I have rents enough to keep me out of the poorhouse.

Now all you have to do in reply to this is to notify me when you get the two pictures back from Des Moines, and I will then tell you what to do with them, and send the "O'B." picture.

Yours respectfully,

WINSLOW HOMER.

P. S. I found that I had very few drawings, but they will go to you to-morrow. They have been ready for some time.

W. HOMER.

Nov. 6, 1902.

M. O'BRIEN & SON,

GENTLEMEN, — I am in receipt of your favor of Nov. 3rd. Please take out of its frame "The Gulf Stream"; pack it in a strong case, not more than three inches deep, with a cover put on with screws. Ship it to me at [Rubber stamp giving his name and address here.]

Directly I receive it I will put into the case the O'B. Gem, and ship it to you.

In the meantime you will please put the frame in good order.

The two pictures are the same size.

If I find there is any difference in the size of the two canvases I will telegraph you, and have the frame whittled to suit, so there will be no delay in putting the canvas in the frame, as it is safer there.

When I send the picture I will give you the few wishes I have in the matter of the exhibition. It will only concern its protection from being used by others before it is widely shown.

I wish it sent to the Union League Club, New York, under your protection, for the loan exhibition of American artists. I will get an invitation for that purpose.

Yours truly,

WINSLOW HOMER.

SCARBORO, ME., *Nov.* 14, 1902.

M. O'BRIEN & SON,

GENTLEMEN, — The O'B. leaves here by the American Express at 3 P. M.

If it is damp when you receive [it] and the canvas wobbles, *do not* key it up, as the keys are glued in to the

stretcher, and everything is in perfect order. Just put it in a warm room.

There was a sleet storm yesterday, but beautiful to-day, so I start O'B., and glad to get it out of my sight before I finish it too highly and spoil it.

I hope the original member of your firm is still alive, after all these tedious years of waiting, and that he will be on hand to greet the O'B.

Yours truly,

WINSLOW HOMER.

This series of letters gives a peep behind the scenes, as it were, affording a glimpse of the processes and difficulties involved in the making of a marine picture. It is an illustration of the artistic conscientiousness of the painter, of his persistency, and the long-continued absorption of his whole mind on the one purpose before him. "Early Morning after Storm at Sea" was exhibited at the Carnegie Institute, Pittsburgh, in 1903. It has a high horizon line, indicating that the painter's view-point was close to the water, and there is a grand wave just breaking on the rocks close at hand. The clouds in the east are breaking and the surface of the sea is all ablaze with the light of the sun, which has just emerged after the storm. The painting is now in the collection of Mr. W. K. Bixby of St. Louis.

Another gratifying official honor was bestowed on Homer in 1902. This came to him from the Pennsylvania Academy of the Fine Arts, Philadelphia, the oldest art institution in the country, where the Temple gold medal was awarded to him for his painting entitled "A Northeaster," which, as well as that other masterpiece from his hand, entitled "The Maine Coast," then belonged to Mr. George A. Hearn of

New York. The Temple Trust Fund, created by the late Joseph E. Temple, yields an annual income of eighteen hundred dollars for the purchase of works of art by Americans, at the discretion of the directors of the Academy, and for the issuance of a gold medal by the painters' jury of selection.

A short time after this medal had been sent to him, Homer walked into Doll & Richards's store in Boston, and attended to some matters of business ; when about to leave, he asked one of the men to get him a postage stamp, as he had a letter in his hand which he wished to post. The request having been complied with, Homer put his hand in his trousers pocket to get some change with which to pay for the stamp. He fished out a key, a button-hook, some coppers, and various other small things, among which was the Temple gold medal ! It must not be supposed, however, that he was indifferent or unappreciative. On the contrary, the honors that came thick and fast in the last years were thoroughly welcome, especially when, as in this instance, they implied the recognition of his fellow-artists. A gold medal from the jury of the Charleston (South Carolina) exposition was received the same year, 1902. "Cannon Rock" was the picture exhibited there.

Mr. Emerson McMillin's pictures, thirty-nine in number, were exhibited in the spring at the Lotos Club, New York. Almost all of them were American works, and the gem of the collection was Homer's "Storm-Beaten" (or, as it has been sometimes catalogued, "Weather-Beaten"). The "Art Interchange," commenting on this work, said : "This artist's passion for the sublime swelling of a billow to its breaking point often restricts him to this motif as the whole picture, with the result that a painting of his often has the suggestion

THE LOOKOUT — ALL'S WELL
From the oil painting in the permanent collection of the
Museum of Fine Arts, Boston

of a magnificent detail. Here there is more sense of the sea, and the color is a delicious blue."

At the sixty-fifth exhibition of the Boston Art Club, Homer exhibited his "Hunter with Dog, North Woods." This is the Adirondacks subject, an oil painting, now well known under the title of "Huntsman and Dogs," and is in the collection of Mrs. Bancel La Farge. The figure of the hunter is shown standing in the centre of the foreground, near the stump of a great tree. The outline of the upper part of a mountain forms the horizon, and the sky is bleak and cold.

At the sixty-sixth exhibition of the Boston Art Club (watercolors), Homer exhibited "The Pioneer." My catalogue marginal notes are as follows : —

"Violent and crude, but pungent and powerful. Vivid light. Fresh and crisp. Cool, bracing air. Sharp opposition of light and shade. Aspect of morning newness. Personal accent. A rough bit of country."

"A High Sea" (or "Watching the Breakers") was exhibited at the sixty-seventh exhibition of the Boston Art Club, in 1903 ; and "Inland Water, Bermuda," a watercolor, was exhibited at the sixty-eighth exhibition of the same club in the spring of the same year.

Early in December, 1903, we find Homer in New York, making ready to go to Key West, Florida, by sea, for the winter, as appears from the following note to his brother : —

Dec. 5th, 1903.

DEAR ARTHUR, — I decide to go direct to Key West. I have stateroom 20, upper deck, "Sabine," go on board to-night, leave early Sunday morning. I know the place quite well, and it's near the points in Florida that I wish to visit. I have an idea at present of doing some work, but do not

know how long that will last. At any rate I will once more have a good feed of goat flesh and smoke some good cigars and catch some red snappers. I shall return through Florida and by May be at Scarboro.

Yours affectionately,

WINSLOW.

CHAPTER XVII

HOURS OF DESPONDENCY

1904–1908. Ætat. 68–72

"Kissing the Moon" — An Unfinished Picture — Atlantic City — Advancing Age — "I no Longer Paint" — "Early Evening" — "Cape Trinity" — The Loan Exhibition in Pittsburgh — First Serious Sickness — Letters.

KISSING the Moon" is the quaint title given to an oil painting dated 1904. This canvas, forty by thirty inches in dimensions, is in the collection of Mr. Louis A. Stimson of New York. Three men in a small boat are only in part visible, the boat itself being all but hid by a great wave in the foreground. The sea is rough, and a wave which is relieved against the horizon appears to just touch with its crest the lower rim of the full moon. We catch a glimpse of the stern of the boat, and the head and shoulders only of the two men who are rowing are to be seen. The men wear sou'-westers and oilskins. The helmsman is visible almost to his waist. The bow of the craft rises as the stern settles in the trough of the waves. Although so much of the boat is concealed, the impression of its buoyancy is strongly conveyed. The novelty of the design is sufficiently suggested by this description of it. The picture was engraved for "The Critic," New York, April, 1905, and for the "Gazette des Beaux-Arts," Paris, volume 51–2, page 330, 1909, where it figured under the title "Le Baiser de la Lune." In the New York memorial exhibition of 1911 it was named "Sunset and Moonrise."

In the art department of the Louisiana Purchase Exposition, at St. Louis, 1904, there were three works by Winslow Homer, two oil paintings and one watercolor. "Early Morning" was lent by Messrs. Knoedler & Company of New York; "Weather-Beaten" was lent by Mr. McMillin of New York; and the watercolor drawing entitled "Snake in the Grass" was lent by Mr. J. C. Nicoll of New York. A gold medal was awarded to the artist.

"Below Zero," painted in 1894, was exhibited in 1904 at the sixty-ninth exhibition of the Boston Art Club.

Much of the painter's time was devoted to watercolors, and some of the most admirably crisp and condensed improvisations of scenes in Florida and the Adirondacks bear the date of 1904. Nothing could be more in tune with the medium than these unrevised, swift, limpid, and resonant drawings, in which the spontaneous working of mind, eyes, and hand appears as natural and easy as the flight of a bird. Referring to two of the Adirondacks subjects that he had sent to Doll & Richards in July, 1904, Homer wrote to the firm asking for a receipt, "as I value them highly." He goes on to say: "I could make a fine picture by combining the two in an oil painting," and he inserts in the middle of the sentence a rough pen sketch of two canoes meeting. A month later he returns to the subject in another letter to Doll & Richards, in which he says: —

"Having sold a picture after waiting a year and a half, I now propose painting another, and, as that subject of the Rapids, Upper Saguenay River, is the most easy thing, as I have many studies of the subject, — and even a trip up there at this time of the year is not a bad thing, — I will ask you to send me the three drawings lately submitted to you."

The proposed painting of the Rapids was not to be fin-

Scarboro Maine
Aug 4—1908

Mr William Howe Downes
Dear Sir:

I returned here last—
Thursday & I will now answer
your letter of June 13th—
It may seem ungrateful
to you that after your
twenty-five years of hard
work in booming my
pictures that I should not
agree with you in regard
to that proposed sketch of
my life —

Bar. I think that it would probably kill me to have such thing appear — and as the most interesting part of my life is of no concern to the public I must decline to give you any particulars in regard to it

I am making arrangements to live as long as my Father & better my grand Fathers — all of them over eighty — five

By that you

may understand. Had
I have given up painting
for good —

No painters color for
me — I have much
to see & do in these
few years but Pictures
are out of it —

I should like very
much to do you some
favor for old times sake
I will think up something

I am very truly
Winslow Homer

ished. It stood on an easel for several years in the studio, but because the painter did not wish to complete it without going to the Upper Saguenay once more, it was left unfinished at the time of his death. It was shown in the New York memorial exhibition of 1911 under the title of " Shooting the Rapids." Changes in the scale and pose of one of the three figures in the birch-bark canoe were required, and some chalk marks show what these were to have been. The work in its present condition is especially interesting to painters, as illustrating methods. It was not carried beyond the blocking-in stage, but it would have been a wonderful picture had it been completed, for we know with what a rush and sweep the foreground water would have borne the frail canoe into the boiling rapids, and how the suspense and excitement of the action depicted would have been brought home to the imagination.

Homer passed the winter of 1904–1905 in Florida, but he found it too cold there to do any work outdoors. He returned to Prout's Neck, as usual, early in the spring. A series of his watercolors was exhibited at the Knoedler galleries in New York in April. This collection contained fishing subjects from the Province of Quebec and the Adirondacks, with a few tropical compositions. " Sharks " appears to have been a variation on the theme of " The Gulf Stream," as it had for its chief feature a derelict abandoned after a cyclone in the Caribbean Sea, and a school of sharks, as in the oil painting, were hovering around the wrecked craft, on board of which, however, there was no sign of life. Among the sporting motives were " Man Fishing in the Adirondacks," " Black Bass, Florida," " In the Rapids," " Blue Ledge of the Hudson," " Ouananiche — A Good Pool," " Channel Bass," etc. A curious conceit of the artist was noticed in the

last-named work, which showed a fish outlined against the blue waters of the sea. A string of bottles lay in the foreground ; they were placed there evidently to show the relative size of the fish. "If any one in Maine buys the picture," said Homer, "I will remove the bottles."

In the last week in June he started for the North Woods Club, at Minerva, Essex County, New York, for a fortnight of fishing and sketching. Writing to Doll & Richards under date of June 24, 1905, he says : —

"I leave to-morrow for the North Woods Club, Minerva, Essex Co., N. Y., but my address is still Scarboro, Me. Nothing will be forwarded to me. I return in two weeks. When I gave you the price yesterday I forgot my favorite picture for my own collection, and that is 'The Pirate Boat' [here is inserted a sketch of the composition], *which I now reserve.* A very blue sky. Please send it immediately to Scarboro, Me."

His correspondence with Doll & Richards reveals the fact that he occasionally asked the privilege of buying back his own watercolors. In 1906 he bought "The Club Canoe," a Canadian subject, for which he sent his check.

He passed a portion of the winter of 1905–1906 at Atlantic City. He could keep warm there, and found the material comforts grateful to him. Writing from the Hotel Rudolf, under date of Dec. 23, 1905, to his younger brother, he said:

I have not yet settled for the winter, but I like this place so much that I shall stay another week, if not longer. I have such a fine room on the south side, first story, European plan, — no crowd. The board walk about forty feet wide and three miles long. No snow yet. I consider it the best place for an old man that I have seen. You should see them being

wheeled about in the bath chairs [drawing] with their pink cheeks and white hair, and gathered up in sheltered corners reading the papers. It would be very slow for a man who cares to be doing anything but loaf and be waited on. You have until you are seventy years old before you would think of this kind of thing. I wish you a Merry Christmas and Happy New Year. Aff'ly,

WINSLOW.

On the same date he wrote to his nephew, Charles Lowell Homer, as follows: —

" After seeing a tramp steamer burn up this morning (out at sea), I had a quiet half-hour to think of my relations, knowing they were not on board, and I made a draft of my impression of things in the way of a Christmas greeting to them. On looking at it now, the design of that stick-pin is too good not to send you, and the other part is all right."

He enclosed a sketch of the stick-pin, which he thought would be a very appropriate present for his nephew, but in case he might prefer something else he also enclosed a check "to boom things along while you are waiting for pay day." This was but one of many similar evidences of his thoughtfulness for others and of his strong family feeling.

In several letters written in 1906, 1907, and 1908, Homer alluded to his purpose to quit painting for good. This determination, to which, however, he did not adhere consistently, and of which he, characteristically, offered no explanation, at first puzzled me not a little. I could not understand how a successful painter, in the enjoyment of good health, and with no family cares or responsibilities, could tolerate the idea of giving up his work. The theory which would account for his attitude in the manner most honorable to

him is in effect as follows: It is quite possible that, in the intervals between the severe efforts which his oil paintings cost him, he felt a sense of despondency, partly due to the reaction from the excitement and nervous strain of creative labor, during which he felt that he had done his best work, and that in future he might retrograde. He doubtless knew that many an artist has outlived himself, so to speak, continuing to produce work after passing his high-water mark of quality, and degenerating into a maker of pot-boilers; and he was determined that this should not happen in his own case. He was true to himself; conscious of the high value of his gifts; he would not, for all that the world had to offer in the way of emoluments, trifle with the sacred fire that had been committed to his charge, or debase his art to any other than the high plane of dignity on which he had always maintained it. It was not in him to delude or to flatter himself on this or on any other point. He knew that with advancing age the keenest eyesight, the steadiest hand, the most resolute will must some day betray the slow or sudden processes of impairment and decay; and the knowledge brought some natural bitterness of spirit. Thus he could write, in an hour of despondency, those sad and strange words, "I care nothing for art. I no longer paint. I do not wish to see my name in print again." [1]

These were not the words of a disappointed artist. On all sides the evidences of his spreading fame and of the increas-

[1] SCARBORO, MAINE, *July* 4, 1907.

MY DEAR MISTER OR MADAM LEILA MECHLIN, — I thank you sincerely for your interest in proposing an article on my work. Perhaps you think that I am still painting and interested in art. *That is a mistake.* I care nothing for art. I no longer paint. I do not wish to see my name in print again.

Yours very truly,

WINSLOW HOMER.

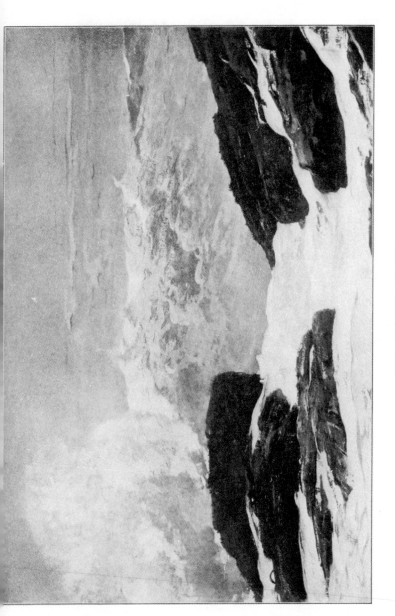

THE MAINE COAST

From the oil painting in the collection of Mr. George A.
Hearn, New York

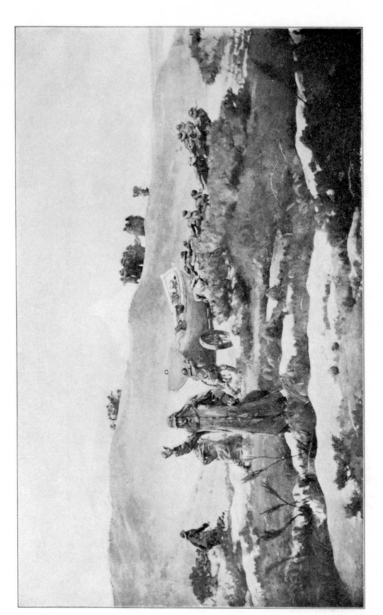

THE WRECK

*From the oil painting in the permanent collection of the
Carnegie Institute, Pittsburg, Pennsylvania*

ing demand for his pictures had never been more numerous or more emphatic. "The Gulf Stream" had been bought by the Metropolitan Museum of Art, New York, only a year before, under circumstances peculiarly gratifying to the artist. Every public art museum in the country had already obtained or was in the market seeking for his works. "High Cliff, Coast of Maine," belonging to Mr. William T. Evans, was exhibited at the Carnegie Institute, Pittsburg, and at the Pennsylvania Academy of the Fine Arts, Philadelphia, and was later presented to the National Gallery of Art, Washington. "Cloud Shadows" and "Sparrow Hall, Newcastle-on-Tyne" were exhibited at the eleventh annual international exhibition of the Carnegie Institute in the same year. "Early Evening," now in the celebrated collection of Mr. Charles L. Freer of Detroit, and which was begun as early as 1881, in Tynemouth, was also completed and sold to Mr. Freer this same year. Finally, the Carnegie Institute was making preparations for a great loan exhibition of Homer's works to be opened in the spring of 1908.

It must be admitted that it is carrying originality far to turn one's back upon Fortune when she is smiling on one in her most engaging manner.

"Early Evening" is a composition of three figures which is a composite of English figures in a New England setting. The two young women at the right centre are unquestionably from studies made at Tynemouth in 1882, for the same plump models appear in more than one of the Tynemouth series of watercolors. Outlined sharply against the sky, these figures have something of the plastic quality of a sculptured group. The gentle sea breeze moves their skirts and aprons as they stand on a ledge overlooking the ocean. These young women are not nervous types; they are almost phleg-

matic, and their natural reposefulness of bearing was one of the qualities that doubtless recommended them to the painter. One of them is knitting, and the other apparently has placed her right arm about her companion's waist. Lower in the picture, and at the left, is the upper half of the form of an old salt carrying a spy-glass. The rocks and junipers are as obviously those of Prout's Neck as the human types are those of Tynemouth.

The oil painting entitled "Cape Trinity, Saguenay River, Moonlight," was begun in 1904, but it was not finished until the winter of 1906–1907, possibly later. It depicts a great promontory with numerous rounded ledges which juts out from the right and occupies a large part of the canvas. At its base is the river, which reflects the dark mass and winds around the point of the cape at the left. On the distant shore at the left there are ranges of hills against the low horizon. The sky is cloudy. A quarter moon just above the headland is reflected in the dark water in the foreground. The work is in the collection of Mr. Burton Mansfield, of New Haven, Connecticut. Mr. Mansfield informs me that when he called on Homer at Prout's Neck in the autumn of 1904, he was at work on this picture. The artist told Mr. Mansfield that there was a gentleman who had shown some interest in it, and might perhaps buy it, but that if he did not, he (Homer) would put his boot through it. The picture is twenty-nine by forty-eight and one half inches in dimensions. Inscribed on the back of the stretcher are the words : "This is to certify that I painted this picture of Cape Trinity. Winslow Homer, June, 1909."

In the Philadelphia watercolor exhibition, held at the Pennsylvania Academy of the Fine Arts, in the spring of 1906, there were nine works by Homer, as follows : "A Good

Pool," "Channel Bass," "Hudson River at Blue Ledge," "Black Bass, Florida," "Building a Smudge," "Pike," "Trout and Float," "View from Prospect Hill, Bermuda," "Herring Fishing."

The unique feature of the twelfth annual exhibition at the Carnegie Institute, Pittsburg, in the spring of 1908, was the special group of works by Winslow Homer, loaned by public and private galleries for the occasion. Twenty-two oil paintings were brought together by Mr. Beatty in this collection, such a group of Homer's pictures as never had been seen in one place. The group was hung in a gallery by itself, with every canvas on the line, and thus displayed to the utmost possible advantage. Here were to be seen "Hark! the Lark," lent by the Layton Art Gallery, Milwaukee, Wisconsin; "Hound and Hunter," lent by Mr. Louis Ettlinger, New York; "The Fisher Girl," lent by Mr. Burton Mansfield, New Haven, Connecticut; "The Wreck," belonging to the permanent collection of the Carnegie Institute; "On a Lee Shore," owned by the Rhode Island School of Design, Providence; "A Light on the Sea," from the permanent collection of the Corcoran Gallery of Art, Washington; "Early Evening," from Mr. Charles L. Freer's collection; "The Fox Hunt," belonging to the permanent collection of the Pennsylvania Academy of the Fine Arts, Philadelphia; "The Gulf Stream," "Cannon Rock," and "Searchlight: Harbor Entrance, Santiago de Cuba," from the Metropolitan Museum of Art, New York; "Sunset, Saco Bay, — The Coming Storm," from the Lotos Club, New York; "The Gale," from the private collection of Mrs. B. Ogden Chisolm, New York; "Banks Fishermen," from the private collection of Mr. Charles W. Gould, New York; "Undertow," from Mr. Edward D. Adams's collection, New York; the "Huntsman and Dog,"

from Mrs. Bancel La Farge's collection ; the " Flight of Wild Geese," from the collection of Mrs. Roland C. Lincoln of Boston ; "The Lookout — All's Well," and "The Fog Warning" from the permanent collection of the Museum of Fine Arts, Boston ; "The Maine Coast," lent by Mr. C. J. Blair of Chicago ; "The Two Guides," from the same collection ; and the "High Cliff, Coast of Maine," from the permanent collection of the National Gallery of Art, Washington.

One of the remarkable things about this list is that it was so largely made up of pictures owned by the public art museums of America. Eight museums were represented by no less than eleven pictures, — just one half of the entire collection. In the history of the art of painting in America it would be quite impossible to find another living artist with such a number of his works in public collections. The exhibition in Pittsburg constituted the first serious attempt to bring together enough of the painter's representative canvases to give an adequate idea of what the man stood for in art, and it was an overwhelming demonstration of his originality, power, and distinction.

The picture owned by Mr. Blair of Chicago and catalogued in the Pittsburg exhibition as the "Maine Coast" was not the work properly and usually called by this name, but the "Coast in Winter," which was acquired by Mr. Blair at the sale of the Clarke collection in 1899. The catalogue contained a small portrait of the artist and reproductions on a small scale of "The Two Guides," "Huntsman and Dog," and the "High Cliff, Coast of Maine."

Dr. George Woodward loaned to the sixth annual Philadelphia watercolor exhibition, held jointly by the Pennsylvania Academy of the Fine Arts and the Philadelphia Watercolor Club, in 1908, four of Homer's Works, namely:

"Prout's Neck, Maine," "The Spanish Flag," "Prout's Neck, Maine," and "Volante." One of the Prout's Neck subjects was illustrated in the catalogue, and appears to have been the broadest kind of a sketch.

In the early summer of 1908 Homer suffered the first serious sickness of his life, the precursor of what was to come two years later. One morning he made his appearance at Arthur B. Homer's cottage, and appeared to be very shaky. He said : —

"I don't know what's the matter with me. I have been two hours getting dressed and getting over here."

He was giddy; his eyesight was affected; and he could not do much with his hands. He would reach for his teacup and miss it by some inches, showing that his vision was impaired. His brother persuaded him to stay with him for a while, and he consented. He remained there for about two weeks. At the end of that time Arthur went to Winslow's bedroom quite early one morning to see how he was feeling, and found that he had gone. There was a note on the desk in the living-room : —

I am well, and have quit.

WINSLOW.

His brother did not see him again for forty-eight hours. He had resumed work in the studio. He soon recovered sufficiently to make a trip to the Adirondacks. Under date of June 15, 1908, he wrote to me : —

MY DEAR MR. DOWNES, — Two weeks ago I found myself utterly unable to write a single word, but I am rapidly recovering the power to do so.

I cheerfully acknowledge my great obligations to you, and

I will answer your letter at length when I return from the Adirondacks in about a month.

I am told not to write too much, at present, and I will recover.

I am very well all but this. I am all packed up and go by way of Montreal, Canada.

<div style="text-align:center">Yours very truly,</div>

<div style="text-align:right">WINSLOW HOMER.</div>

After his return from the Adirondacks, in August, he wrote as follows : —

<div style="text-align:right">SCARBORO, MAINE, *Augt.*, 1908.</div>

MR. WILLIAM HOWE DOWNES,

DEAR SIR, — I returned here last Thursday, and I will now answer your letter of June 13th.

It may seem ungrateful to you that after your twenty-five years of hard work in booming my pictures I should not agree with you in regard to that proposed sketch of my life.

But I think that it would probably kill me to have such [a] thing appear, and, as the most interesting part of my life is of no concern to the public, I must decline to give you any particulars in regard to it.

I am making arrangements to live as long as my father and both my grandfathers, all of them over eighty-five.

By that you may understand that I have given up painting *for good*.

No painter's colic for me. I have much to see and do in these few years, but pictures are out of it.

I should like very much to do you some favor for old times' sake. I will think up something.

<div style="text-align:center">Yours very truly,</div>

<div style="text-align:right">WINSLOW HOMER.</div>

To a young girl in Chicago who had sent to him asking for his autograph he wrote the following letter: —

SCARBORO, MAINE, *Sept.* 10, 1908.

MY DEAR MISS YOUNG, — You are certainly very kind to write me this interesting letter, and I am quite sure that after hearing Prof. Zug you are on the right track, if you wish in any way to follow in my footsteps in matters of art. It is some time since you wrote that letter asking for the autograph, but I have only just received the letter from Minerva. I was there for a month in the spring, but my only address is Scarboro, Maine.

I now take pleasure in sending you the autograph.

WINSLOW HOMER.

With great respect, to Miss MARGARET L. YOUNG.

Early in the winter of 1908–1909 he went to Bermuda for several months' stay. He seemed to gain strength, but he was never quite the same man physically as he had been previous to the sickness of the summer of 1908. For the most part he now stuck to his resolution to leave painting alone, except that he made a few watercolors. As will be noticed, he clung with peculiar pertinacity to his purpose of prolonging his life. He began to look like an old man, however, and showed traces of suffering.

His brother Arthur tried in vain to persuade him to make a list of his pictures and their whereabouts. Asked if he knew where his works were, and who owned them, he replied that he knew where most of them were.

"Well, then," said his brother, "why won't you make a list?"

"Why should I, so long as I know?"

" But nobody else will know after you are gone."

" After I am dead I shan't care."

Writing to the same brother in November to acknowledge a gift of cigars, to decline an invitation to spend Thanksgiving with him, and to report that he was again at work painting, he took occasion to playfully pay his respects to that Boston institution, " The Evening Transcript:" —

November 19, 1909.

(Or, as you would say, S. T. 1860 X.)

DEAR ARTHUR, — I rec'd the cigars with thanks. As I must write to acknowledge the cigars, I may as well say that I cannot accept your invitation to Thanksgiving, — which, as the old maid " Boston Transcript" would say, was to be expected in the " *near future.*" *I call it soon.* And so, also quoting that same newspaper, which originated the saying " *thanking you in advance,*" and again quoting that old maid newspaper, I am still thanking you for " *that long felt want* " — the cigars.

I breakfast at seven every [morning]. I have little time for anything; many letters unanswered, and work unfinished. I am painting. I am just through work at 3.30. Cannot give you any more time.

W. HOMER.

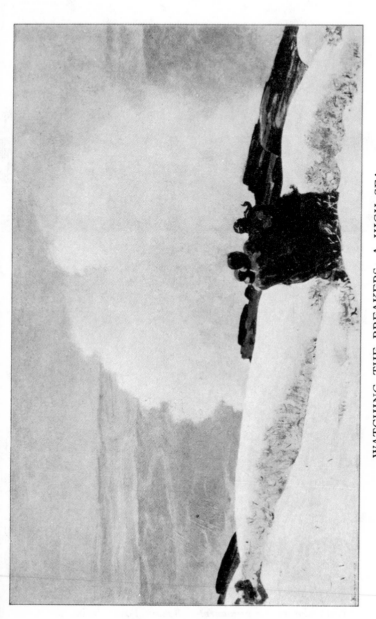

WATCHING THE BREAKERS: A HIGH SEA

From the oil painting in the collection of
Mrs. H. W. Rogers

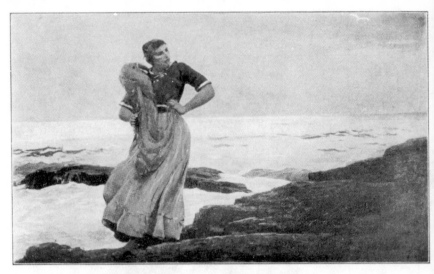

A LIGHT ON THE SEA

*From the oil painting in the permanent collection of the
Corcoran Gallery of Art, Washington*

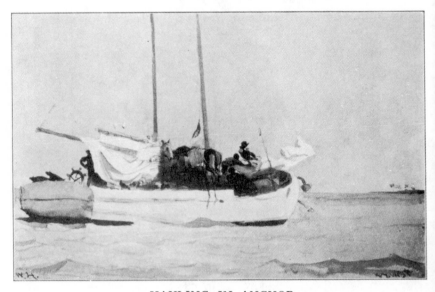

HAULING IN ANCHOR

*Watercolor in the permanent collection of the Cincin-
nati Museum Association. Painted at Key West*

CHAPTER XVIII

INCIDENTS OF THE LAST YEARS

1908–1910. Ætat. 72–74

Aversion to Notoriety — The Rubber-Stamp Signature — Characteristic Sayings — Mural Paintings — " Right and Left " — " Driftwood " — Foreign Opinion — Dread of Counterfeiters — Mr. Macbeth's Visit — Questions that were Never Answered.

WITH advancing age the grooves of habit are deepened, and Winslow Homer's reluctance to consort with people was never more pronounced than during the last years of his life. He had become a celebrity in spite of himself; but with the widening of his fame his aversion to notoriety became all the stronger. He refused to be lionized. He accepted homage with small grace. He received compliments with unconcealed coolness. For flattery he had nothing but silent contempt. He did not want to be bothered; he wanted to be let alone; there are a thousand and one little things in the daily lives of most folk which he could and did gladly eliminate from his existence as futile and foolish. The ultimate expression of his enthusiasm for a work of art which appealed to him was: "That is a good thing." He loathed superlatives; wasted no words; and had a holy horror of bores. The one thing that saved him from becoming downright misanthropic at times was the Yankee sense of humor which enabled him to see the comical side of humanity's unbounded capacity for rambling and earnest vapidity.

As he seldom arranged to have his mail forwarded to him

when he was away from home, there would often be a batch
of fifty or sixty letters awaiting him on his return to Prout's
Neck. If the weather was fine and he was interested in mak-
ing a picture, he would let the mail lie on his desk unopened
until there came a rainy day, when he would turn his atten-
tion to his correspondence. Requests from strangers for his
autograph annoyed him. Finally his younger brother had a
rubber stamp made and presented it to him, saying, "Here,
Win, now you can get even with the autograph fiends."
He accepted the suggestion, and actually used it in lieu of
his own signature in some cases.

Among the letters that he received from admiring and in-
quisitive women was one asking him what was "in that bar-
rel" aboard the dory, in the picture of "The Fog Warning."
In telling of this he made no comment in words.

As a young man, Mr. Baker says Homer was "as fine as
silk," meaning that he was fastidious, having a vein of aris-
tocratic feeling, or, to put it in the gracious French phrase,
was *une nature d'élite*. This is the testimony of one who
stood exceptionally close to him, and one who, besides, was
by nature and training a keen observer. To a man of Homer's
temperament it is but a measure of instinctive self-defense to
erect invisible barriers against easy intimacies, to tacitly ig-
nore many of the petty interests which complicate existence
needlessly and stand in the way of concentration.

Emerson understood the type. Many of the things he
wrote in his essays describe Homer, and might well have
been written about him personally. Speaking of the neces-
sity of solitude, he says we are "driven, as with whips, into
the desert." But there is danger in this seclusion. "Now
and then a man exquisitely made can live alone and must;
but coop up most men and you undo them." Again he

says: "Solitude, the safeguard of mediocrity, is to genius the stern friend, the cold, obscure shelter, where moult the wings which will bear it farther than suns and stars." In another place Emerson writes: "I count him a great man who inhabits a higher sphere of thought into which other men rise with labor and difficulty; he has but to open his eyes to *see things in a true light and in large relations.*" The italics are mine. And yet again, — as if he were actually thinking of Winslow Homer, — "he is great who is what he is from nature, and who never reminds us of others."

Winslow Homer has been compared with Walt Whitman more than once. Aside from the Americanism of the two men, as inarticulate in Homer's case as it is vocal in Whitman's, I can see but little likeness in their characters. Why compare Homer with any man? He was unique. He never reminds us of others.

If it is commonly the fate of greatness to be misunderstood, Winslow Homer was a happy exception to the rule. The sincere and unanimous and unfaltering admiration of the artists of America for his work was his from his very début as a painter, and it was generously shared by the American critics, picture buyers, and even the public at large. He was understood, admired, and loved. Indeed, there was every reason why this should be so. There was nothing recondite, obscure, or occult in his art: it was made not for a special clientèle of cultured cognoscenti, but for the man in the street, and it had in it the large, homely truthfulness, the modesty of nature, that appeals to the mind and heart of humanity, gentle and simple. To be understood is a great happiness for the artist, and this satisfaction came early to Homer and stayed to the end. Perhaps we do not yet realize how great a man he was, but it is pleasant to reflect that he was not

neglected, and that, as such things go in our day and country, the measure of his success was as exceptional in its completeness as it was prompt in point of time.

Mr. Chase, in his reminiscences,[1] speaks of Homer as "a charming companion, not effusive, witty and racy in his conversation. The wrinkles around the eyes in this somewhat austere face recorded the rare humor that had helped as a solvent to the difficult things in life which I feel that he must have known." His words were often open to an ironical interpretation, and one could not always make sure whether he was speaking seriously or, as the pithy slang phrase has it, "through his hat." Mr. Bernard De Vine, a young artist, who spent a season at Prout's Neck, tells me that not long ago a New York gentleman of an adventurous disposition traveled all the way to Scarboro to make Homer's acquaintance, and when he arrived there, found the studio door locked, and the owner absent. He wandered about the cliffs for a while, and presently he met a man wearing a rough old suit of clothes, rubber boots, and a battered felt hat, and carrying a fish-pole. He accosted the fisherman thus : —

"I say, my man, if you can tell me where I can find Winslow Homer, I have a quarter here for you."

Instantly the fisherman replied : "Where's your quarter?"

He handed it over : and was astounded to hear the quizzical Yankee fisherman say : "I am Winslow Homer." The sequel of this novel meeting was that Homer took the enterprising person up to the studio, entertained him, and, before he left, sold him a picture.

To Mr. De Vine I am also indebted for the following incident : Father H., the Catholic priest who officiated at the little chapel at Prout's Neck that summer, knocked at the

[1] In *Harper's Weekly*, October 22, 1910.

door of the studio late one evening. Homer came to the door and stormed at him for presuming to disturb him at that hour. "Why," said he, "even my own brothers do not dare to disturb me at this time of night."

"But," said the young clergyman, sweetly, "I am not your brother, Mr. Homer; I am your Father."

Homer smiled, softened, let him in, and by and by sent him home with a generous gift for the little chapel.

There is something very attractive about these bitter-sweet characters.

Some of Homer's sarcasms were severe. Mr. De Vine asked him if he had heard that Mr. J., a mediocre artist, had quit painting and gone into business. He looked at the young man a moment, and then said dryly: "When did he ever begin painting?"

At another time he was told that two well-known New York landscape painters were sketching in the neighborhood, and he growled, "What are those amateurs doing around here?" But when I repeated this remark to his brother, he said: "That was not like him." He was usually courteous and kindly towards his professional brethren, and had a becoming esprit de corps.

When Homer called on Mrs. Joseph De Camp, the daughter of his old comrade Joseph E. Baker (the De Camp family being at Prout's Neck for the summer), he told her that one of the mistakes of his life had been that he did not affiliate with "the boys," meaning the artists. He declined repeated invitations to dinner, and excused himself frankly on the plea that his teeth were in such poor case that he was not able to masticate his food properly. Mrs. De Camp found him "a very courteous old gentleman." He brought her a quaint nosegay of old-fashioned flowers from his garden. He also

brought and presented to her a portrait of himself drawn in lead-pencil by her father, Mr. Baker, in 1857, in Boston, at the time when they had been fellow-apprentices at the Buford lithograph shop; and this drawing, made when Homer was a youth of twenty-one, Mrs. De Camp has kindly loaned to the publishers of this volume for reproduction. It is undoubtedly the earliest existing portrait of Homer.

In 1908 Homer wrote to Mr. Charles A. Green of Rochester, New York, that during his absence from his studio at Prout's Neck in the winter, thieves broke in and carried off much that was of value. His lament was greatest over the loss of a watch which had been given him by his mother, long since dead. He made a drawing of the dial of this watch, which was of an unusual character, and enclosed it in his letter.

A woman artist had made a copy of a fine old painting. It was such a good copy that some people went so far as to say that they could not tell the original from the copy. The artist suggested to Charles S. Homer that he should show the copy to Winslow, without telling him anything about it, in order to see what he would have to say of it. This was done. Winslow Homer, after examining the canvas, somewhat deliberately, said : —

"This is a copy, made by a woman, after an original which may be a good thing."

When the woman artist heard what he had said, she was angry.

"Enchanted," a painting by Homer, was in the private collection of the late John T. Martin of New York, which was sold at auction on April 15 and 16, 1909, by the American Art Association. The picture, twelve by twenty inches in dimensions, was bought by Mr. N. Strauss, for three hundred and fifty dollars.

"The Unruly Calf," belonging to Mr. Charles A. Schieren, was exhibited at the Brooklyn Institute of Arts and Sciences the same year.

At the fourth annual exhibition of selected paintings by American artists, at the Albright Art Gallery, Buffalo, New York, May 10 to August 30, 1909, "Early Evening," from Mr. Freer's collection, and a picture entitled "Spring" were exhibited.

We are not accustomed to thinking of Homer as a painter of mural decorations, nevertheless he had tried his hand at this difficult, and, to him, unaccustomed undertaking, and the subjoined passage from a letter written by Augustus Saint-Gaudens, the sculptor, to Charles F. McKim, the architect, in regard to the then proposed mural decorations for the Boston Public Library,[1] will serve to show the esteem in which his work was held by Edwin A. Abbey: —

"I've just seen Abbey again, and he is all wound up, as I am, about the Library business, and if anything should turn up, he would come back from Europe next year for it. We have made up a list of names, all strong men, and he suggests having them meet at your office next week, to pow-wow some evening — Wednesday, if possible. He suggests that White be there, and that all the photos of decorative work be got out, — Masaccio, Carpaccio, Benozzo Gozzoli, Botticelli, &c., to show and to talk over. If you think well of this let me know, and I'll get the fellows together. Aside from La Farge, 'qui va sans dire,' and to whom undoubtedly the big room should be given, the following are the names that you should consider in this matter: Abbey, Bridgman, Cox, Millet, Winslow Homer (who, Abbey tells me, has done some bully decorative things in Harper's office that we can go

1 In the *Century Magazine* for August, 1909.

see together), and Howard Pyle. These are all strong men — every darned one of them."

The mural paintings by Homer of which Mr. Abbey had told Mr. Saint-Gaudens were made for the business office of Harper & Brothers, Franklin Square, New York. They were three in number, and represented : 1. Castle Garden ; 2. Harper & Brothers' building and the interior of the press-room ; 3. The Genius of the Press. When I called at Harper & Brothers' establishment, in February, 1911, and asked about these decorations, nobody knew anything about them, and, though a frieze in the office was shown, it apparently did not include the panels by Homer.

Homer had asked John La Farge for advice about these mural paintings when the commission was given to him, and we have La Farge's testimony as to their merits in the guarded statement that they were as learned as if the artist had consulted all necessary books. "Many people," said La Farge,[1] "do not know that he had even thought of stained glass and wall decoration. He came to me late to consult me about these questions. The wall decoration I saw the project for, and it was as learned as if this man had consulted all necessary books. His glass I had no idea of. I doubt if he himself had any notion, but I regret that such an impossible thing should not have been tried. It is a great honor to me that he came to me once to ask, and he was very frank in his admiration or his criticism. . . ."

After having abstained heroically from doing any work in oils for a time, Homer painted another picture in November, 1909. The title of it is "Right and Left." The artist had bought a fine pair of plump wild ducks for his Thanksgiving

[1] Letter from La Farge to Gustav Kobbé, published in the New York *Herald*, December 4, 1910.

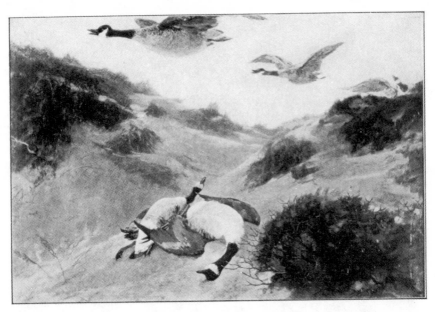

FLIGHT OF WILD GEESE

*From the oil painting in the collection of Mrs. Roland
C. Lincoln, Boston. Photograph by Baldwin Coolidge*

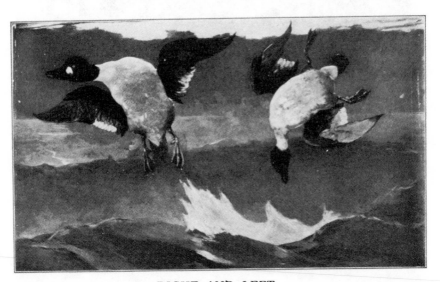

RIGHT AND LEFT

*From the oil painting in the collection of Mr. Randal
Morgan, Philadelphia*

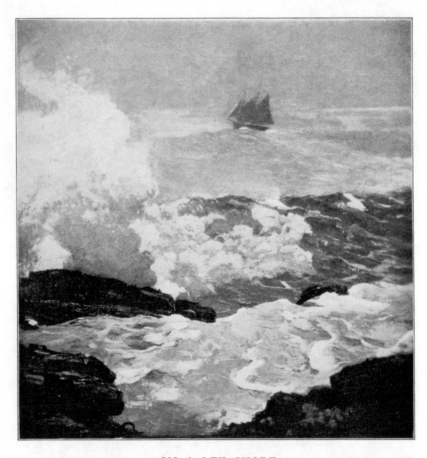

ON A LEE SHORE

From the oil painting in the permanent collection of the
Rhode Island School of Design, Providence, Rhode Island

dinner. He did not intend to make a painting of them, but their plumage was so handsome, he was tempted; and before he got through with them his Thanksgiving dinner was spoiled. It may be a subject of speculation how he came to show the ducks in the air, above the waves, falling, as if just mortally wounded by a hunter. He employed his usual careful methods of observation in this case. He went out, day after day, in a boat, with a man who was armed with a double-barreled shotgun, and studied the positions and movements of the birds when they were shot. He had no title for the picture. It was sent to Knoedler & Company's gallery in New York; a sportsman came in, caught a glimpse of the picture, and at once cried out: "Right and left!" — admiring, not so much the picture *per se*, as the skill of the hunter who could bring down a bird with each barrel of his double-barreled shotgun in quick succession. So the work was christened. It was bought by Mr. Randal Morgan, who loaned it for exhibition at the one hundred and fifth annual exhibition of the Pennsylvania Academy of the Fine Arts in Philadelphia, January to March, 1910.

What proved to be his last oil painting was a canvas called "Driftwood," painted in the fall of 1909. It represents some wood drifting to the shore, a man in oilskins and sou'-wester going out into the water with a rope to secure it. This picture, twenty-eight by twenty-four inches in dimensions, was sent to Knoedler & Company, New York, in November, 1909, and was sold to Mr. Frank L. Babbott of Brooklyn.

The "Northeaster," dated 1895, was given to the Metropolitan Museum of Art, New York, by Mr. George A. Hearn, in 1910. The gift was announced in the May issue of the "Bulletin" of the Museum, which contained an excellent re-

production of the canvas, and alluded to the original as "the magnificent 'Northeaster,' by Winslow Homer, considered by many to be his best work." There are so many of his best works !

"Early Morning," belonging to Mr. W. K. Bixby of St. Louis, Missouri, was exhibited at the fifth annual exhibition of selected paintings by American artists, in the Albright Art Gallery, Buffalo, New York, May 11 to September 1, 1910. At the summer exhibition of the Worcester Art Museum, the "Flight of Wild Geese," belonging to the collection of Mrs. Roland C. Lincoln of Boston, was exhibited. Mrs. Lincoln informs me that the original title of this picture was "At the Foot of the Lighthouse," and she thinks that this title gives the true explanation of the death of the birds in the foreground.

Three of Homer's oil paintings were shown at the Exhibition of American Art held at Berlin and Munich in 1910. In a paper on "American Paintings in Germany," C. Lewis Hind, writing in "The International Studio" for September, 1910, discusses this exhibition, and asks: "Can we find . . . any signs of a national American art?" And his answer is Winslow Homer. "This old master," says Mr. Hind, "who is still with us — for it is as a master that I always regard Winslow Homer — lives, I believe, in retirement on the coast of Maine. I read that in daily companionship with the ocean he has led for many years a solitary life upon a spit of coast near Scarborough. Goethe says somewhere that talent is nurtured in a crowd, genius in solitude. And I think it must be due to the solitude in which Winslow Homer has lived, surrounded by the elemental forces of nature, that he has produced in his big, comprehensive work something that seems to me entirely personal and entirely American. No one who

has studied his pictures can doubt that they are characteristically spiritually as well as physically American and that they could have been painted nowhere but in America. His finest picture, ' Cannon Rock,' is in the Metropolitan Museum, New York, but this exhibition included his powerful and realistic ' Gulf Stream' (also called ' The Castaway '), as vigorous in color as in design, a result of his visit to the West Indies; his marine, with the massive timbers of a wreck in the foreground, and his strong and simple 'Lookout-Man' sending his cry of 'All's Well' through the night. . . ."

The revelations of alleged rascality in regard to the counterfeiting and retouching of paintings by Homer Martin and George Inness at the time of the trial of the case of Evans *versus* Clausen in New York in 1910 made a painful impression on Winslow Homer, who had an almost morbid dread of something of the same sort happening to his own works. A New York collector who owned two of Homer's paintings wrote to him saying that they were in need of attention, and asking him if he would be willing to examine them and do whatever was necessary to them. He consented, and the pictures were sent to him at Prout's Neck. On examining them, he discovered that one of them had been retouched by some one. He was much displeased, naturally, and sent that picture back to the owner, telling him that it had been tampered with, and declining to touch it. The other picture, which had not been retouched, needed some slight care, and after attending to it, he returned it in good condition.

"Below Zero," painted in 1894, was exhibited at the National Academy of Design in 1910; and later in the same year it was exhibited at the Art Institute of Chicago. It belonged at that time to the collection of Mr. F. P. Moore of New York.

Mr. William Macbeth, the picture dealer, made a visit to Homer in the month of August, 1910, and gives this pleasant account of it : —

"I shall always cherish the memory of a very delightful day spent as the guest of the late Winslow Homer towards the end of August. What proved to be his last illness had already laid its grip upon him, but in spite of pain he insisted on giving himself to me, and together we roamed over his Prout's Neck possessions, with their many wonderful views far and near. He found an excuse for going to the farthest point in order to cut out some branches of shrubbery where insects were playing havoc on the grounds of one of his tenants. Girt with a leather belt, in which he carried a formidable pruning blade, he was well prepared for an even more serious fray. 'From this point I painted "The Fox Hunt," from over there "The Undertow," ' and so on, pointing to the scene of many a familiar canvas. Several times in years past he had allowed me to possess quite a number of his splendid charcoal drawings, and although I said not a word about business, he knew I was always greedy for more. So, after luncheon, when he had asked for time to put his inner sanctum to rights, he went over all his portfolios in a vain effort to find sketches he would care to have seen. 'No,' he said, after the last portfolio was closed, 'you have had them all.' There were a few unframed watercolors and perhaps a dozen others, framed and on his walls, that stirred and delighted me beyond measure. He told me of their expected destination, and I knew that he would never part with them during his lifetime. He knew that his work was over, and, indeed, he had voluntarily abandoned it years before. He was sufficiently discerning to realize that he could not keep up to his highest-water mark reached a few years ago, and he was de-

termined that no inferior work should survive him. So there will be no sketch or failure to be dragged out to hurt his memory. His artistic record was made long ago, and it adds a brilliant chapter to the annals of truly American art."

In 1909 I had written to Winslow Homer, enclosing a list of no less than fifty questions which I asked him to answer at his leisure. He despatched a short note acknowledging the receipt of my letter and promising to answer it soon ; but as he had not done so a year later, I wrote again in the summer of 1910, reminding him of his promise, and received the following, his last letter to me : —

SCARBORO, MAINE, *Aug.* 13, 1910.

No doubt, as you say, a man is known by his works. That I have heard at many a funeral. And no doubt in your thoughts [it] occurred to you in thinking of me. Others are thinking the same thing. One is the Mutual Life Insurance Co., in which I have an annuity. But I will beat you both.

I have all your letters, and will answer all your questions in time, *if you live long enough.*

In reply to your recent letter I will say that I was in Tynemouth in 1881 and 1882, and worked there.

Yours very truly,

WINSLOW HOMER.

To W. H. DOWNES.

In the light of subsequent events, the grim humor of the allusion to the insurance company and the would-be biographer, and the defiant prophecy, " I will beat you both," become tragic. Alas ! my questions were never answered.

CHAPTER XIX

HOMER'S DEATH

1910. Ætat. 74

The Last Sickness — Heart Failure — A Glorious Passing — The Funeral — Burial Place at Mount Auburn — His Will — The Memorial Exhibitions of 1911 in New York and Boston — The Verdict.

D URING the summer of 1910 Homer was unmistakably a sick man, but he was unwilling to give up. He appeared to resent inquiries after his health, and when his own people tried to do anything for him he persisted in the assertion that he was "all right," and needed no attention. He endured his pain in stoical silence, and uttered no complaint. His strength perceptibly though gradually failed, and the traces of physical and mental suffering became more palpable as the days passed, until at last there came a time when even his iron spirit succumbed to the strain, and he was forced to take to his bed and to submit to those ministrations which he never would have countenanced save in the extremity of his helplessness. His brothers believed that he would be more comfortable and could be better cared for in Arthur B. Homer's cottage than in his own, and preparations were made to move him there; but when he found that something of the sort was on the tapis he asked: "What are you going to do?" And when he was told of the plan, he said: "I will stay in my own house."

He stayed. There followed an anxious time; yet, presently, by slow degrees, the patient seemed to be gathering strength

again, and he looked forward to recovery, with something of his old optimism, speaking of his plans for the future, and of how he expected to enjoy the restoration of his impaired eyesight. He even planned the coming winter's journey to Florida with his elder brother, and the bass-fishing at Enterprise. As September drew towards its close, with the shortening days, he would chat cheerfully with his brothers, and review, in his half-serious and half-ironical tone, almost forgotten episodes of yore, and the adventures of the happy fishing-grounds. Even with these loved brothers of his he maintained a certain reticence, a reserve which was so much a part of his nature that he did not know how to overcome it. In these days they took hope; all appeared to be going on well. On September 17, his nephew Arthur P. Homer assured me that he was convalescent, and that he had sat up in bed and asked " how soon he was going to be allowed to have a drink and a smoke." It was thought that he could be taken up to West Townsend, Massachusetts, there to recuperate in the bracing air of the hills, at his elder brother's summer home, and arrangements had been partially made for a special car for his accommodation on the journey.

The real or apparent improvement continued up to the morning of September 29, when a sudden and alarming change took place, and it was evident that the end was near. He expired at half-past one o'clock in the afternoon of the same day, Thursday, the twenty-ninth day of September, at the age of seventy-four years, seven months, and five days.

All that love and devotion could possibly do for him had been done. All the resources of medical science and experience, the services of two excellent trained nurses, the constant and tender care of his nearest and dearest relations were his, night and day, to the end. Both of his brothers

were with him. The immediate cause of death was heart failure.[1]

An artist is so much more alive than most men, his ceasing to live seems almost like a violation of the natural order. He has a special right to live, to continue living, to reap the harvest of his hard-won experience. No one else can carry forward his work. His death is the end of it. And Homer had the wish to live. His vitality was strong. He had little or no experience of sickness. He could not realize that the end of life was at hand. As it was, he may be said to have died " in the harness." He passed away in the little studio at Prout's Neck, where he had so long and so fruitfully labored, and it was a most fitting place for him to die; it was like a soldier dying on the field of battle, with the flag waving over him, a glorious passing of the brave, indomitable spirit.

A laconic despatch sent out by the Associated Press from Portland apprised the American people that Winslow Homer was no more, and the news was received with unfeigned and universal sorrow from the Atlantic to the Pacific. The dominant note in all the hundreds of press tributes was the American quality in his art: that had become already so

[1] The following brief history of the case is from a letter written to me by B. F. Wentworth, M. D., Scarboro, Maine, under date of January 23, 1911: "I attended Winslow Homer during his last sickness. He came to my office with a history of indigestion, which had troubled him for some time, and two days later I was called to his cottage in the early morning, and found him nearly exhausted from the loss of blood; on close examination found he had had a rupture of a blood-vessel in the stomach and a profuse hemorrhage. This checked for a time, and then another hemorrhage; following the second attack, he had the loss of eyesight and delirium for several days; then his mind cleared, but his sight was lost. He made a gradual gain in strength, till he was able to sit up a very little; and suddenly, very much to our surprise, the heart grew very weak, and he died of collapse in a few hours."

EARLY MORNING AFTER STORM AT SEA

From the oil painting in the collection of Mr. W. K. Bixby, St. Louis

KISSING THE MOON; OR, SUNSET AND MOON-
RISE

From the oil painting in the collection of Dr. Lewis A.

widely recognized. It was proclaimed by many writers who, in all probability, had never seen any of his works in the originals.

The funeral took place at Mount Auburn Cemetery, Cambridge, Massachusetts, on Monday, October 3, at half-past two o'clock. It was a perfect October day. In the little red-stone Gothic chapel a brief service was conducted by the Reverend Stanley White of New York, a personal friend of the artist, in the presence of a small company. The coffin was covered with roses, some of them sent by the American Academy of Arts and Letters. There was no music and no eulogy. All was over in about fifteen minutes. Following the service, the body was cremated, in accordance with Winslow Homer's wishes, and the ashes were laid in the family lot.

This lot, No. 563, is on Lily Path, overlooking Consecration Dell. It is on one of the terraced sides of a rather steep little hill, such as abound in Mount Auburn, and it is a lovely spot in summer, as there are fine old trees, a pond, shrubbery, and flowers. The Homer lot is enclosed by a low red granite boundary mark, polished as to its upper surface, and in it are two simple markers of the same material, indicating the burial places of Winslow Homer's father and mother: "Charles S. Homer. 1809-1898." "Henrietta M. Homer. 1809-1884."

Winslow Homer's ashes have been laid alongside the grave of his mother, in the southeast corner of the lot. To reach the spot from the North Gate, one follows Central Avenue to the top of the first little rise, then, bearing to the left, Beech Avenue, Locust Avenue, and Poplar Avenue, to Lily Path. This is not far from the geographical centre of the cemetery.

Among all the celebrated Americans whose names are associated with this city of the dead, there are but few painters. Felix O. C. Darley, I think, is the only one of any note besides Winslow Homer. There are many great and good men buried here — statesmen, philanthropists, men of letters, churchmen, scientists — I recall the names of Lowell, Longfellow, Holmes, and Aldrich, of Agassiz, Gray, and Shaler, of Motley, Prescott, and Parkman, of Everett, Choate, and Sumner, of Channing and Brooks, of Story, Howe, Booth, Willis, and of that dear old friend of my childhood and yours, Jacob Abbott, the author of the Rollo books ; yes, and many more, an illustrious roll ; but I know of no better name than Winslow Homer.

It is well that his ashes should lie in this hallowed ground, so beautiful and sequestered, — close by the grave of his mother, who adored him, and in Cambridge, the home of his boyhood, where he learned to love the country, and where his great Mother Nature took him to her heart of hearts and taught him her secrets.

Winslow Homer's will, which was made in 1884, was filed for probate at Portland in October. By it all his real and personal estate was left unconditionally to his brother Charles S. Homer of New York. The will was handsomely engrossed on parchment, but this was not done by the artist himself, as was erroneously stated at the time. In his petition for appointment as executor Charles S. Homer certified that the value of the estate was not more than forty thousand dollars. There can be no doubt that Winslow Homer might have left a considerably larger fortune if he had not given away so much money. "There will be real tears shed among the fisherfolk of the little village of Prout's Neck, for they loved him as a brother," wrote the Portland correspondent

of the "Boston American," October 1, 1910; and he goes on to quote the simple, heartfelt benediction of the Scarboro postmaster when he heard of Homer's death : —

"He was a good man and a good citizen. If any man had a setback he was the first to help him. He was good to the poor. We shall miss him for a long time to come."

The truth and sincerity of this tribute are self-evident. Few eulogies, though couched in all the studied and resounding phrases of oratory and embellished by all the devices of rhetoric, could match in true eloquence these plain words. The memory of the just is blessed.

I hope that the laudable purpose of Charles S. Homer to keep the little Prout's Neck studio as a memorial, and to throw it open in the summer months to artists and art students who in future may make the pilgrimage to Scarboro, may be found feasible and may be carried out; and I venture also to express the hope that the generous project which he has under consideration, to offer to several of the leading art schools of America a certain number of Winslow Homer's studies and sketches, now in his possession as executor, may be met with the cordial welcome and encouragement which it deserves. Such sensible and unpretentious memorials as these are peculiarly appropriate, and would, no doubt, have been approved by the most modest of artists. It is pleasant to think that in the days to come there will be many a young American art student who will gladly avail himself of the privilege of visiting the Prout's Neck studio, and who in entering it will uncover his head in instinctive homage to Homer, remembering, as he well may, that the strong, silent, stern man who lived, worked, and died in this place dedicated all his great gifts to the service of truth.

The two cities associated with the artist's life, Boston and

New York, the one his birthplace, the other his home for a quarter of a century, vying in a generous rivalry to show their appreciation, made haste to do him honor in the winter of 1911, by the opening of memorial exhibitions in their respective art museums. These events took place simultaneously, the New York exhibition opening on Monday, February 6, in Gallery XX of the Metropolitan Museum of Art, and the Boston exhibition opening on the following day in the East Gallery of the Museum of Fine Arts. The two exhibitions did not conflict with each other, though it was commonly thought that they might have been consolidated to advantage. The New York exhibition contained so much the greater number of important works, especially in oil paintings, that the impression it gave was distinctly more weighty and imposing than that of its friendly rival in Boston. The New York exhibition had been more systematically prepared for and more carefully planned out by a special committee composed of officers of the Metropolitan Museum and representative artists and collectors. Of this committee Mr. John W. Alexander, president of the National Academy of Design, was chairman, and with him were associated Mr. Edward Robinson, director of the museum, Mr. Bryson Burroughs, curator of paintings, Mr. Charles S. Homer, the artist's brother, Mr. Daniel C. French, the sculptor, Mr. Roland F. Knoedler, the picture dealer, Mr. Charles W. Gould and Mr. George A. Hearn, the collectors, and eight painters, namely, Mr. Edwin H. Blashfield, Mr. William M. Chase, Mr. Kenyon Cox, Mr. Thomas W. Dewing, Mr. Samuel Isham, Mr. Will H. Low, Mr. F. D. Millet, and Mr. J. Alden Weir. From all the available material this distinguished and experienced body of men selected a small collection of fifty-two works, which admirably represented the achievement of the

artist, and, on the whole, satisfactorily illustrated the various periods and phases of his art. There was no attempt to make the collection complete, comprehensive, exhaustive; and probably this was wise. It was a choice group, and in the discrimination exercised by the committee the painter was more intelligently honored than he would have been by a larger, more miscellaneous exhibition, in which there must have been naturally some repetition, redundancy, and, possibly, an element of second-best, which would have been altogether repugnant to his own ideals.

A sufficient notion of his early work in oils was conveyed by "The Bright Side" of 1865, "Snap the Whip" of 1872, "The Visit from the Old Mistress" of 1876, and "The Camp Fire" of 1880. The general opinion in New York seemed to be that these early pictures were relatively meagre, and, in some cases, almost commonplace. A picture dealer of my acquaintance, standing in front of "Snap the Whip," shrugged his shoulders, and said it reminded him of Prang's chromo-lithographs. This is like casting contempt upon some good and beloved old melody because it has been played by the street hand-organs. On my pointing out some of the interesting and delightful things in the picture, my friend the dealer retorted, "Oh, you are prejudiced. Everything from Homer's hand looks fine to you." There was truth in this accusation: I had to admit the soft impeachment. But there are many who share my sentiment — and that it is a matter of sentiment I frankly confess also. Everything from the hand of a great artist has something of his mind and temperament in it. Mr. Huneker, in "The Sun," speaking of Homer's departure from New York and his settlement at Prout's Neck, expressed the view that to paint as he had been painting up to that time would have been artistic stag-

nation, if not artistic death. This is a hazardous guess as to what might have been ; but I do not believe anything of the kind. Of course Homer would never have been content to paint as he had been painting, but he was an original force in art from the first, and the germs of his mature masterworks were living in those despised early pictures.

Then followed, in chronological sequence, the "Early Evening," begun in Tynemouth in 1881 and completed and dated as late as 1907 in Scarboro ; the "Banks Fishermen" (or "The Herring Net") of 1885 ; " Undertow" and "Eight Bells" of 1886; "Coast in Winter" and "Sunlight on the Coast"of 1890 ; the glorious "West Wind" of 1891 ; the "Hound and Hunter" of 1892 ; "The Fox Hunt" and the "World's Columbian Exposition — the Fountain at Night" of 1893 ; "Moonlight, Wood Island Light" and "The Fisher Girl" of 1894; "Watching the Breakers: A High Sea," "Sunset, Saco Bay — The Coming Storm," and the famous "Maine Coast" of 1896; "The Gulf Stream" of 1899; "Kissing the Moon" of 1904; "Cape Trinity, Saguenay River, Moonlight" and "Right and Left" of 1909 ; and the unfinished picture of "Shooting the Rapids, Saguenay River" of 1910. These twenty-four oil paintings formed a fairly complete array of the representative works of forty-five years. One would have been glad to see a few others which were missing, such as the " Prisoners from the Front," which it was impossible to obtain at the time, " The Life Line," and three of the paintings in the Boston exhibition, — " The Fog Warning," "The Lookout — All 's Well," and " On a Lee Shore," — but, as it was, the showing was enough to give assurance of a man.

The oil paintings were supplemented by a magnificent collection of twenty-eight watercolors. The earliest of these were

the "Berry Pickers" and "Boys Wading" of 1873, charming in their precision of style. A very interesting period of work in this medium was represented by the "Shepherdess" and "Hillside" of 1878. From that phase of rustic and juvenile life we were led on to the transitional Tynemouth series of 1881 and 1882, which marked the beginning of a distinct development in our artist's career as a watercolorist. This prolific phase was exemplified by six dramatic works, which included "A Voice from the Cliffs," "Watching the Tempest," and "The Perils of the Sea." The watercolor collection culminated in the superb series of southern subjects from the Bahamas, Bermuda, Florida, and Key West, which Homer had retained for himself for some years in his Prout's Neck studio and which he considered his best work. From them the Metropolitan Museum of Art had made its choice of a dozen works for its permanent collection, an amazing group for splendor of tropical color, luminosity, and individuality. They are wonderful, these tropical scenes, perhaps the most wonderful things that Homer ever produced. For pure beauty of color and light they have never been surpassed, and it is hard to believe that they ever can be.

The twelve works acquired by the Metropolitan Museum are the "Natural Bridge, Nassau," "Palm Tree, Nassau," "Tornado, Bahamas," "A Wall, Nassau," "Bermuda," "Flower Garden and Bungalow," "Shore and Surf, Nassau," "The Bather," "Sloop, Bermuda," "The Pioneer," "Taking on Wet Provisions," and "Fishing Boats, Key West." Several of these are not dated, but those which bear dates are of 1898, 1899, 1900, and 1903; the similarity of style would go to show that all of the tropical scenes belong to this same period. The museum made an excellent selection, and Homer on his part manifested his customary sagacity in setting

aside these works for the permanent collection of the leading art institution in America. With the five oil paintings owned by the Metropolitan Museum, they form a splendid monument to his genius.

Drawing freely upon the substance of the descriptive notes in the catalogue of the memorial exhibition in New York, by permission of the Metropolitan Museum, I will briefly outline the design and character of these twelve watercolors. "The Natural Bridge, Nassau," depicts a ledge of white shale which extends across the foreground, with the blue sea beyond. In the foreground, at the left, is a natural arch in the rock, and at the right a soldier in a red uniform lies prone on the ground looking over a precipice. "Palm Tree, Nassau," represents a lofty cocoa palm bent by the wind, and several smaller palms beyond. In the background is a deep blue sea, a narrow strip of land, and a white light-house. "Tornado, Bahamas," shows a group of house-tops, above which rise cocoa palms swaying in the gale. At the left is a glimpse of dull green sea; heavy storm clouds fill the sky. "A Wall, Nassau" (1898), shows a white plastered wall with a gateway; bright scarlet flowers growing on the farther side, which look like poinsettias, show above the wall. The blue sea, with a sail-boat, may be seen in the distance. "Bermuda" (1899) is thus described in the catalogue: "On the white beach in the immediate foreground are three rusty cannons; deep blue sea beyond. A sail-boat, manned by two negroes, is near the shore, and several other vessels are farther out. In the distance is a line of brown shore." The "Flower Garden and Bungalow," painted in Bermuda in 1899, has red and yellow flowers and palm-trees in the foreground; a yellow bungalow with a white roof and chimney stands by the side of a blue bay, the shore of which is dotted at the right by white

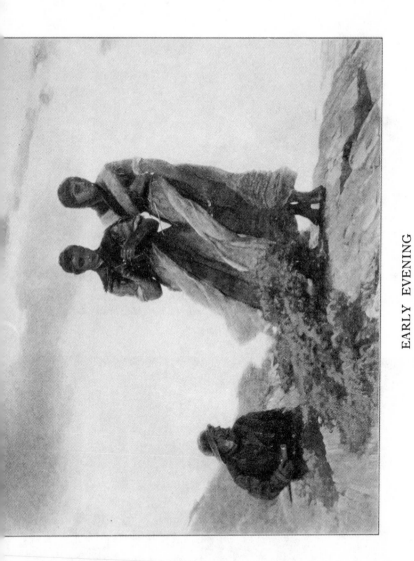

EARLY EVENING

From the oil painting in the collection of Mr. Charles L.
Freer, Detroit

DRIFTWOOD
*From the oil painting in the collection of Mr. Frank L.
Babbott, Brooklyn, N. Y.*

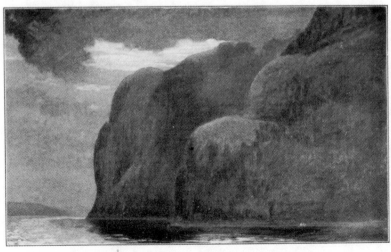

CAPE TRINITY, SAGUENAY RIVER
*From the oil painting in the collection of Mr. Burton
Mansfield, New Haven, Connecticut*

buildings. "Shore and Surf, Nassau" (1899), depicts a stony beach in the foreground, beyond which are green waves and surf and floating brown seaweed; at the left is a white lighthouse, and on the horizon, where the water is deep blue, is a large steamer. "The Bather," painted in Nassau in 1899, represents a negro standing waist-deep in the blue water. At the left, farther back, is another negro with his head and shoulders only showing above the water. On the shore in the distance at the right is a pavilion decorated with flags. "Sloop, Bermuda," is a picture of a white sloop seen from the stern, where a reddish row-boat is tied. The water is green and blue. Aboard the sloop are two negroes. The sails hang in wind-blown swirls. Clothes are hung out to dry on the boom. There is a small boat at the right, and a strip of brown shore at the horizon. "The Pioneer," the only Adirondacks motive in this group, has been described already. "Taking in Wet Provisions," painted at Key West in 1903, is one of the most brilliant of all the brilliant tropical scenes. A small boat is fastened near the bow of a schooner, and a keg is being hoisted on board by means of a block and tackle worked by a man in a red shirt near the foremast. A man in the small boat steadies the keg, and a third sailor is on the farther side of the schooner. The water is light blue-green, and in the distance, at the left, is a small sail-boat. "Fishing Boats, Key West" (1903), is another dazzling flood of southern sunlight. A white sloop with the name Lizzie painted on the side, near the bow, is in the foreground at the right. A sailor wearing a red shirt is seen on the deck. At the left is a part of another boat which casts a dark green reflection on the light blue-green water.

An excellent descriptive catalogue was prepared for the New York exhibition, which gave a brief account of the

artist's life, a list of his works in public collections, a bibliography, and an index. There were some slight errors in the biographical sketch, as, for instance, in the statement that after 1868 Homer "remained in New York only a short time, and during the rest of his life came to this city only for brief visits," which is rather wide of the mark in view of the fact that New York was his home for twenty-five years. The dates are incorrect in several instances. He was not sixteen, but nineteen, years of age when he was apprenticed to Bufford, the lithographer, in Boston; the years that he spent in England were 1881 and 1882; and, finally, it was in 1884, not in 1890, that he settled in Scarboro. These lapses are matters of no very great consequence; on the other hand this catalogue is the first specimen of Homeriana to give the correct date of the first exhibition of "Prisoners from the Front"—1866.

The most elaborate and thoughtful review of the exhibition was that written for the "Evening Post" of March 4 by Frank Jewett Mather, Junior. This critic professed great admiration for Homer's work, but found the "absence of formulas" in his art baffling. It seemed to him impossible that "so many fine works by one hand should be so discordant." Homer "faces nature with a kind of ruthless impersonality." He "repels while he attracts," is "distinguished in virtue of a magnificent commonness and a wilfully prosaic probity." If he bulks large to-day, it is because of "the debilitated estate of American painting during his lifetime." He "seems to have had but little music in his soul, but he had a blunt and forceful way of saying what he meant." A more fortunate age, that has arrived at what Mr. Mather calls vital formulas, "may perhaps find his work a shade anarchical, brusque, and incomplete." In a word, strong and original as he was, Mr.

Mather longs to have him something different. There is much
that is interesting and suggestive in his review, but the note
of personal sympathy with the work is wanting. On the
whole, in spite of some expressions of admiration which seem
to have been extorted from the writer in spite of himself, his
article leaves the impression of a peculiar lack of the inti-
mate understanding that can only be attained through sheer
love and enthusiasm. It is a case of —

> I do not love thee, Doctor Fell.
> The reason why I cannot tell;
> But this alone I know full well,
> I do not love thee, Doctor Fell.

It is now time to turn to the Boston memorial exhibition.
This offered an interesting contrast to the New York ex-
hibition, in that watercolors predominated in numbers. Out of
the total of seventy works, eight were oil paintings, ten were
drawings, and fifty-two were watercolors. All the loans came
from Boston and its vicinity. The Rhode Island School of
Design, Providence, lent its masterpiece, "On a Lee Shore,"
which was given the place of honor on the north wall. With
this, the other oil paintings were "The Fog Warning" and
"The Lookout — All's Well," belonging to the permanent
collection of the Museum of Fine Arts; the "Flight of Wild
Geese," belonging to Mrs. Roland C. Lincoln; the "Hunts-
man and Dogs," belonging to Mrs. Bancel La Farge; the
"Zouaves Pitching Quoits," belonging to Mr. Frederic H.
Curtiss; "Mount Washington," belonging to Mrs. W. H. S.
Pearce; and a small study of a young girl, belonging to Mr.
Arthur B. Homer. The array of fifty-odd watercolors com-
prised good examples of all periods and of all the geogra-
phical phases of the painter's activities, from his pictures of
children and negroes of the seventies, his Gloucester series

of 1880, the Tynemouth series of 1881 and 1882, the Bahamas and Santiago de Cuba series of 1885 and later, and the Adirondacks and Canadian subjects of recent years, with a few marine pieces from Prout's Neck. There was no catalogue, and in the appendix I give a list of the titles and names of owners compiled by myself as a matter of record. The prodigious ease and simplicity of the artist's watercolor method, the blended delicacy and strength of his style, its sturdy individuality and distinction, the extraordinary carrying power of his well-defined masses and planes, with those constantly recurring felicities of the most unexpected character which form such a fascinating subject for study, were more than ever manifest in this collection. In this elusive medium he was perfectly at home and expressed himself with stimulating directness and pungency. Prior to the Tynemouth watercolors the dominant note is of an exquisite delicacy of detail, but after that the manner gradually broadens and becomes more emphatic, sweeping, and dramatic, until in the Adirondacks and Province of Quebec subjects of the nineties and later we mark the full development of that rapid, bold, loose, and authoritative style in which the essentials of the subject are, as it were, flung upon the paper with all the abandon and freedom of a complete master of the art, sure of himself, and exulting in his strength, unequaled and alone in the capacity of forcible and succinct expression.

The collection revealed the immense variety and scope of his subject-matter. The "Children Wading at Gloucester," "Girl with Letter," "Going Berrying," "Children and Sailboat," "The Green Dory," "Sailing Dories," and the two little figure subjects of 1878, matched in charm and naïveté the Houghton Farm and Gloucester watercolors of Mrs.

Lawson Valentine's collection in the New York exhibition. In the "Wreck off the English Coast" of 1881, which showed the Tynemouth life-saving crew going to the rescue of the crew of the ship Iron Crown, October 25, 1881 (one of the least meritorious of his marine pieces), we saw the dawning inspiration of the long suite of finely conceived and highly dramatic shipwreck themes of that period, which was also illustrated by the "Fisherwomen, English Coast," "An Afterglow," "Storm on the English Coast," "Three Fishermen and Girl," "Fishermen's Wives," and the "Mouth of the Tyne." The beauty and romance of the tropics, as shown in the Nassau and South Coast of Cuba motives, were richly set forth in "The Road in Nassau," the "Spanish Club" in Santiago, "Street in Santiago de Cuba," "Diver, Nassau," and "Government Building." The grave and melancholy nobility of the northern forests and mountains and streams and the wild rush of the torrents and rapids were pictured in a great series of wilderness compositions, among which I need mention only the "Shooting Rapids," "Canoes in Rapids," "Wild Ducks," "Fishing," "The Portage," "Indian Camp," "Three Men in a Canoe," "Guide," "Men in Canoe," "Adirondacks," etc.

"In these later watercolors," wrote Mr. A. J. Philpott, in the Boston "Globe," February 13, 1911, "there is none of the restraint or indecision which this medium so often imposes on the artist. He was superior to all technical difficulties in these sketches. They are the work of a master." The same writer pointed out that Homer was able to synthesize as no other man in his day "the best picturesque feeling in the American people — the large things in which life and nature met and which appealed to the imagination." A pretty touch was that in Mr. Philpott's comment on the black-and-

white drawings in this collection: "There is a little sketch here of Gloucester harbor in pencil outline with the high lights on sails, water, foreground, and sky in Chinese white. It is a simple little sketch, yet full of suggestion. . . . The three boys in the foreground, lying at full length on the grass, kicking up their bare heels and looking out on the scene, give this sketch just that human, that imaginative touch that Homer always seemed to regard as vital to the impression he wished to convey. He is looking on that moving panorama of fishing schooners going to and coming from the Banks through the eyes, the thoughts, and the imagination of those three boys."

In delivering an informal address in the gallery, on Sunday afternoon, February 19, 1911, Mr. Albert H. Munsell said: —

"In attempting an appreciation of Homer's masterly art, first place should be given to its broad human message, rather than its technique, which is unsophisticated and almost brutal, yet never obscures the genuineness of his expression. Technique is an external quality, and may be rough or smooth; the drawing may be academic or clumsy, the color grim or suave, yet if it conveys a direct message from one human being to another, and leaves the impression of nature, its work is complete. The sense of nature breathes through Homer's art. Whether it takes us to the camps of the Civil War or those of the hunter in Canada and the Adirondacks, whether he shows the fishermen of Tynemouth in old England or those of Gloucester in the New, or in the later sunlit waters of the West Indies, so fully does he impart his enthusiasm for nature that we seem to be with him on the spot.

"Large art is the expression of large conceptions. It does not appeal to a single class or mental attitude, like the recent

RUM CAY, BERMUDA

*From the watercolor in the permanent collection of the
Worcester Art Museum. Copyright, Detroit Publishing
Company*

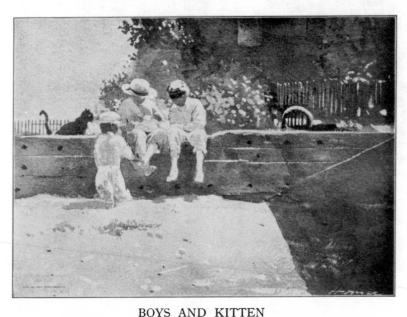

BOYS AND KITTEN

*From the watercolor in the permanent collection of the
Worcester Art Museum. Copyright, Detroit Publishing
Company*

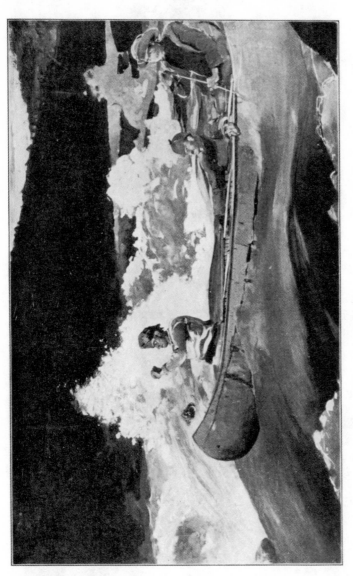

SHOOTING THE RAPIDS, SAGUENAY RIVER

From the unfinished oil painting, given to the Metropolitan Museum of Art, New York, by Mr. Charles S. Homer, in 1911

wail of art for art's sake. It plunges deeper, to fundamental feelings and broad human interests. Homer is not to be classed with any school or group. He is a distinct personality, and his design often rises to a sculpturesque, almost monumental impression. His 'Lookout — All's Well,' 'Eight Bells,' 'The Fog Warning,' and 'A Voice from the Cliffs' could be rendered in bronze, instead of in paint, and still move us profoundly.

" La Farge's caustic remark that America has more painters than artists does not hurt such work; it rather emphasizes its value, for although Homer's earlier paintings were not coloristic, they possessed large qualities of design, and his later canvases are full of beautiful color. One cannot dismiss such pictures with a casual glance. They grasp the attention, stimulate thought, and leave an indelible image. Thirty years ago, as a student, I saw his 'Wreck,' 'Voice from the Cliff,' and 'Fox Hunt.' To-day I can see where they hung in the Park Street gallery, even with eyes shut, so deep and complete was the impression. The public is debtor to the Museum of Fine Arts, which has gathered so many examples from private collections, where only a few were privileged to see them. Such works of contemporary genius deserve the same sincere and prolonged study which we willingly give to masterpieces of music or literature, but rarely accord to modern works in painting and sculpture."

With his life-work spread before us like an open book, it is now possible to form some estimate of the distinguishing characteristics of that *œuvre*, to attempt the formulation of a verdict, and to assign a just place in the history of painting in America to this unique personality. In looking back to Homer's boyhood, we must remember that he started out upon his career as a painter with unusually definite convic-

tions as to his policy. It is a remarkable circumstance that he should have thought out a plan of campaign at the age when most boys are drifting along, coming first under this and then under that influence. "I am going to be a painter," he said; "and if you are going to be a painter, it is best not to look at pictures." Allowing for the exaggeration and bravado of youth, this line of policy, in a large general way, thus early determined, constituted his declaration of independence, and was a sincere expression of strong personal conviction and of temperamental bias. We know what it led to; we know in what an uncommon degree it was adhered to throughout a long career; and artists will realize how much of courage, patience, will power, and hard work it implied.

The way could have been made far easier, under different conditions, but it will always be an open question whether, in Homer's case, a rigorous course of academic training, which would have saved him so many difficulties, would have been to the advantage of an artist constituted as he was, or, on the other hand, whether it would not have in some measure taken away from his work the virgin quality of fresh and individual perception, offering the inadequate compensation of a smoother, more fluent, more sophisticated style. Such speculations would lead us too far afield, involving as they do the whole great question of the value of art instruction as it is given in the schools. For good or ill, he made his own choice, and that it was a wise one, for him, cannot be doubted. He justified it time and again triumphantly and conclusively.

This does not mean that he was a faultless painter; on the contrary, he had many faults; and he was fully aware of all his shortcomings; he was his own severest critic. There are

no perfect painters, and, if there were such, we would not like them. But the criticism that counts takes note of positive, affirmative qualities, and, while not ignoring defects, strikes the balance in favor of the creative and original. Homer created his conceptions, coined his own metal. His style was the style of a man having something to say, and, argue as we may about what constitutes style, that is the best which contains the most meaning, sentiment, and poetry. Technique is a beautiful and desirable thing; it is sacred, if you will, in the sense that good workmanship is sacred, but where are you going to draw the line, and say, Here technique ends and the artist's soul begins to speak? We cannot thus dissect the work of art, for it is a living thing. And, again, shall we say that there is a standard of technique to which the work of a painter, for instance, must measure up? Who sets that standard? All this hair-splitting is idle, and it has nothing to say to real art. That leaps over barriers, and finds its own means of expression as it may. It is a direct, personal, unambiguous, recognizable message, a confession of faith, a revelation, which, originating in a strong emotion, and delivered with travail, comes straight to our minds and hearts, a communication of one man to another, which can and does stretch out a hand of brotherhood across the long ages.

There are generations yet unborn in America who will receive Winslow Homer's message with joy and gratitude. He kept his nature unspoiled, simple, open, and sensitive to the call of nature and life. He held holy that something in himself which echoed the voice of the ocean, the forest, the mountain, and responded with such perfect harmony and sympathy to the stern, sad, noble beauty of the North, and the sensuous romance and splendor of the South. He excluded

much from his life that most men cherish, that he might devote himself with utter singleness of purpose to his vocation. In all the history of art you will find no man — no, not even Rembrandt himself, the supreme pictorial artist — more self-respecting. I speak reverently of this trait, for on it is based the dignity and nobility of his art.

From my boyhood I have loved his pictures, the least of them, — a drawing in a little book, a slight affair, perhaps a sail-boat with a group of boys and girls aboard, but so full of a good, sound, expressive naturalism, that one said, "What a jolly thing it is to sail a boat!" — and from that day to the time of "The Lookout — All's Well," with its inscrutable, mystic suggestion of all the wonders of the life of the seaman, and its still more mysterious hint of the wonders of life itself, the solitary figure of Winslow Homer has loomed up in my imagination with a strange persistency and a singular, commanding impressiveness. In him, more than in any other American painter, dwelt that racy, native, pungent, Yankee note which seemed to me beyond all price. The things that he painted interested me; the way that he painted them suited me; the way that things looked to him was the way that they looked to me; I felt that I understood him; and I rashly resolved that I would make a book about him. How he repelled my advances we have seen; it was not done in an unkind spirit; I believe he was wholly honest when he said that he thought such a thing would kill him. Nevertheless, being overmuch persuaded, he finally promised to answer all my questions, if I lived long enough; and when he died one of my letters containing fifty questions was on his desk awaiting the responses which never were to come.

What the influence of his life and work upon the coming generation of American painters is to be, is a difficult ques-

tion, which it is yet too early to settle. An artist of his kind founds no school, and is likely to have few followers. If his example is valued, as it should be, it will simply lead to the cultivation of a more and more intense individualism. Whether this is good or not depends entirely upon the man. Homer's policy would be suicidal for the vast majority. Left to their own devices, they would go to pieces in short order. They must have somebody to lean upon; they are those who require the "artistic atmosphere." There will be, however, from time to time, exceptional men, who have a real vocation, and these men may subject themselves to the test, and try to stand alone. He who attempts such a great adventure must be very sure of his calling; must be ready to "scorn delights and live laborious days." To daring souls, eager to measure their strength against all the forces of the world, the example of Homer will always be an inspiration.

In other walks of life than that of the painter it may well be that such an extreme development of individualism as his would be regarded as deplorable. But in the art of painting a man cannot make a more valuable contribution to the civilization of his time than by creating his own traditions and making the best of his own talents. What we want in painting is not a school; we want men; and the problem for the painter is not to fit himself comfortably into the social order, but to cultivate narrowly his personal creative capacity. It has happened before now that in order to do this a man has found it necessary to exclude from his scheme of existence most of the items that go to the making of the average man's life.

APPENDIX

APPENDIX

APPENDIX

THE chronology of many of Winslow Homer's oil paintings and watercolors offers some difficulty to the cataloguer. Some of his works are not dated. Others have been exhibited and catalogued at various times and places under different titles. Some of his watercolors either have no titles, or the titles have been forgot by the owners, so that, in the Boston Memorial Exhibition of 1911, some of the titles had to be extemporized for the occasion. The subjoined lists of the works exhibited in many exhibitions in New York, Philadelphia, Pittsburg, and Boston — including all the exhibitions of the National Academy of Design, from 1863 to 1910, in which any of his works were shown, all the exhibitions of the American Watercolor Society in which he was represented, and the Memorial Exhibitions of 1911 in New York and Boston — contain a very large majority of the entire *œuvre* of the artist, since there are but very few of his works in either medium which did not find their way into some one of these exhibitions. The dates are believed to be in most cases correct, but, as it has been necessary in some instances to rely upon circumstantial evidence, their exactitude cannot be guaranteed. In the lists of works exhibited in the National Academy of Design, the American Watercolor Society, the Society of American Artists, and the Pennsylvania Academy of the Fine Arts, the dates given are those of the exhibitions. In the lists of the Clarke collection, the loan exhibition at the Carnegie Institute at Pittsburg in 1908, and the New York and Boston Memorial Exhibitions of 1911, the dates given are those of the works themselves.

LIST OF PICTURES BY WINSLOW HOMER EXHIBITED IN THE EXHIBITIONS OF THE NATIONAL ACADEMY OF DESIGN, NEW YORK, FROM 1863 TO 1910

DATE TITLE

1863. The Last Goose at Yorktown.
 Home, Sweet Home.
1864. In front of the Guard-house.
 The Briarwood Pipe.
1865. The Bright Side.
 Pitching Quoits.
 The Initials.
1866. The Brush Harrow.
 Prisoners from the Front.
1867. A Study.
 Confederate Prisoners at the Front. (Johnston Collection.)
1868. Picardie.
 The Studio.
1869. The Manchester Coast.
 Low Tide.
1870. White Mountain Wagon.
 Sketch from Nature.
 Mt. Adams.
 Sail-boat.
 Salem Harbor.
 Lobster Cove.
 As You Like It.
 Sawkill River, Pa.
 Eagle Head, Manchester.
 The White Mountains.
 Manners and Customs at the Seaside.
1872. The Mill.
 The Country School.

APPENDIX

DATE TITLE

1872. Crossing the Pasture.
Rainy Day in Camp.
Country Store.
1874. School Time.
Girl.
Sunday Morning.
Dad's Coming.
1875. Landscape.
Milking Time.
Course of True Love.
Uncle Ned at Home.
1876. The Old Boat.
Cattle Piece.
Over the Hills.
A Fair Wind.
Foraging.
1877. Answering the Horn.
Landscape.
1878. The Watermelon Boys.
The Two Guides.
In the Fields.
Morning.
Shall I Tell Your Fortune?
A Fresh Morning.
1879. Upland Cotton.
Sundown.
The Shepherdess of Houghton Farm.
1880. Summer.
Visit from the Old Mistress.
Camp Fire.
Sunday Morning.
1883. The Coming Away of the Gale.
1884. The Life Line.
1885. The Herring Net (or, Banks Fishermen).
1886. Lost on the Grand Banks.

DATE TITLE

1887. Undertow.

1888. Eight Bells.

1906. The Gulf Stream.

1908. The West Wind.
 Hound and Hunter.

1910. Below Zero. (Spring Exhibition.)
 Weather-beaten.
 Camp Fire.
 Sunset, Saco Bay, the Coming Storm.
 High Cliff, Coast of Maine.
 The West Wind.

} Exhibited *in memoriam* at the Winter Exhibition

LIST OF WATERCOLORS BY WINSLOW HOMER EXHIBITED AT THE EXHIBITIONS OF THE AMERICAN WATERCOLOR SOCIETY, NEW YORK, FROM 1867 TO 1909

DATE TITLE

1867. Study

1870. Long Branch.

1875. A Lazy Day.
 The Changing Basket.
 What Is It?
 A Pot Fisherman.
 A Fisherman's Daughter.
 On the Fence.
 Fly Fishing.
 A Sick Chicken.
 A Basket of Clams.
 Skirting the Wheat.
 How Many Eggs?
 An Oil Prince.
 On the Sands.

DATE TITLE

1875. Green Apples.
A Clam Bake.
Why don't the Suckers Bite?
Pull Him In!
Cow Boys.
The Bazaar Book of Decorum.
Good Morning.
A Farm Team.
Another Girl.
The "Thaddeus of Warsaw."
The City of Gloucester.
Adirondacks Guides.
Seven Sketches in Black-and-White.

1876. After the Bath.
A Chimney Corner.
The Busy Bee.
A Penny for Your Thoughts.
The Gardener's Daughter.
A Flower for the Teacher.
Contraband.
Poor Luck.
A Fish Story.
Fiction.
Furling the Jib.
Study.
Too Thoughtful for Her Years.
A Glimpse from a Railroad Train.

1877. Book.
Blackboard.
Rattlesnake.
Lemon.
Backgammon.

1879. Husking.
Fresh Air.
Oak Trees with Girl.

DATE TITLE

1879. Chestnut Tree.
 Sketch.
 On the Fence.
 Girl in a Wind.
 Watching Sheep.
 Sketch from Nature.
 In the Orchard.
 Girl on a Garden Seat.
 On the Hill.
 The Strawberry Field.
 Girl and Boy.
 Old House.
 A Rainy Day.
 October.
 Oak Trees.
 Corn.
 Girl, Sheep, and Basket.
 Girl and Boat.
 Willows.
 Girl with Half a Rake.
 Girl, Boat, and Boy.

1881. Gloucester, Mass.
 Winding the Clock. (Lent by Gen. F. W. Palfrey.)
 Something Good About This !
 Girl Reading.
 Watercolor.
 Clover.
 Girl.
 Eastern Point Light.
 Sunset.
 Coasters at Anchor.
 July Morning.
 Gloucester Boys.
 Watercolor.
 A Lively Time.

1881. Bad Weather.
 Early Morning.
 Sunset.
 Schooners at Anchor.
 Ozone.
 Field Point, Greenwich, Conn.
 Three Boys.
 The Yacht Hope.
 Fishing Boats at Anchor.

1883. Tynemouth.
 A Voice from the Cliff.
 Inside the Bar.
 The Incoming Tide.

1884. The Ship's Boat.
 Scotch Mist.

1887. Sketch in Key West. (Lent by C. S. Homer.)
 Sketch in Florida. (Lent by C. S. Homer.)

1888. Tampa.
 " For to be a Farmer's Boy."
 Florida.
 A Norther, Key West.
 Sand and Sky.
 Eels.

1891. Mending Nets.

1905. Pulling in the Anchor.

1906. The Turkey Buzzard.
 Black Bass, Florida.
 Taking on Provisions.

1909. By the North Sea.
 Five Drawings.

LIST OF OIL PAINTINGS BY WINSLOW HOMER EXHIBITED AT THE EXHIBITIONS OF THE PENNSYLVANIA ACADEMY OF THE FINE ARTS, PHILADELPHIA, FROM 1888 TO 1910

DATE	TITLE	REMARKS
1888–1889.	Undertow.	
1893–1894.	The Fox Hunt.	
	On the Lake.	
	Just Caught.	
	Afternoon.	
1895–1896.	Northeaster.	
	Moonlight, Wood Island Light.	} *Lent by Thomas B. Clarke*
	Storm-Beaten.	
1896–1897.	Sunset, Saco Bay, the Coming Storm.	
1899–1900.	The Gulf Stream.	
	High Seas.	} *Lent by Col. George C. Briggs*
1900–1901.	The Signal of Distress.	
1901–1902.	Northeaster.	*Lent by George A. Hearn*
	Flight of Wild Geese.	*Lent by Mrs. R. C. Lincoln*
1902–1903.	Eastern Point.	
	The Unruly Calf.	
1903–1904.	Early Morning, Coast of Maine.	
	Eight Bells.	*Lent by E. T. Stotesbury*
1905–1906.	Kissing the Moon.	
1906–1907.	Long Branch.	*Lent by R. W. Vonnoh*
	Bermuda. (Watercolor.)	*Lent by Dr. George Woodward*
1907–1908.	High Cliff, Coast of Maine.	*Lent by William T. Evans*
1908–1909.	Searchlight, Harbor Entrance, Santiago de Cuba.	
1909–1910.	Early Evening.	*Lent by Charles L. Freer*
1910–1911.	Right and Left.	

LIST OF WORKS EXHIBITED BY WINSLOW HOMER IN THE EXHIBITIONS OF THE SOCIETY OF AMERICAN ARTISTS, NEW YORK, FROM 1897 TO 1903

DATE TITLE

1897. Marine — Coast.
 The Lookout — All 's Well, Lights All Up.
 Saco Bay.
1900. High Seas.
1901. West Point, Prout's Neck, Maine.
 Eastern Point.
1902. Northeaster.
1903. Early Morning.
 Cannon Rock.

LIST OF OIL PAINTINGS AND WATER-COLORS BY WINSLOW HOMER IN THE COLLECTION OF MR. THOMAS B. CLARKE OF NEW YORK

[NOTE. — Mr. Clarke's collection was sold at auction, February 14, 15, 16, and 17, 1899. In this list the dates, when available, and the names of the purchasers are given. Many of the works have changed hands since 1899.]

Oil Paintings

DATE	TITLE	BUYER
1863.	Rations.	*E. H. Bernheimer*
1865.	The Bright Side.	*S. P. Avery, Jr.*
1876.	The Visit from the Old Mistress.	*M. H. Lehman*
	The Two Guides.	*C. J. Blair*
1877.	The Carnival.	*N. C. Matthews*

DATE	TITLE	BUYER
1880.	Camp Fire.	*Alexander Harrison*
1882?	To the Rescue.	*T. L. Manson, Jr.*
1884.	The Life Line.	*G. W. Elkins*
1885.	The Market Scene.	*R. A. Thompson*
1886.	Eight Bells.	*Herman Schaus*
1891.	The West Wind.	*Samuel Untermyer*
1892.	Coast in Winter.	*C. J. Blair*
1893.	The Gale.	*T. Harsen Rhoades*
1894.	Moonlight, Wood Island Light.	*Boussod, Valadon & Co.*
1896.	Maine Coast.	*F. A. Bell*
	The Lookout — All's Well.	*Museum of Fine Arts, Boston*

Watercolors

DATE	TITLE	BUYER
1874.	In the Garden.	*F. Rockefeller*
1881.	Watching the Tempest.	*Burton Mansfield*
	Perils of the Sea.	*A. C. Humphreys*
1883.	The Breakwater.	*Emerson McMillin*
1885.	The Buccaneers.	*E. D. Page*
1886.	Under a Palm Tree.	*F. Rockefeller*
1887.	Danger.	*H. Sampson*
	Sea on the Bar.	*W. S. Rainsford*
1890.	Rowing Homeward.	*Charles L. Freer*
1891.	On the Cliffs.	*Thomas L. Manson, Jr.*
1892.	Canoeing in the Adirondacks.	*Thomas L. Manson, Jr.*
	Fodder.	*J. B. Mabon*
	Rise to a Fly.	*D. A. Davis*
	An Unexpected Catch.	*F. Rockefeller*
	Leaping Trout.	*Museum of Fine Arts, Boston*

LIST OF WORKS IN THE LOAN EXHIBITION OF OIL PAINTINGS BY WINSLOW HOMER HELD AT THE CARNEGIE INSTITUTE, PITTSBURG, PENNSYLVANIA, IN MAY AND JUNE, 1908

DATE	TITLE	OWNER
1885.	Banks Fishermen.	*Charles W. Gould*
	The Fog Warning.	*Museum of Fine Arts, Boston*
1887.	Hark, the Lark!	*Layton Art Gallery, Milwaukee*
	Undertow.	*Edward D. Adams*
1891.	Huntsman and Dogs.	*Mrs. Bancel La Farge*
1892.	Hound and Hunter.	*Louis Ettlinger*
1893.	The Gale.	*Mrs. B. Ogden Chisolm*
	The Fox Hunt.	*Pennsylvania Academy*
1894.	The Fisher Girl.	*Burton Mansfield*
	High Cliff, Coast of Maine.	*National Gallery of Art*
1895.	Cannon Rock.	*Metropolitan Museum*
1896.	The Lookout — All's Well.	*Museum of Fine Arts, Boston*
	Sunset, Saco Bay, The Coming Storm.	*Lotos Club*
	Maine Coast.	*C. J. Blair*
	The Two Guides.	*C. J. Blair*
	The Wreck.	*Carnegie Institute*
1897.	Flight of Wild Geese.	*Mrs. R. C. Lincoln*
	A Light on the Sea.	*Corcoran Gallery of Art*
1899.	The Gulf Stream.	*Metropolitan Museum*
	Searchlight, Harbor Entrance, Santiago de Cuba.	*Metropolitan Museum*
1900.	On a Lee Shore.	*Rhode Island School of Design*
1907.	Early Evening.	*Charles L. Freer*

LIST OF WORKS IN THE WINSLOW HOMER MEMORIAL EXHIBITION HELD IN THE METROPOLITAN MUSEUM OF ART, NEW YORK, FEBRUARY 6 TO MARCH 19, 1911

Oil Paintings

DATE	TITLE	OWNER
1865.	The Bright Side.	*W. A. White*
1872.	Snapping the Whip.	*Richard H. Ewart*
1876.	The Visit from the Old Mistress.	*National Gallery of Art*
1880.	Camp Fire.	*H. K. Pomroy*
1881–1907.	Early Evening.	*Charles L. Freer*

("Painted in 1881 — Cut down from large picture and put in present shape December, 1907.")

1885.	Banks Fishermen (or, The Herring Net).	*Charles W. Gould*
1886.	Undertow.	*Edward D. Adams*
	Eight Bells.	*Edward T. Stotesbury*
1890.	Coast in Winter.	*John G. Johnson*
	Sunlight on the Coast.	*John G. Johnson*
1891.	West Wind.	*Samuel Untermeyer*
1892.	Hound and Hunter.	*Louis Ettlinger*
1893.	The Fox Hunt.	*Pennsylvania Academy*
	World's Columbian Exposition — The Fountain at Night.	
		C. S. Homer
1894.	Moonlight, Wood Island Light.	*George A. Hearn*
	The Fisher Girl.	*Burton Mansfield*
1896.	Watching the Breakers: A High Sea.	*Mrs. H. W. Rogers*
	Sunset, Saco Bay, the Coming Storm.	*The Lotos Club*
	Maine Coast.	*George A. Hearn*
1904.	Sunset and Moonrise (or, Kissing the Moon).	*Lewis A. Stimson*
1909.	Cape Trinity, Saguenay River, Moonlight.	*Burton Mansfield*
	Right and Left.	*Randal Morgan*
1910.	Shooting the Rapids, Saguenay River (Unfinished).	
		Charles S. Homer

Watercolors

DATE	TITLE	OWNER
1873.	Berry Pickers.	*Mrs. Lawson Valentine*
	Boys Wading.	*Mrs. Lawson Valentine*
1878.	Shepherdess.	*Mrs. Lawson Valentine*
	Hillside.	*Mrs. Lawson Valentine*
1881.	On the Beach, Tynemouth.	*Charles S. Homer*
	Peril of the Sea.	*Alexander C. Humphreys*
	Watching the Tempest.	*Burton Mansfield*
1882.	Fishwives.	*Charles S. Homer*
	Fishing Boats off Scarborough.	*Alexander W. Drake*
1883.	A Voice from the Cliffs.	*Alexander W. Drake*
1889.	Trout.	*Charles S. Homer*
1890.	Salt Kettle.	*Charles S. Homer*
	St. John's River, Florida.	*Charles S. Homer*
1892.	Sketch for Hound and Hunter.	*Charles S. Homer*
1898.	Turtle Pound.	*Hamilton Field*
	Natural Bridge, Nassau.	*Metropolitan Museum*
	Palm Tree, Nassau.	*Metropolitan Museum*
	Tornado, Bahamas.	*Metropolitan Museum*
	A Wall, Nassau.	*Metropolitan Museum*
1899.	Bermuda.	*Metropolitan Museum*
	Flower Garden and Bungalow.	*Metropolitan Museum*
	Shore and Surf, Nassau.	*Metropolitan Museum*
	The Bather.	*Metropolitan Museum*
	Sloop, Bermuda.	*Metropolitan Museum*
1900.	The Pioneer.	*Metropolitan Museum*
1903.	Taking on Wet Provisions.	*Metropolitan Museum*
	Fishing Boats, Key West.	*Metropolitan Museum*
1904.	Homosassa, Florida.	*Charles S. Homer*

LIST OF WORKS IN THE WINSLOW HOMER MEMORIAL EXHIBITION HELD IN THE MUSEUM OF FINE ARTS, BOSTON, FEBRUARY 7 TO MARCH 1, 1911

Oil Paintings

DATE	TITLE	OWNER
1865.	Zouaves Pitching Quoits.	Frederic H. Curtiss
1869.	Mount Washington.	Mrs. W. H. S. Pearce
	Study.	Arthur B. Homer
1885.	The Fog Warning.	Museum of Fine Arts
1891.	Huntsman and Dogs.	Mrs. Bancel La Farge
1896.	The Lookout — All's Well.	Museum of Fine Arts
1897.	Flight of Wild Geese.	Mrs. Roland C. Lincoln
1900.	On a Lee Shore.	Rhode Island School of Design

Watercolors

DATE	TITLE	OWNER
1878.	On the Fence.	William H. Downes
	Sketch.	Henry Sayles
1879.	Girl with Letter.	Edward Hooper estate
	Going Berrying.	Horace D. Chapin
1880.	Children Wading at Gloucester.	Edward Hooper estate
	Children and Sail-boat.	Mrs. Greely S. Curtis
	Sailing Dories.	Edward Hooper estate
	The Green Dory.	Dr. Arthur T. Cabot
	Gloucester Harbor.	Edward Hooper estate
1881.	Wreck off the English Coast.	Edward Hooper Estate
	Three Fishermen and Girl.	John T. Morse, Jr.
	Fishermen's Wives.	John T. Morse, Jr.
	Mouth of the Tyne, England	Arthur B. Homer
	Fisherwomen, English Coast.	Edward Hooper estate
1882.	Tynemouth Boats.	Grenville H. Norcross
	An After-glow.	William P. Blake

DATE	TITLE	OWNER
1882.	The Dunes.	Mrs. Samuel Cabot
1883.	Scotch Fishwomen.	Museum of Fine Arts
	Returning Fishing Boat.	Horace D. Chapin
	Storm on the English Coast.	Roger Warner
	(Painted at Flamborough Head.)	
	Landscape and Lake.	Arthur B. Homer
1885.	Bahamas.	Edward Hooper estate
1885?	The Road in Nassau.	William P. Blake
	Diver, Nassau.	Mrs. Greely S. Curtis
	Spanish Club, Santiago de Cuba.	Mrs. C. A. Coolidge
	Street in Santiago de Cuba	Mrs. Robert Osgood
	Custom House, Santiago de Cuba	Roger Warner
1887.	In a Corn-field.	Edward Hooper estate
1889.	Deer in Canada Woods.	Edward Hooper estate
1892.	Adirondacks.	Edward Hooper estate
	In the Adirondacks.	Mrs. S. D. Warren
1894.	Surf at Prout's Neck.	Mrs. Orlando H. Alford
1895.	Men in Canoe.	Clement S. Houghton
	Indian Camp.	Museum of Fine Arts
	("Montagnais Indians, Point Bleue, Quebec.")	
	Trout Fishing.	Museum of Fine Arts
	Marine.	J. Reed Whipple & Co.
	Leaping Trout.	Museum of Fine Arts
1897.	Men in a Canoe.	Mrs. A. S. Bigelow
	Guide.	William P. Blake
?	Ouananiche Fishing in Lake St. John.	H. O. Underwood
	Three Men in a Canoe.	Mrs. James M. Longyear
	Mountain and Sky.	W. S. Bigelow
	Lumberman.	W. S. Bigelow
	Ouananiche, St. John River.	Hollis French
	Wild Ducks.	Mrs. Arthur H. Sargent
	Fishing.	Frederic H. Curtiss
	Shooting Rapids.	Mrs. J. J. Storrow
1902.	Canoes in Rapids.	Mrs. Orlando H. Alford
	Scene in the Adirondacks.	Dr. A. Coolidge, Jr.

DATE	TITLE	OWNER
1902.	Palms in a Storm, Key West.	*Greely S. Curtis*
1907.	The Portage.	*Desmond FitzGerald*
	Cliffs at Prout's Neck.	*Arthur B. Homer*

Black-and-White Drawings

DATE	TITLE	OWNER
1879.	Boy with a Stick.	*Mrs. Robert Osgood*
	Boy with Scythe.	*Horace D. Chapin*
	Boys Swimming.	*Horace D. Chapin*
1880.	Gloucester Harbor.	*Horace D. Chapin*
1881.	Wreck.	*Roger Warner*

("Wreck of the Iron Crown, Tynemouth, October 25, 1881.")

	Sketch.	*Edward W. Forbes*
	Fisherwomen, English Coast.	*Roger Warner*
1882.	Fisherwomen.	*William H. Downes*
	Fishing Vessels off Rocks.	*Roger Warner*
1884.	Woman in Storm.	*Francis H. Lee*

BIBLIOGRAPHY

BIBLIOGRAPHY

ANONYMOUS. An unsigned paper on Winslow Homer and F. A. Bridgman, in the *Art Journal*, London, August, 1878. American edition, pp. 225–227.

ANONYMOUS. *Descriptive Catalogue* of the Loan Exhibition of Paintings by Winslow Homer at the Metropolitan Museum of Art. New York: 1911. 53 pages.

ANONYMOUS. " Great Painters of the Ocean." *Current Literature*, New York, vol. 45, pp. 54–57.

ANONYMOUS. " Winslow Homer." *The Outlook*, New York, October 15, 1910, pp. 338–339.

BRINTON, CHRISTIAN. " Winslow Homer." *Scribner's Magazine*, January, 1911, pp. 9–23. 13 illustrations.

CAFFIN, CHARLES H. *American Masters of Painting* (New York: Doubleday, Page & Co., 1906), pp. 71–80.

CAFFIN, CHARLES H. *Story of American Painting* (New York: 1907), pp. 233–236.

CAFFIN, CHARLES H. " Winslow Homer's Marine Paintings." *The Critic*, New York, vol. 43, p. 548.

CHAMPLIN & PERKINS. *Cyclopedia of Painters and Paintings.* (New York: Charles Scribner's Sons, 1886), vol. 2, p. 285.

CHASE, J. EASTMAN. " Some Recollections of Winslow Homer." *Harper's Weekly*, New York, October 22, 1910, p. 13.

CLEMENT & HUTTON. *Artists of the Nineteenth Century and Their Works* (Boston: Houghton, Mifflin & Co., 1880), vol. 1, pp. 362–363.

COBURN, F. W. " Winslow Homer's Fog Warning." *New England Magazine*, 1908; New Series, vol. 38, pp. 616–617.

COFFIN, WILLIAM A. " A Painter of the Sea." *Century Magazine*, September, 1899, pp. 651–654.

COLE, W. W. " Crayon Studies, by Winslow Homer." *Brush and Pencil*, Chicago, January, 1903, pp. 271–276.

Cox, Kenyon. "Three Pictures by Winslow Homer in the Metropolitan Museum." *The Burlington Magazine*, London, November, 1907, pp. 123–124.

Downes, William Howe. *Twelve Great Artists* (Boston: Little, Brown & Co., 1900), pp. 103–125.

Downes, William Howe. "American Paintings in the Boston Art Museum." *Brush and Pencil*, Chicago, August, 1900, pp. 202–204.

Fowler, Frank. "An Exponent of Design in Painting." *Scribner's Magazine*, New York, May, 1903, pp. 638–640.

Hartmann, Sadakichi. *A History of American Art* (Boston, L. C. Page & Co., 1902), vol. 1, pp. 189–200.

Hearn, George A. *The George A. Hearn Gift to the Metropolitan Museum of Art in the City of New York in the Year MCMVI* (New York, 1906), pp. 191–197.

Hind, C. Lewis. "American Paintings in Germany." *The International Studio*, September, 1910, p. 189.

Hoeber, Arthur. "Winslow Homer, a Painter of the Sea." *The World's Work*, New York, February, 1911; pp. 14009–14017.

Howard, W. Stanton. "Winslow Homer's Northeaster." *Harper's Magazine*, New York, March, 1910, pp. 574–575.

Isham, Samuel. *The History of American Painting* (New York: The Macmillan Company, 1905), pp. 350–358, 408, 461, 462, 472, 475, 500, 501, 510.

McSpadden, J. Walker. *Famous Painters of America* (New York: Thomas Y. Crowell & Co., 1907), pp. 169–189.

Mechlin, Leila. "Winslow Homer." *The International Studio*, June, 1908, pp. cxxv–cxxxvi.

Mechlin, Leila. "Winslow Homer." *The Review of Reviews*, July, 1908. (A condensation of the foregoing article.)

Morton, Frederick W. "The Art of Winslow Homer." *Brush and Pencil*, Chicago, April, 1902, pp. 40–54.

Morton, Frederick W. *The Critic*, vol. 46, p. 323.

Muther, Richard. *History of Modern Painting* (New York: 1896), vol. 3, p. 482.

PACH, WALTER. "Quelques Notes sur les Peintres Américains." *Gazette des Beaux-Arts*, Paris, vols. 51–52, p. 330.

PATTISON, JAMES WILLIAM. *Painters since Leonardo* (Chicago: Herbert S. Stone & Co., 1904), pp. 199, 210–211.

SAINT-GAUDENS, HOMER. "Winslow Homer." *The Critic*, April, 1905, pp. 322–323.

SHELDON, G. W. *American Painters* (New York, 1879), pp. 25–29.

STRACHAN, EDWARD. *The Art Treasures of America.* Philadelphia: George Barrie, 1879.

TUCKERMAN, HENRY T. *Book of the Artists* (New York: 1867), p. 491.

VAN RENSSELAER, M. G. "An American Painter in England." *The Century Magazine*, November, 1883, pp. 13–20.

VAN RENSSELAER, MRS. SCHUYLER. *Six Portraits* (Boston: Houghton, Mifflin & Co., 1894), pp. 237–274. (An expansion of the magazine article mentioned above.)

INDEX

INDEX

ABBEY, E. A., 207, 243, 244.

Abbott, Jacob, 254.

"Academy Notes" (1884), 123.

Adams, E. D., 144; collection of, 231.

"Adirondacks," 265.

"Advance Guard — Crossing the Long Bridge, etc., The," 39.

"Afterglow, An," 265.

Albright Art Gallery, exhibitions, 243, 246.

Alexander, J. W., 207, 212, 256.

American Academy of Arts and Letters, 253.

American Art Association, 242.

"American Paintings in Germany," 246.

"American Type, The," 81.

American Watercolor Society, 56; exhibitions, 92, 94, 105, 106, 126, 146, 151, 162.

"Answering the Horn," 89.

"Anything for Me, etc.," 54.

"Appleton's Journal," 94.

"Approach of the British Pirate 'Alabama,' The," 46.

"Approach to the Rapids," 180.

"Approaching Tornado," 131.

"April Showers," 31.

Armour Institute of Technology, 208.

"Army of the Potomac, The — A Sharp-shooter on Picket Duty," 45, 46, 47.

"Army of the Potomac, The — Our Outlying Picket in the Woods," 43.

Arnold, Matthew, 125.

"Arrival at the Old Home," 31.

Art Institute of Chicago, 247; exhibition (1910), 142, 172.

"Art Interchange," 204.

"Art Journal," 34.

"Art Students and Copyists in the Louvre, etc.," 60.

"Art Treasures of America," 90.

"As You Like It," 64.

Associated Press, 252.

"At Sea — Signalling a Passing Steamer," 66, 67.

"At the Foot of the Lighthouse," see "Flight of Wild Geese."

"August in the Country — The Seashore," 31.

Avery, G. A., 66.

Avery, S. P., 55; S. P. Jr., 53.

Babbot, F. L., 245.

"Backgammon," 89.

"Bad Weather," 94.

Baker, J. E., 18, 27, 28, 29, 50, 60, 167, 238, 241, 242.

Ball, T. R., 48.

"Ballou's Pictorial," 29.

"Banana Tree," 129.

"Banks Fishermen," 137, 231, 258.

Banks, Governor, 32.

Barbizon School, 84.

Barlow, Colonel Francis C., 43, 56.

"Bathe at Newport, The," 30.

"Bather, The," 259, 261.

"Bathers, The," 73.

"Bathing at Long Branch, etc.," 66, 68.

"Battle of Bunker Hill, The, etc.," 80.

Beatty, J. W., 200, 201, 231.

"Beetle and Wedge, The," 25.

Bell, F. A., 187.

"Below Zero," 170, 171, 224, 247.

Benson, Eugene, 35.

Benson, F. W., 200, 201, 212.

Benson, George, 26.

Benson, John, 22, 23.

Benson, Sarah (Buck), 22.

Berenson, Bernhard, 170.

"Bermuda," 259, 260.

Bernheimer, E. H., 47.

"Berry Pickers," 74, 78, 259.

Bicknell, A. H., 70.

Bicknell, W. H. W., 184.

"Bivouac Fire on the Potomac," 40, 42.

Bixbee, W. J., 198.

Bixby, W. K., 219, 246.

"Black Bass, Florida," 225, 231.

"Blackboard," 89.

Blair, C. J., 82, 163, 232.

Bloomingdale, L. G., 208.

"Blue Ledge of the Hudson," 225, 231.

"Book," 89.

"Book of the Artists," 58.

"Boston American," 255.

Boston Art Club, 224; exhibitions, 171, 202, 212, 221.
"Boston Common, The," 30.
"Boston Globe," 265.
Boston Memorial Exhibition (1911), 53, 92, 94, 161, 197, 201, 256, 263.
Boston Public Library, 243.
"Boston Watering Cart, A," 29.
Boussod, Valadon & Co., 174.
"Boys Wading," 74, 75, 259.
"Breakwater, The," 106.
"Breezing Up," 90.
"Briarwood Pipe, The," 51.
"Bright Side, The," 52, 53, 54, 57, 58, 85, 91, 203, 257.
Brimmer, M., 129.
British School, 121.
Brooklyn Institute of Arts and Sciences, 243.
"Brush Harrow, The," 54.
Bryant, W. C., 96.
"Buccaneers, The," 130.
Bufford, 27, 28, 262; lithograph shop, 11, 25, 28, 29, 34.
"Building a Smudge," 231.
Burroughs, B., 55, 256.
"Busy Bee, The," 81.
Byron, 118.

Cabot, A. T., 95.
"Cadet Hop at West Point, A," 32.
Caffin, C. H., 54.
"Camp Fire, The," 95, 96, 165, 203, 257.
"Campaign Sketches," 49.
"Camping Out in the Adirondack Mountains," 79.
"Cannon Rock," 9, 177, 178, 179, 220, 231, 247.
"Canoeing in the Adirondacks," 162.
"Canoes in the Rapids," 203, 265.
"Cape Diamond," 181, 203.
"Cape Trinity — Moonlight," 230, 258.
Carnegie Art Gallery, 188; Institute, 200, 212, 219, 229; exhibitions, 82, 149, 161, 173, 187, 201, 203, 231.
"Carnival, The," 85, 87, 203.
"Castaway, The," see "Gulf Stream, The."
"Cavalry Charge, A," 44.
Century Club, 89.
"Century Magazine," 182.
"Channel Bass," 225, 231.
Chapin, Mrs. H. D., 126.
"Charge of the First Massachusetts Regiment . . . near Yorktown, The," 43.
"Charge of the Light Brigade, The," 98.
Charleston Exposition (1902), 220.

Chase, J. E., 152, 153, 240.
Chase, W. M., 35, 200, 207, 256.
"Children and Sail-Boat," 95, 264.
"Children Wading at Gloucester," 94, 264.
"Children's Christmas Party, A," 37.
"Chinese in New York, The," 78.
Chisolm, Mrs. B. O., collection, 231.
"Christmas Belles," 63.
"Christmas Out-of-Doors," 31.
"Christmas Tree, The," 31.
Church, Frederic E., 51, 57.
Church, F. S., 94.
Cincinnati Art Museum Association, 193; exhibition, 192.
Civil War, 3, 8, 53, 61.
Clarke, Sir C. P., 135.
Clarke, Thomas B., 47, 53, 72, 82, 87, 95, 126, 127, 133, 148, 163, 165, 174, 185, 187, 188, 203, 205, 206; collection, 101, 106, 130, 145, 154, 184; catalogue, 100, 101, 123, 145, 162; sale, 47, 53, 126, 148, 154, 156, 162, 163, 174, 184, 187, 204, 205, 232.
"Cloud Shadows," 153, 229.
"Club Canoe, The," 226.
"Coast in Winter," 154, 162, 165, 205, 232, 258.
"Coast of Maine, The," see "Maine Coast, The."
"Coasters at Anchor," 94.
"Coffee Call, The," 49.
Coffin, W. A., 81, 182, 183.
Cole, J. Foxcroft, 11, 27, 28, 29, 60, 61.
"Collector, The," 156, 161.
"Coming Away of the Gale, The," 106.
"Conch Divers," 130.
"Confederate Prisoners at the Front," see "Prisoners from the Front."
Copley Society of Boston, 212.
Corcoran Gallery of Art, 202, 231.
Cortissoz, R., 125.
"Cotton Pickers," 89.
"Country School, The," 70.
"Country School-Room, A," 91.
"Country Store, A — Getting Weighed," 66, 67.
"Country Store, The," 70.
"Course of True Love," 81.
"Courtin', The," 98.
Cox, Kenyon, 134, 179, 243, 256.
"Critic, The," 223.
"Crossing the Pasture," 70, 116.
Curtis, Mrs. G. K., 17, 18.
Curtis, Mrs. G. S., 95.
Curtis, Sidney W., 18.
Curtiss, F. H., 53, 263.
"Cutting a Figure," 66, 68.

"Dad 's Coming," 77.

"Dance, The," 31.

"Dance after the Husking, The," 31.

"Dancing at the Casino," 59.

"Dancing at the Mabille," 59.

"Danger," 145.

Darley, F. O. C., 254.

De Camp, Mrs. J., 241, 242.

"Deer-Stalking in the Adirondacks in Winter," 66, 67.

"Defiance," 48.

De Vine, B., 240, 241.

"Dinner, The," 31.

"Dinner Horn, The," 65.

"Diver, Nassau," 265.

Doll & Richards, 174, 185, 224, 226; gallery, 105, 126, 127, 136, 171, 193, 220, exhibition, 203.

"Dressing for the Carnival," 165.

"Driftwood," 245.

"Drive in the Central Park, The," 38.

"Driving Home the Corn," 31.

Duveneck, F., 193, 200, 207.

"Eagle Head, Manchester," 64.

"Early Evening," 229, 231, 243, 258.

"Early Morning After Storm at Sea," 214, 219, 224, 245.

"Eastern Point," 207.

"Eastern Point Light," 94.

"Eating Watermelons," 90.

"Eight Bells," 137, 146, 147, 148, 150, 151, 165, 183, 188, 189, 203, 205, 258, 267.

"1860–1870," 64.

Elkins, G. W., 126.

Emerson, R. W., 10, 76, 238, 239.

"Enchanted," 242.

"End of the Portage," 203.

"Entering the First Rapid," 203.

Ettlinger, L., 163, 231.

Evans, W. T., 87, 88, 171, 172, 201, 229; sale, 88, 171.

"Evening Post," New York, 135, 202, 262.

"Evening Transcript," Boston, 212, 236.

"Every Saturday," 66.

Ewart, R. H., 73.

Fair Oaks, Battle of, 44.

"Fair Wind, A," 90.

"Fall Games — The Apple Bee," 32.

"Fifth Avenue," 37.

"Fifty-ninth Street," 37.

"Fireworks on the Night of the Fourth of July," 62.

"Fisher Girl, The," 174, 231, 258.

"Fishermen's Wives," 265.

"Fisherwomen, English Coast," 265.

"Fishing," 265.

"Fishing Boats at Anchor," 94.

"Fishing Boats, Key West," 259, 261.

"Fishing Ground, The," 203, 204.

"Fishing, Upper Saguenay," 203.

"Flight of Wild Geese," 201, 232, 246, 263.

"Flirting on the Seashore and on the Meadow," 79.

"Flower Garden and Bungalow," 259, 260.

"Flowers for the Teacher," 81.

"Fly Fishing, Saranac Lake," 150, 151.

"Fog," 212.

"Fog Warning, The," 137, 138, 139, 165, 183, 232, 238, 258, 263, 267.

"Forebodings," 100, 101, 102, 103.

"Fountain, The," 98.

Fowler, F., 97, 169.

"Fox and Crows," see "Fox-Hunt, The."

"Fox Hill," 129.

"Fox Hunt, The," 168, 206, 207, 231, 248, 258, 267.

Freer, C. L., 154, 229; collection, 229, 231, 243.

"Fresh Morning, A," 90.

"From Richmond," 44.

"Gale, The," see "Great Gale, A."

"Gathering Berries," 78.

"Gathering Evergreens," 31.

"Gazette des Beaux-Arts," 57, 58, 223.

"General Thomas Swearing in the Volunteers . . . at Washington," 39.

Gest, J. H., 193.

Gibbs, F. S., collection, 48.

"Girl," 77.

"Girl in a Fog," 174.

"Girl with Letter," 264.

"Gloucester Boys," 94.

"Gloucester Harbor," 76.

"Gloucester, Massachusetts," 94.

Godwin, P., 73.

"Going Berrying," 264.

"Good Pool, A," see "Ouananiche — A Good Pool."

Gould, C. W., 138, 231, 256.

"Government Building," 265.

"Grand Review at Camp Massachusetts, . . . The," 32.

"Great Fair . . . New York, in Aid of the City Poor," 40.

"Great Gale, A," 156, 166, 205, 231.

"Great Russian Ball, The," 46.

Green, C. A., 242.

"Green Dory, The," 95, 264.

"Guide," 265.

"Guide, The," 181.
"Guides Shooting Rapids," 203.
"Gulf Stream, The," 132, 133, 134, 149, 204, 213, 214, 215, 218, 225, 229, 231, 247, 258.
Gunsaulus, Dr. F. W., 208.
Guy, Seymour J., 51.

Hall, R. C., 154.
"Halibut Fishing," see "Fog Warning, The."
Hamilton, W. H., 52.
"Hark! The Lark," 148, 149, 151, 152, 231.
Harper & Brothers, 34, 47, 98, 164, 243, 244.
"Harper's Weekly," 8, 29, 30, 31, 32, 37, 38, 39, 41, 43, 44, 45, 46, 54, 59, 60, 61, 63, 64, 65, 70, 71, 72, 73, 76, 77, 78, 80, 96, 164.
Harrison, A., 95.
"Hauling in Anchor," 192.
"Head Guide, The," 203.
Hearn, G. A., 133, 177, 178, 187, 219, 245, 256; collection, 174.
"Herring Fishing," 138, 165, 231.
"Herring Net, The," see "Banks Fishermen."
"High Cliff, Coast of Maine," 9, 114, 170, 172, 215, 217, 229, 232.
"High Sea, A," 181, 190, 191, 221, 258.
"Hillside," 91, 92, 259.
Hind, C. L., 246.
"History of the Second Army Corps," 44.
"Holiday in Camp — Soldiers Playing Football," 42, 54.
"Home from the War," 46.
"Home, Sweet Home," 47, 48, 49.
Homer, Arthur B., 22, 26, 43, 109, 115, 116, 145, 146, 227, 233, 235, 236, 250, 263.
Homer, Mrs. A. B., 115.
Homer, A. P., 115, 251.
Homer, C. L., 115, 227.
Homer, Charles S., 21, 22, 23, 24, 26, 27, 55, 70, 109, 115, 198, 199, 200, 253.
Homer, Charles S., Jr., 22, 24, 26, 64, 109, 110, 112, 115, 117, 145, 153, 166, 179, 211, 242, 251, 254, 255, 256.
Homer, Mrs. C. S., Jr., 115.
Homer, Eleazer, 22.
Homer, Henrietta Maria (Benson), 22, 23, 109, 253.
Homer, James, 22.
Homer, Captain John, 21.
Homer, Mary, 22.
Homer, Winslow, birth, 21; youth, 24; New York, 34, 46, 59, 87; Peninsular Campaign, 41; voyage to Europe, 56; trips to Adirondacks and New England, 59-85;

Virginia, 85; New England Coast, 94; England, 99; Prout's Neck, 109, 137, 181; Bahamas and Cuba, 129; Canada, 179; death, 250.
"Homeward Bound," 60.
Hooper, E. W., 126, 161; collection, 126; estate, 95.
"Hound and Hunter," 163, 165, 231, 258.
Howard, W. S., 178.
Howland, A. C., 34, 35.
Howland, Judge Henry, 34.
Hoyt collection, sale, 191.
"Hudson River at Blue Ledge," see "Blue Ledge of the Hudson."
Humphreys, Dr. A. C., 101, 149.
Huneker, 257.
Hunt, W. M., 3, 57.
"Hunter with Dog," see "Return from the Hunt."
"Huntsman and Dogs," see "Return from the Hunt."
"Husking the Corn in New England," 30.

"Ile Malin," 203.
"Incoming Tide, The," 100, 102, 103.
"Indian Boy," 204.
"Indian Camp," 203, 204, 265.
"Indian Girls," 204.
"In Front of the Guard-House," 51.
"Initials, The," 52.
"Inland Water, Bermuda," 221.
Inness, George, 3, 51, 202, 247.
"Inside the Bar," 100, 102.
International Society of Sculptors, Painters, and Gravers, exhibition, 159.
"International Studio, The," 246.
"In the Fields," 90.
"In the Garden," 77, 81.
"In the Rapids," 225.
"In the Twilight," 104.
Isham, Samuel, 11, 12, 93, 256.
"Item," Philadelphia, 135.

"Jessie Remained Alone at the Table," 98.
Johnson, Eastman, 3, 51, 121, 203.
Johnson, J. G., 154, 165.
Johnston, J. T., 55; collection, 61; sale, 55.
"Jurors Listening to Counsel, etc.," 63.
"Kissing the Moon," 223, 258.

Klackner, C., 150, 151, 152, 164.
Knoedler, R. F., 256; & Co., 171, 215, 224; galleries, 225, 245.
Kobbé, G., 56, 83.
Kurtz, C. M., 123.
La Farge, Mrs. B., 126, 161, 221, 232, 263.

La Farge, John, 3, 35, 36, 51, 56, 83, 84, 185, 200, 207, 212, 243, 244, 267.
"Lake Shore," 203, 204.
"Lake Tourilli," 181.
"Landscape," 81.
"Last Days of Harvest, The," 77.
"Last Goose at Yorktown, The," 47, 48, 49.
Laurvik, J. N., 61.
Layton, F., 149; Art Gallery, 149, 231.
"Lee Shore," see "On a Lee Shore."
Lehman, M. H., 87.
"Lemon," 89.
"Life Boat, The," 104.
"Life Brigade, The," 100, 103.
"Life in Harvard College," 29.
"Life Line, The," 120, 121, 122, 123, 126, 133, 137, 142, 150, 151, 183, 203, 205, 258.
"Light on the Sea, A," 202, 231.
Lincoln, Mrs. R. C., 201, 232, 246, 263.
"Little Arthur in Fear of Harming a Worm," 115.
"Little Charlie's Innocent Amusements," 115.
"Little More Yarn, A," 104.
"Lobster Cove," 64.
"London Art Journal," 57, 58, 90, 93.
"Lookout, The — All's Well!" 181, 182, 183, 184, 185, 201, 203, 205, 206, 207, 232, 258, 263, 267, 270.
"Lost on the Grand Banks," 137, 140, 142, 165, 183.
Lotos Club, 192, 220, 231; exhibition, 201.
Louisiana Purchase Exposition, art department, 224.
Lowell, J. R., 98, 254.
"Lumbering in Winter," 66, 67.
Luxembourg Museum, 59, 161, 207.

Macbeth, W., 248.
"Maine Coast, The," 9, 177, 181, 185, 186, 187, 190, 205, 206, 207, 219, 232, 258.
"Making Hay," 70.
"Manchester Coast," 62.
Manson, T. L., Jr., 162; Mrs., 206.
"Man Fishing in the Adirondacks," 225.
"Man with a Wheelbarrow, A," 25.
"Manners and Customs at the Seaside," 64.
Mansfield, B., 101, 175, 230, 231.
Mantz, Paul, 57.
"March Wind," 165.
"March Winds," 31.
"Marine on the Coast, A," 158.
"Market Boat," 129.
"Market Scene, The," 130.
Martin, Homer D., 35, 36, 247.
Martin, J. T.; collection, 242.

Mather, F. J. Jr., 262.
Matthews, N. C., 88.
McClellan, General, 40, 42, 53.
McKim, C. F., 243.
McMillin, E., 171, 220, 224.
McSpadden, J. W., 26.
Mechlin, Miss Leila, 13.
"Men in Canoe," 265.
"Mending the Nets," 150, 151, 161.
Merrill, Mrs., 75.
Merrill, M., 127.
"Merry Christmas and A Happy New Year, A," 37.
Metropolitan Museum of Art, 133, 134, 177, 178, 229, 231, 245, 247, 256, 259, 260; collection, 132, 179; exhibition, 55.
"Milking Time," 81.
"Mill, The," 70.
"Miller's Daughter, The," 98.
Millet, J. F., 12, 13, 58, 118.
"Moonlight," see "Summer Night, A."
"Moonlight, Wood Island Light," 170, 173, 179, 181, 205, 258.
Moore, F. P., 171, 247.
Morgan, Randal, 245.
"Morning," 90.
"Morning Bell, The," 77.
"Morning Walk, The, etc.," 62.
"Mt. Adams," 64.
"Mount Washington," 263.
"Mouth of the Tyne," 265.
Munsell, A. H., 266.
Museum of Fine Arts, Boston, 140, 184, 204, 205, 256, 267; collection, 233, 263.
"Musical Amateurs," 61.

National Academy of Design, 36, 48, 49, 51, 52, 56, 61, 62, 64, 71, 77, 89, 247, 256; exhibitions, 37, 52, 54, 70, 81, 92, 94, 95, 106, 120, 134, 138, 142.
National Gallery of Art, Washington, 87, 172, 229, 232.
"Native Cabin," 129.
"Natural Bridge, Nassau," 259, 260.
"Near the Queen's Staircase," 129.
"Negress with Basket of Fruit," 129.
"New England Country School, A," 71, 72, 73, 91.
"New England Factory Life — 'Bell Time,' " 62.
"New Year, The — 1869," 63.
"New York Charities," 78.
"New York Mail and Express," 82, 123.
New York Memorial Exhibition (1911), 74, 91, 166, 225, 256, 263, 265; catalogue, 154.
"News for the Fleet," 43.

"News for the Staff," 43.
"News from the War," 43.
"Newspaper Train, The," 43.
"Niagara," 57.
Nicoll, J. C., 88, 224.
"Noon," 129.
"Noon Recess, The," 72.
"Nooning, The," 73.
Norcross, G. H., 140.
Norcross, Miss, 140.
Norcross, O., fund, 140.
North Woods Club, N. Y., 226.
"Northeaster, The," 177, 179, 201, 219, 245, 246.
"November," 91.

O'Brien, M., & Son, 148, 162, 210, 213, 214.
"Old Mountain Philips," 83.
"On a Lee Shore," 9, 149, 177, 185, 190, 208, 209, 231, 258, 263.
"On the Banks — Hard-a-Port — Fog," 208.
"On the Beach — Two are Company, etc.," 71.
"On the Beach at Long Branch — The Children's Hour," 78.
"On the Bluff at Long Branch, etc.," 65.
"On the Cliffs," 161, 162.
"On the Fence," 92.
"On the Hill," 92.
"One Boat Missing," 106.
"Origin of Christmas, The," 37.
Osgood, J. R. & Co., 66, 98.
"Ouananiche — A Good Pool," 225, 231.
"Ouananiche, Lake St. John," 203.
"Ouananiche Fishing," 203.
"Our Next President," 62.
"Our Special Artist," 44.
"Our Thanksgiving," 31.
"Our Watering-Places — Horse-Racing at Saratoga," 54.
"Our Watering-Places — The Empty Sleeve at Newport," 54.
"Over the Hills," 90.

Page, William, 34.
Palfrey, General Francis W., 44, 94.
"Pall Mall Gazette," 159.
"Palm Tree, Nassau," 259, 260.
Pan-American Exposition, 212.
Paris International Exhibitions, 55, 57, 58, 72, 91, 206.
"Pay Day in the Army of the Potomac," 42, 46.
Pearce, Mrs. W. H. S., 63, 263.
Peninsular campaign, 40, 41, 42, 43, 46, 48, 49.

Pennsylvania Academy of the Fine Arts, 72, 171, 192, 219, 229, 232; collection, 170, 231; exhibitions, 179, 191, 208, 230, 245.
"Perils of the Sea, The," 100, 101, 102, 150, 259.
Philadelphia Watercolor Club, 232.
Philadelphia Centennial Exposition (1876), 74, 81.
Philpott, A. J., 265.
"Picardie," 61.
"Pike," 231.
"Pioneer, The," 221, 259, 261.
"Pitching Quoits," see "Zouaves Pitching Quoits."
"Pirate Boat, The," 226.
Pomroy, H. K., 95.
"Port of Nassau," 129.
"Portage, The," 265.
Potter, Mrs. J. B., 126.
"Prisoners from the Front," 54, 55, 56, 57, 58, 61, 82, 90, 258, 262.
"Prout's Neck, Maine," 233.
Prout's Neck Improvement Society, 110.
"Province of Quebec, The," 181.

"Rab and the Girls," 90.
"Raid on a Sand-Swallow Colony — 'How Many Eggs?'" 78.
Rainsford, Rev. W. S., 145.
"Rainy Day in Camp," 70.
"Rapids are Near, The," 203.
"Rapids below Grand Discharge," 203.
Rathbun, R., 87.
"Rations," 47, 53, 203.
"Rattlesnake," 89.
"Rebels Outside their Works at Yorktown," 43.
Reichard, G., 188, 189; & Co., 165; gallery, 156.
"Return from the Hunt, The," 161, 165, 221, 231, 232, 263.
"Return up the River, The," 203.
Rhode Island School of Design, 208, 231, 263.
"Right and Left," 244, 258.
"Road in Nassau, The," 265.
Robinson, E., 256.
Robinson, T., 57.
Rogers, Mrs. W. H., 191.
"Rolling Sea, A," 104.
Rondel, Frederic, 36.
"Rowing Homeward," 154.
Royal Academy, 121.

"Sail-Boat," 64.
"Sailing Dories," 264.
"Sailors Take Warning," 165.

Saint Botolph Club, exhibitions, 142, 180.
"St. John's Gate," 204.
Saint-Gaudens, A., 4, 243, 244.
"St. Valentine's Day — The Old Story in All Lands," 61.
"Salem Harbor," 64.
Sanford, H., 58.
"Santa Claus and His Presents," 31.
Sargent, J. S., 206, 207.
"Saved," see "Undertow."
"Sawkill River, Pa.," 64.
Sayles, H., 92.
Schaus, H., 148.
Schenck, A., 57.
Schieren, C. A., 243.
"School Time," 77.
"Schooners at Anchor," 94.
"Scotch Mist," 126.
"Sea Fans," 129.
"Sea on the Bar," 145.
"Searchlight, Harbor Entrance, Santiago de Cuba," 132, 231.
"Sea-Side Sketches — A Clam Bake," 73.
"Seesaw, Gloucester, Massachusetts," 79.
"Shall I Tell Your Fortune ? " 90.
"Shark Fishing, Nassau Bar," 131.
"Sharks," 225.
"Shell in the Rebel Trenches, A," 45.
"Shepherdess," 91, 259.
"Shepherdess of Houghton Farm, The," 92, 94.
Sherwood, J. H., 73, 91.
"Ship-Building, Gloucester Harbor," 76.
"Ship's Boat, The," 100, 104, 126.
"Shooting the Rapids," 225, 258, 265.
"Shore and Surf, Nassau," 259, 261.
Shurtleff, R. M., 35, 46, 83, 95, 162.
"Signal of Distress, The," 151, 152, 156, 158, 159, 183.
"Skating at Boston," 31.
"Skating in the Central Park," 37.
"Skating on the Ladies' Skating Pond in the Central Park," 37.
"Skating Season, The, 1862," 40.
"Sketch from Nature," 64.
"Sketch in Florida," 146.
"Sketch in Key West," 146.
"Sleighing Season, The — The Upset," 37.
"Sloop, Bermuda," 259, 261.
Smith, C. S., 90.
Smith, F. H., 89.
Smithers, F. S., 171.
"Snake in the Grass," 224.
"Snap the Whip," 26, 73, 74, 81, 91, 257.
"Snow Slide in the City, A," 37.
"Song Birds, Nassau," 129.

"Songs from the Writings of Tennyson," 97.
"Songs of the War," 39.
"Spanish Club," 265.
"Spanish Flag, The," 233.
"Sparrow Hall, Newcastle-on-Tyne," 229.
"Sponge Fisherman, Nassau," 128.
Spoor, J. A., 142.
"Spring," 243.
"Spring Blossoms," 65.
"Spring Farm Work — Grafting," 65.
"Spring in the City," 30.
"Station-House Lodgers," 77.
Stimson, L. A., 223.
"Storm-Beaten," 170, 171, 179, 189, 201, 220, 224.
"Storm on the English Coast," 265.
Stotesbury, E. T., 148.
Strachan, E., 90.
Strauss, N., 242.
"Street in Santiago de Cuba," 265.
"Studio, The," 61, 123, 203.
"Study, A," 61.
Sturgis, R., 130.
"Summer," 95.
"Summer Night, A," 9, 156, 157, 159, 160, 173, 181, 206, 207.
"Summit of Mount Washington, The," 62.
"Sun, The," New York, 135, 257.
"Sunday Morning," 77, 95.
"Sunday Morning in Virginia," 85, 88, 91.
"Sundown," 92, 94.
"Sunlight on the Coast," 154, 155, 165, 258.
"Sunset," 94.
"Sunset, Lake St. John," 203.
"Sunset, Saco Bay, The Coming Storm," 181, 191, 231, 258.
"Sunset and Moonrise," see "Kissing the Moon."
"Surgeon at Work, The," 44.
Swift, S., 82, 123.

"Taking on Wet Provisions," 259, 261.
"Tatler," London, 144.
"Tears, Idle Tears," 98.
Temple, J. E., 220; fund, 170.
"Tenth Commandment, The," 65.
"Thanksgiving Day, 1860," 38.
"Thanksgiving Day in the Army," 54.
"Thanksgiving in Camp," 42, 45.
Thomas, Washington B., The, 210.
"Three Fishermen and Girl," 265.
"Three Men in a Canoe," 265.
"Tornado, Bahamas," 259, 260.
Tourilli Club, 179, 181.
"Tribune," New York, 135.
"Trip to Chicoutimi, The," 203.

"Trout and Float," 231.
"Trout Fishing," 204.
Trumble, A., 156, 158, 159, 161.
"Trysting Place, The," 81.
Tuckerman, H. T., 58.
Turner, Ross, 135, 193.
"Two Guides, The," 82, 83, 90, 162, 165, 203, 232.
"Tynemouth," 100, 102, 103.

"Uncle Ned at Home," 81.
"Under a Palm Tree," 130.
"Under the Falls, Grand Discharge," 203, 204.
"Under the Falls, Catskill Mountains," 71.
"Undertow," 121, 137, 142, 143, 144, 150, 183, 231, 248, 258.
"Union Cavalry and Artillery Starting in Pursuit of the Rebels, The," 43.
Union League Club, New York, 16, 210, 218; exhibitions, 132, 202.
"Unruly Calf, The," 243.
Untermeyer, S., 156.
"Upland Cotton," 92, 93, 94.

Valentine, Lawson, 52.
Valentine, Mrs. L., 91, 265; collection, 74, 78.
Van Rensselaer, Mrs. S., 12, 124, 125, 143.
Vedder, Elihu, 51.
Velasquez, 5.
"View from Prospect Hill, Bermuda," 231.
"Visit from the Old Mistress, The," 85, 86, 87, 91, 95, 172, 203, 256.
"Voice from the Cliffs, A," 100, 102, 148, 149, 259, 267.
"Volante," 233.

"Waiting for a Bite," 79.
"Walk Along the Cliff, A," 104.
"Wall, A, Nassau," 259, 260.
"War for the Union, The, 1862 — A Bayonet Charge," 44.
"War, The — Making Havelocks for the Volunteers," 39.
Warner, C. D., 83.
Warner, Mrs. R. S., 126.
"Watching Sheep," 92.

"Watching the Breakers," see "High Sea, A."
"Watching the Tempest," 100, 101, 103, 259.
"Watch-Tower, The," 77.
"Watermelon Boys, The," 90.
"Ways and Means," 31.
"Weather-Beaten," see "Storm-Beaten."
Weir, John F., 35, 36, 81.
"West Wind, The," 9, 155, 156, 203, 205, 258.
White, Rev. S., 253.
White, W. A., 53.
"White Mountain Wagon," 64.
"White Mountains, The," 63, 64.
"Wicked Island," 203.
Wight, Moses, 29.
"Wild Ducks," 265.
"Winding the Clock," 94.
"Winter," see "Fox Hunt, The."
"Winter — A Skating Scene," 61.
"Winter at Sea — Taking in Sail," 62.
"Winter Morning, A — Shovelling Out," 66.
"Winter Quarters in Camp — The Inside of a Hut," 45.
Wolfe, Catherine L., 126.
"Wolfe's Cove," 204.
Woodward, Dr. G., 232.
Worcester Art Museum; exhibition, 1910, 201, 246.
"World's Columbian Exposition — The Fountain at Night," 258.
World's Fair, Chicago, 95, 165; exhibition, 138.
"Wounded," 43.
"Wreck, The," 181, 187, 188, 189, 231, 267.
"Wreck of the Atlantic, The — Cast up by the Sea," 72.
"Wreck of the Iron Crown, The," 104.
"Wreck off the English Coast," 265.
Wyant, A. H., 51.
Wyeth, Ned, 26.

"Yacht Hope, The," 94.
"Young Ducks," 203.
"Youth of C. S. H., The," 25.

"Zouaves Pitching Quoits," 52, 53, 263.

A CATALOG OF SELECTED
DOVER BOOKS
IN ALL FIELDS OF INTEREST

A CATALOG OF SELECTED DOVER
BOOKS IN ALL FIELDS OF INTEREST

DRAWINGS OF REMBRANDT, edited by Seymour Slive. Updated Lippmann, Hofstede de Groot edition, with definitive scholarly apparatus. All portraits, biblical sketches, landscapes, nudes. Oriental figures, classical studies, together with selection of work by followers. 550 illustrations. Total of 630pp. 9⅛ × 12¼.
21485-0, 21486-9 Pa., Two-vol. set $25.00

GHOST AND HORROR STORIES OF AMBROSE BIERCE, Ambrose Bierce. 24 tales vividly imagined, strangely prophetic, and decades ahead of their time in technical skill: "The Damned Thing," "An Inhabitant of Carcosa," "The Eyes of the Panther," "Moxon's Master," and 20 more. 199pp. 5⅜ × 8½. 20767-6 Pa. $3.95

ETHICAL WRITINGS OF MAIMONIDES, Maimonides. Most significant ethical works of great medieval sage, newly translated for utmost precision, readability. Laws Concerning Character Traits, Eight Chapters, more. 192pp. 5⅜ × 8½.
24522-5 Pa. $4.50

THE EXPLORATION OF THE COLORADO RIVER AND ITS CANYONS, J. W. Powell. Full text of Powell's 1,000-mile expedition down the fabled Colorado in 1869. Superb account of terrain, geology, vegetation, Indians, famine, mutiny, treacherous rapids, mighty canyons, during exploration of last unknown part of continental U.S. 400pp. 5⅜ × 8½. 20094-9 Pa. $6.95

HISTORY OF PHILOSOPHY, Julián Marías. Clearest one-volume history on the market. Every major philosopher and dozens of others, to Existentialism and later. 505pp. 5⅜ × 8½. 21739-6 Pa. $8.50

ALL ABOUT LIGHTNING, Martin A. Uman. Highly readable non-technical survey of nature and causes of lightning, thunderstorms, ball lightning, St. Elmo's Fire, much more. Illustrated. 192pp. 5⅜ × 8½. 25237-X Pa. $5.95

SAILING ALONE AROUND THE WORLD, Captain Joshua Slocum. First man to sail around the world, alone, in small boat. One of great feats of seamanship told in delightful manner. 67 illustrations. 294pp. 5⅜ × 8½. 20326-3 Pa. $4.95

LETTERS AND NOTES ON THE MANNERS, CUSTOMS AND CONDITIONS OF THE NORTH AMERICAN INDIANS, George Catlin. Classic account of life among Plains Indians: ceremonies, hunt, warfare, etc. 312 plates. 572pp. of text. 6⅛ × 9¼. 22118-0, 22119-9 Pa. Two-vol. set $15.90

ALASKA: The Harriman Expedition, 1899, John Burroughs, John Muir, et al. Informative, engrossing accounts of two-month, 9,000-mile expedition. Native peoples, wildlife, forests, geography, salmon industry, glaciers, more. Profusely illustrated. 240 black-and-white line drawings. 124 black-and-white photographs. 3 maps. Index. 576pp. 5⅜ × 8½. 25109-8 Pa. $11.95

THE ART NOUVEAU STYLE BOOK OF ALPHONSE MUCHA: All 72 Plates from "Documents Decoratifs" in Original Color, Alphonse Mucha. Rare copyright-free design portfolio by high priest of Art Nouveau. Jewelry, wallpaper, stained glass, furniture, figure studies, plant and animal motifs, etc. Only complete one-volume edition. 80pp. 9⅜ × 12¼. 24044-4 Pa. $8.95

ANIMALS: 1,419 COPYRIGHT-FREE ILLUSTRATIONS OF MAMMALS, BIRDS, FISH, INSECTS, ETC., edited by Jim Harter. Clear wood engravings present, in extremely lifelike poses, over 1,000 species of animals. One of the most extensive pictorial sourcebooks of its kind. Captions. Index. 284pp. 9 × 12.
23766-4 Pa. $9.95

OBELISTS FLY HIGH, C. Daly King. Masterpiece of American detective fiction, long out of print, involves murder on a 1935 transcontinental flight—"a very thrilling story"—NY Times. Unabridged and unaltered republication of the edition published by William Collins Sons & Co. Ltd., London, 1935. 288pp. 5⅜ × 8½. (Available in U.S. only) 25036-9 Pa. $4.95

VICTORIAN AND EDWARDIAN FASHION: A Photographic Survey, Alison Gernsheim. First fashion history completely illustrated by contemporary photographs. Full text plus 235 photos, 1840–1914, in which many celebrities appear. 240pp. 6½ × 9¼. 24205-6 Pa. $6.00

THE ART OF THE FRENCH ILLUSTRATED BOOK, 1700–1914, Gordon N. Ray. Over 630 superb book illustrations by Fragonard, Delacroix, Daumier, Doré, Grandville, Manet, Mucha, Steinlen, Toulouse-Lautrec and many others. Preface. Introduction. 633 halftones. Indices of artists, authors & titles, binders and provenances. Appendices. Bibliography. 608pp. 8⅜ × 11¼. 25086-5 Pa. $24.95

THE WONDERFUL WIZARD OF OZ, L. Frank Baum. Facsimile in full color of America's finest children's classic. 143 illustrations by W. W. Denslow. 267pp. 5⅜ × 8½. 20691-2 Pa. $5.95

FRONTIERS OF MODERN PHYSICS: New Perspectives on Cosmology, Relativity, Black Holes and Extraterrestrial Intelligence, Tony Rothman, et al. For the intelligent layman. Subjects include: cosmological models of the universe; black holes; the neutrino; the search for extraterrestrial intelligence. Introduction. 46 black-and-white illustrations. 192pp. 5⅜ × 8½. 24587-X Pa. $6.95

THE FRIENDLY STARS, Martha Evans Martin & Donald Howard Menzel. Classic text marshalls the stars together in an engaging, non-technical survey, presenting them as sources of beauty in night sky. 23 illustrations. Foreword. 2 star charts. Index. 147pp. 5⅜ × 8½. 21099-5 Pa. $3.50

FADS AND FALLACIES IN THE NAME OF SCIENCE, Martin Gardner. Fair, witty appraisal of cranks, quacks, and quackeries of science and pseudoscience: hollow earth, Velikovsky, orgone energy, Dianetics, flying saucers, Bridey Murphy, food and medical fads, etc. Revised, expanded In the Name of Science. "A very able and even-tempered presentation."—The New Yorker. 363pp. 5⅜ × 8. 20394-8 Pa. $6.50

ANCIENT EGYPT: ITS CULTURE AND HISTORY, J. E Manchip White. From pre-dynastics through Ptolemies: society, history, political structure, religion, daily life, literature, cultural heritage. 48 plates. 217pp. 5⅜ × 8½. 22548-8 Pa. $4.95

SIR HARRY HOTSPUR OF HUMBLETHWAITE, Anthony Trollope. Incisive, unconventional psychological study of a conflict between a wealthy baronet, his idealistic daughter, and their scapegrace cousin. The 1870 novel in its first inexpensive edition in years. 250pp. 5⅜ × 8½. 24953-0 Pa. $5.95

LASERS AND HOLOGRAPHY, Winston E. Kock. Sound introduction to burgeoning field, expanded (1981) for second edition. Wave patterns, coherence, lasers, diffraction, zone plates, properties of holograms, recent advances. 84 illustrations. 160pp. 5⅜ × 8¼. (Except in United Kingdom) 24041-X Pa. $3.50

INTRODUCTION TO ARTIFICIAL INTELLIGENCE: SECOND, EN-LARGED EDITION, Philip C. Jackson, Jr. Comprehensive survey of artificial intelligence—the study of how machines (computers) can be made to act intelligently. Includes introductory and advanced material. Extensive notes updating the main text. 132 black-and-white illustrations. 512pp. 5⅜ × 8½. 24864-X Pa. $8.95

HISTORY OF INDIAN AND INDONESIAN ART, Ananda K. Coomaraswamy. Over 400 illustrations illuminate classic study of Indian art from earliest Harappa finds to early 20th century. Provides philosophical, religious and social insights. 304pp. 6⅜ × 9⅜. 25005-9 Pa. $8.95

THE GOLEM, Gustav Meyrink. Most famous supernatural novel in modern European literature, set in Ghetto of Old Prague around 1890. Compelling story of mystical experiences, strange transformations, profound terror. 13 black-and-white illustrations. 224pp. 5⅜ × 8½. (Available in U.S. only) 25025-3 Pa. $5.95

ARMADALE, Wilkie Collins. Third great mystery novel by the author of *The Woman in White* and *The Moonstone*. Original magazine version with 40 illustrations. 597pp. 5⅜ × 8½. 23429-0 Pa. $9.95

PICTORIAL ENCYCLOPEDIA OF HISTORIC ARCHITECTURAL PLANS, DETAILS AND ELEMENTS: With 1,880 Line Drawings of Arches, Domes, Doorways, Facades, Gables, Windows, etc., John Theodore Haneman. Sourcebook of inspiration for architects, designers, others. Bibliography. Captions. 141pp. 9 × 12. 24605-1 Pa. $6.95

BENCHLEY LOST AND FOUND, Robert Benchley. Finest humor from early 30's, about pet peeves, child psychologists, post office and others. Mostly unavailable elsewhere. 73 illustrations by Peter Arno and others. 183pp. 5⅜ × 8½. 22410-4 Pa. $3.95

ERTÉ GRAPHICS, Erté. Collection of striking color graphics: *Seasons, Alphabet, Numerals, Aces* and *Precious Stones*. 50 plates, including 4 on covers. 48pp. 9⅜ × 12¼. 23580-7 Pa. $6.95

THE JOURNAL OF HENRY D. THOREAU, edited by Bradford Torrey, F. H. Allen. Complete reprinting of 14 volumes, 1837–61, over two million words; the sourcebooks for *Walden*, etc. Definitive. All original sketches, plus 75 photographs. 1,804pp. 8½ × 12¼. 20312-3, 20313-1 Cloth., Two-vol. set $80.00

CASTLES: THEIR CONSTRUCTION AND HISTORY, Sidney Toy. Traces castle development from ancient roots. Nearly 200 photographs and drawings illustrate moats, keeps, baileys, many other features. Caernarvon, Dover Castles, Hadrian's Wall, Tower of London, dozens more. 256pp. 5⅜ × 8¼. 24898-4 Pa. $5.95

CATALOG OF DOVER BOOKS

AMERICAN CLIPPER SHIPS: 1833–1858, Octavius T. Howe & Frederick C. Matthews. Fully-illustrated, encyclopedic review of 352 clipper ships from the period of America's greatest maritime supremacy. Introduction. 109 halftones. 5 black-and-white line illustrations. Index. Total of 928pp. 5⅜ × 8½.
25115-2, 25116-0 Pa., Two-vol. set $17.90

TOWARDS A NEW ARCHITECTURE, Le Corbusier. Pioneering manifesto by great architect, near legendary founder of "International School." Technical and aesthetic theories, views on industry, economics, relation of form to function, "mass-production spirit," much more. Profusely illustrated. Unabridged translation of 13th French edition. Introduction by Frederick Etchells. 320pp. 6⅛ × 9¼. (Available in U.S. only)
25023-7 Pa. $8.95

THE BOOK OF KELLS, edited by Blanche Cirker. Inexpensive collection of 32 full-color, full-page plates from the greatest illuminated manuscript of the Middle Ages, painstakingly reproduced from rare facsimile edition. Publisher's Note. Captions. 32pp. 9⅜ × 12¼.
24345-1 Pa. $4.95

BEST SCIENCE FICTION STORIES OF H. G. WELLS, H. G. Wells. Full novel *The Invisible Man*, plus 17 short stories: "The Crystal Egg," "Aepyornis Island," "The Strange Orchid," etc. 303pp. 5⅜ × 8½. (Available in U.S. only)
21531-8 Pa. $4.95

AMERICAN SAILING SHIPS: Their Plans and History, Charles G. Davis. Photos, construction details of schooners, frigates, clippers, other sailcraft of 18th to early 20th centuries—plus entertaining discourse on design, rigging, nautical lore, much more. 137 black-and-white illustrations. 240pp. 6⅛ × 9¼.
24658-2 Pa. $5.95

ENTERTAINING MATHEMATICAL PUZZLES, Martin Gardner. Selection of author's favorite conundrums involving arithmetic, money, speed, etc., with lively commentary. Complete solutions. 112pp. 5⅜ × 8½.
25211-6 Pa. $2.95

THE WILL TO BELIEVE, HUMAN IMMORTALITY, William James. Two books bound together. Effect of irrational on logical, and arguments for human immortality. 402pp. 5⅜ × 8½.
20291-7 Pa. $7.50

THE HAUNTED MONASTERY and THE CHINESE MAZE MURDERS, Robert Van Gulik. 2 full novels by Van Gulik continue adventures of Judge Dee and his companions. An evil Taoist monastery, seemingly supernatural events; overgrown topiary maze that hides strange crimes. Set in 7th-century China. 27 illustrations. 328pp. 5⅜ × 8½.
23502-5 Pa. $5.95

CELEBRATED CASES OF JUDGE DEE (DEE GOONG AN), translated by Robert Van Gulik. Authentic 18th-century Chinese detective novel; Dee and associates solve three interlocked cases. Led to Van Gulik's own stories with same characters. Extensive introduction. 9 illustrations. 237pp. 5⅜ × 8½.
23337-5 Pa. $4.95

Prices subject to change without notice.

Available at your book dealer or write for free catalog to Dept. GI, Dover Publications, Inc., 31 East 2nd St., Mineola, N.Y. 11501. Dover publishes more than 175 books each year on science, elementary and advanced mathematics, biology, music, art, literary history, social sciences and other areas.